CHINESE ART

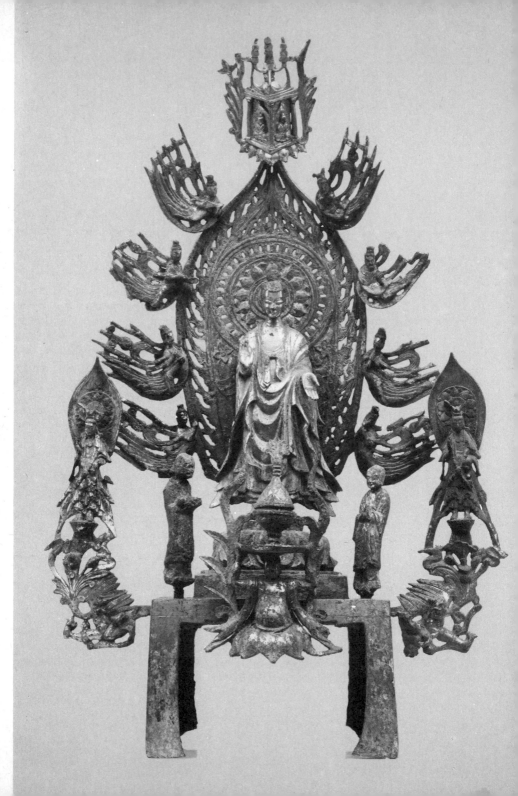

MARY TREGEAR

CHINESE ART

New York and Toronto
OXFORD UNIVERSITY PRESS
1980

Frontispiece. Gilt bronze Buddhist altarpiece. The standing Buddha in teaching *mudra* is flanked by Bodhisattvas and monks, and surrounded by flying *apsaras*. Such pieces were cast in sections and fitted together. Wei style. 6th century AD. (See p. 89)

© 1980 Thames and Hudson Ltd, London
All Rights Reserved

Library of Congress Cataloging in Publication Data

Tregear, Mary.
 Chinese art.
 (The World of art)
 Bibliography: p.
 Includes index.
 1. Art, Chinese. I. Title. II. Series: World
of art.
N7340.T73 709'.51 79–24744
ISBN 0–19–520189–2
ISBN 0–19–520190–6 pbk.

Printed in Great Britain by Jarrold & Sons Ltd, Norwich.

Contents

Introduction

The arts of a culture, however remote that culture may be from our own, are primarily to be enjoyed for their own sake. However, as expressions of a particular culture, they often reflect a unique aesthetic standpoint which we must seek to understand if we are to deepen our initial response to the arts in question. In attempting to trace such a standpoint, this short survey of the Chinese visual arts can but open the subject a little, for the visual arts have played several distinctive roles in China whose importance has varied with developments in Chinese culture itself.

In earliest times in China, Neolithic man's visual sense is revealed to us only in the shape and decoration of his pottery. Already familiar with the properties of clay, potters were inventing shapes which became established as part of a long heritage. Their decorative schemata, although distinctive to the period, show the sensitivity and judgment of scale which were to characterize Chinese decoration in succeeding centuries.

There followed a period of great hieratic art in the service of a Bronze Age culture of considerable duration and stature. This art was largely expressed in the form of cast bronze vessels and jade carvings. The shapes and decoration, marvellous in their own right, provide a vivid insight into a society for which symbols of ritual were the chief means of expression. With a loosening of theocratic controls, the hieratic symbols were adapted to serve a status-conscious feudal culture. The once-potent motifs on bronze vessels increasingly became avowedly decorative, and new techniques were developed to emphasize richness.

In the absence of any graphic expression, the works of craftsmen in metal, jade, lacquer and clay constitute our only indication of the nature of artistic life in late Bronze Age China. At the same time, in a visual culture still dominated by artefacts, calligraphy had already played an integral part in the form of cast inscriptions. Styles of writing developed and gradually, as longer inscriptions were cast into bronzes or cut into stone and bone, ideas of spatial composition emerged.

With the introduction of brush, ink and paper, calligraphers and painters took over the expressive arts. Calligraphers were the first to turn their attention to and develop a sophisticated brushwork, and with it criteria for compositional judgment. Painters took from them the skills of brush and ink

and at first used them to express narrative themes of myth and history. Later, painters explored a more poetic and allusive form of expression in landscape painting and more decorative compositions in bird and flower painting. The development of an expressive, graphic art by painters and calligraphers completely superseded all other artistic endeavours in esteem, and painting and calligraphy became the dominant visual arts in what was a pre-eminently literary culture.

In all its diverse forms – narrative, decorative and romantic – expressive painting was pursued both by professional painters and by scholar–painters (the so-called *literati*). This distinction between professional painters and scholar-painters is more than one of status. The professional painters, trained as portrait painters and decorative artists, produced a wide range of work intended for private houses, palaces and temples, and worked in ateliers. Their names are very rarely recorded and their work was not collected or preserved. The scholar, a member of the exclusive, educated class, rose within the examination system to official rank in the administration of the country. Part of his education was in calligraphy and often also in painting. Painting always ranked high among the cultural concerns of this group and many scholars were full-time or part-time painters. By tradition they did not sell their works, which were shown and given to friends. The scholar-painters were often at pains not to be confused with the professional painters and they even affected a gaucherie of brush style to emphasize the gap between themselves and the latter. The paintings which were avidly collected by connoisseurs are largely the works of scholar-painters.

In a complex milieu dominated by literature and painting, the scholar-painter evolved an ascetic form of ink painting which he supplemented with rich and rare crafts to provide colour and form. From a very early period there was a tradition of collecting and ardent connoisseurship by scholars, and the many and varied crafts of China came to occupy a place not far from the centre of 'high' artistic concern in the eyes of the cultured man, forming an integral part of his visual culture. Bronze and other metalwork, jade carving and pottery formed the major complement to painting. Sculpture, introduced with Buddhism, played a much lesser role; it was only rarely pursued by Chinese artists and patrons for other than Buddhist or ceremonial settings.

In summary, the Chinese visual arts gradually evolved in response to Neolithic, theocratic and feudal society to find·their most distinctive expression in painting, an art closely linked to a strong literary tradition, and further surrounded and extended by a rich tradition of decorative and applied arts.

Neolithic Period

c. 5th millennium–18th century BC

This is of necessity a wide date. Current archaeological work is extending the period backwards in time. The relative dating of the many groups of distinctive settlements in this period is also not definitive.

Shang Dynasty

1766–1111 BC

It seems clear from archaeological investigations to the present that the major Shang settlements were in the Yellow River Valley area and that the longest established Shang capital was at Anyang (1384–1111 BC). However, the long time span sees an enlargement of the territory of the Shang state and the spread of Shang influence over a very wide area, as is shown by finds in the south-west.

Chou Dynasty

1111–221 BC

Western Chou	1111–771
Spring and Autumn Annals	
(Eastern Chou)	771–481
Warring States	481–221

As can be seen from the subdivisions, this was not a settled period. The title Spring and Autumn Annals for the period 771–481 BC is a literal translation of the title of the official history of the period; such histories exist in unbroken series from the Han Dynasty onwards. The division between Western and Eastern Chou marks the move of the capital from Ch'angan to Loyang. The proliferation of states, a result of the organization of the Chou Dynasty, led to a period of eventual disintegration, graphically called Warring States, in which one of the dominant states was the Ch'u.

Ch'in Dynasty

221–206 BC

A short period dominated by the first Emperor, Shih Huang-ti ('First Yellow Emperor'), who unified the country. In the course of this unification he established an internal communication system, started the Great Wall, as we know it today, as a means of defence against the nomads of the north, and suppressed the scholars and the Classics as divisive influences. In many ways the Ch'in Dynasty created the conditions which allowed the Han Dynasty to prosper.

Han Dynasty

206 BC–AD 221

Western Han	206 BC–AD 12
Hsin	12–23
Eastern Han	25–221

One of the major dynasties. A period of great geographical expansion in which Chinese influence spread west into Central Asia, north to Korea, and south towards the Malaysian peninsula. The division between Western and Eastern Han again marks the move of the capital from Ch'angan to Loyang. The short break, AD 12–23, marks a usurping reign. Buddhism was introduced to China during the Han Dynasty.

Northern and Southern Dynasties

219–580

Northern:
Northern Wei 386–532
Western Wei 535–554
Southern:
Western Chin 219–316
Eastern Chin 317–419
In the north, the Toba Turkic Wei people established a state. The first capital was at Lanchow, near Tun Huang, and the second capital at Ta T'ung; both of these are Northern Wei capitals. When the capital was moved south to Ch'angan, the state took the title of Western Wei.

Sui Dynasty

581–618

Another short period of unification.

T'ang Dynasty

618–906

Another expansionist dynasty. A period of enormous vitality, especially in the seventh and eighth centuries. T'ang boundaries extended into Asia and north China became a cosmopolitan society. Culturally this is a rich period in music, literature and the visual arts.

Five Dynasties

907–960

Following a recurrent pattern, the organization of the huge country broke down in this period, and many states emerged in uneasy independence.

Liao Dynasty

907–1125

A state to the north of the Manchu border which is often included as a Chinese dynasty. It is culturally interest-ing as a link between Korea and north China.

Sung Dynasty

960–1279

Northern Sung 960–1127
Southern Sung 1128–1279
(Chin 1115–1234)
At first, with the capital at Kaifeng, this was a period of great aesthetic richness. An invasion from the north-west defeated the state, but although the Chin Turkic invaders set up their own capital at Peking, the Chinese court fled south and established the Southern Sung state with its capital at Hangchow in 1128.

Yüan Dynasty

1260–1368

The divided country was overrun once again from the north-west and unified by the Mongols of Genghis Khan. The ensuing Yüan Dynasty was one of the two foreign dynasties in the history of China and ruled for less than one hundred years, with its capital at Peking.

Ming Dynasty

1368–1644

Reign titles:

Hung Wu	1368–1398
Chien Wen	1399–1402
Yung Lo	1403–1424
Hsuan Te	1426–1435
Cheng T'ung	1436–1449
Ching T'ai	1450–1457
T'ien Shun	1457–1464
Ch'eng Hua	1465–1487
Hung Chih	1488–1505
Cheng Te	1506–1521
Chia Ching	1522–1566
Lung Ch'ing	1567–1572
Wan Li	1573–1619
T'ai Ch'ang	1620
T'ien Ch'i	1621–1627
Ch'ung Cheng	1628–1643

This began as a triumphant return to native rule. Peking was established as the capital, inheriting the palace sites of both Chin and Yüan. The Forbidden City site was laid out and at least partly developed as the home of the immediate Imperial family and the administrative centre of the country. It had long been the custom for Chinese emperors to give a name to their reign, sometimes more than one. In the Ming Dynasty, which had sixteen reigns, the reign title was often inscribed on ceramics or lacquer to identify and date the piece. The name was not that of the person of the emperor, but of his reign period; the emperor had his own personal and official names.

Ch'ing Dynasty

1644–1911

Reign titles:
Shun Chih	1644–1661
K'ang Hsi	1662–1722
Yung Cheng	1723–1735
Ch'ien Lung	1736–1795

Chia Ch'ing	1796–1820
Tao Kuang	1821–1850
Hsien Feng	1851–1861
T'ung Chih	1862–1874
Kuang Hsu	1875–1908
Hsuan T'ung	1909–1912

Again a foreign dynasty. This time the invaders were Manchu coming south through the north-east corridor. They also set up their capital in Peking and rebuilt the Forbidden City, which had suffered much in the disorders at the fall of the Ming. The Ch'ing Dynasty had a total of ten reigns, of which three – K'ang Hsi, Yung Cheng and Ch'ien Lung – were the most distinguished and provided the major cultural activity of the period.

The Republic of China

1912–1949

The People's Republic of China

1949 to the present

Neolithic Crafts
c. 5th millennium—18th century BC

In the subcontinent of China there were Neolithic peoples settled over a wide area, along the valleys of the Yellow River and its tributaries, on the marshy plains of present-day Shantung, and southward along the coast to the Yangtse and beyond. At least from the fifth millennium BC these diverse peoples inhabited villages, tilled the land, hunted and fished. Very early on they domesticated the pig and the dog, and made pots and simple stone and bone implements. Their visual taste can now be judged only from the shapes and decoration of their pottery. As far as we know, no wall paintings or carvings from the Neolithic period exist, and it seems that the artists of these communities were the potters. They made coiled, slab and modelled pots in a low-fired earthenware, in an ever increasing variety of shapes. In most Neolithic communities two qualities of pot were made. The everyday, cord-impressed grey ware is ubiquitous; but pots of finer technique and decoration are also found. The earlier pots of the Shensi region (fifth to fourth millennia BC), and those of the north-westerly communities (third to second millennia BC), were smoothed, burnished and painted in slip colours of black, red and white; to the east and south the contemporary Black Pottery people made undecorated wares in exotic shapes.

A picture, as yet incomplete, of the long period from *c.* 4000 BC to *c.* 1700 BC shows early settlements in the central Yellow River Basin and in the Wei River Valley. The most completely preserved site of the Yellow River Neolithic peoples is at Pan P'o, near present-day Sian, where a large riverside village has been excavated and preserved. Inhabited, probably in two phases, over a long period (*c.* 4000–3000 BC), the Pan P'o site comprises a spreading settlement, with a defined dwelling area consisting of small round houses and a community house, a burial area away from the village, and a potters' area with simple up-draught kilns. The Pan P'o potters used the distinctive decorative motifs which have earned this whole culture (originally identified at the Yang Shao site) the title of 'Painted Pottery'. Probably of a symbolic significance which can only be guessed at today, the fish and the human head with three-pointed 'halo' motifs of Pan P'o move slowly towards abstraction. This movement from representation to abstraction is repeated in much of the other Painted Pottery decoration of north China. It can be seen, for instance, in the flower motifs of Honan. Here

1 Single shouldered polished stone axe head. Designed to be mounted on a wooden handle and used either for chopping or as a chisel. From Ho-yin, Honan. Neolithic period.

the sinuous movement of the motif complements the profile of the pot in a way which makes it clear that it was deliberately chosen by the decorator. The potters of the Chinese subcontinent have retained their concern for unity of shape and decoration, and in this sense the pottery of the Neolithic period should be regarded as part of a long tradition which has continued in China up to the present day.

Perhaps the most dramatic creations of the Painted Pottery decorators were the pots of the later western Neolithic settlements of the T'ao River in Kansu. Here a Neolithic culture related to the Wei River settlements survived even into historic times. The finds from Pan Shan, Ma Ch'ang and Hsin Tien all show elaborate and rich decoration in the traditional black, red, and occasionally white, line-drawn decoration. Swirling and geometric motifs exist alongside representational animal motifs. The progression from representation to abstraction seems to be complex and uneven. The colours are drawn in thick and thin lines, and space-filling motifs and solid colour are also used. It is thought that these pots were painted with the frayed stump of a piece of wood or bamboo, the brush being a later invention.

5, 6
37

The similarities between the Kansu decoration and other Neolithic decoration in Western Asia raise questions about the origins of the Kansu culture: did its source perhaps lie across the Central Asian desert? Recent scholarship in China favours its native origin, partly on the grounds of the later date (c. 3500–1700 BC) of the sites of north-westerly China. The archaeological sites of central China being all considerably earlier in date (c. 5200–3500 BC), the movement of culture seems to be from the centre towards the north-west. The whole question of the sequence of Neolithic cultures in China is gradually becoming clearer, and it is now possible to place the Painted Pottery decorators of the central Yellow River as earlier than the Black Pottery people (c. 3500–2000 BC) of the Shantung and the south-easterly area. Although the Painted Pottery and Black Pottery peoples appear in some places to have been contemporary, there seems to exist no evidence in support of the theory that one derived from the other.

13

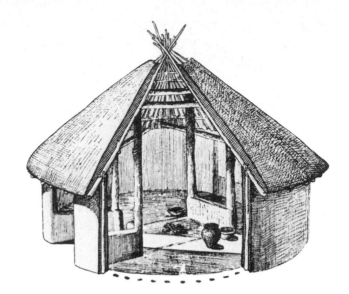

2 Reconstruction of a circular hut of the type excavated at Pan P'o, Shensi. The huts were constructed on a system of posts, for which the holes have been found. It is thought that the walls and roofs were of wattle and thatch.

3 Excavation of a circular hut foundation at Pan P'o. Subsidiary pits seem to indicate craft activity, such as pottery, close to the dwelling houses.

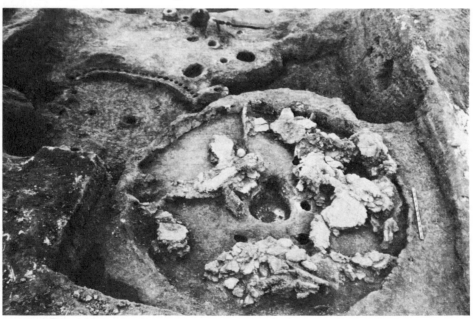

4 Buff earthenware basin with dark slip-painted decoration. A human face, with three-pointed 'halo', is associated with a geometric shape, an abstraction of two confronted fish. From Pan P'o, Shensi. 5th–4th millennium BC.

5 Large burial urn of burnished red earthenware, painted in black and purple slip in swirling designs. Pan Shan type, from Kansu. 3rd millennium BC.

The Black Pottery people, first identified at the Ch'eng Tzu Yai site in Shantung, populated a large area spreading from the east coast into the loess area of fertile wind-blown soil of the central Yellow River Basin. Like the Painted Pottery people, they lived in villages with defined craft and burial areas. Although the media of their crafts were principally bone, stone and pottery, it seems, from burial imprints (where the surrounding earth has taken up the imprint of an object which has disappeared in burial), that these early people also made baskets of some distinction and probably wove simple cloth. The archaeological evidence, however, does not allow any judgment of the artistic quality of this craft work. Once again, the potters seem to have been the only artists as far as we know. They made at least two qualities of pots. The everyday, cord-impressed wares, which are very similar to those of their western neighbours, are grey and potted in a variety of cooking and storage shapes. The special quality wares are distinguished by an absence of decoration; they are made in a paper-thin, brittle, fine-grained earthenware, potted in a wide range of intricate and often multi-sectioned shapes, and baked either black or red and burnished. Whereas the Painted

6 (*below*) Footed *tazza* of burnished red earthenware, painted in black slip in waving and swirling designs. From Lanchow, Kansu. Late 3rd millennium BC.

7 (*right*) Tall beaker of thin burnished black pottery. A shape which is unique to the eastern area of the Black Pottery culture. From Wei Fang, Shantung. 3rd or early 2nd millennium BC.

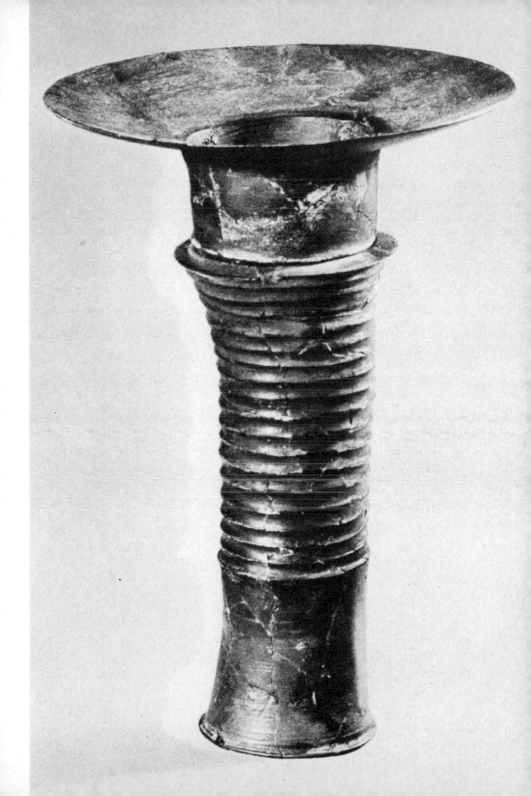

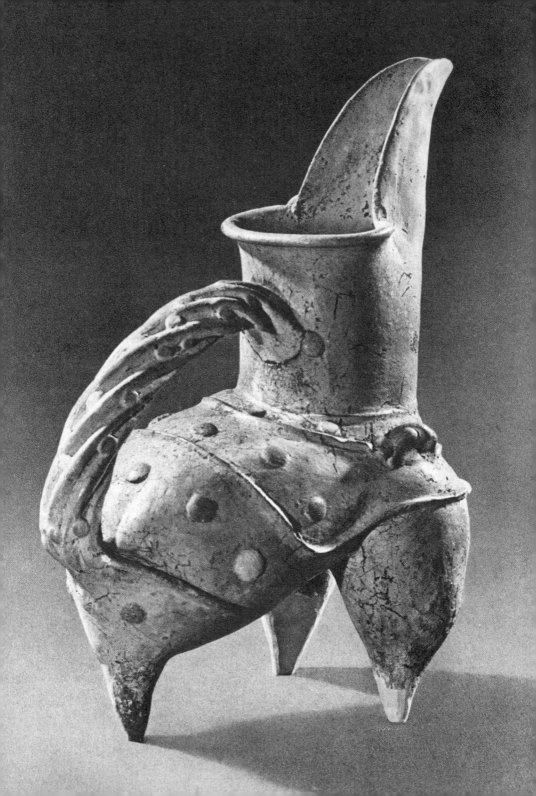

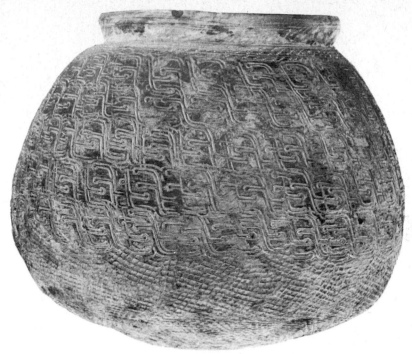

8 (*left*) White pottery tripod jug. Another shape peculiar to the east, which seems to be a replica of a vessel made in another material. The bag-leg tripod shape is carried through into the Bronze Age. From Wei Fang, Shantung. 3rd or early 2nd millennium BC.

9 (*above*) Impressed 'double F' decorated round-based jar. The unglazed mottled buff body is relatively high-fired and the decoration is stamped with a die; the walls are much distorted. From Wu Hua, Kwangtung. Late Neolithic or Bronze Age period.

Pottery people had used a restricted range of bowl and jar shapes for their more elaborate wares, the Black Pottery people extended the range to include spouted jugs with handles, tall beakers, straight-sided pots and tall stemmed cups. A variety of methods was required in the making of these pieces, which seem, in some cases, to suggest even a replica of a vessel made originally in another material. The three-legged jug with the 'studs' at the fixing of the handle and to each side of the lip is perhaps such a case. This kind of imaginative potting moves right away from the pottery decorators' art; here the potter is concerned solely with form and profile. This concentration on invention of form seems to be accentuated by the use of an impractical and fragile material; for these vessels could have been of ritual or decorative

7

8

use only. No comparable artist–potter tradition was attained again in China for several centuries.

Contemporary with the Black Pottery people, and outlasting them in the more remote areas, was a group of people who appear to have made their home on or near water. They lived around the mouth of the Yangtse, down the coast and along the river valleys. Again, pottery constitutes their only claim to artistic production. They made squat jars and dishes of very simple shape. In the grander pieces they used a noticeably harder, higher–fired ware. The surface decoration of these pieces is carried out in impressed geometric motifs covering the wall of the pot, creating a surface texture and richness which is something entirely new. The clay, and the firing used, produced a surface which, while not a true glaze, is smooth and needs no burnishing. From the point of view of ceramic technology this southern culture is of great significance in the consideration of later styles, for it was in the higher–fired wares that Chinese potters were to achieve their finest productions.

There is no doubt that even at this very early period, before the advent of metal and higher civilization to China, there existed a richness and variety of artistic expression. Although there is little evidence to suggest a direct relationship between any one of these Neolithic cultures and the Bronze Age people who followed, there are enough links, particularly between the Black Pottery people and the people of the Yangtse Delta, to hint at technological and artistic continuities amongst the craftsmen.

Hieratic Art and the Bronze Age
18th–12th centuries BC

As the Shang Dynasty (1766–1111 BC) gained control of a large area of north China, technological and cultural changes demanded innovation of the artist-craftsmen. The date and nature of the introduction of bronze and bronze casting techniques to China is not yet documented in archaeological studies. It is assumed to coincide with the rise of the Shang Dynasty. The date given for the start of the dynasty is computed from written records, but the earliest sites have not yet been identified archaeologically. In the face of these unresolved problems, theories have been proposed outlining possible solutions. As the Bronze Age came relatively late to China, Western-trained archaeologists have been tempted to trace its source outside China, adopting a theory of cultural drift. The supposition of a movement of peoples from Central Asia, entering China from the north-west through the Kansu corridor, is not acceptable, however, partly because of the extended Neolithic culture of those areas (including Kansu) in which Painted Pottery settlements continued to the end of the Shang period, with no signs of Shang state culture. Some scholars have given weight to a possible influence from the far north, where there was a bronze-casting tradition in the Lake Baikal area; here again the route of entry proposed is through the north-east corridor. However, there is today a growing body of evidence to support the theory of a spontaneous development of Bronze Age culture in China, a development dependent on technology from the south-east.

Whichever theory may emerge as correct, it is clear that the Chinese craftsmen made an entirely individual contribution to bronze technology, using an alloy which is peculiar to China and a technique of casting by multiple-piece moulds which they brought to an unusual complexity. Bronze is a variable alloy of copper and tin, of which the major component is copper. To this alloy the Chinese metal-workers added lead. The reason for the addition of lead is not evident, but it may have been to improve the pouring quality of the molten alloy. The addition of lead imparts a greyness to the sheen which is typical of most Chinese bronzes. The use of this unusual alloy seems to indicate a native understanding of smelting of metallic oxides. As all the constituents of the alloy must be prepared separately, there is no question of a mixed ore being found naturally; the scattered presence of copper and tin, and the relative concentration of lead in the remote south-

west of China, also point to a knowledge of the materials required and systematic collection of these materials from a wide area. Furthermore, the method of forming the objects is quite distinctive. There is no evidence that metal was ever prepared by beating and, thus far, no copper vessels have been found. The Chinese either adopted or themselves arrived at the technique of casting from the start. As mentioned above, the method favoured was by piece mould. The original model was probably constructed in clay; from this model, clay moulds were made in multiple sections which could be reassembled and keyed together to produce the final mould into which the molten bronze was poured for casting. The Chinese undoubtedly also used the 'lost wax' or *cire perdue* method by which the matrix is made in wax; here the matrix is coated with clay, the wax melted out, and the molten bronze poured into the resulting clay mould. In the process matrix and mould are both lost, but this is the only method by which intricate undercut and pierced work can be cast. At present it is thought that the Chinese craftsmen used the 'lost wax' method only in later times and then only when the nature of the piece required it.

The Shang rulers possibly came from a tribe inhabiting the central Yellow River Valley area. At the head of the Shang state was a god-king whose control was exercised through ritual, oracle-taking and warfare. It is clear from archaeological evidence that ritual lay at the heart of Shang society: it permeated most aspects of life for the ruling caste and it naturally required the service of the arts. The Shang craftsmen and designers adapted themselves to the special requirements of the theocratic regime and to the new material at their disposal, creating a style to express an unmistakable code of ideas, coherent and compelling, but not completely comprehensible today. Most of our information about Shang culture is derived from excavations of capital cities and of the elaborate pit-burials of the rulers, whose equipment and regalia were buried with them for future use in an after-life. There is no evidence of artistic activity, not even of folk pottery, for other than the rulers.

The oldest Shang city site (sixteenth century BC) is at Cheng Chow, where the early capital of Ao was sited. Here a simple walled city was found with

10, 11 differentiated craft areas for bronze casting, stone carving and pottery. A large central house, perhaps a palace, dominates the dwelling section and the whole lay-out is orientated north to south. The bronze objects found here were in the early Shang style, frail and relatively poorly cast, but complex in form. The extensive burial site at Hsiao T'un, Anyang (*c.* 1384–1111 BC), was first excavated in China in 1927. This mid-Shang Imperial burial ground, in use over many centuries, is the source for the majority of the finds of the period. The excavations, continuing today, have so far revealed no dwelling

areas and no city wall, but an extensive bronze foundry site and craft areas, a ceremonial hall and a series of rich burial sites. It has consequently been postulated that this is not a dwelling site, but may have been the royal burial site for another capital city. While this remains an attractive idea, it raises the question of the identity of the site of the later Shang capital, for the Shang was a tightly controlled state whose capital would have been of great importance, and no other city has been recorded. However, from present-day excavations it is becoming clear that the Shang, from the fourteenth to twelfth centuries BC, extended their influence over a wide area of China. Shang finds in Yunnan, in the far south-west, are the latest in a series which changes the traditional picture of this dynasty as a geographically compact one.

There exist numerous examples of the ritual possessions of the king and those of his personal household. The most durable buried objects were of bronze and jade, but we know that, like the Neolithic peoples whom they had conquered, the Shang also used painted and carved wooden beams in architecture, and wove textiles and baskets all of which is evidenced only by burial imprints. Stone carving is very rare. Bronze was the new material on which craftsmen lavished such skill that by the fourteenth century BC they were producing hauntingly grand vessels.

As we have seen, the Neolithic potters of the east had already experimented with vessels of complex shape, and although there is no evidence that they were familiar with casting techniques, either they, with their skill in handling clay, or their neighbours further south, with their technique of producing a higher-fired impressed ware, may have mastered the craft of making first the model and then a mould in sections. As art objects the Shang vessels have such distinction that one easily overlooks the technical skill required in their construction, in admiration of the richness of their shapes and decoration. The shapes, which seem to have been demanded for ritual usage, are derived in many instances from the Black Pottery vessels, but in metal these shapes take on a monumental character. The Shang vessels are not large but they are so proportioned and decorated as to demand attention. The shapes were named and classified and, by the fourteenth century BC, had become 'classic'; the decoration of the surface, cast into the vessel with very little added tooling, shows an ever-growing richness.

The development of hieratic motifs is so impressive that it cannot rightly be called 'decoration' any longer. It amounts rather to an expressive art and it is one of the great achievements of the Shang designers. The seventeenth-century BC bronze vessels, from the site at Cheng Chow, while clearly not the earliest experiments of the Shang bronze caster, show a simple form of thread and low relief decoration, laid in a band around the body of the piece.

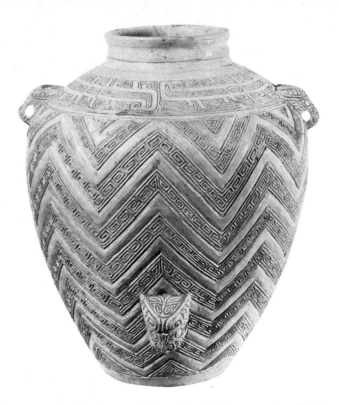

10 White pottery jar. The impressed decoration is in bronze style, with *k'uei* round the shoulder and horned mask cartouches. The body is of a pure white clay of very high Kaolin content. From Anyang, Honan. 14th–13th century BC.

This style quickly developed to embrace an elaborate relief treatment of the whole of the surface of the vessel. It is, however, typical of Shang decoration that it is designed to be arranged in horizontal zones around the vessel. The scale of the decoration, as it becomes more and more complex, is finely judged. The use of thread relief gives way to a shallow relief, set off against a background itself covered all over with a squared whorl known as *lei-wen* or 'thunder spiral'. Precision of line, indeed slight undercutting to achieve a clean line even in this background motif, is a characteristic feature of the fourteenth-century BC pieces.

The basic motifs for the decoration are animal. There is a dichotomy of themes apparently operating contemporaneously: the so-called 'realistic'

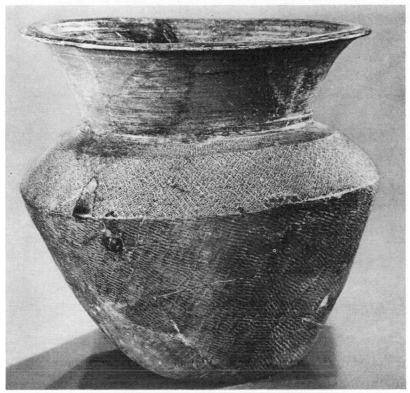

11 Impressed stoneware jar with wide flaring lip and angled shoulder. The geometric impress motif is covered by a high-fired glaze. The earliest example of glazed stoneware. From Cheng Chow, Honan. 16th–15th century BC.

style, by which is meant the use of representational masks and features of non-mythical subjects – human faces, deer and elephant heads – contrasts *15* with the equally vivid representation of mythical animals. These two themes sometimes appear on the same object, resulting in a rather weird effect, *18* which, however, seems to evoke the original symbolism more strikingly than on those objects in which one style or the other is used alone. There seems no reason to suppose a significant transition from one style to the other. As the vessels with which we are concerned were all meant for ritual use, it is probable that there is a meaning in the decoration. It is thought that the readily recognizable representations refer to the animals associated with the sacrifice for which the vessel was prepared. The question of the mythical

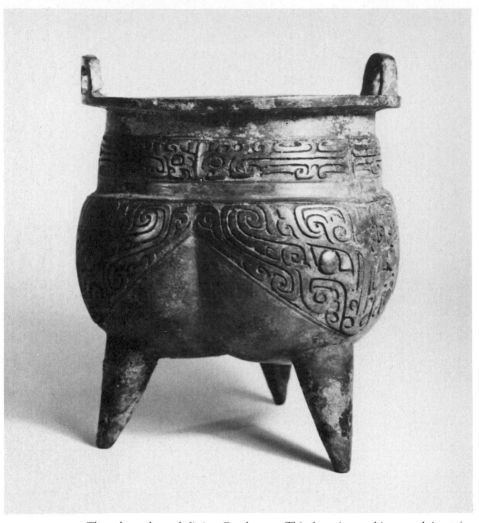

12 Three-legged vessel, *li-ting*. Cast bronze. This shape is a cooking vessel; it retains the hollow legs of earlier pottery (see Pl. 8). Decoration is composed of *k'uei* in flat raised relief. 14th century BC.

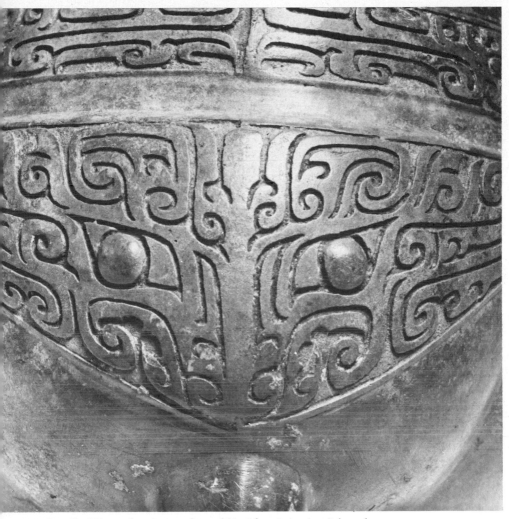

13 Detail of Pl. 12, showing confronted *k'uei* forming a *t'ao-t'ieh* mask.

motifs is more difficult. The all-pervading *t'ao-t'ieh* mask, with its protruding eyes and ferocious upper jaw, must represent something important in terms of the rituals, which we know were much concerned with blood sacrifices; it has been thought to be a symbol of gluttony or simply a terror mask. Even less easily interpreted are the small *k'uei*, loosely translated as 'dragons', small two-legged animals with a clearly visible snout, ears and a short curved tail. *K'uei* constitute the chief element in the main zone of decoration, sometimes forming a band running head to tail, or soon dismembered to create a continuous abstract design; later the *t'ao-t'ieh* mask itself may be built up of *k'uei* whole and dismembered. The lesser zones of decoration contain geometric or animal motifs such as that of the cicada, a creature full of significance throughout Chinese culture for its habit of burrowing away during part of its life-cycle to appear as a beautiful singing insect from out of the earth, a ready symbol of life after burial.

The vessels on which this kind of relief decoration appear are also interesting for their form. The three-legged vessels, used for heating wine or for cooking food as they stand in the embers, are the very elegant heirs to the crude grey pottery or Black Pottery three-legged vessels of the Neolithic period. But in the bronze version the legs are lengthened, cast separately and brazed on. The *chüeh* and *ku*, for presenting heated wine, are very early shapes soon to die out, but the *ting* (cauldron) and *hsien* (steamer) survived for many centuries. Of the storage vessels for liquid and solid foods alike, the *kuei* is perhaps the most persistent shape, and the *yu* (bucket), with its swinging handle, an exceptionally beautiful one. It is typical of China that these vessels should early on be categorized, named and recorded. From the mid-Shang period onwards, it became customary for inscriptions to be cast into the vessel, often recording the occasion of the making of the vessel (when it is named), for whom it was made and for what reason. The inscriptions are short, consisting of a few characters of a simple pictorial script.

12, 13

12, 13

8

38, 14
15, 27

16–18
25, 26
19, 20

14 (*right*) High-footed goblet, *ku*. Cast bronze. This trumpet-mouthed shape is a wine-drinking vessel; the hollow foot reaches up to the central zone. The rising blades are of cicada motif. 14th–13th century BC.

15 (*overleaf, left*) Four-legged vessel, *ting*. Cast bronze. The human mask motif may refer to human sacrifice, but this vessel bears an inscription 'large grain'. The simplification of the surrounds and the enlarged flanges point to a late Shang date. From Ning-hsiang, Honan. 14th–12th century BC.

16, 17 (*overleaf, above and below right*) Food storage vessel, *kuei*. Cast bronze. The reduced *t'ao-t'ieh* mask separates two confronted snouted animals and is surmounted by a feline cartouche. The decoration of the main motif in simple relief is surrounded by *lei-wen* in many forms (see detail). 12th–11th century BC.

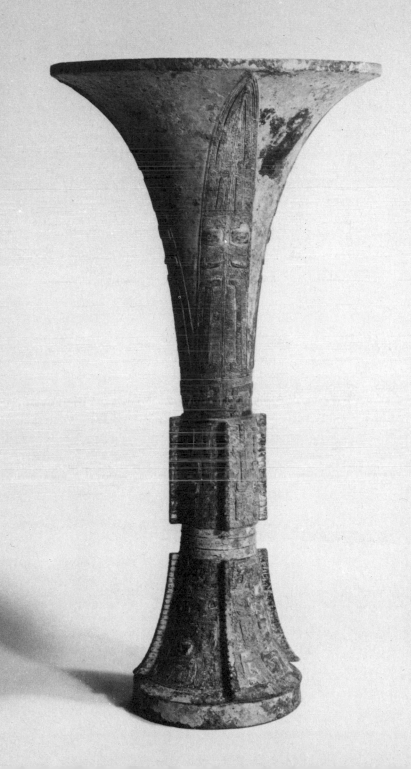

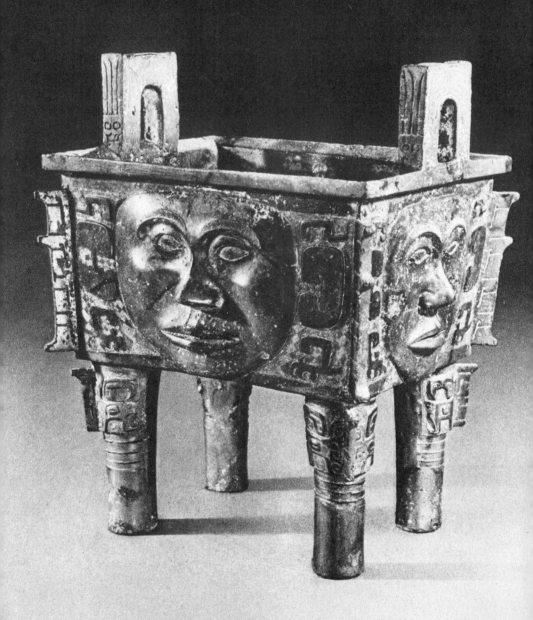

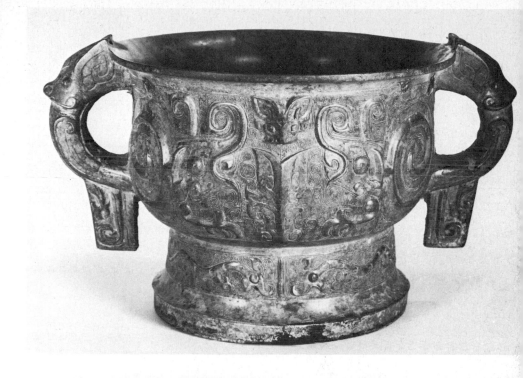

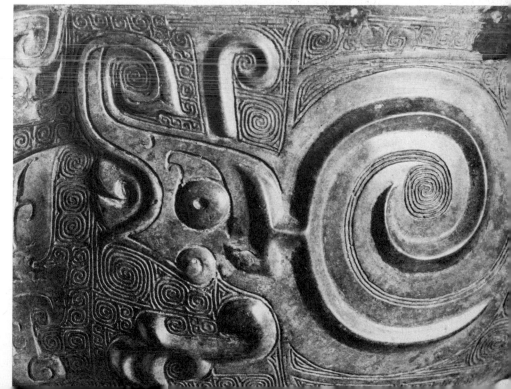

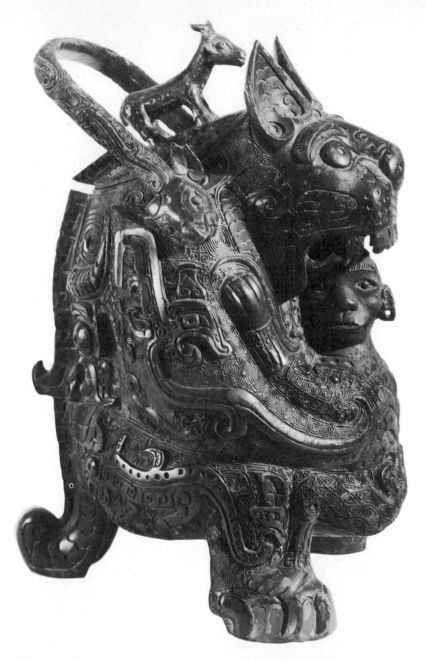

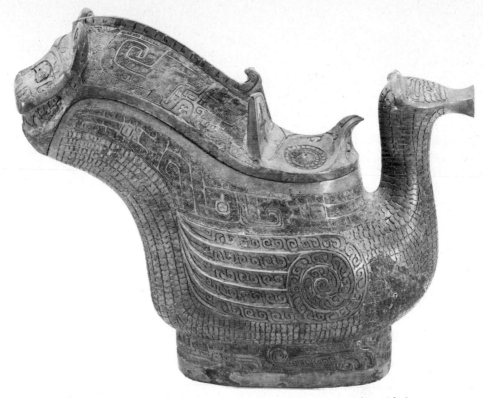

18 (*left*) Bucket with swinging handle, *yu*. Cast bronze. The monster with terrified human being embodies much of the late Shang style. The elaborate surface decoration includes *k'uei*, felines and serpents; a small deer forms the knob. Much use is made of *lei-wen* to enrich the surface. 11th century BC.

19 (*above*) Wine storage and pouring vessel, *kuang*. Cast bronze. This is a fine zoomorphic example in the form of a duck, with a monster mask on the tail and an owl on the shoulder. The surface is enriched with *k'uei* and a scale motif. 12th century BC.

A more continuous script is used in the oracle bone inscriptions. The oracle bones were prepared for divination, following the tradition of the Black Pottery people, by cutting shallow indentations in the concave side of the bone at regular intervals. If a hot point is applied to one side of an indentation, this will crack the bone vertically and laterally. The angle formed by these two cracks provides relevant indication of the answer to the question asked in the oracle. In the Shang Dynasty the question was incised into the bone beside such a crack; this was often dated and the name of the

21

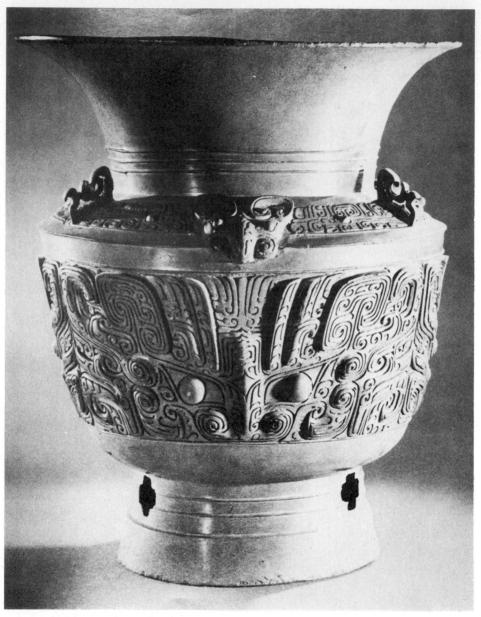

20 Wide-mouthed high-footed vase, *tsun*. Cast bronze. The cruciform holes in the foot are similar to those found on a *ku* (Pl. 14) and are related to casting techniques. Although composed of *t'ao-t'ieh*, the decoration is now executed on a rippling surface. From Funan, Anhui. 14th–11th century BC.

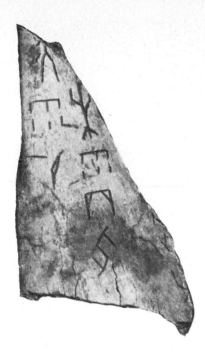

21 Fragment of oracle bone with incised inscription containing questions about rain. From Anyang. *c.* 1500 BC.

ruler mentioned. These bone inscriptions have been used by scholars for establishing the chronology of rulers and their relations with other states, and as a source of information on Shang agriculture and warfare. Although the exact date of the appearance of written characters is not established, by the mid-Shang period a considerable vocabulary of characters, usually of pictorial style, was in use. These characters are decipherable to the modern scholar and in many cases are recognizably the ancestors of the modern Chinese script. Furthermore, they show a growing awareness of the possibilities of the aesthetic quality of writing. The characters are designed, balanced and even composed over a wide area of bone with considerably greater freedom than is the case with the cast inscriptions, and a different style of calligraphy is used. This is the very beginning of an art form which was to be of great importance in China in later periods.

In tombs, Shang bronzes are found in association with jade, a stone which has retained its fascination for the Chinese since probably pre-Shang times. Endowed with all sorts of magical qualities, Shang jade seems to have been *23, 24* valued for its indestructibility; this was the reason why it was used in burial for sealing the orifices of the body. It was also appreciated for its resonant tone and early on was used as a chime. In such larger pieces the surface was *22* decorated in a style similar to that found on cast bronzes. The techniques of carving and shaping the jade, which is harder than metal, by grinding it with

35

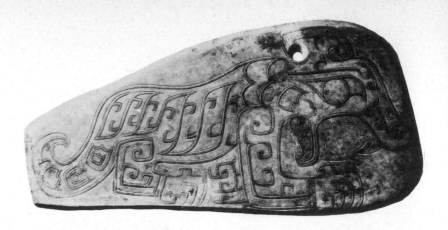

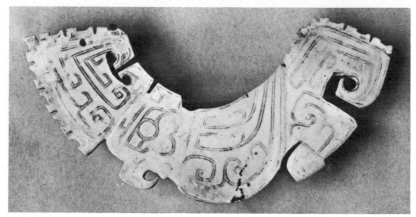

22 (*top*) Stone chime, pierced to be suspended in series and struck. The surface decoration of a crouching tiger in double line relief is closely related to contemporary bronze style. From Anyang. 14th–12th century B C.

23 (*above*) Carved jade plaque, pierced to be suspended. The design of a crested bird with serrated edge and surface motifs is also related to bronze style. 13th–11th century B C.

24 (*right*) White jade *tsung*. A ritual object of unknown use. The shape, a cylinder contained within a quadrangular form, has become traditional. 12th–11th century B C.

the aid of an abrasive powder, were inherited by the Shang craftsmen from their Neolithic ancestors. For the Shang peasant was still living in a Neolithic age; bronze and the arts associated with it were for the aristocrats and their rituals.

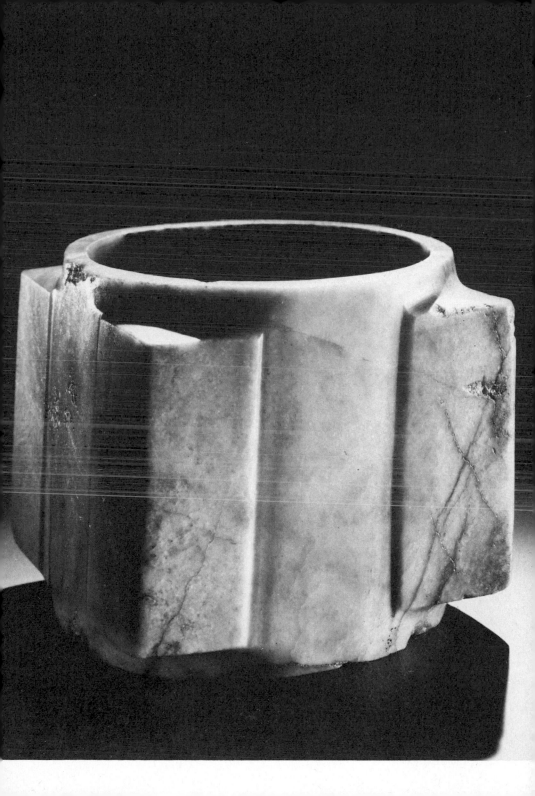

CHAPTER THREE
Status and Decoration
12th–3rd centuries BC

When the Shang fell it was to a warlike tribe who set up their capital on the Fen River close to present-day Sian. The Chou, as this people called themselves, had been mentioned on the Anyang oracle bones (fourteenth to twelfth centuries BC) as a troublesome tribe to the west. The new rulers allowed the defeated Shang ruler to remain in Anyang under the control of three Chou princes. However, when the first Chou king, Wu Wang, died, this arrangement collapsed with the insurrection of the captive and his guards. The regent restored the situation and established a system of enfeoffed states, each ruled by a prince of the blood. Under such a feudal system the Chou flourished and more and larger states grew up while the central royal state dwindled, although the latter retained ceremonial and Imperial power. As a result of these developments the theocratic art of the Shang lost its *raison d'être*: although the crafts of the former artisans continued, an important change had come over them. Relative status in society now became a matter of great importance. Bronzes and the products of other crafts became symbolic of honours and rank, and thus lost their hieratic character. Stylistically, the bronzes of the eleventh to ninth centuries BC show a continuation of the tendency, already noticeable in the late Shang period, to enlarge the vocabulary of decorative motifs, notably through the introduction of bird motifs. The shapes of vessels also changed: the *chüeh* and *ku* were replaced by the *yu, kuei* and *ting*. The wider forms of the *yu* and *kuei* lend themselves particularly well to the motif of the bird with the upswept pheasant tail. Finds from Anhui in the south are of especial beauty in their use of this interlocking motif. Bronzes were made in great quantity and are of bold shape, decorated with motifs derived rather closely from the Shang models, but in a broader style. The decoration became progressively secularized and the *t'ao-t'ieh*, where it remained, changed its character to that of a horned monster mask. Exaggeration, a characteristic feature of the new style, is evident in the extension of the flanges on the vessels, which often became vicious-looking, with hooked, upswept blades marking the profiles

25–27

26

25

25 Bucket with swinging handle, *yu*. Cast bronze. A piece showing some of the exaggeration characteristic of the early Chou period. The hooked and upswept flanges give a new profile to the vessel, although the decoration is still completely traditional. 12th–11th century BC.

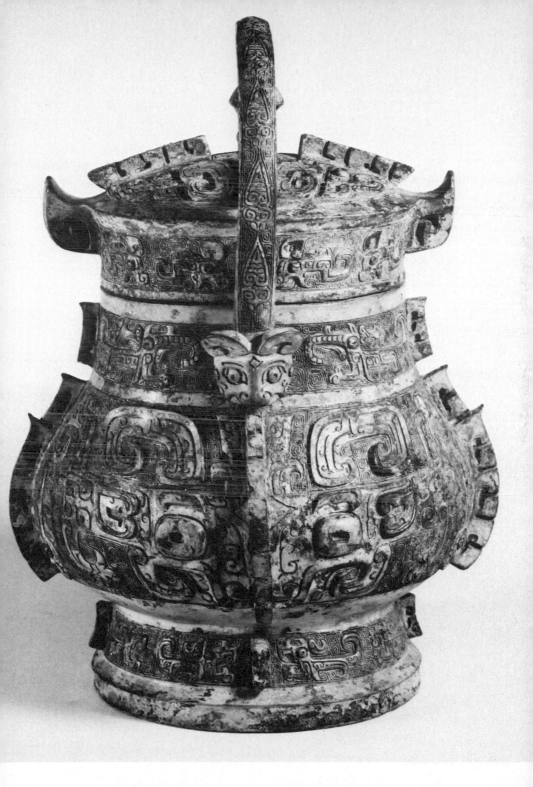

of the piece. The finds from Fu Feng, a site close to the capital, illustrate many of these features of the bronzes of the tenth to ninth centuries BC.

Not least of the characteristics of the bronzes of this period is the much greater length of the inscriptions cast into the pieces. These inscriptions consist of extended accounts of the occasion of the making and presentation of the vessel. They are carried out in a calligraphy more closely related to the modern script than the Shang inscriptions, in a style adapted to the medium and one, in further adaptation, used today in seal script. This longer, fuller prose implies a larger vocabulary. The information contained in these inscriptions makes these bronzes literary sources for historical study. Indeed, the period spanning the later Western Chou and the early Spring and

26 Bucket with swinging handle, *yu*. Cast bronze. The motif and design of the birds with long crests and swirling tails fit the squat shape of the vessel. Comparison with Pl. 18 shows the striking change in style between mid-Shang and mid-Chou. From Anhui. 10th–9th century BC.

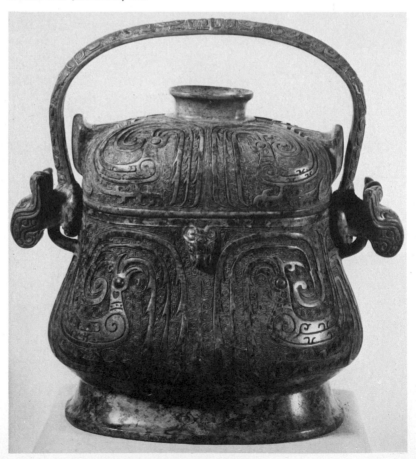

Autumn period (eighth to sixth centuries BC), covering the move of the capital from Ch'angan to Loyang, is regarded as one of decline in artistic quality but one in which bronzes acquire still greater documentary importance.

However, there was a considerable artistic renaissance during the last half (771–450 BC) of the Chou. During this time local styles established themselves in all crafts, which are some of the finest yet attempted. Despite the high quality of Chou craftsmanship and design, there seems to be a curious absence of expressive art during this period, whose broader cultural flavour is hard to gauge. This may be due only to lack of surviving materials, and poor conditions of pit burial, the major source of our

27 Three-legged vessel with cover, *ting*. Cast bronze. The cover can be reversed to make a bowl. At this period elegance of form demanded subordination of the decoration, which is here abstract, with a quatrefoil motif in the centre of the cover. *c.* 6th century BC.

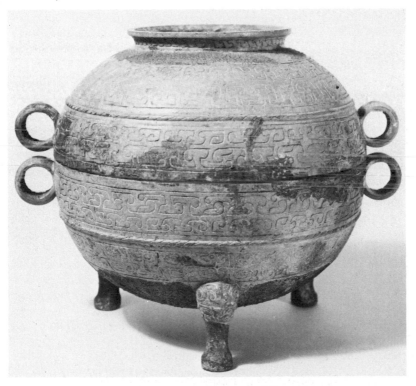

information, probably militate against the preservation of graphic art. Two squares of shamanistic cloth on which figures and signs have been painted do survive, however. These, although of great interest, cannot in themselves give a clear picture of an expressive art of the period.

Chou China covered a wide area, including states bordering on the Central Asian and Mongol deserts to the west and north, as well as a state to the south whose flourishing culture had developed independently from the old Yellow River culture. This state, Ch'u, was the source of much of the poetic element in subsequent Chinese art. The principal Ch'u craft consisted of woodcarvings painted in brilliant lacquer, depicting strange and exotic symbolic birds, snakes, and antlered deer with long hanging tongues. The Ch'u people excelled in architecture, especially palace architecture, which was much admired by the people of the north in this and later centuries. The two squares of shamanistic cloth mentioned above also come from Ch'u state sites. These are executed in sinuous line, in a scattered format with little concern for pictorial composition. There are no surviving bronze objects from the southern Ch'u state, but in eastern Ch'u (present-day Shou Hsien, Anhui) delicately cast bronze mirrors and fittings from the fifth and fourth centuries BC have been found. On these mirror backs a minutely fine all-over background design of angular geometric lines is overlaid with a broader concave line motif, which is sometimes enhanced with inlays of malachite.

This style is regarded as a variant of the so-called 'Huai style', which is more properly associated with the metropolitan Loyang area. Here the mirrors display a similar style, but the raised design is usually of lizard-like dragons twisting over the sharp surface decoration; sometimes the animal seems on the point of changing to a vegetable scroll. This element of ambiguity is present in much decorative work of the metropolitan style, carried through with such elegance as to to avoid grotesquerie. In general, the surfaces of late Chou bronze vessels display a complexity of intertwined dragon forms which sometimes dissolve into a hook and dot motif, enriching the surface texture. The use of undercut and pierced decoration *28, 29* necessitated the use of a wax matrix and the 'lost wax' process of casting. *30* Gold and silver were also used in inlaid decoration and in gilding, techniques which became popular in the production of such adornments as belt hooks. Inlay, at first a thread laid and beaten into an incised line, is associated with Chin Ts'un, near Loyang; but it was practised in many places. The use of a bright metal inlay of completely abstract motifs of curls and volutes, particularly on small objects and fittings, is typical of the later Chou period. The general effect in the decorative arts of lacquered wood, inlaid or gilt metal fittings, and richly textured surfaces of bronze is one of clean-lined *34* elegance and sober taste, qualities extending even to pottery.

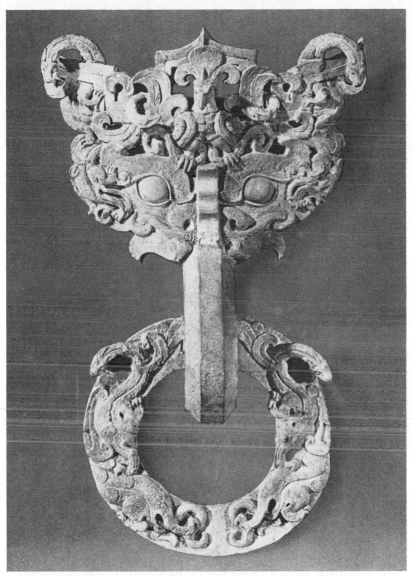

28 Cast bronze monster mask and ring handle. This piece may have formed the handle of a coffin or of a door. The mask is no longer the traditional *t'ao-t'ieh* and is surmounted by a bird and serpents. From Yi Hsien, Hopei. 5th century BC.

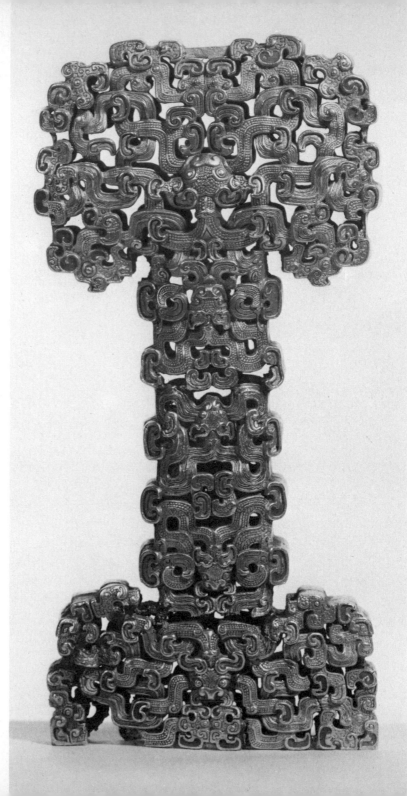

The personal adornment of Chou nobles seems to have been suitably decorative: belt hooks have already been mentioned, but decorated dagger handles and small swords with gold inlays were also in vogue. Scabbards were often intricately cast and sometimes contained tiny inlays of stone.

31
29

29 (*left*) Gold dagger handle. This piece, formed of interlocking dragons, has been cast by the 'lost wax' method, allowing for the openwork style. 4th century BC.

30 (*below*) Cast bronze table leg inlaid with gold and silver. The scroll and volute motif of the inlay has been adapted to the border and also to the body of the figure. This type of decoration is found in embroidery and lacquer of the period. 6th–3rd century BC.

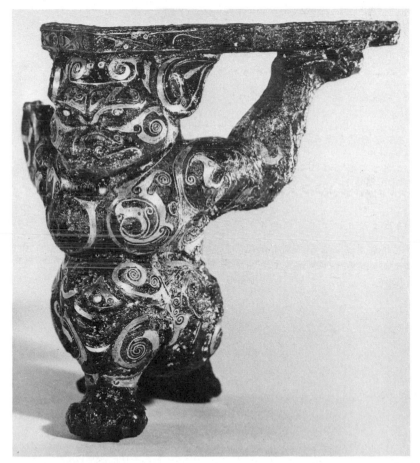

Jade and hard, semi-precious stone were also used in the decorative art of the later Chou states. As the hardest and rarest of the hardstones, jade acquired a mystique to which many attributes were to be added over the centuries. As jade is not found in China, its rarity value has always been high. During this period, its main source was in Central Asia. 'White' jade, which often has a brownish tinge, was the favourite colour in the fifth to fourth centuries BC. Thought to be indestructible, it was much valued especially for burial purposes. But as the taste for surface decoration became more subtle, the surface of jade was finely carved in the Huai style of curves and points, with a softened and polished treatment of concave and convex surfaces.

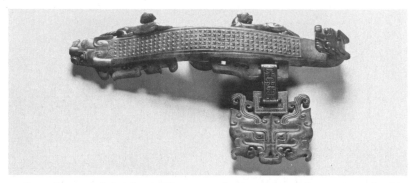

31 Carved green jade belt hook. The neat surface treatment and monster mask of the pendant can be compared with the bronzes of Pls 27 and 28. The small crouching felines on the upper edge of the belt hook are characteristic of the period. 3rd century BC.

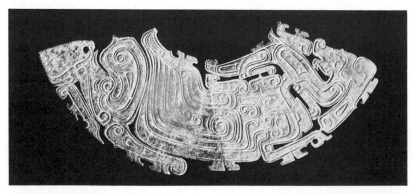

32 Carved jade crescent plaque. This piece can be compared with the 13th-century jade of similar shape and use (Pl. 23). Here the treatment is more elaborate and the composite bird and dragon motif makes a richer design. Early 10th century BC.

The Chou people were great city builders but little of their work survives except for city walls based on a core of *pisé* earth, and the stamped earth platform of major buildings. Chinese architecture had already established a tradition which was to persist, the main elements of which were wooden beams and pillars. Placed on a beaten earth floor, the weight-bearing pillars were 'tied' with cross-beams and topped by a further cross-beam structure which carried the roof. This roof support was at first simple, as it appears to have carried a light roof, perhaps of thatch. But as pottery tiles were adopted, the roof support gained in complexity to take the growing weight of the tiles. In the rare appearances of houses in early reliefs we can see this

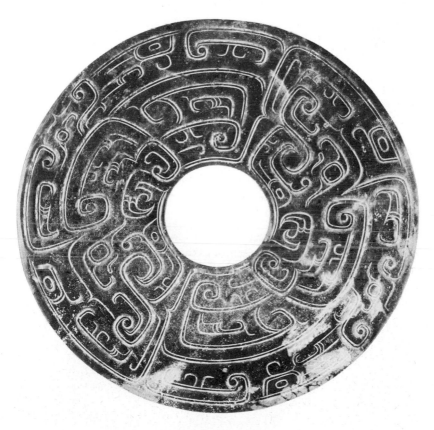

33 Carved green jade disc, *pi*. A very ancient ritual object of uncertain significance. The Shang examples are undecorated; this piece, perhaps datable to the 8th century BC, has an abstract meander decoration.

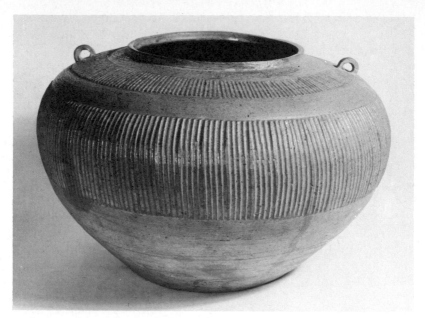

34 Grey stoneware jar with a slightly yellowish glaze, from the north Chekiang area. An example of the continuation by craftsmen in east China of the glazed stoneware techniques first seen at Shang sites (Pl. 11). 4th century BC.

supporting structure growing to incorporate eventually the complex lever and bracketing which became such a distinctive feature of Chinese architecture.

The contact which Chou China enjoyed with its nomadic neighbours is reflected in the northern bronze decorative arts of the fifth to third centuries BC; this seems to be an example of the adaptation of a style, not wholesale borrowing. In the north, the Chinese were in contact with the nomads of the Ordos region, who in turn provided a link with the nomads of Central Asia. The Ordos nomads had evolved their own style of animal bronzes and from this halfway house the Chinese evolved the animal style found in northern China. The depiction of fighting animals in plaques or in relief motif, and the use of the animal-in-the-ring theme, appear late in the Chou period. This *35* representational decoration was outside the general mode or style of the metropolitan areas of north China and had an enlivening effect in later times.

The loose hegemony of the states of Chou inevitably lost cohesion and was brought to an end during the fragmented Warring States period (481–221 BC), a period remarkable for its magnificent craftsmanship. So much craft activity was encouraged perhaps by the very competition between the states and the proliferation of courts, which meant a greatly increased number of patrons. Even the oppressive move towards centralization initiated by the Ch'in Dynasty (221–206 BC) did not curb it. Chinese culture was on the brink of fresh developments.

35 (*left*) Cast bronze plaque showing tiger and tree. Ordos style. The motif of fighting animals stylized to fit into a rounded shape derives from the animal art of Central Asia. 4th–3rd century BC.

Nationalism and Expression

3rd century BC–*3rd century* AD

The arts of the brief Ch'in Dynasty and of the Han Dynasty demonstrate an entirely new aspect of Chinese artistic expression. Whereas in previous ages art had been associated with rituals and ceremonies, gradually evolving into a decorative expression of social status, the art first of the Ch'in and then of the Han is concerned with myths and everyday life. It was from the outset both a narrative and an expressive art.

The nation newly unified under the Ch'in embraced not only the metropolitan Chou states but also many foreign tribes with their own myths and beliefs, and, in some cases, with their own traditions of expression. This diversity made it imperative to seek a uniform cultural expression. The concept of 'Han' as quintessentially Chinese stems from this period, and the Han Dynasty is regarded as one of the golden ages of Chinese culture.

An explosion of activity in all fields of artistic expression accompanied the welding of a nation. Although there is some evidence for an earlier use of brush and ink, the use of brush, ink and paper is traditionally said to start in the early part of this period. It is certain that the free use of all three materials contributed to the increased volume of writing; histories were written and legends recorded. The extensive use of writing seems to have led naturally to pictorial narrative representation and to the development of painting as an expressive art. This is a logical evolution and it introduced the pattern of Chinese art which has held to this day. Painting and calligraphy remain the major expressive arts in China, all the other arts retaining something of the decorative character which they had acquired by the end of the Chou Dynasty.

In calligraphy, variant scripts had already been established for the cast inscriptions in bronze and for the incised and carved inscriptions in bone and stone. But the use of brush, ink and paper opened up many new possibilities and led to a proliferation of styles. The chief styles, designated by a system of aesthetic rules known to this day, were developed during this period: the seal script, based on the ancient cast bronze inscriptions; the *li* script, based on a script used for stone inscriptions, with a heavy stroke end (similar to the heavy serif of the Roman stone script); the flamboyant 'grass' or 'draft' scribes' script, designed for speed writing and adapted to become an art form in itself. Using a resilient brush made of animal hair, or sometimes the barbs

36

36 *Li* script with heavy serif, in ink on wood. This style, here adapted to brush and ink, was first used for incised calligraphy on stone. The overall balancing of thick and thin strokes and characters is evident even in this small sample. From Yumen, Kansu. AD 100.

of a bird's feather, bound into a bamboo stick, with ink made of compressed pine carbon and light glue rubbed down in water, the Chinese calligrapher exploited all the possibilities of his medium. Control of the brush, of the absorbency of the paper, and of the density of the ink, resulted in the full richness of thick and thin strokes, the subtle contrast of heavy and light strokes, and the studied expression of line – a strength of brush stroke that has nothing to do with weight, a liveliness of stroke that has nothing to do with speed of movement. Calligraphy also demanded a clear sense of composition, both for achieving balance within the single character and for establishing the relationship between the characters forming a surface composition on the page. From the first centuries of using brush, ink and paper, the Chinese *literati*, a select and self-selecting group, were conscious of their calligraphy and capable of a sophisticated connoisseurship towards it considerably in advance of their judgment of the charming narrative painting which had just started making its appearance.

37 (*below*) A group of burial jars from sites in the Kansu region. They are all slip decorated and show variants of the designs found in the villages of the area: Pan Shan, Ma Ch'ang and Hsin Tien. 3rd–2nd millennium BC. (See p. 13)

38 (*right*) Three-legged vessel for heating wine, *chüeh*. Cast bronze. This shape is unique to the Shang period although it is a development of a Neolithic Black Pottery shape. 13th–12th century BC. (See p. 28)

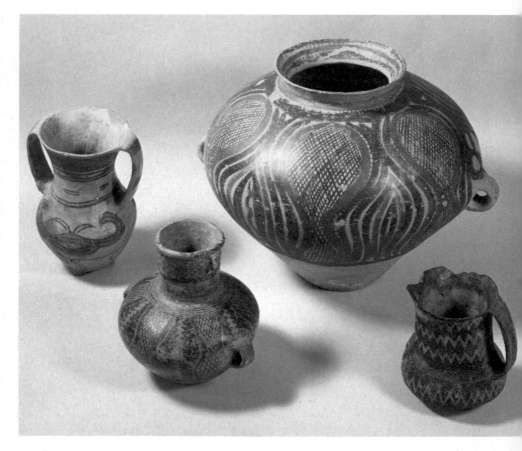

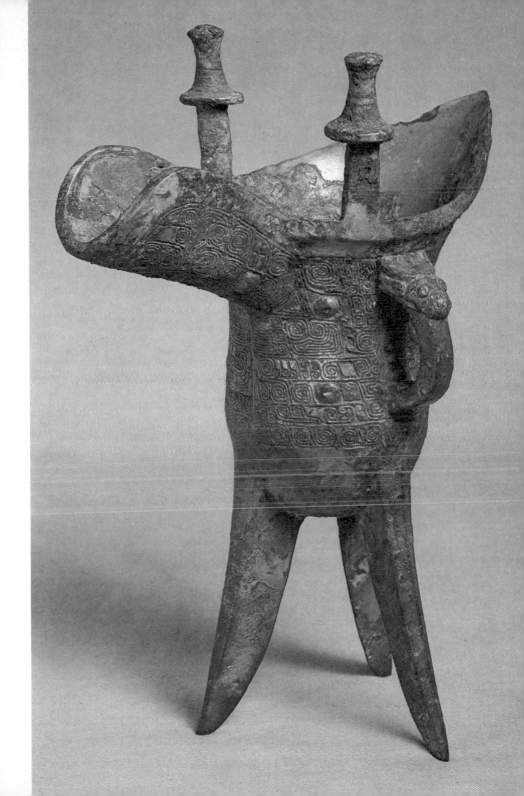

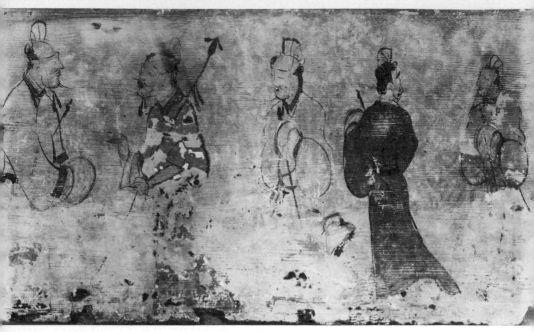

39 Painted brick from the frieze of a tomb near Loyang. This early example of brush painting shows sensitivity to brush line and interest in individual facial types. Although simply composed, the figures are related to each other by gesture. Han.

The concept of narrative painting perhaps came with the Buddhist sutras and temple art, brought to China by missionaries in the first century AD. However, when narrative painting first appears in China, it shows characteristics of a fully-fledged native style. Some of the earliest Han *39* paintings on the walls of brick tombs show witty observations of people, almost caricatures, depicting individual facial types. Already they show an emphatic concern with the face as expressing the human being as a whole. Although little painting has survived, painting on brick tomb walls and lacquer-painted wood panels, again from tombs, show vivid narrative scenes in which a story is told in a series of 'stills', arranged in either vertical or horizontal episodes. A scroll-like composition is used even in wall painting.

40, 41 The painted hangings of the Ma Wang Tui tombs at Changsha, dated to the mid-second century BC, present a more complete painting style. Successive scenes, arranged in a vertical series, show the upper world of the heavens, the earth, and the underworld or sea. There is a marvellous unity between the representation of the mythical world and the representation of the mundane world, both worlds being equally real to the artist. These

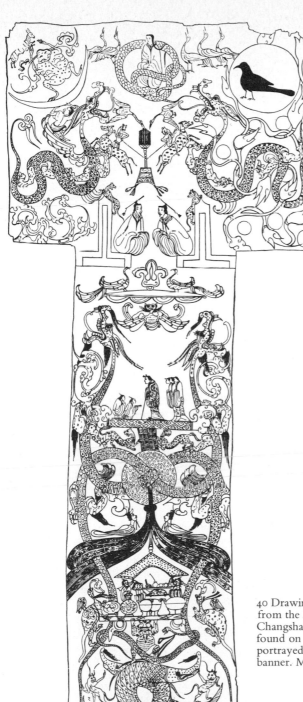

40 Drawing of funerary banner from the Ma Wang Tui tombs, Changsha. A symbolic painting found on the coffin of the lady portrayed in the centre of the banner. Mid-2nd century BC.

55

41 Lower portion of the Ma Wang banner (see also Pl. 40). The style of painting in sinuous line and rich colour is probably close to the style of finer contemporary works on fabric, none of which have so far been found.

'T'-shaped hangings are painted in opaque colours, in a palette probably subdued with time, on a dark background. The upper section symbolizes the sky and the heavens and depicts several Han cosmological myths simultaneously; among other less easily recognizable creatures are the black birds, silhouetted against a sun, which the Hunter Li shot to relieve a scorching drought, and the three-legged toad in the moon.* The strange inhabitants of the sky fill the space above the small huddled scene of the deceased lady and the members of her household. That this is a portrait of the occupant of the tomb can here be proved by the freak preservation of the body in burial as a 'soft mummy' completely recognizable as the lady in the painting. The figures stand on a defined stage plane, not scattered in space, but in a group, with even a little overlapping. The relationship between them is simply established. Below them is another group of figures surrounded by burial objects, perhaps depicting the funeral ceremonies. The

41 murky underworld or sea is again represented by mythological scenes. The sinuous line of serpentine dragons, entwined in the jade ring (*pi*) and encircling the humans, seems to link this composition to Ch'u art of a century earlier. However, the treatment of the humans and of the mythological scenes is conceived in the 'new style', in which painting unites the real and the imaginary worlds. The juxtaposition of real and imaginary,

18, 42 first seen in the Shang bronzes, is characteristic of the Han period.

43 Related to the narrative paintings are the scenes cut in stone relief or impressed in brick. Because of the material used, these have survived better than the cloth hangings. They are all associated with burials or shrines, which determine their subject, and they are very varied in style. For, even in a period of intense nationalism, local art styles persisted. The reliefs on the

44 walls of the Wu Liang Tzu, a family shrine in Shantung, of the second century AD, are cut into a hard stone in a crisp, clear, silhouette-style composition. The stories depicted are from the official histories. The mode of composition is formalized and seems a little archaic. The figures are set on a platform, as in the Ma Wang Tui hanging, but here they rarely overlap, and depth is indicated by lifting a figure off the base plane, the foreground line being regarded as both the front and the main level. Minor characters in the composition are also represented on a smaller scale. The striking style of these reliefs depends partly on their lively use of silhouette, which gives a bold decorative strength to the compositions, and partly on their equally

* See M. Loewe, *Ways to Paradise*, London, 1979.

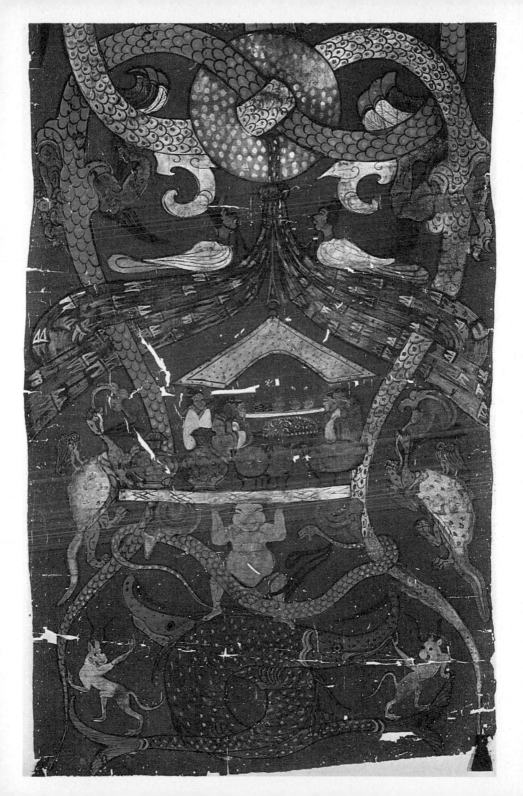

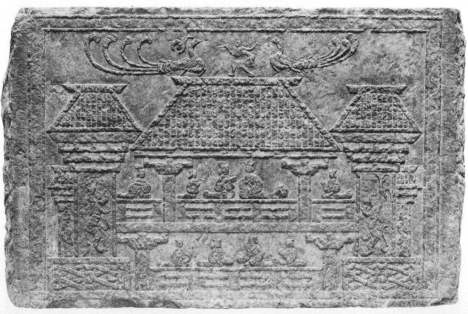

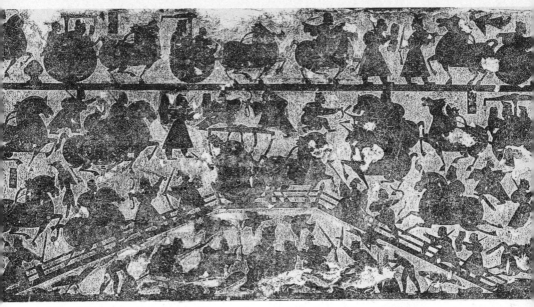

42 (*above left*) Bronze mirror back. The cosmic motifs include the animals of the four directions, and an angular arrangement used on a gaming board of the period. The reflecting surface of the mirror (not shown) is slightly convex and highly polished. Han.

43 (*below left*) Stone relief carving of a concert in a palace. The musicians sit on a balcony above the audience, and magic birds and spirits hover on the roof. From a funerary chapel at Ching Ping Hsien, Shantung. *c.* AD 114.

44 (*above*) Rubbing of a stone relief from the Wu Liang Tzu shrine, Shantung. This section shows a battle scene on a bridge over a river. The scattered surface composition reads from the base line upwards. AD 147–168.

lively and humorous narrative quality. The illustration shown here is of a rubbing, a method of reproducing reliefs which became popular in China at this time.* In the present case, the result looks almost like a woodcut, again a technique developed in China shortly after this period for the reproduction of pictorial work, particularly in connection with printed books which first appeared in the third or fourth century AD.

Distant from Shantung, but contemporary with the Wu Liang Tzu reliefs, are the reliefs from Szechwan in western China. There the local stone was

* Instead of the wax ball used by Europeans the Chinese use a silk pad which absorbs damp ink. A supple yet strong paper is dampened and then beaten into the surfaces of the relief to be rubbed. The inked pad is then dabbed firmly over the surface of the paper. In this process there is considerable control over the tone and the depth of the relief reproduced, for the weight and sharpness of the rubbing can be regulated. This art, as it is recognized in China, is used to reproduce any relief from a coin to monumental sculpture.

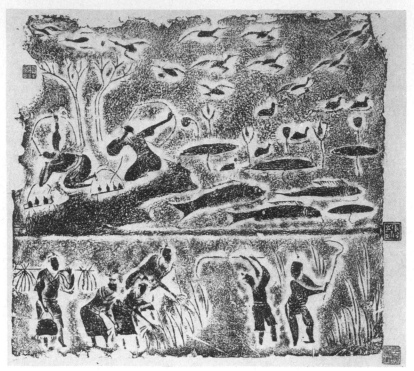

45 Rubbing of a stamped brick from Chengtu, Szechwan, showing hunting and reaping scenes. The Szechwan artists had a more adventurous pictorial approach than the contemporary Shantung artists (Pls 43, 44). Late Han.

unsuitable for carving, and stamped bricks were substituted as the cladding for the walls of underground tombs. The narrative decorations on these bricks seem to derive from free brush drawings and consist of a joyous mixture of real and mythological subjects. Scenes of harvesting, hunting and teaching record, if somewhat sketchily, the various activities of the time. Scenes as a whole are loosely composed on the surface with indications of depth, but with no strong ties in the third dimension. Indeed, the scenes owe much of their charm to their understatement and informality which allow each episode in a picture to be read separately. When mythological beings appear in these brick pictures they are often difficult to identify; such beings reflect, perhaps, a strong local tradition, unrecorded in the corpus of national myth but surviving in the visual arts. Stamped brick of a different type was used in the tombs of the Loyang area. Here the repetitive quality of a stamp is exploited. The motif of the figure flanked by trees, used in many early

45
46

60

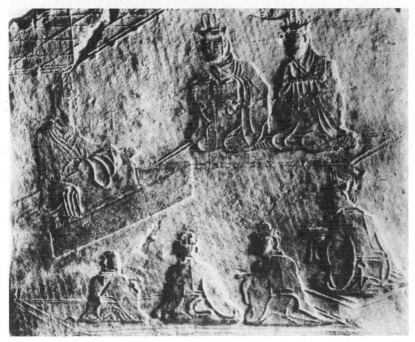

46 Stamped brick from Chengtu, Szechwan, showing a teacher with students. The grouping of figures on a flat surface develops the use of an isometric projection much used in later Chinese and Japanese painting. Late Han

painting compositions, is a favourite one, becoming almost a cliché. At this date it survives only on the bricks, probably copied from contemporary paintings.

Magnificent tomb furnishings provide further information about the applied arts in this period. The life-size human and horse figures found in one of the gateway chambers of the tomb at Lin T'ung, Shensi, of the Ch'in Emperor (Ch'in Shih Huang-ti, *c.* 221–209 BC) are rare examples of sculptures in clay. Partly modelled and partly cast, they are made of terracotta approximately 3 inches (7·5 cm) thick. The heads and hands of the men are removable and appear to have been modelled with much attention to details of hair style and individual facial types. They are not glazed but were probably originally coloured with slip or paint, as traces of a red pigment remain. These figures must have represented the entourage of the Emperor (perhaps only a small proportion of the guardians of his tomb, for

50–52

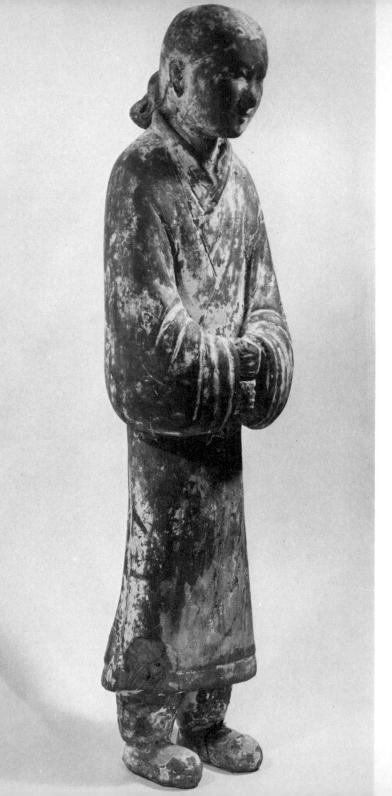

excavations are still incomplete) and include types which may be portrayals of actual members of his bodyguard. They accord with Chinese concepts of characterization in that they display much more interest in personality than in the form of the human body. Although these figures can in no sense be compared with Indian or Greek sculpture, they possess a quality which is memorable and they stand at the beginning of a tradition of human and *47* animal tomb art which continued over many centuries, gradually becoming miniaturized. The tomb models of the T'ang period (AD 618–906), *86* sometimes regarded as an art form in their own right, should be seen in this context. They reflect one aspect of a tradition of comment on the human situation, typical of Chinese genre art, both pictorial and sculptural. Related *48* to the tomb figures are the very rare bronze figurines of wrestlers or acrobats. *49* Only some 4 inches (10·2 cm) tall, these little figures are full of life and must have been intended as ornaments for the house.

47 (*left*) Standing figure of a servant. Grey earthenware with traces of pale slip. This is a solidly modelled tomb figure which apparently once held a staff. Probably of Han date and close to the style of the figure of Pl. 52.

48 (*below*) Unglazed pottery tomb model of a farmhouse. The two-storey dwelling houses the family upstairs, and the animals below and in the yard. From Canton. Han.

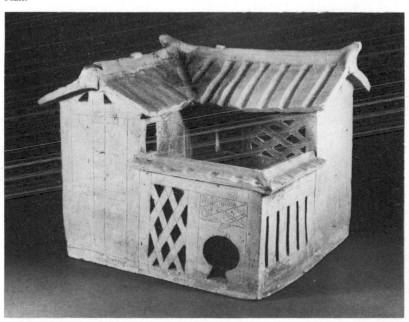

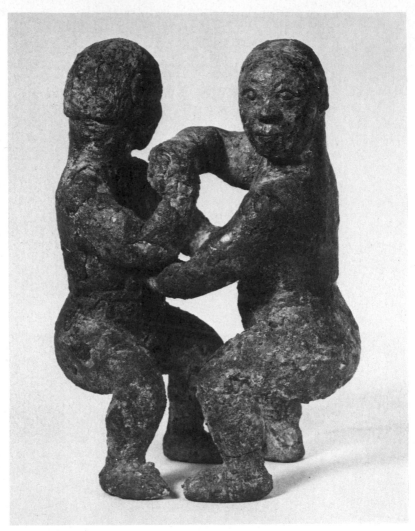

49 Pair of cast bronze wrestlers or acrobats. These unusual figures were apparently not primarily intended for burial use. Late Chou or early Han.

50 Covered box for the storage of mirrors, *lien*. A gilt bronze vessel with a meander design etched on the outside and a painted phoenix among cloud scrolls within the cover. The animal legs and swinging ring mask cartouches are characteristic of the period. Han.

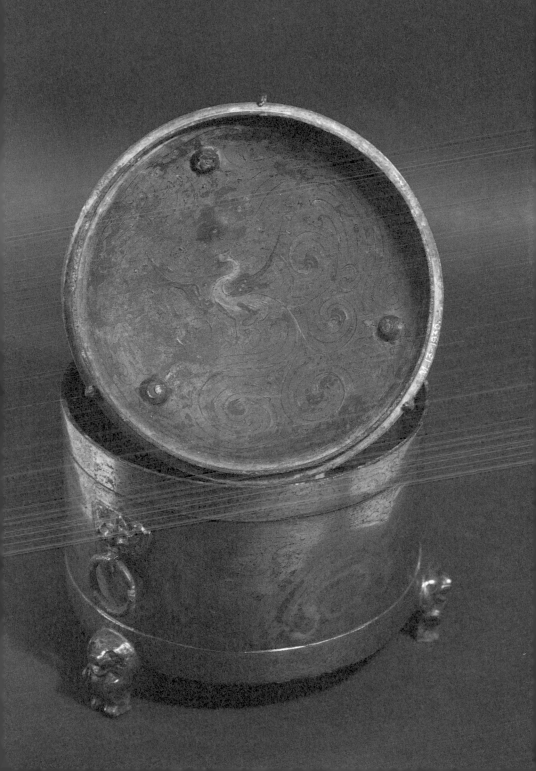

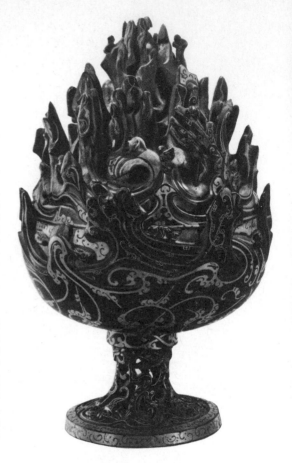

51 (*right*) Incense burner in the form of a mountain. Cast bronze with gold and silver inlays. The cover is pierced so that the incense smoke wreathes out. Small animals and humans wander amongst the peaks. From the tomb of Prince Liu Sheng, Man Ch'eng, Hopei. Late 2nd century BC.

52 (*far right*) Gilt bronze oil lamp in the form of a kneeling servant girl. Her right arm and sleeve form the chimney of the lamp, and the cylinder around the wick revolves to allow the light to be directed. From the tomb of Princess Tou Wan, Man Ch'eng, Hopei. *c.* 2nd century BC.

An increase in prosperity and the spread of Han authority took officials to distant regions, and grand Chinese tombs can be found in remote places, furnished with metropolitan riches. A pair of such tombs, found at Man Ch'eng, 95 miles (150 km) south-west of Peking, date from the late second century BC. These are rock tombs cut 165 feet (50 m) into the hill and were built for Prince Liu Sheng and his wife, Princess Tou Wan. The couple were closely related to the Imperial family and the tombs, though idiosyncratic in construction, represent in every other way a rich Western Han burial. Both husband and wife were buried in jade 'suits' and surrounded by treasures. These were arranged in antechambers and side chambers cut at right angles to the central passage leading to the burial chamber. The contents of the

66

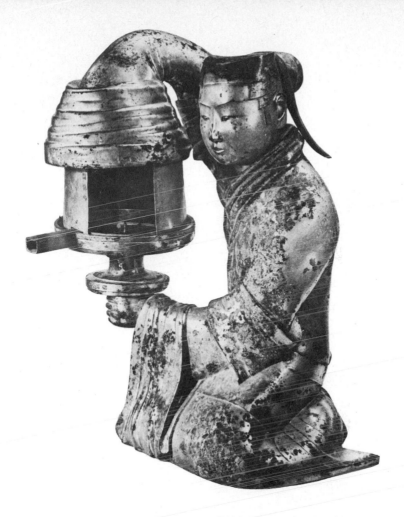

tombs include pottery, jade and gilt bronze. In keeping with the richness of the owners – for the Prince was the local ruler – the objects are for the most part, perhaps excluding the pottery only, not burial replica wares but actual treasure. The Prince's tomb contained gilt bronze vessels which, although classical in shape, have bold decoration in gold of evident splendour but no apparent symbolism. The style seems to derive from the Huai style of previous centuries, but it here becomes much more flamboyant with the addition of gold and inset jewels. The pottery found in this tomb is grey and slip-painted in close imitation of bronze decoration; it was perhaps intended for use in the burial ceremonies carried out within the tomb. It is in the Princess's tomb that the leopard pall-weights shown in the 1973 Chinese

51

Exhibition were found. These small animals are of bronze with gilded spots, and each animal has ruby eyes. The stylization of the animals is perfect for their scale. The small servant girl in gilt bronze, who acts as an articulated lamp, is another of the chief treasures of the Princess's tomb. Inscribed to show that it once belonged to her grandmother at court, this is probably an heirloom piece dating from the very early Han period. A small genre sculpture, it bears a strong resemblance in style and subject to the kneeling female figures found in the Lin T'ung tomb.

Far to the north-west, in Kansu, Han tombs of a later date (second century AD) have been found to contain many lively horse sculptures cast in bronze.

53 Large heavy stoneware jar with incised decoration on the shoulder and green high-fired glaze. Probably from the north Chekiang area, this storage jar in bronze shape is part of a long tradition of high-fired potting in east China. Han.

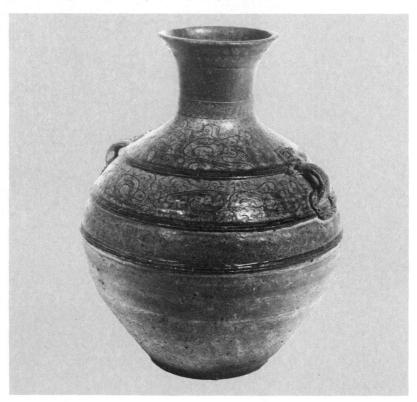

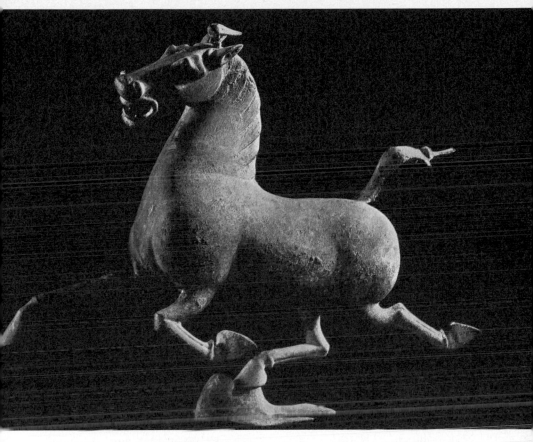

54 Cast bronze figure of a horse with one foot poised on a flying swallow. This famous piece comes from Kansu and represents a lively tradition of horse models in the area. 2nd century AD.

The famous 'flying' horse comes from this region and is one of many vivid 54 representations of an animal which was to continue to fascinate both artists and owners for many centuries.

The Han period brought improved technology and great vitality to the 53 arts: calligraphy was established as an art form allied to the growing literary arts; painting began to be explored for its narrative quality, and also as a complement to the written word; portrayal of genre subjects seems to have become the main concern of the painters, who were also experimenting with compositional techniques. From the Han period painting began to emerge as the major expressive art in China: despite variations in style and content, it has retained this position up to the present day.

The Imprint of Buddhism
1st–10th centuries AD

Although the first Buddhist missionaries had come to China in the Han Dynasty, and Buddhism was established at court during this period, the effect of the new religion on the arts in China was only gradually felt. The introduction of a mature, much travelled artistic tradition into a lively and developing society brought many and varied results. Just as Buddhist narrative traditions enriched the literary culture of China, so Buddhist traditions of iconography, temple and tomb building, and painting on scrolls and walls, opened up new possibilities for the artistic culture of China. In sculpture and painting, Buddhist iconography was adopted and adapted to fit native systems of belief, while the Buddhist temple became the model for all Chinese temples, Taoist and Confucian. Scrolls of silk and paper became the format for written and pictorial records, replacing the bamboo slip 'book' records of the Han. The handscroll was quickly joined by the hanging scroll as the favourite format for painting. In all these ways, and in many others, Buddhism left a large imprint on Chinese art.

As a compound of buildings, each with its own well-defined ecclesiastical function, the Chinese Buddhist temple came to be formalized in the metropolitan area of China, and it is today reflected in the classic temple compounds preserved in Japan. The ground-plan and the separate buildings of the Horyuji, Nara, faithfully reflect those of a seventh-century temple of Ch'angan. At the Horyuji the walled compound encloses a series of buildings, diverse in plan and function, but related to a central axis. Both the building technique, executed in wood and based on a pillar and beam structure, and the concept of the plan were derived from native Chinese traditions of palace building.

The one building in the Horyuji compound which does not derive from the Chinese palace, but which is unique to Buddhist architecture, is the pagoda. Starting as a simple one-storey building, it seems to correspond to the Indian stupa. However, very soon the Chinese added extra storeys until they reached the very considerable height of twelve storeys. The earliest remaining pagodas were built in stone and brick, but the Horyuji pagoda is the best early example of a wooden pagoda and preserves Chinese seventh-century styles. It is of seven storeys and built around a central pillar. The Kondo building in the Horyuji is a hall very close to the mainland style of the

55

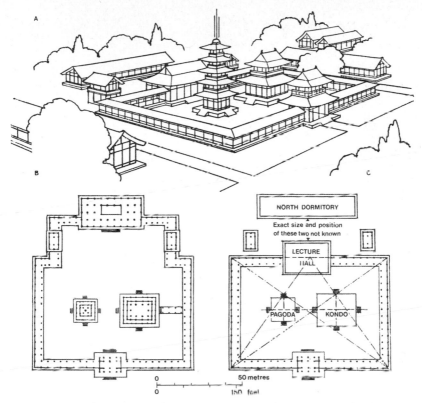

A

B

C

NORTH DORMITORY

Exact size and position
of these two not known

LECTURE
HALL

PAGODA KONDO

0 50 metres

0 150 feet

55 Projection and plans of the Hōryuji, Nara, Japan. 7th century. **A** and **C** show the original layout of the temple; **B** shows the present plan.

seventh century, and by considering it together with the Fo Kuang Ssu hall on Mount Wu T'ai, which is a mid-ninth-century (T'ang) construction, we can draw some general conclusions as to the technique and style of building in what is considered the classical period of Chinese architecture. The platform plan of the Kondo building is laid out on stone, and a double row of pillars (an inner and an outer series) supports the roof on branching bracketing, which enables the eaves to be extended far beyond the outer row of pillars. At this period an *ang* was used in the roof structure. This is a slanting curved arm, reaching right out under the eaves, which was used as a lever bridging the two sets of bracketing. This clever means of construction

71

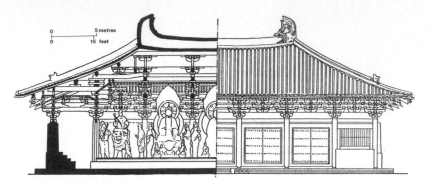

56 Section and elevation of the Fo Kuang Ssu hall on Mount Wu T'ai. Mid-9th century. Comparison with Pls 120 and 121 shows the changes in proportion and the more pronounced roof curve used in later buildings. The section shows the *ang* lever, here used double.

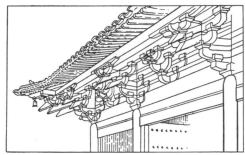

57 Detail of the bracketing and eaves of the Fo Kuang Ssu, showing the projecting bracketing on three arms and the intermediate bracket between the pillars, which all act with the *ang*.

56, 57 was dropped in the Ming period when the interior structure of the roof was simplified and the proportion of the building changed with the adoption of taller columns and narrower roofs. The Fo Kuang Ssu, an image hall, is a handsome building of squatter proportions than later Chinese buildings; it is often described as 'masculine' in style, as the proportion of the pillar to bracket and roof, and the weight of woodwork in the eaves, all add up to an impression of strength.

Such wooden buildings were easily destroyed in the repeated attacks by the State upon established Buddhism which reached a crescendo in the ninth century, leaving few early temples in China. What have survived, however, are the temples cut into rock. These reflect a tradition of building brought to China from the north Indian subcontinent; the route can be traced through Bamiyan (Hindu Kush), Kizil and Turfan (Central Asian Basin) and Tun Huang (north-west China). When it reached north-west China, the tradition

was already fully developed. The rectangular caves were cut into a cliff face, and wooden or stone stairways led to the higher caves which were sometimes connected by verandahs and passageways along the cliff face. These caves were usually quite small and consisted of simple cells, but they could be expanded and they contained many niches. Depending on the suitability of the stone, the caves were decorated with relief carvings or with stucco and painting on a prepared gesso wall. Each cave temple contained a stone or stucco stupa, or images of the Buddha with attendant Bodhisattvas. It had already become a tradition to make at least one colossal Buddha figure, standing or seated, which dominated the whole site. Foreign though this idea was to China, it was adopted with enthusiasm, and many large cave temple sites were excavated from the fifth to the eleventh centuries, when the impetus seems finally to have petered out. These cave temples are of especial importance both for their own beauty and because they are the repository of the major sculpture of China. Because of the destruction of the T'ang Dynasty urban temples, much of the free-standing work in them has also disappeared, and it is in the cave temples that the main body of this art has been preserved.

The earliest cave temple sites now known (fourth century AD) are at Ping Ling Ssu and Tun Huang, in Kansu. Tun Huang is a border town and the gateway to the trade routes which crossed Central Asia. It was a garrison post for the Chinese border guards, an important trading post and the entry point of Buddhist missionaries. Near the town, monks established temples, monasteries and extensive libraries where scholars and translators gathered to undertake the production of Chinese sutras and to prepare translations of Buddhist literature. The Buddhist settlement at Tun Huang included three groups of cave temples made initially directly on the model of those of Central Asia, presumably by itinerant artist monks. Now known under the general title of Ch'ien Fo Tung ('Thousand Buddha Caves'), the three sites are at Mo Kao K'u, Hsi Ch'ien Fo Tung and Yu Lin. Mo Kao K'u is the largest and most important site, situated in the valley of the Ta Ch'uan River. The caves are cut into a cliff, approximately 1 mile (1,698 m) long and 130 feet (40 m) high, on the west bank of the north–south flowing river. Some four hundred and eighty caves, in two or three tiers, were made over a period of four centuries and they provide a survey of the changing styles of Buddhist art in this area.

The earliest date recorded (on a stele of 698) is the opening of a cave in 366. However, the earliest surviving caves are of a fifth-century date. The Northern Wei captured Tun Huang in 440 and from then until the latter half of the eighth century, when the city was occupied by the Tibetans, Tun Huang was in close touch with metropolitan China. The caves at the

northern end of the cliff include the earliest Northern Wei and Western Wei caves. As the local conglomerate rock is quite unsuitable for carving, these caves are decorated with stucco figures in the round set against rough gesso walls, the whole painted in sombre body colours. The Northern Wei decorators created flickering, sweeping compositions of Jataka stories of the life of the Buddha, told in horizontal narrative strips, in which the real and the mythical intermingle in a way reminiscent of the Han artists' work. A feeling of airy lightness is everywhere as apsaras float with trailing ribbons and scarves in a sky scattered with clouds and flowers. The solemn-faced Buddha and Bodhisattvas have a grave quietness which is emphasized by the colour scheme of these early works. The painting is executed in earth-greens, blues, ochres, and a red which has oxidized to black, resulting in a severity which was not originally intended. This style is regarded as Chinese, in contrast to the stolid Asian styles of Kizil, and it is also very characteristic of painting in other more central areas. Metropolitan paintings and reliefs, of non-Buddhist subjects, show some of the same stylistic effects. Episodic narration, floating drapery and elongated figures are found, for example, in the late fourth-century *Admonitions* scroll of Ku K'ai-chi (see chapter 6, below). This points to Chinese artists being used in Tun Huang from the beginning. It also underlines the complete adoption of Buddhist iconography into Chinese style.

Later on, at Tun Huang, the Sui period (sixth to seventh centuries) is characterized by a stillness in both painted and sculpted figures. The Buddha and his attendant Bodhisattvas become more important and the Jataka stories recede. Mahayana was the form of Buddhism which took root in China and this led naturally to the cult of Bodhisattvas. The Bodhisattvas, beings who have achieved Nirvana but who elect to stay in touch with the world to lead lesser mortals, are portrayed as bejewelled, foreign princelings of Indian origin. In the sixth century, the figure representation became stiffer and the jewellery richer, probably reflecting a wave of influence from the Middle East. The floating ribbons noted in the work of the Northern Wei decorators have gone, but the palette has become much brighter and more varied. The Tun Huang cave area was extended still further during the first part of the T'ang Dynasty (618–906) until the Tibetan invasion (late eighth century) temporarily stopped Buddhist activity.

Buddhist art had already moved into metropolitan China. Even though Tun Huang is the most extensive and the longest surviving cave temple site, it has many rivals in richness. When the Wei moved their capital from Lanchow, in Kansu, to P'ing Ch'eng, in Honan, a new cave temple site was opened at Yun Kang in 460. Here the stone is suitable for carving and the entire decoration is carried out in relief and in free-standing sculpture. This

58 Cave no. 428, Tun Huang. The richness of effect is achieved by a combination of painted stucco figures in the round set against a painted background which extends over walls and ceiling. 5th century.

59 General view of part of the caves at Yun Kang; all the frontal structure is missing, but the colossal Buddha (Pl. 60) is clearly visible. The size of the cave temples ranges from small shrines to quite large chambers.

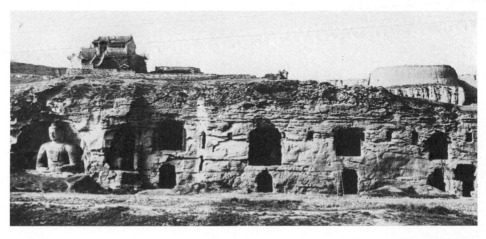

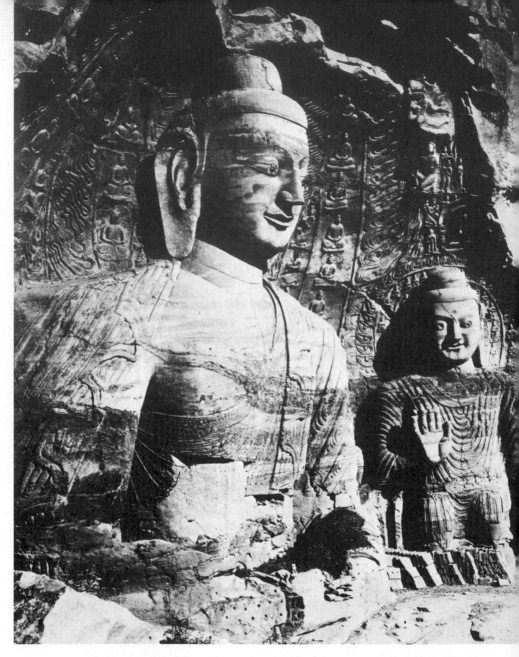

60 The colossal Buddha with attendant Buddha, Yun Kang. The seated Buddha is a fine example of Northern Wei monumental Buddhist sculpture, and the standing attendant shows the early style of rendering folds of drapery. *c.* 460–470.

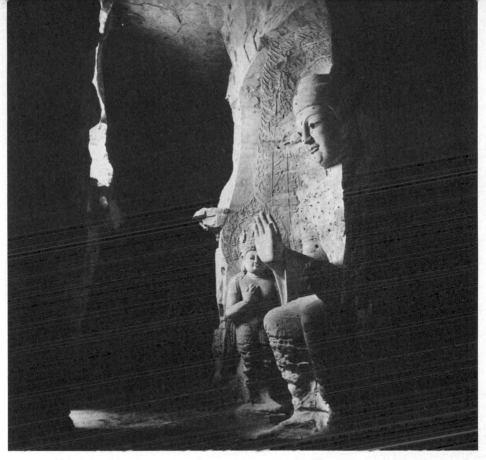

61 Side view of a Buddha at the Si Ku Ssu temple, Yun Kang. The style is slightly later than that of the colossal Buddha (Pl. 60), as is shown in the rounder face of the Buddha and the more static Bodhisattva to the left. 460–494.

series of caves is in the mainstream of the late fifth-century stone sculpture style, one which shows some remains of Asiatic influence in the poses of the Buddha and in details of the head-dresses and costumes of the Bodhisattvas, yet is moving towards the metropolitan style of Lung Men and Kung Hsien in Shensi. The style and content of the decoration are close to that of the 62 contemporary painting at Tun Huang, with the same floating figures and strip narratives, and the same solemn Buddhas with their elongated limbs, long faces and quiet smiles. The colossal figure triad at Yun Kang, one of the 60 earliest stone sculpture groups in China, is a massive work which dominates the whole site.

77

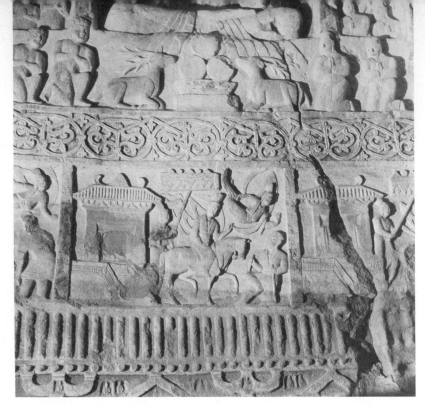

62 Detail of a relief from Yun Kang. The relief shows an episode in the life of the historic Buddha, who is here seen riding on his horse and meeting a beggar. Such narrative reliefs replaced the paintings of Tun Huang (Pl. 58). Second half of 5th century.

At Yun Kang the caves are in a high cliff, quite difficult to reach and very big, especially caves 16–20. The caves are rich in sculpture, and it is possible to trace development of style within the cave complex. Here the typical *60* fifth-century Buddha figure is broad-shouldered, with a sturdy face and a serene expression. This is the style immediately preceding the more fleshy, round-faced, early sixth-century model, found in caves 7 to 8. The later *61* sixth-century style carries this elaboration still further with a more richly clothed and elegant type of figure. This later Yun Kang style is picked up at Lung Men, near Loyang.

The Wei moved their capital yet again in 494, to Loyang. This city was destined to be a capital for successive dynasties until the Sung finally moved away east, to Kaifeng, in the eleventh century. The Lung Men caves, close to Loyang, were cut in the cliffs on both sides of the Feng River which flows south to north. The eastern side, containing mainly T'ang period caves, has

78

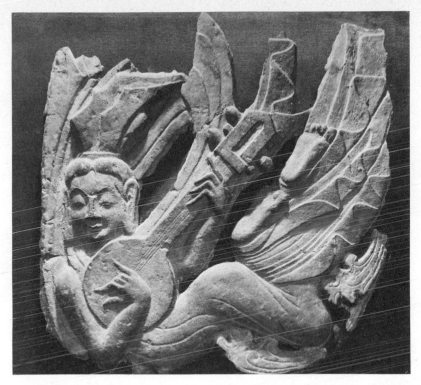

63 Shallow relief carving of a celestial musician (*gandharva*). The floating draperies and beautiful treatment of the folds give such figures grace and lightness. Probably from Lung Men. Early 6th century.

been badly damaged by the earthquakes which occur in this area. The western bank is honeycombed with over a thousand caves, ranging from impressive named temples to small shrines. The river is wide, shallow and slow-flowing, and is fed by many small streams tumbling down the hillsides. Although the rock is suitable for carving, it is susceptible to water damage, landslips and earthquakes. At the Feng Hsien Ssu (672 and 675), the colossal triad flanked by two pairs of guardians is now exposed although it was 66 originally sheltered by an enormous superstructure. This round-faced, benevolent Buddha, some 56 feet (17 m) high, provides a striking contrast to its Yun Kang predecessor, and the guardians display a dramatic movement and ferocity which is new to Chinese sculpture but which heralds the T'ang style. Earlier caves on this west side include twenty-eight larger temples of Northern Wei to Sui date (420–618). The most noted Northern Wei carving 63 is to be found in four of these caves: Ku Yang Tung, Ping Yang Tung, Lien 69

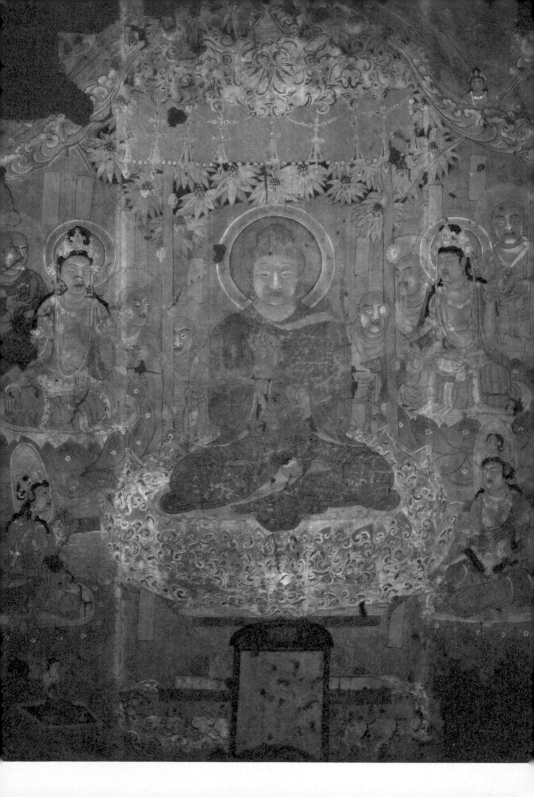

64 *The Paradise of Amitabha*. The Buddha, holding a crystal globe and seated on a lotus throne, is surrounded by Bodhisattvas and monks. The donor is shown in a very humble position to the lower left. Silk painting from Tun Huang. 8th century. (See p. 87)

65 Detail from the murals in the tomb chamber of Princess Yung T'ai, near Ch'angan. A serene expression of gentle movement now complements the traditional linking of figures by facial expression and gesture. There is here a real representation of space and volume on the ground plane and around each figure. Dated 706. (See p. 95)

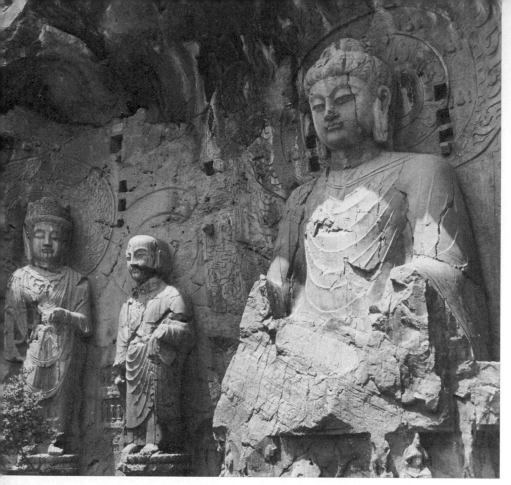

66 The colossal Buddha at the Feng Hsien Ssu, Lung Men. Comparison with Pl. 60 demonstrates the changes in stone sculpture style. The monk and Bodhisattva also show the softening of representation and gradual change in proportion. 672 and 675.

67 Hua Tung and Shih K'u Shih. The Ku Yang Tung cave is entirely lined with relief carvings. Dedicated shrines in three tiers fill the walls; in each a seated Buddha is enshrined in a draped niche flanked by two attendants. The ceiling is also covered with carvings, apparently in no ordered plan, but each unit added until the entire surface is covered. Originally, there was a stone Buddha in the centre of the cave; this was replaced in the Ch'ing Dynasty with a Bodhisattva. The dates of the dedication of this cave are between 495 and 502. The Wan Fo Tung cave was dedicated by a nun who donated the delightful Kuan-yin relief at the left of the doorway. It is of plainer decor; the walls are covered with tiny Buddha figures in relief, almost like a textured

67 Central lotus boss of the Lien Hua Tung ('Lotus Blossom Cave'), Lung Men. A ring of *apsaras* carved in relief encircles the lotus, which is the canopy for the Buddha. 6th century.

68 (*overleaf*) *The Emperor Ming Huang Travelling in Shu*. Colour on silk. The picture reads from left to right and falls into three episodes. It is executed in the style of idyllic landscape painting of the T'ang Dynasty. Later copy of 8th-century original. (See p. 97)

wall-paper. The stone carved triad is of imposing Sui (late sixth-century) style, weight and solemnity. This is the equivalent, in sculpture, of the painting of the same period in Tun Huang. The change of style in stone from Wei to Sui is reflected in the change of the proportion of the figures. The head has become enormous and the limbs shortened to produce that grotesque proportion sometimes used in large sculpture which is to be viewed from below. The Chinese adopted this mannerism which accentuates the massive stillness of the figures. The style is far-reaching, for Chinese ceremonial sculpture, from this time onwards, tended towards the heavy and imposing, relying very much on sheer size for effect.

Not more than 25 miles (40 km) to the east of Lung Men, is the Kung Hsien site of cave temples, started and largely completed in the sixth century. This site includes one colossal Buddha, five caves, and two hundred and thirty-eight niches; there is also some T'ang carving. But it was inevitable that temple building should decline during the persecutions of the later T'ang period.

Indeed, T'ang style is not well represented in cave temples, but it can be seen in the lovely, free-standing figures preserved in museums. After the stillness of the Sui stone figures, the 'International' T'ang styles produce a *70* strong and almost turbulent movement in sculpture. The twist of the body *71* into a mild dancing pose is far removed from its Indian equivalent. But, at its best, it is distinctive to China and it inspired a Japanese tradition; indeed, the two traditions of China and Japan should be considered together in the ninth century.

Where ninth-century sculpture takes a strong turn in style, so too does painting, perhaps with more far-reaching effects on the whole course of Chinese art. After the still richness of the Sui compositions, the T'ang paintings erupt into activity. The huge Paradise scenes beloved of the Amitabha sect, which was now dominant, are complex compositions *64* showing palace and temple compounds in which crowds of mortals and immortals are disporting in a pleasure garden, with singing, dancing, discussion and preaching, and magical happenings. These compositions consist of an isometric projection of the buildings seen from above, in which the figures are shown at eye level and usually out of scale. The colour is brilliant and decorative rather than atmospheric. The total effect is, once again, an amalgam of the real and the supernatural which sparks the scene into life. These large compositions, whether pure landscapes or religious subjects, are the start of a long tradition in Chinese painting.

Large, single-figure painting was also popular at this time. In terms of surviving evidence, the nearest we can come to such works are the now damaged panels in the Horyuji, Nara, in Japan. These show sensuous, freely moving figures, bejewelled and richly coloured. They are the counterpart of contemporary sculptures and led to a tradition of figure painting on a more monumental scale, both religious and secular.

Buddhist painting traditions contributed much to Chinese compositional techniques, particularly the strip narrative, for both mural and scroll *72*

69 Standing Buddha with attendants at the Ping Yang Tung, Lung Men. The all-over treatment of the wall surface by relief carving is equivalent to the painted decoration at Tun Huang (Pl. 58). *c.* 523.

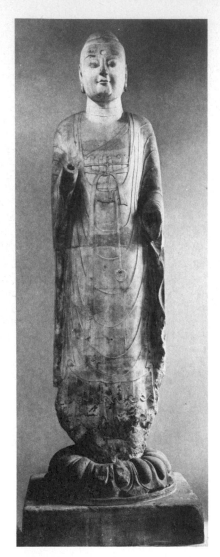
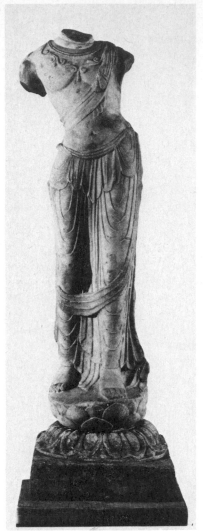

70 Colossal standing Amitabha Buddha. Marble sculpture in the calm style of Sui. The Buddha is now much more fully clothed, and the treatment of the folds and threads of the drapery has become an important part of the sculptor's expression of form. From Hopei. Dated 585.

71 Headless torso of a Bodhisattva. Marble. The walking movement of the figure brings an entirely new character while the sensitive treatment of clothing emphasizes the sculptor's awareness of the form of the figure underneath. *c.* 670.

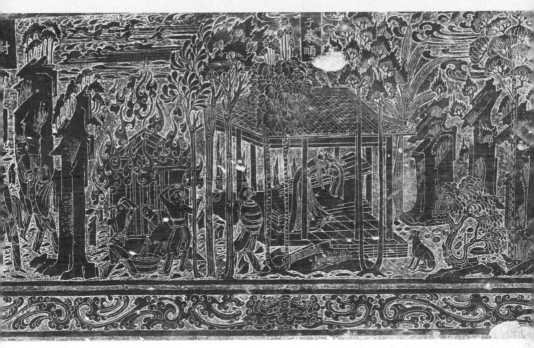

72 Detail of incised carving on a stone sarcophagus. The narrative is acted out in a mountain and forest setting. Such carvings give some indication of the sophistication of pictorial composition in the Wei period. *c. 525*.

painting, and the huge composition, both of crowded scenes and of single figures. The use of colour is more difficult to be sure about, but there seems reason to associate pre-Buddhist painting in China with a very restricted palette, perhaps confined to colours derived from lacquer painting with its stress on red, black and yellow. Thus Buddhist painting, introduced for religious purposes, can be said to have enriched Chinese painting in ways far beyond the religious sphere. In sculpture, the impetus of Buddhism brought life to a tradition which has had periods of great beauty but which has never been as near to the centre of expressive art in China as in many other cultures. The bronze figurines cast for Buddhist use, from the fourth century AD, are a *frontis.* part of a longer Chinese tradition which was adopted in the service of Buddhism. The earliest cast bronze figurines known are of Chou date. The small wrestlers and animal figures of the Han show a lively tradition already *49* established. The craftsmen of the affluent T'ang period made beautiful groups and single figures as portable altarpieces for use in the temple and home. These miniature sculptures follow the general trend of style of the larger sculptures, but often achieve a special charm.

Internationalism and Showmanship
4th–10th centuries

Once the rich possibilities of painting as more than a decorative adjunct have been discovered and adopted in a culture, the artist's fascination in the art carries him to perennial elaboration. Although little remains of their work, it is evident from written records that Chinese painters became involved in experimenting with the medium from the first century AD, when narrative painting was first introduced. At this very early period, painters were employed to paint portraits and to decorate temples, palaces and tombs. The proliferation of states and their courts during the Northern and Southern Dynasties period (219–580) contributed to the development of painting by leading to increased and more varied patronage of the arts.

With very little painting surviving from the Northern and Southern Dynasties period, we must look to such works as Ku K'ai-chih's *Admonitions* and *Nymph of the Lo River*, both preserved in the British Museum in the form of later copies of the fourth-century originals. These are narrative handscrolls, one an illustrated text, the other a continuous narrative scroll telling in pictures the story of a king who was tempted by a nymph of the Lo River. The *Admonitions* scroll is intended as a work of homily or advice to a girl entering the palace; it consists of a series of illustrated figure scenes, each with an accompanying text, which provide comments on right conduct or allude to stories of honoured concubines. The illustrations tell the tale economically and with great elegance of line. Groups of figures relate to each other both spatially and psychologically; there is absolutely no doubt about relationships within each scene. Just as there is almost no setting surrounding the figures, so there is no clear boundary to individual scenes, which fade off to give way to the text to be illustrated next. The style of composition is still that of a Han narrative work, as the artist relies on establishing the space around his figures and uses the tension between the figures to hold the picture together.

Ku K'ai-chih painted in the fourth century at the capital of the Çhin Dynasty, close to present-day Nanking. His beautiful line was much admired as was the likeness of his portraits. Sinuous line and floating draperies were the style at this time, and it is interesting to compare his paintings with those of the journeymen painters of the Buddhist caves at Tun Huang and other contemporary sites.

74
73

73 Ku K'ai-chih (*c.* 344–*c.* 406), *The Nymph of the Lo River* (detail). Handscroll, ink and colour on silk. Later copy. The group of figures around the Emperor as he talks to the nymph reflects early painting techniques (compare Pls 58, 72).

74 Ku K'ai-chih, *Admonitions of the Instructress to the Court Ladies* (detail). Red and black ink on silk. Probably a very near copy. Contemporary with the Tun Huang Northern Wei paintings (Pl. 58), but done for the court of the Chin state at Nanking.

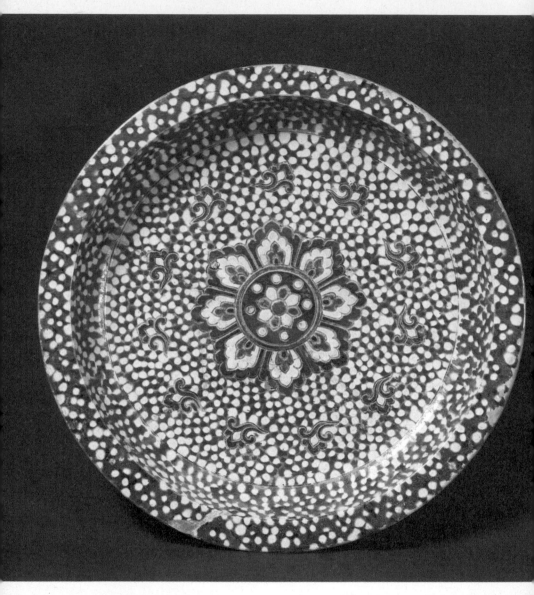

75 Three-colour lead glazed earthenware dish. The type of ware made for grand burial in China. There is a close relationship between this ware and contemporary Middle Eastern wares, both in technique and in the floral motifs. 8th century. (See p. 106)

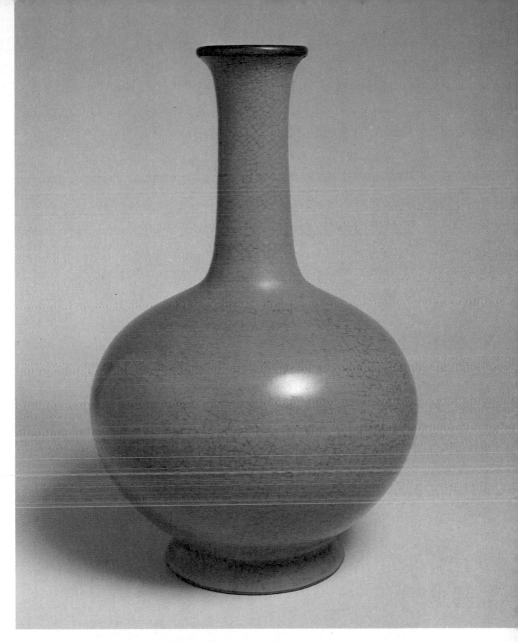

76 Ju ware vase. The aristocratic ware of the 12th-century court at Kaifeng. One of the masterpieces in the great stoneware tradition of grey-bodied wares with blue-green monochrome glazes. (See p. 117)

Ku's own contemporaries, however, judged him not to be amongst the most dynamic artists of the day. Owing to a shortage of evidence this judgment is impossible to check. What nevertheless is important is the judgment itself. Growing out of the early tradition of connoisseurship in calligraphy, a whole critique of painting existed at this time. The earlier texts are preserved in the commentaries of later (ninth-century) critics. A survey of ancient painting, *Ku Hua P'in Lu* (*Old Record of the Classifications of Painters*), by Hsieh Ho, of the sixth century, is perhaps preserved unchanged.* In his introductory comments Hsieh Ho lists six points to consider in judging a painting:

1. Spirit Resonance, which means vitality ('Spirit' here seems to denote nervous energy which is to be transmitted from the artist through the brush into his work).
2. Bone Method, which means using the brush (this seems to be an allusion to an ancient term dealing with anthroposcopy, the reading of character from the bone structure in the head and body).
3. Correspondence to the object, which means depicting the forms.
4. Suitability to type, which has to do with laying on of colour.
5. Division and planning, that is, placing and arranging.
6. Transmission by copying, that is, the copying of models.

Hsieh Ho says that the most important of these critical principles is the first, and that if this element is absent one need look no further. The very simplicity of this categorization has given rise to several interpretations among scholars. But it is generally agreed that Hsieh Ho thought that, having first confirmed the 'life' of the painting, one could then proceed to assess the quality of brushwork, composition, structure and likeness. The mention in Hsieh Ho's sixth principle of the importance of antiquity and of the need to imitate the ancients has led some students to consider these points as exhortations to painters, rather than as critical principles. However, the first five points seem designed as principles of art criticism or of connoisseurship for the collector.

This seems to have been what was intended in a later, larger work, completed in 847, by Chang Yen-yüan, *Li Tai Ming Hua Chih* or *Record of Famous Painters of All the Dynasties*. The first three chapters of this work cover briefly the origins and history of Chinese painting; they provide lists of painters, repeat the six principles of Hsieh Ho, offer a classification of painters relating them to their teachers, discuss signatures and other considerations of connoisseurship, technique and materials, and finally give a survey of

* See W.B.R. Acker, *Some T'ang and Pre-T'ang Texts on Chinese Paintings*, Leiden, 1954.

94

Buddhist and Taoist temple painting and of private collections of the day. In the rest of the book the author goes back over his list of painters and grades them into classes, giving brief biographical details. It is interesting to see that by this time Ku K'ai-chih's work is considered to be very rare and is extremely highly valued, and Chang advises the collector to pay anything to acquire even a tiny fragment of Ku's work.

Chang Yen-yüan repeats Hsieh Ho's six principles without altering their meaning, but it is clear that he is writing as a critic with the style preferences of his own time in mind. Chang admired his contemporary Wu Tao-tzu, apparently an opinion widely shared in Ch'angan where the artist worked prodigiously. To us, Wu Tao-tzu is only a legend, as none of his paintings survive, but his linear brush style engendered much later work. Regarded as a magical painter, able to transmit actual life into his pictures, Wu produced wall paintings for temples and palaces, as well as hanging scrolls and handscrolls. He was believed to have executed paintings of horses which galloped away and of dragons which flew out of the picture over night, such was the feeling of life in his work. In this respect, he must have been the embodiment of a certain aspect of Hsieh Ho's first principle. His line was apparently calligraphic, thick and thin, nervous and energetic, expressing life within the line as does the hand of many a great draughtsman.

It was the bravura of Wu's line which was so much admired in his own day. This bravura may perhaps be reflected in the work of the later Ch'an artists. To some degree it is demonstrated in the tomb paintings of the Ch'angan district. Ch'angan was one of the capitals of the T'ang Dynasty and in the eighth century it was the site of many grand tombs. Recently excavated are the three royal tombs of the Princess Yung T'ai, of her brother and of her uncle. The Princess's tomb is particularly rich in wall paintings. A painted procession of civil and military guardians lines the passageway underground to the tomb chamber where the walls are painted with a group of the Princess's household women. Almost life-size, the figures are arranged 65 in an informal group in a sketchy setting. The drawing is in free line, executed with great fluency, at first in a light ochre but finally drawn in black. The painting is only partly coloured and there is a half-finished air about the whole. The composition within the procession is arranged in recurrent groups in which not only is the ground plane established but also the volume of each figure is surrounded by space. The female attendants in the chamber are beautifully expressed in loose groupings moving towards the site of the coffin. Each girl is so individual that one is tempted to believe that the attendants were painted from life. This is a royal tomb for which the decoration would have been supplied by the relevant palace office. At one time this office was headed by the noted artist Yen Li-pen and his family.

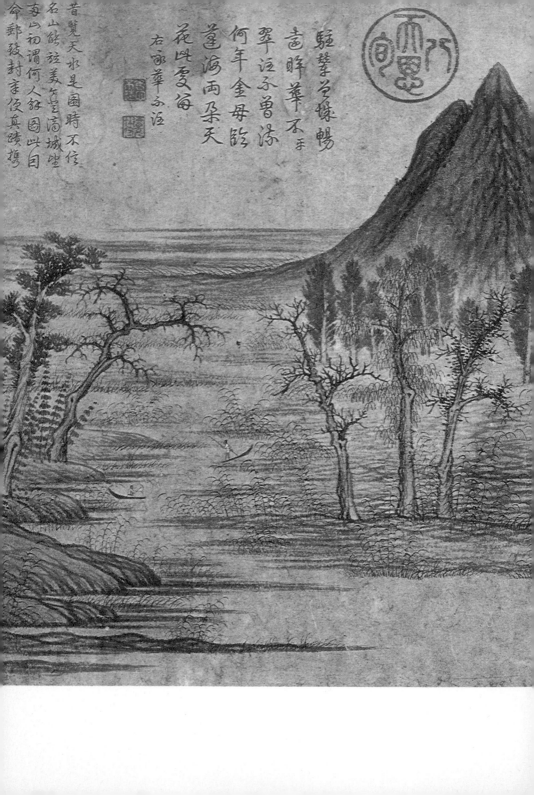

There is no indication of the identity of the painter of these murals, which indeed seem to be the work of an atelier. Incomplete as these murals are, they give a clue to the possible style of palace decoration of the period – racy, full of life and colourful. Drawing, in a bold, thick-and-thin line, is the basis of the painting, and colour the embellishment to a rich composition.

Figure painting probably reached its greatest vitality at this time; it seems to have been the dominant style of painting. However, there was a kind of landscape painting closely related to the background and side scenes in the larger Buddhist murals. Very few scroll paintings have survived which may be as early as the ninth century. One of the most famous is the landscape with horses, *The Emperor Ming Huang Travelling in Shu*, now in the Palace Museum, Taipei. This is executed in colour on silk, in three related narrative scenes, and rather like an abbreviated handscroll, it reads from right to left. The cavalcade of horsemen come through the defile to rest on the plateau in the centre, they remount and move off up the mountain to the left. There is decorative solidity in this style of painting in which the hills are built up as piles of rocks and coloured with cobalt-blue and copper-green, with touches of gold. In the decorative trees there is still a hint of the Han style. This is an example of the T'ang decorative landscape style later summed up in the term 'blue and green'.

The late T'ang period (ninth century) saw the introduction of a school of painting which was to become absorbing to many painters. This is the poetic monochrome landscape style. Wang Wei is credited with the invention of quiet, contemplative, allusive painting in ink on silk. None of his work survives, but the definition of his style as 'a poem without words' stands at the beginning of a school of landscape painting. That the vogue for painting in ink and for avoiding the use of colour arose in the midst of this most colourful and flamboyant period, should perhaps be seen as a reaction, as also perhaps the choice of subject, away from the recording of splendours and paradises, so popular in both religious and secular art in this dynasty.

Although developments in painting dominated the artistic culture, and painters gradually asserted themselves as the artists most worthy of serious attention, the T'ang period as a whole was rich in the major decorative arts. Never accorded the same literary attention as calligraphy or painting, but valued as complementary adjuncts to visual culture, selected crafts were held in high esteem. In the period from the third to the ninth centuries the

78, 79

68

77 Chao Meng-fu (1254–1322), *Autumn Colours on the Ch'iao and Hua Mountains* (detail). Handscroll, ink and light colour on paper, dated 1295. The brush style reaches back from the 14th to the 10th century. Compare the trees with Pl. 88 and the long modelling lines with Pl. 89. (See p. 138)

cultivation of these complementary arts began, and, at first, it seems that ceramics held pride of place. This craft maintained its position as both a useful and a decorative part of the domestic culture. During the period from the fourth to the sixth centuries, technical developments resulted in two traditions of stoneware potting. Centres in Chekiang (Chin), in the south, and in Shensi and Hopei (Northern Wei) developed two contrasting styles:

98

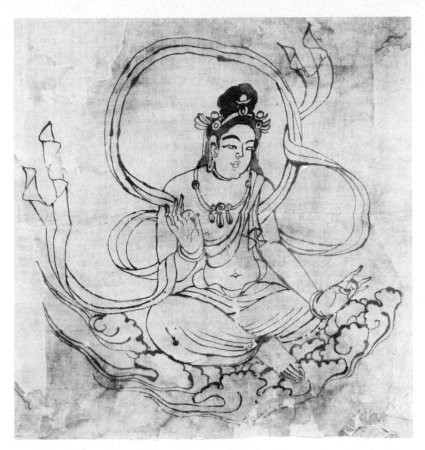

78 (*left*) Rubbing of incised decoration from the sarcophagus of the Princess Yung T'ai tomb, Ch'angan. This carving indicates the style of figure painting in the 8th century: a flowing line and simple composition expressing both space and volume (see also Pls 65, 73). Dated 706.

79 (*above*) Bodhisattva flying on a cloud. Ink painting on hemp preserved in the Shosoin, Nara, Japan. This is perhaps the closest we can get to the vital thick-and-thin line so much admired in the work of Wu Tao-tzu. 8th century.

grey-bodied with a green glaze, in the south, or white with a straw-coloured glaze, in the north. Obviously of great practical importance, this stoneware was used by potters for their most prestigious wares. The discovery of stoneware clay and of its qualities of plasticity and fusibility to the point of imperviousness, together with the development of a kiln capable of long, high firing to mature the clay and its related glaze, were the great

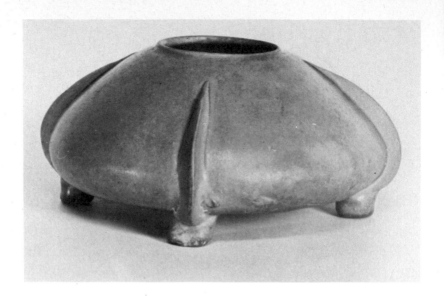

80 Water pot from Shàng Lin Hu, Chekiang. This is Yüeh quality ware, one of the most highly regarded wares of its time. The green glaze is applied thinly and smoothly so that it enhances the elegance of the potting. 10th century.

81 White ware indented jar from the north, possibly from the Ting Chou region. The body is quite white and unoxidized, while the glaze has a faint ivory shade much accentuated in the 'tear drop' on the side and in the finger marks at the base. 10th century.

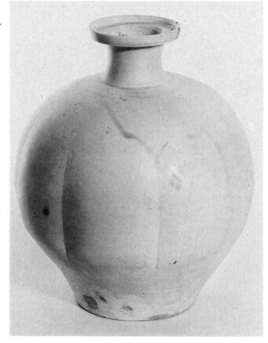

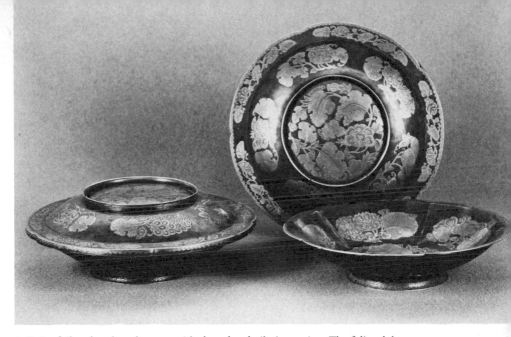

82 Pair of silver bowls and covers with chased and gilt decoration. The foliated shape with a rim perhaps came to China in metal forms from the Middle East and quickly transferred to ceramics. The decoration of rich flower motifs seems established at this time. *c.* 750–850.

innovations of the Chinese potters; from these materials and techniques they produced what are considered the classic Chinese wares. The high-fired wares are of strong simple shapes, often reminiscent of bronzes and clothed in a smooth glaze of restrained colour. These colours range from dark green-brown, through green-blues, to a pale straw; all are derived from iron in the glaze, which has been fired in a reducing atmosphere. In reduction conditions oxygen is removed from the metallic compounds in the glaze, and reduction firing became traditional in the production of Chinese high-fired wares. Iron is the most persistent metallic oxide and varying quantities of iron supplied glaze colour. How far the resulting green-blue colour was achieved by choice at first is not clear, but the sombre range soon became an established taste, probably closely related to the taste for jades and bronzes.

The appeal of sombre colour in pottery did not exclude, however, the equally evident delight in exoticism and richness, which reached great heights in the Buddhist sculpture, gold ware, textiles, glass and other crafts of the T'ang period. The artists and craftsmen of China were never closed to new ideas. At this period of ebullient experimentation in the fine arts, craftsmen evolved a whole canon of style which has been called

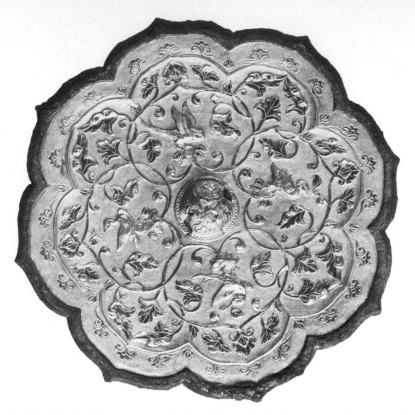

83 (*above*) Foliated bronze mirror back with a gold relief sheet inlay. Far removed from the Han mirror of magic powers (Pl. 42), such T'ang mirrors were treasured as decorative objects. The bird and flower scroll motif is developed in the 'International' style of the mid-8th century.

84 (*right*) Pilgrim flask. Stoneware with brown glaze over white slip. The flattened shape is based on the leathern flask carried by Central Asian travellers, and the moulded decoration showing a vintage scene is also derived from the tooled original. Mid-8th century.

'International' to denote that it is part of a wider tradition than that of the subcontinent alone. This wider tradition has roots as far away as Asia Minor and the Caucasus. It remained a strand in the many styles recurrent in China and is most clearly seen in the gold and silver wares of the T'ang period, made by Chinese techniques, which favoured casting, in contrast to the Sassanian models, which are turned and beaten. Decoration is also subtly adapted at this time, themes originating in Central Asian and Near Eastern motifs being absorbed but their scale changed to suit Chinese ideas. A taste

82, 83

84, 85

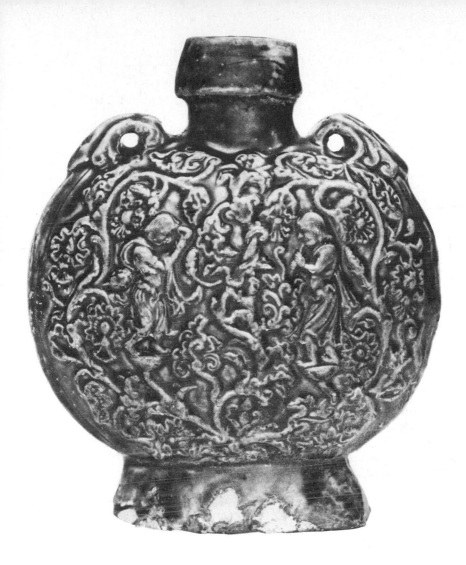

for the exotic recurs throughout much of the metropolitan craftwork of the seventh and eighth centuries.

Glass was also made in China in bright blues, or in brownish yellows when in 'International' style, or as a substitute for jade, moulded in the shapes of archaic pieces and imitating their colours. Hardstones of every variety, carved as vessels or ornaments, inlaid wood, amber and inlaid bronze mirrors all crowd the tombs of this period, and they presumably also filled the houses of metropolitan China at one of the most flamboyant moments of its history.

85 Fragment of woven silk with a design of wine drinkers. From Astana, near Turfan, Sinkiang. Both the technique of woven tapestry, which probably originated amongst the nomadic tribes of Central Asia, and the motif of confronted figures in a roundel became traditional in China (see also Pl. 110). 8th century.

86 Tomb model of a saddled camel. Cream, green and yellow glazes over a white earthenware body. Such models of animals, servants, entertainers and household goods were produced in quantity in the 8th century. Cast from moulds and assembled in sections, they achieve many lively poses.

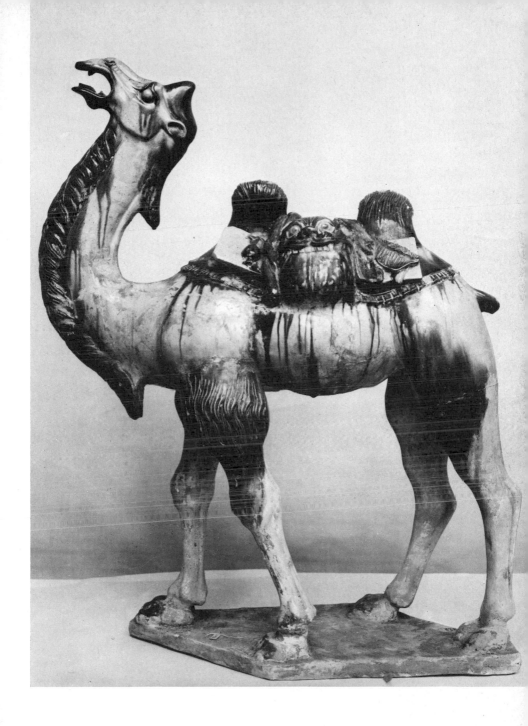

T'ang silks – dyed, printed and embroidered – are beautifully preserved today in the Shosoin collection in Japan. Also in this collection are two painted and inlaid wooden musical instruments with decoration of exceptional quality. Particularly noteworthy are the fanciful landscape paintings in full colour on the face of the *p'i-pa*, a lute-like instrument.

87

Amongst the most colourful works of this period are the tomb models made in low-fired pottery and glazed with brightly coloured, lead-fluxed glaze, a technique used by the Han. The vogue for such models became so insistent in the eighth century that great quantities were made in the metropolitan area. At their best, the quality of modelling of these tomb figures justifies their being considered as sculpture. In true Chinese fashion, their interest lies primarily in genre representation and human characterization. By the tenth century the varied and cosmopolitan society which they reflect was no more; the richness had passed and a more contemplative mood was to be expressed in landscape painting in the style of Wang Wei.

75, 86

87 Detail of a lacquer landscape painting on the face of a *p'i-pa*, a type of lute. This is the upper part of a Buddhist figure scene and is one of the earliest painted river and mountain compositions known. 8th century.

Space and Monumentality
10th–early 12th centuries

The possibilities opened up by ink painting on silk and the richness of landscape themes were soon to provide painters with compositional alternatives in the scroll format. In particular, the large hanging scroll was to become the chosen format in which classical masterpieces were painted. Space, recession and volume became the central preoccupations of artists. Once a rectangular framework had been established, these qualities could be expressed in various ways, and in the early period painters explored the possibilities offered by the manipulation of eye level. Perhaps as a development from the vertically arranged narrative 'stills' of previous centuries, a technique evolved of raising the eye level in a continuous, upright composition so that successive eye levels are established. This allows the expression of great distance and height within a restricted format, avoiding vertiginous effects. Not only does a huge mountain not menace or overhang as one looks square at its face from a respectful distance, but chasms and many receding valleys can also be expressed comfortably within the same frame. Using a completely different formula for pictorial perspective from that evolved in Europe, the Chinese artists of this period proceeded to compose elaborate and evocative paintings of mountain landscapes. The moving eye level was allied to a control of the surface composition by judgments of balance of line and tone close to that developed in the composition of calligraphy and entailing a fine understanding of the surface tension which holds a painting to its frame. The receding composition is tied to the picture edges, but the balance of the painting is preserved through the manipulation of line and tone. Curious anomalies of tone and recession are conceded to gain this balance. The result is that the composition can be read from many points because there is not one focal point in the composition, just as there is not one viewpoint or one eye level. These massive compositions, often six feet high and three feet wide ($1·8$ m $×$ $0·9$ m), are complex constructions. The conventions of scale worked out at this time became traditional to a school of landscape painting in which, for instance, the figures, although insignificant, are usually too big and considerations of visual scale are secondary to those of pictorial scale.

Mountains as a subject appealed in China for many, almost inherent, reasons. Taoist-beliefs can be expressed in landscape, and particularly in what

mountains evoke: the remote, the eternal, an overpowering sense of scale when they are related to human beings. All these aspects became part of the Chinese painter's concern, part of that elusive quality of 'life' or 'breath' – the same first principle as in Hsieh Ho's list of six. Painters also sought to express the 'life' which they found in the world, in both animate and inanimate things, and themselves in relation to the world. In choosing landscape as their major theme, painters were doing no more than seeking to express, as directly as possible, the very ancient Chinese belief in the unity of man and nature.

Although we know the names of painters who became famous in the tenth century, like Tung Yüan and Chu Jan, few paintings from this period have survived, but two fine examples from the Palace Museum in Taiwan embody much of the style. *Travelling in Streams and Mountains*, by the court painter Fan K'uan (*c*. 950–1050), is the earlier of the two. This is a large scroll, painted in ink, with very slight, sombre colour, on a silk now darkened to the tone of pale tea. The massive rock dominates the scene and controls the picture which is divided into background and foreground by a cloud-filled chasm. The tiny figures on the right struggle along a stony road in a rocky landscape, in which groups of trees and rocks create pyramidical inner units echoing the greater mass. This is a still and impressive picture painted with beautiful, nervous ink strokes which build up the tone and texture. The composition is of the style known as 'Master Mountain' on which many variations have been played and in which the landscape is dominated by one peak, often expressed as a cluster of rocks. This picture is probably a later interpretation of the original theme; it is simple in conception and has a great, quiet dignity.

About fifty years later, Kuo Hsi (*c*. 1020–1090) painted *Early Spring*. This artist also painted at court, by now that of the Northern Sung at Kaifeng. He was not only a court painter – which implied portraiture, decoration and religious painting – but also the head of the Imperial Academy. He must, therefore, have been an artist of considerable standing amongst his contemporaries. There are, indeed, records which confirm that he was a good painter in many fields, who painted landscapes for his own satisfaction. Few of his works have survived, and of these *Early Spring* is probably the best known. It is, again, an ink painting, with very slight colour, on darkened silk. The signature and date of 1040 may well be subsequent additions, as the

88 (*right*) Tung Yüan (*fl*. 947–970), *Festival for Evoking Rain*. Ink and slight colour on silk. Comparison with Pl. 87 shows a more conscious knitting of the composition, but a similar evocation of space. Tung Yüan, from Nanking, painted the gentle mountains of that part of China.

89 (*overleaf, left*) Chu Jan (*fl. c.* 960–980), *Seeking the Tao in the Autumn Mountains*. Ink on silk. A classic of the 'master mountain' type of landscape, in which the viewer is taken from the foreground up into the mountain. Chu Jan was famed for his use of long modelling strokes and accenting dots.

90 (*overleaf, right*) Fan K'uan (*c.* 950–1050), *Travelling in Streams and Mountains*. Ink and slight colour on silk. Another masterpiece of the Northern Sung School. The artist builds on clearly discernible eye levels, using a mist to create depth between the nearer ground and the huge mountain mass.

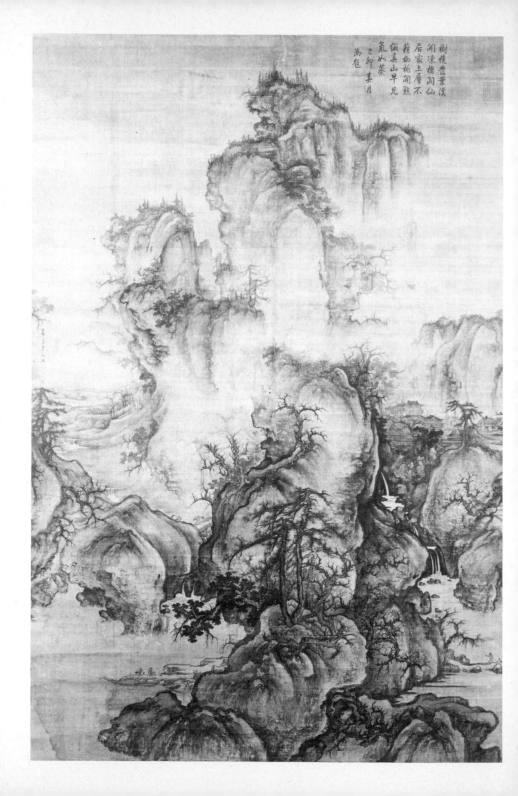

樹繞前葉溪
間凍擁陶仙
居家上屬不
接物相間然
似壽山早兄
氣如蒸
己卯春月
馮超

practice of signing work became customary only later. If Fan K'uan's picture was a representation of a classic theme, Kuo Hsi's is a Baroque variation. The mountain stands in the centre of the composition like a great column of smoke. On both sides of this central pillar are many smaller scenes, each with its own eye level and each painted to catch and hold the eye before it makes its way on a journey through the landscape and around the surface of the painting, up the steep path to the temples, to the right, or away into the wide valley, to the left. Such is the spatial complexity of the work that the artist is able to project the viewer into varying heights and depths within the composition, and to take him for a journey within the landscape, as indeed is his intention. *Early Spring* is painted more richly than *Travelling in Streams and Mountains*. Kuo Hsi used wash and ink strokes, wet and dry ink. The faint colour is of earth-browns and green, used to emphasize lightly but not to 'colour' the picture. Kuo Hsi's handling of trees was much admired, but it became a cliché in the hands of lesser artists. This is one of the last pictures of a classic tradition. Like the Baroque in Europe, it was succeeded by a move towards a smaller compositional format as well as by an apparent change in compositional devices.

The handscroll painting by Hsu Tao-ning is almost contemporary with \qquad 92 Kuo Hsi's *Early Spring* and is also painted in ink, on silk. The case of this artist was unusual in that he did not belong to the official class from which most painters came; at least in his early life he had earned his living as an apothecary. The landscape which is represented in his handscroll is more stylized and avowedly 'romantic' than the Baroque landscape of Kuo Hsi, and it shows a fresh move towards elegance of brushwork. The more intimate handscroll format, designed to be viewed at openings which can be comfortably selected by the viewer, is also unique to the Far East. The long strip presents novel problems of composition: it is, in fact, planned by the artist in a series of overlapping compositions which reveal themselves as the scroll is slowly unrolled on a table by the viewer, who holds both rollers in his hands and rolls and unrolls the two as he views small sections from right to left. A handscroll is not meant to be unrolled completely to be viewed as one long strip. The Hsu Tao-ning river landscape is very simply constructed, with a river foreground and receding valleys divided by dramatic rocky cliffs. Each end of the scroll is bounded by trees and rocks coming close to the foreground, which, as with other landscape painting of this time, is established at quite a distance from the viewer.

91 Kuo Hsi (*c.* 1020–1090), *Early Spring*. Ink and slight colour on silk. Comparison with Pls 89 and 90 shows the movement towards a richer composition and a more Baroque style.

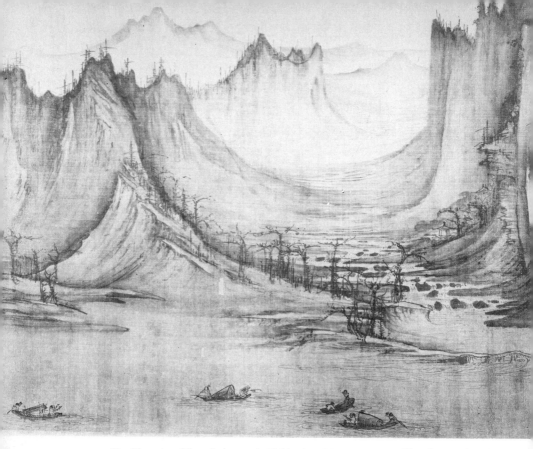

92 Hsu Tao-ning (*fl.* 11th century), *Fishing in a Mountain Stream* (detail). Handscroll, ink on silk. A highly individual handling of this bleak landscape, as can be seen from a comparison of the distant valley with that of Pl. 91.

Landscape was the major theme for serious painting, but not preferred to the exclusion of all other subjects. The love of classification quickly led the Chinese to attribute roles to selected subjects. Thus 'bird and flower' painting at this time is regarded as decorative, while 'bamboo and orchid' painting may well be very scholarly with calligraphic connotations. Clear divisions were also established between paintings in ink alone and those in which colour played a major part. The use of colour came to be the dividing point between decorative and non-decorative painting.

Decorative art does not imply artistic inferiority; it formed a highly valued part of Chinese domestic culture and it applied to all the crafts of the period. One cannot emphasize enough the richness and quality of craftsmanship and imaginative inventiveness which characterized the

93

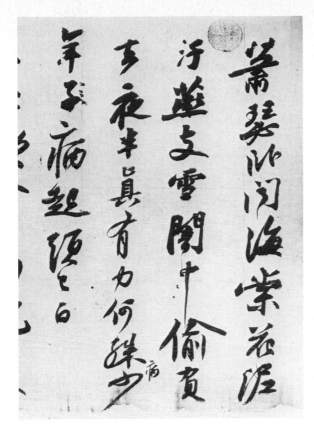

93 Fragment of calligraphy by Su Shih (1036–1101) of his poem 'Cold Provisions Day'. Su Shih was a fine scholar, poet and calligrapher, and a noted painter of bamboo.

decorative arts at this time, alongside the apparently growing asceticism of landscape painting as it was evolved by the major school of court painters. The increasing sophistication of life, and probably the increasing complexity of urban living, demanded much from the craftsman. In the tenth century, whilst the country was divided and several courts flourished, local crafts received a great boost. In ceramics, the potters of Chekiang, notably at the Shang Lin Hu kilns, produced Yüeh ware for the Wu court, at present-day *80* Nanking. This grey-green stoneware was of such beauty that it was treasured by contemporary collectors and even inspired poetry. The Yüeh stoneware is restrained and largely undecorated, relying for its distinction on subtle and elegant surface texture and colour.

In the meantime, in the north, the Honan potters produced black glazed *96* stoneware and a wide variety of white wares. Ting ware, reputed to have *81, 94* been made at Ting Chou, in Hopei, was the most distinctive among the many white wares made in the province. This, at its best, is a white-bodied

94 Shallow foliated Ting ware bowl. The incised floral decoration is made with a sloping blade which gives a shaded line as the glaze gathers in the cut; one side of the line is sharp while the other shades off in the slope of the cut. 11th–12th century.

but not translucent ware which has a transparent, ivory-coloured glaze. The potting is exquisitely refined and often, apparently, based on silver vessels. The distinctive metal binding of the lip of Ting bowls and saucers is the result of firing face down in a special saggar; this resulted in an unglazed lip which was then bound with silver or bronze. The decorators at Ting Chou used a shallow, incised line for free floral motifs, in a style imitated later by other potters. Also imitated was a technique of impressing the decoration: the thrown bowl was laid on a clay mould and turned on the wheel to result in a thin-walled bowl with a relief decoration inside. Ting ware was the most

95 Chun ware dish of pale-blue glazed buff stoneware. The purple zigzag splash is copper painted into the glaze. One of the brightest coloured wares produced at this time. 12th century.

highly esteemed ware in the early eleventh century but it lost favour owing to glaze flaws called 'tear-drops'. The taste of the court then turned to the other great tradition of Chinese ceramics, the grey-bodied stoneware with an iron-bearing glaze. At this period the finest northern stoneware of this type was the Ju ware made at Lin Ju, near Loyang. This is characterized by a fine-grained body, simple but elegant shapes – mostly bowls and vases – and an exceptional bluish glaze which could result in a soft hazy colour. The glaze is thick and semi-opaque with bubbles. Ju ware was highly prized in its day and is very rare today. The more readily available, related, ware is Chun

76

96 Pear-shaped vase. This is a northern pale-bodied stoneware with an almost black glaze into which the design of a flower spray has been painted, resulting in a metallic lustre effect. Probably from Honan. 12th–13th century.

95 ware, also made near Kaifeng. This was a more ordinary kind of pottery for everyday use. It is a very heavy, high-fired stoneware, thrown with a pronounced heavy foot; the glaze is thick and misted with bubbles and impurities. Chun ware glaze is a pronounced blue with a lavender shading to

97 Tzu Chou ware pillow with slip decoration under a colourless glaze. Comparison both of the motifs and of the layout of the design with later blue and white porcelain (Pl. 140) suggests possible but unexplained links. 12th century.

which a bright purple splash is often added. Both Ju and Chun wares established a type of stoneware which was imitated at other kilns in both north and south China. Northern celadons, from kilns north of Sian, Shensi, are of a different style: in these pieces a severe olive-green, clear, shining glaze was used over a richly worked surface, either incised or impressed. The love of such decoration is nowhere better expressed than in the Tzu Chou pottery. This was another utility ware, made in Hopei. It is distinguished by its heavy, grey body which was slipped white and then decorated by incised lines of slip painting. The painting in particular can be lively and, especially when figure scenes are involved, very painterly. One group of ceramic pillows, decorated with what appear to be copies of woodcut book 97 illustrations, are exceptional and introduce a type of decoration which was developed to great heights in the fourteenth century in the south.

This diversity of high quality potting in Northern Sung is evidence of a degree of connoisseurship which was not reserved for pottery alone; it extended also to woven and embroidered silks, tapestry, lacquer, carved jades, hardstones and ivory – although many of these objects have not survived very well. At this time, alongside the appeal of contemporary styles, there was also a taste for archaistic style. The persistence of this taste in the applied arts at all times is something that has to be taken into consideration; it is a positively creative force in Chinese design and it emerges again and again as a major factor.

Court and Ch'an Buddhist Arts
early 12th–early 14th centuries

Like the decorative arts, painting in the Kaifeng court of the Northern Sung, in the early part of the twelfth century, enjoyed Imperial patronage and it reached one of its zeniths. The Emperor Hui Tsung, the last of the Northern Sung rulers in Kaifeng, was a man of definite tastes and autocratic temperament. He surrounded himself with artists and formed an Academy, which he controlled personally. He met his painters every day and it is recorded that he organized competitive painting exercises. Such was the vitality of the arts at this time that even this apparent interference by the Emperor did no damage, but rather gave impetus to a new movement already underway.

Avowedly decorative, the Northern Sung Academy School exerted an influence which survives to the present day. Using the format of a small album leaf, the Academy painters discarded the compositional devices used by contemporary landscape painters. By severely restricting their subject, they were able to develop a surface, almost two-dimensional, composition in which the judgment of line, mass and space and the awareness of balance within the frame could be brought to perfection. This twelfth-century court art of the Northern Sung is typified by jewel-like representations of birds and flowers, exquisitely observed, painted feather by feather, stamen by stamen, in enamel-bright colours. It is a style far removed from that of the grand landscapes of the eleventh century.

98

When northern China suffered a Turkic invasion, resulting in the setting up of the Chin state, with its capital in Peking, the Kaifeng court fled south, in 1127, and established a capital at Hangchow. Here the Southern Sung ruled, from 1128 to 1279, until the whole country was conquered by Genghis Khan and his son Kublai, who ruled over China in the Yüan Dynasty (1260–1368), when the capital was once again moved north, to Peking.

As far as the artistic life of China was concerned, the chief significance of all this movement, and of the period during which the capital was in the south, lies in the unusual prominence given to the southern style (until that time a provincial style far removed from the court) and the virtual suppression of the northern style. Although little work survives to facilitate a detailed comparison between northern and southern painting of the late

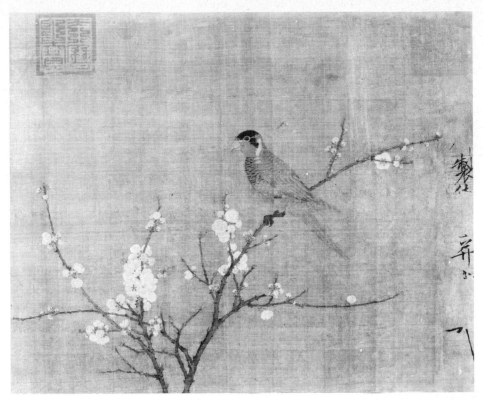

98 Emperor Hui Tsung (1082–1135), *Five-coloured Parakeet on a Branch of Apricot Blossom*. Colour on silk. The exquisite style of the Northern Sung Academy School greatly influenced painters in both China and Japan throughout later centuries.

twelfth and thirteenth centuries, such as there is suggests a continuation in the north of the traditional 'realist' school of painting often identified with it. But this style is also manifest in the south in such works of vivid observation as the *Ch'ing Ming Festival* handscroll, of Chang Tse-tuan, which stands witness to a living tradition from the north now transplanted south. This silk handscroll records, in ink, the festivities and bustle of Suchow at the time of the Spring Ch'ing Ming festival, when families gather to tend tombs. Such genre painting relates directly to the details of fishermen and village life which are found in the large northern scrolls.

 The Southern Sung court style of landscape painting developed in a more romantic direction. But this too derived, in part, from the work of the

99

99 Chang Tse-tuan (late 11th–early 12th century), *Life Along the River on the Eve of the Ch'ing Ming Festival* (detail). Handscroll, ink on silk. This busy market scene is fascinating for its acute observation and is a fine example of Chinese genre painting.

northern court painters with their concern for supremacy of surface composition and elegance of drawing.

However, the use of an isolated subject, eliminating everything but the essential elements, led to a very different style of painting when applied to landscape. Faced with the problem of expressing depth within a surface composition, landscape painters turned their attention to the creation of atmospheric space: to express 'one thousand *li* of space in one foot of silk' was how they put it. The illusion of distance was achieved by touching in carefully judged tone washes and by an equally carefully judged attention to

The combination of an overhead view of buildings with an almost side-on view of figures is a convention common to both Chinese and Japanese painting.

scale, so that a distant hill seen across water sits exactly right and establishes the intervening space. The area around Hangchow, the southern capital, was a land of lakes surrounded by gentle hills, a scene far removed from the imposing peaks of the Tsin Ling mountains, south of Kaifeng, beloved of the Northern Sung landscape painters. In the hands of the Southern Sung painters, these lake-scapes became unashamedly romantic with their wide distances, low hills and silhouetted trees. Evocative of gentle sadness, evenings and half-light, they are above all else elegant paintings. In the great tradition of the Chinese landscape artists, the Southern Sung painters used

123

only ink. But, increasingly, they used paper rather than silk, which allowed a greater freedom of texture. Employing many of the compositional devices developed by the painters of birds and flowers of the Emperor Hui Tsung's Academy, the thirteenth-century landscape painters adopted what has been called the 'one corner' composition: shifting the balance of the picture, they were able to exploit the juxtaposition of form and space, line and mass. This compositional device, however, has inherent limitations and the pictures may seem repetitive. But the expressiveness of the brush stroke itself now became an important consideration. It was at this time that brush strokes acquired names, a development which indicates a more self-conscious brush style.

Hsia Kuei and Ma Yüan, two great masters of the later thirteenth-century court, perfected a dramatic ink style which has become associated with the 'one corner' composition, and together they typify the Southern Sung landscape style. In his *Pure and Remote Views of Hills and Streams* handscroll, Hsia Kuei painted a bravura ink painting on paper in which brushwork is as much part of the subject as is the spectacular water-scape and rocky shore. Hsia Kuei here reveals his mastery of the chopping 'axe cut' brush stroke, the dragged dry brush, the 'flying white' stroke and the subtler wet wash. Moving from stress to stress abruptly, shifting the eye from the foreground to long distance with just an evocation of the space in between, this scroll also shows the evolution in handscroll painting. The handscroll now became a more adventurous format in which the artist attempted to move the viewer in and out of the depth of the painting.

Ma Yüan and his son, Ma Lin, used the same mode of composition as Hsia Kuei, but their smooth beguiling brushwork produced a gentler kind of painting; this style of brushwork became classic, although in lesser hands it degenerated into cliché. The subject of *On a Mountain Path in Spring* is a gentleman with his servant in a garden setting – one of Ma Yüan's favourite themes. The figures, together with the trees and the rocks, take the weight of mass to one corner of the picture, but the dramatic lines of tree branches, and, more vividly, the direction of the look of the gentleman, take the eye across a misty space to the distance. In this way there is a delicately created and constant balance between the surface composition and the depth which it creates, which is not over-emphatic.

Close to the northern and southern court painters in technique, but worlds away in spirit, were the Ch'an Buddhist painters of this time. Many scholars and artists were much influenced by the asceticism and directness of the demanding teaching of this sect, which is known as Zen in Japan. The Ch'an sect had been in existence since the sixth century AD, but the thirteenth century saw a resurgence of interest in Ch'an around the Hangchow area.

100 Hsia Kuei (*fl.* 1180–1230), *Pure and Remote Views of Hills and Streams* (detail). Handscroll, ink on paper. The chopping 'axe cut' stroke is used in the modelling of the rocks, and the dragged dry and wet brush in the trees.

125

The chief quality required of the Ch'an artist was a directness of expression which stood, in some respects, for the sudden enlightenment and insight which is the experience most highly valued by the adherents of the sect. This quality was in contrast to the sophistication and artificiality admired in the court art of the time. Perhaps as a counter-balance to the self-conscious artificiality of court painting, several major artists produced paintings inspired by Ch'an beliefs. Trained as court artists and using the same astonishing sureness and control of brush, ink and tone, they added the immediacy and simplicity of vision demanded by Ch'an, to produce such masterpieces as Mu Ch'i's *Persimmons* and Liang K'ai's figure paintings.

So little is known about the personal lives of artists at this time, and still less of the monk painters, that there remains a doubt about the identity of Mu Ch'i, who may have been a Japanese monk. His paintings are not all as

101 Ma Yüan (*fl.* 1190–1225), *On a Mountain Path in Spring* (detail). Ink and light colour on silk. An album leaf in which Ma Yüan uses surface compositional devices close to Hui Tsung (Pl. 98) but adds the illusion of space and depth with the hill to the left and the flying bird.

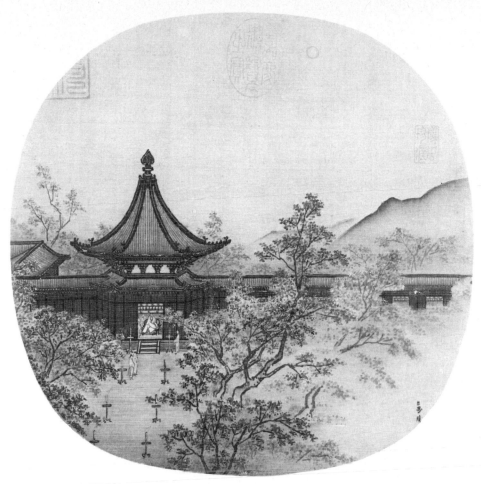

102 Ma Lin (*fl*. early 13th century), *Waiting for Guests by Lamplight*. Fan, ink and colour on silk. Atmospheric effect is vivid here, with the use of glowing colour inside the lamplit room and a faint cool white for the blossom in the twilight. The ink tone is very rich.

unusual in subject-matter as *Persimmons*, which is a monochrome painting of a subtlety in tone and composition which is very easy for the twentieth-century Western viewer to comprehend. Mu Ch'i also painted large Buddhist paintings which have a spiritual quality unusual in Chinese iconographic work. Mu Chi's contemporary, Liang K'ai, was also trained as a court painter but turned to Ch'an painting. His portraits are witty and humorous, and the extraordinary verve of their ink play makes them immediately accessible and places them in the finest tradition of Ch'an.

104
103
105

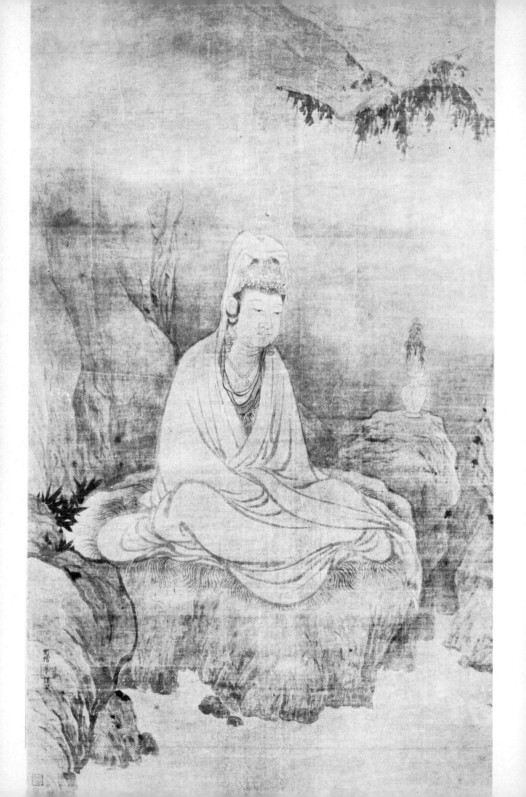

103 Mu Ch'i (active 1269) *White-robed Kuan-yin*. Ink on silk. The elegant brushwork of Hsia Kuei and Ma Yüan is here used to create a meditative painting of unusual power.

104 Mu Ch'i, *Persimmons*. Ink on paper. This small painting epitomizes the Ch'an ideal with its subtle evocation of colour in tone and its witty brushwork.

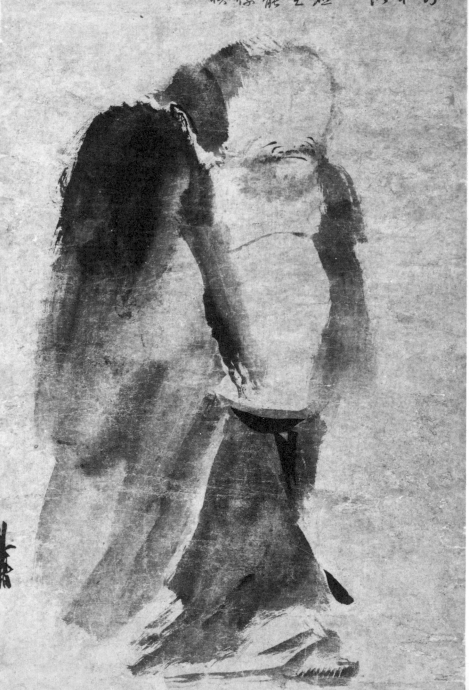

地行不識名和
識名和姓大江
姓大陽一
高陽一洞泥
洞泥光瑤臺
光瑤臺仙宴罷
仙宴罷淋漓襟
淋漓襟袖尚糢
袖尚糢糊

Admiration for Southern Sung craftwork reflected the distinction between court and Ch'an taste. A third type of taste was that for export wares in all crafts. These various tastes can be seen notably in pottery. The kilns of south China grew in importance during the twelfth and thirteenth centuries, taking up the markets of the earlier northern kilns. A huge complex of kilns at Ching-te Chen, Kiangsi, was growing during the Southern Sung period. Ching-te Chen supplied white porcelain with a pale blue glaze, called Ying Ch'ing. This ware was the southern replacement for Ting ware, with which it shared decorative styles and techniques. The Ching-te Chen potters threw and turned their pots in the shapes of the silver and gold vessels fashionable at this time. The bowls ring beautifully when struck; the sides are thin and translucent, and often foliated at the rim. The foot is thick and heavy, with a thin foot rim and a typical firing scar on a ring of grit which oxidizes almost black on the base. Thirteenth-century Ying Ch'ing ware may have incised or _106_ moulded decoration. It was produced in a whole range of qualities, the finest of which would have been used at court and for high-class exports to Japan. Lower grades for more general use were also sent to Ningpo, and later to Chuan Chow on the coast to be exported in the growing trade with nearby countries. At this period China was exporting ceramics, tea and silk in exchange for gold, silver and spices from Japan and Indonesia.

The green glazed stonewares of Chekiang also played an important part in the export trade. By this time the market had moved from Shang Lin Hu to the more southerly Chekiang kilns around Lung Ch'uan on the Ou River. Lung Ch'uan ware has a characteristic grey body, strong and heavy but _107_ almost white. The green glaze is a distinctive blue-green and applied very thick; it has a special quality of sheen and translucency which imparts a jade-like character. The highest grade Lung Ch'uan ware both replaced the northern Ju ware at court and established a reputation of its own at a time when jade carving was highly esteemed by connoisseurs. Japanese visitors to Hangchow, monks, diplomats and traders, greatly appreciated the celadon ware and took special pieces back to Japan as treasures.

Japanese monks also discovered a black ware from Fukien, Chien An, _108_ being used at the Ch'an Buddhist temples at Tien Mu Shan, close to Hangchow. This was a peasant ware, local to a group of kilns in west central Fukien, whose brown-bodied dark glazed tea bowls had been adopted by the Ch'an for their ceremonies in the thirteenth century. The popularity of this

105 Liang K'ai (c. 1140–1210), *Ch'an Priest*. Ink on paper. Liang K'ai is a Ch'an artist of great elegance and his painting often displays the humour characteristic of Ch'an work.

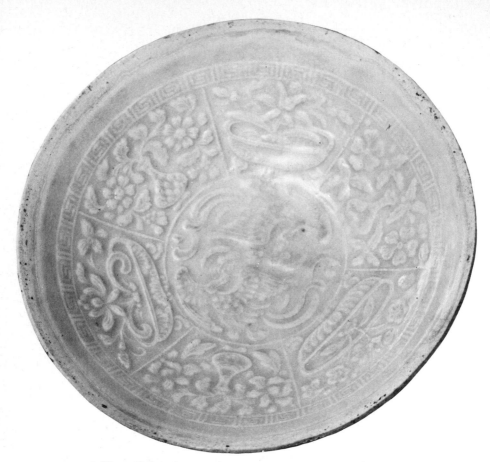

106 Ying Ch'ing impressed porcelain bowl. The formal segmented style of decoration is a feature of the impressed technique; both style and technique reflect a general move towards greater elaboration. From Ching-te Chen. 13th–14th century.

107 Celadon bowl with lotus petal relief decoration. A typical product of the Lung Ch'uan group of kilns in southern Chekiang. The body is a fine pale-grey stoneware and the glaze a thick crackled blue-green with a jade-like sheen. 13th–14th century.

108 Temmoku ware tea bowl of the 'hare's fur' type, from Chien An, Fukien. The thick dark glaze runs away from the lip, which is almost unglazed, and gathers in rich rolls and drops above the foot. The 'hare's fur' effect is just visible inside the bowl. 13th–14th century.

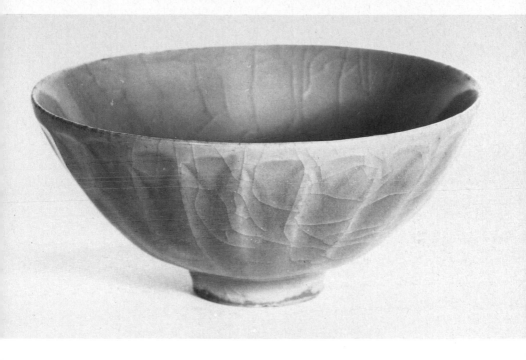

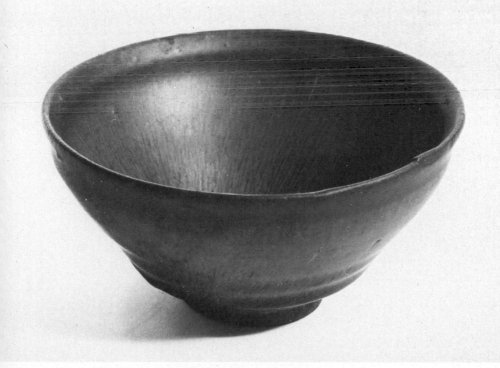

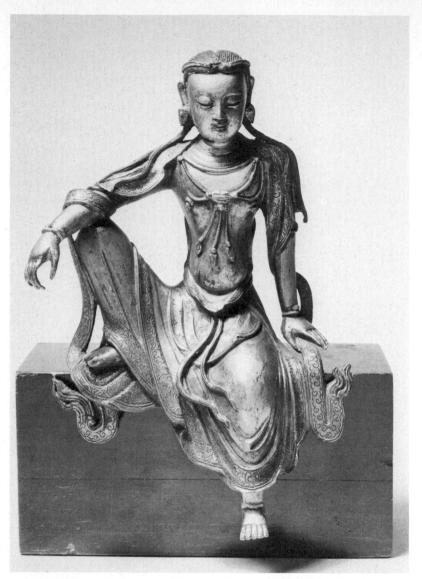

109 (*above*) Seated gilt bronze Bodhisattva. This elegant little figure has the pretty, more feminine features of the southern style of Buddhist sculpture in the Sung period.

110 (*right*) Parakeet on a cherry twig. Woven silk tapestry (*k'o ssu*). The contemporary style of bird and flower painting lent itself to reproduction in fine textiles. 13th century.

ware engendered many imitations at other kilns, each with a distinctive body but all with a streaky dark glaze. An appreciation of a sophisticated 'simplicity' is part of Sung Ch'an taste, with its respect for directness allied to elegance of technique. The Japanese monks took the tea bowls back to Japan with the ceremony; they named the bowls Temmoku, this being their pronunciation of Tien Mu Shan where they had found the bowls. This Japanese term has been adopted as a generic name for all black tea wares, which come from many different kilns.

As one would expect, refined southern crafts of bamboo and ivory carving, lacquer painting, and bronze and silk, came to the fore in the *109, 110* thirteenth century. Although examples of the more delicate materials are rare, enough has survived of jade and ivory, and particularly of porcelain, to show that a taste for the quiet southern style permeated court and *literati* circles. The *literati* remained broadly faithful to this taste from the thirteenth century onwards.

Tradition and Invention
14th–15th centuries

In 1260, the Mongols, under Ghengis Khan and more notably his son Kublai, conquered China, first sweeping out the Chin invaders of the north. By 1280 they had unified the country and had built a new capital at Peking, incorporating the Chin city. The Chinese traditional ruling class, who were settled around the old capital at Hangchow, were faced with the difficult decision of whether or not to serve a foreign ruler. For those who took up an official career, this inevitably meant a return to the north and the rediscovery of what had been the centre of Chinese culture before the Southern Sung. For those who resolved to remain outside the administration of Yüan, the new dynasty, it meant a retirement which was to last for their whole lives. There were major painters both among those who accepted the new circumstances and among those who chose to turn their backs on them. But none of these artists could be regarded as court painters in the old sense, that is, that they were attached to the court by right of their painting alone. 77 Indeed, Chao Meng-fu, the highest official ranking painter of the period, seems to have painted chiefly in retirement. He and many of the notable painters of the time lived in the area around Hangchow known as Chiang Nan (south of the Yangtse River), which had already become a major cultural centre of China in the thirteenth century.

Perhaps because of the change of status forced upon many writers and painters by the painful situation of foreign domination, the Yüan period is one of individuality and inventiveness. In painting, even given the constraints of the traditions of landscape painting, some Yüan painters have come to be regarded as innovators within the classic school; they opened up the way to further evolution of the style by later painters. This group of landscape painters seem to have been engaged in creating variations on a theme. After them, the variations were treated as themes and more variations were played upon them.

This is the first period in which painters emerge as individuals and in which much is known about their lives. Enough painting has also survived to allow us an overall view of the work of particular artists. There were six artists, two from a more academic tradition and four who are traditionally known as the 'Four Great Masters of Yüan', to whom all later painters looked with great respect.

111 Ch'ien Hsuan (c. 1235–1301), *Squirrel on a Peach Bough*. Ink and colour on paper. This small painting, though owing much to the 12th-century bird and flower style, has a new air of movement and 'naturalness'.

Ch'ien Hsuan (c. 1235–1301), a scholar from Suchow who was never in fact given office, was a painter of distinction in a style which was totally in tune with his time. Ch'ien had trained in the traditional way, by studying and copying old painting and calligraphy, which would have included examples of the Southern Sung court style. Perhaps having fresh access to the old masters in the northern collections, he developed a distinguished archaistic style which was not a pale reflection of earlier prototypes, but a personal vision based on the paintings then extant of the ninth and tenth centuries. Archaism, always a creative force in Chinese art, was at this time particularly prevalent in painting. Ch'ien's painting was regarded as being close to the original prototypes and the artist himself said that he signed his pictures 'to distinguish them from imitations'. *Wang Hsi-chih feeding Geese* is a fine example of this kind of archaism. Such small, coloured paintings have great dignity and strength. The use of colour itself established a clear connection with the T'ang paintings of the 'blue and green' style. But his composition, although it owes a little to the 'one corner' Southern Sung model, is closed in and it is combined with a minute observation of every element in the painting. Even when Ch'ien uses the bird and flower style of *111* the Northern Sung, he loosens the composition to produce a more natural-seeming balance and expression of his subject.

Ch'ien Hsuan's younger contemporary, Chao Meng-fu (1254–1322), had completed his training at the start of the Yüan Dynasty (1270). He was a brilliant scholar and calligrapher. When he was called, in 1286, to Peking, he took up an official career with considerable success, rising to be secretary of the Board of War. However, he retired early, in 1295, and returned to his native Wu Hsing, bringing with him a collection of paintings which are said to have included tenth-century works. His painting, *Autumn Colours*, of the mountains of Shantung, is an unassuming but vivid account of a specific scene. It is recorded that this picture was painted for a friend who had not been able to visit the area, his old home, and so it had a special significance. There is no hint here of the artifices of the thirteenth century, but there is more than a passing reference to the brushwork and recording skills of the tenth century. Chao Meng-fu felt strongly about his place in a tradition which he saw as linking him directly with Tung Yüan and Chu Jan. Even so, he did not avoid the use of colour in his paintings. He also wrote about his paintings in a well-trained but highly personal calligraphy. Chao was much admired in his own time and seemed to be the ideal scholar-artist. But his reputation has been clouded by those who disapproved of his action in serving a foreign court. This may be the reason for the relative scarcity of his surviving work. Of his contemporaries who chose to retire from official life, Huang Kung-wang, Wu Chen, Ni Tsan and Wang Meng are grouped as the 'Four Great Masters of Yüan'. Each one has his own style, although all four artists lived in the Chiang Nan area, at a time when not only was the centre of national power far away, but the area itself was controlled by the salt-smuggler Chang Shih-ch'eng.

Huang Kung-wang (1269–1354) was a generation younger than Chao Meng-fu and came from a quite different background. Adopted into a family, he was a child prodigy. He had a short official career, but he is best known for the paintings of his old age and in particular for one ink on paper handscroll, *Wandering in the Fu Ch'un Mountains*, which inspired many later painters. The artist records that he worked on this painting for seven years during which time he made sketches and notes in the mountains and gradually built up the picture. The brush style seems absolutely assured but unselfconscious, rather like that of the older Titian; the brush strokes are laid on boldly but with subtlety of tone. The composition encompasses a whole sweep of a lake, mountain tops and wooded slopes. The spectator's eye is led to wander through the terrain and at many eye levels; foreground and background depths are varied to create a rich texture and an effect similar to that achieved by Kuo Hsi, but are executed in a brush style which is very different. A comparison of Huang's work either with the theatrical passages of Hsia Kuei or with the complex and grandiose details of Kuo Hsi

138

112 Huang Kung-wang (1269–1354), *Wandering in the Fu Ch'un Mountains* (detail). Handscroll, ink on paper. Comparison both with the early masters whom Huang admired (Pls 89, 90) and with the contemporary paintings by Chao Meng-fu (Pl. 77) and Ch'ien Hsuan (Pl. 111) show the strength of this master's work.

demonstrates the eclecticism of the Chinese painter. Huang is valued for his lovely brushwork and economy of means. He was also concerned with the representation of light, an aspect of landscape which artists began to explore at this time.

Wu Chen (1280–1354) was an unassuming man who earned his living as a fortune-teller and diviner. He described himself disarmingly in a colophon to one of his paintings:

I would like to have composed another 'Homecoming' ode [like Tao Yuan-ming's], but am ashamed to have no such lovely verse as 'The three paths are almost obliterated'. I would have liked to have wandered around the Yangtse and Hsiang rivers, but unfortunately hadn't the proper bearing to go about in a coat and hat of green leaves. I might have studied agriculture, but hadn't the strength needed for ploughing; I might have taken up vegetable gardening, but taxes are oppressive and the foreigners [the Mongols] would only have confiscated my land. Advancing [in public life], I could not have fulfilled any useful function; retiring, I could not have concealed myself happily in idleness. So I have lived by the Changes practising frugality and done what I pleased. Through a harmonious life I have drifted into old age. What more could I have wanted?★

★ Quoted from James Cahill, *Hills Beyond a River*, New York and Tokyo, 1976.

113 (*above*) Wu Chen (1280–1354), *Fishermen* (detail). Handscroll, ink on paper, dated 1352. The expression of space over water is similar to that of a 13th-century painting, but the softness of brushwork and the very subject-matter change the spirit of the work.

114 (*right*) Ni Tsan (1301–1374), *The Jung Hsi Studio*. Ink on paper. This is a fine example of the 'stretched' landscape composition held together by the foreground trees.

Wu Chen's paintings in ink on silk or paper are strongly individual. His *113* many lakeside genre scenes of the T'ai Hu, where he lived, are painted in wet ink, usually in the middle tones which create an atmosphere of calm. Genre painting was probably one of the most popular types of painting in China and the surviving examples from Sung times up to the present day show that it could be adapted to a multitude of styles. Wu Chen worked as stylishly in bamboo painting as in genre. He clearly enjoyed working in wet ink on a fairly non-absorbent paper, which produced a smooth stroke and a full sweep, allowing full play to the calligraphic brush.

Ni Tsan (1301–1374) came from a comfortably well-off family which owned a fine house and a famous library. He was an educated man who chose not to take up the office for which he would have been fitted. During the period of national troubles, both taxation and local unrest hit his family and eventually he sold up the family estate and, to avoid having to submit to the local ruler, he and his wife lived on a boat on the lakes. It seems that his highly *114* personal landscapes, variations on the same lakeside subject, date from this period. His vision is one of calm waters and of uninhabited land in a silvery light. Painted in light ink on paper, Ni Tsan's paintings are executed with a light, staccato brushwork and in a very narrow range of tone. The artist has a sure eye for expressing space across water. He uses a vertical hanging scroll format and he is the finest exponent of the 'stretched' composition: whereas the eleventh-century landscape painter bound his painting to the edges of the

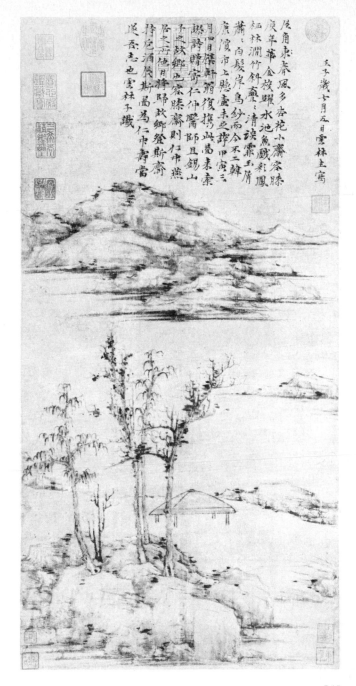

辰角東春風多杏花小齋容膝
庭年華金梭躍水池魚戲彩鳳
栖林澗竹針蘑清詎霏玉屑
蕭蕭角髮岸鳥紗而今不二韓
焦濱市上懸盡未必辞甲寅三
月四日榤斯翁復攜此屬朱索
縣詩贈寄仁仲醫卸且錫山
不之故鄉必客膝齋則仁中燕
居之西德月將歸故鄉登斯齋
待飽酒慶斯囑屬為仁中壽當
暖吾志也雲林子識

141

frame and related one eye level to another by interlocking units within the composition, Ni Tsan and other fourteenth-century painters expanded the space between these units, daring almost to split the composition horizontally, but tying it by the use of vertical elements, such as a tall tree in the foreground, to unite the surface.

The fourth of the Yüan masters was Wang Meng, a grand-nephew of Chao Meng-fu. It is possible that he knew his uncle's collection of old master paintings. Wang Meng was arguably the most inventive of this group of fourteenth-century painters. Nevertheless, he used a tenth-century type of composition for his big paintings, building his mountain scenes with multiple eye levels and using a *tour de force* perspective construction to produce a receding mountain ridge beside an open expanse of water. Wang Meng was also a master of complex brushwork, modelling his forms all over in tiny *ts'un* (this technical term, which derives from the word for the wrinkles on the back of the hand, refers to strokes which express both texture and modelling). After a brief official career between 1354 and 1368, Wang Meng retired to the mountains near Suchow. He was later called to the court of Hung Wu (1368–98), who was the first Emperor of the Ming Dynasty. But shortly after, purged by Hung Wu, together with several *literati* of whom the new Emperor was very suspicious, Wang Meng was thrown into prison where he died.

Although life for the painter-official was not straightforward, nor in some cases even safe, there was a rich patronage available at court and among the growing merchant class. This affluence is evident in the domestic culture of the minor arts. The fourteenth century saw much enriched decorative art: the introduction of underglaze painting on porcelain, in cobalt and copper, the increased use of carved and painted lacquer, and a distinctive use of metalwork. All these crafts, whether they were carried out in north or south China, show a move towards ornate decoration carried out on more substantial forms. Even the pottery shapes produced by the Lung Ch'uan kiln, which was a kiln in decline, changed at this time, and incised decoration was reintroduced; potting became heavier and the glaze denser. The kilns at Ching-te Chen, on the other hand, were in the ascendant and expanding fast, as were the kilns in Fukien and Kwangtung, mainly owing to increased overseas trade. With the taste for decoration clearly growing, the decorators at Ching-te Chen experimented with both cobalt and copper on the white

115

116–118

115 Wang Meng (1308–1385), *Thatched Halls on Mount T'ai*. Ink and colour on paper. An eccentric composition in which the waterfall to the left and the valley to the right come dangerously close to the edge of the picture. The central 'spine' of the composition grows from the trees and up the mountain ridges.

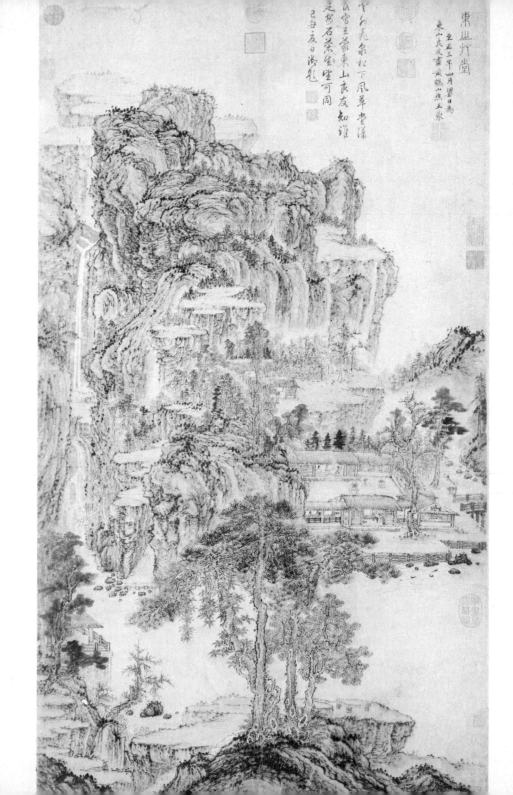

116 Iron underglaze decorated stoneware dish. This large piece is a development of the Tzu Chou style (see Pl. 97). Perhaps from Chi Chow, Kiangsi. 14th century.

porcelain body, covered by a pale, transparent blue Ying Ch'ing glaze. The motifs used in the early Ching-te Chen decorated ware are of birds and flowers in the main zone, with various flower scroll motifs in the borders. The arrangement of decoration is, interestingly, entirely traditional, that is, arranged in horizontal bands or concentric rings. Of the two metallic oxides used in underglaze decoration, copper and cobalt, copper proved to be much the most difficult to control and was quite quickly abandoned; but, once its

117 Large porcelain dish decorated in underglaze blue (cobalt oxide). The blue is painted on to the porcelain body and then covered with a Ying Ch'ing glaze. From Ching-te Chen. Late 14th century.

tendency to run with the glaze and to rise through the latter had been conquered, cobalt became the favourite colour, and a rich blue is typical of the fourteenth-century Ching-te Chen decorated ware. This experimental, decorated ware is contemporary with a monochrome white ware, characteristically potted more heavily than the thirteenth-century pieces from the same kiln, in a style known as 'shu fu', after two characters often found included in the ornate slip trail decoration. The 'shu fu' glaze, although

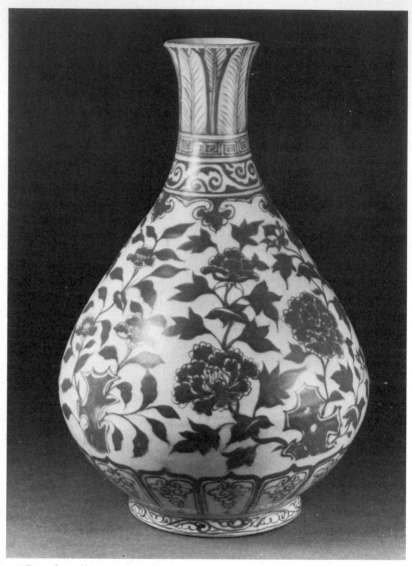

118 Pear-shaped vase with underglaze copper-red decoration. At this early date the floral decoration often seems to grow from the foot of the vase. The lip is slightly cut down. From Ching-te Chen. 14th century.

119 Large Ying Ch'ing porcelain figure of a seated Kuan-yin. The torso is moulded, and the hair, jewellery and drapery modelled separately. From Ching-te Chen. Dated 1298 or 1299.

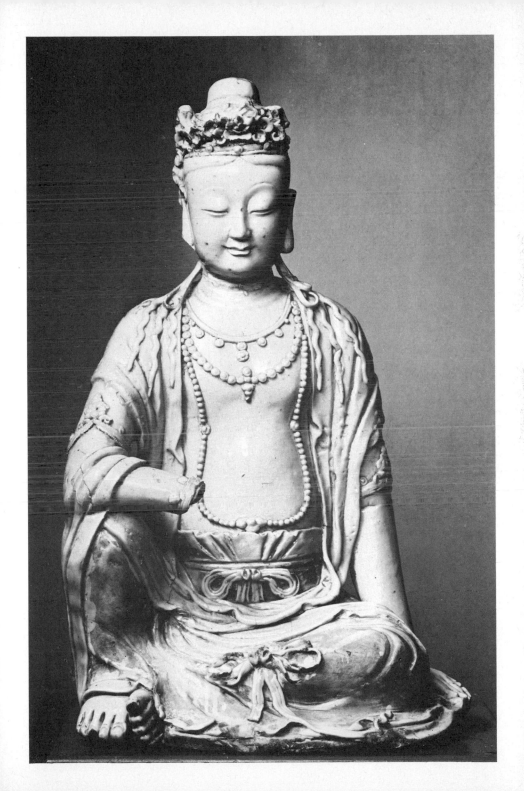

more opaque than the Ying Ch'ing glaze from the same kiln, was also of a bluish tinge, unlike another white ware of the period called 'sweet' white, which is almost pure white. A few new shapes, such as the monk's-cap jug and the stem-cup, were introduced, but it is the underglaze decoration, both in metallic oxide and in slip trail, which distinguishes fourteenth-century porcelain. Grand Buddhist figurines were another innovation of the Ching-te Chen kilns.

119

Lacquer must have been a prominent craft from a very early period. But while the surface of painted lacquer is strong and impermeable, once it is cracked or damaged by over-exposure to light, deterioration is fast in either wet or dry conditions. Since the tradition of extensive, careful burial of objects had become less common, very little lacquer has survived, and it is difficult to follow the varying styles of this craft. However, several examples of Yüan Dynasty lacquer have been preserved in China and Japan, mostly boxes and dishes of foliate shapes derived, apparently, from gold and silver wares. Lacquer was made in black and red with the occasional use of gold for inlay and signature. This strange material is the resin of *rhus vernificera*, the 'Lacquer Tree', which is native to east China. The resin is tapped from the living tree and collected as a slow-flowing liquid which oxidizes to an opaque whitish colour and which will dry only in a humid atmosphere. Lacquer workers use a matrix, usually of finely turned light wood, on to which successive coats of lacquer are painted very thinly. Each coat is polished smooth. Carbon, cinnabar and ochre are used for colouring and are mixed into the lacquer. When the lacquer is dry and very hard it may be carved, just like wood, and the surface burnished to a glossy finish. The full thickness required for carving has to be painstakingly built up from many hundreds of coats of lacquer before carving can be carried out. The ornate carved lacquer of the Ming and Ch'ing Dynasties was later made in exactly the same way.

137

Fourteenth-century craftwork has a richness and generosity of scale in decoration, and both decorative and expressive painting is also freed from the mannerism of the Southern Sung. A broadening of style in all media and a widening of the tradition on which painting was based enlivened the visual arts, opening the way for many new styles to flourish.

Eclecticism and Innovation
15th–17th centuries

When Peking was chosen by the Yung Lo Emperor (1403–24) as his capital, in 1403, the building of the Forbidden City, and all the other palaces, tombs and Imperial temples in and near Peking, was started. The Forbidden City, as the palace of the Emperor and his administration was called, was laid out to include, and enlarge, the rectangular palace area of the previous Chin and Yüan Dynasties. The grand plan, which included ceremonial, religious, administrative and domestic quarters, was approved by Yung Lo and, although much of the building now standing is of seventeenth-century and eighteenth-century date, the lay-out is typical of a Ming palace. The ceremonial buildings are oriented in series down a central north-south axis, facing south. This axis is also aligned with the south gate of the city wall. When empty, the huge courtyards and terraces before each of the ceremonial halls are almost oppressively imposing; they were used as meeting areas for large gatherings of officials. The walled enclosure surrounding the central halls contains smaller halls also used for ceremonial and administrative offices, and the outer box, just within the walls of the city, contains the courtyards, each with a garden, where members of the Imperial family lived. Temples and altars for the use of the Imperial family are sited within the city walls and in the south eastern corner. All the buildings are constructed in the traditional style of wooden beams and pillars. The wide tiled roofs are supported on elaborately bracketed eaves and cross-beams. Used from the first century AD, bracketing had grown and spread to take the progressively wider roofs, but by the Ming period it had also become a decorative feature and the details of the woodwork were picked out in colour. The construction of the roof was simplified and the *ang* lever had disappeared. The roofs of the Forbidden City are of yellow glazed tiles. The profile of the roofs is typically northern in the restraint of the curve of the roof ridge, which is much more pronounced in the south. Roof ridge ends are embellished with dragon finials and the hip ridges are now also decorated with animal tiles. From the fifteenth century architectural techniques and design were static; it is only in details of finials and decoration that originality was shown.

Although Peking became the administrative centre of the country, to which professional artists and craftsmen were summoned, it was not the

*120–
124*

149

120 The Forbidden City, Peking. General view of one of the inner courtyards of the Palace. 15th-century foundation.

121 The Forbidden City, Peking. View of the canal and covered way leading to the side of the main halls. 15th-century foundation.

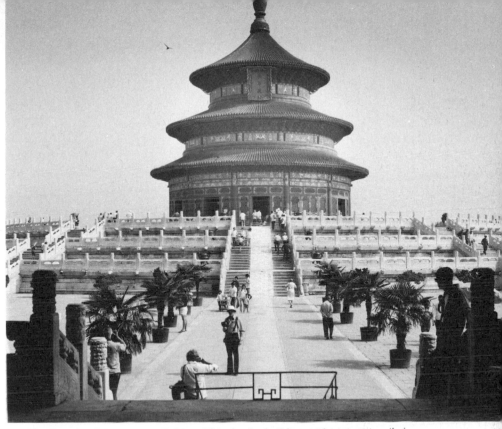

122 The Temple of Heaven, near Peking. This circular building with violet-blue tiled roof and brilliantly painted woodwork faces the Altar of Heaven at which the Emperor performed seasonal rituals. 15th-century foundation.

cultural centre; the Chiang Nan area remained the favourite haunt of painters and writers. Suchow, Yangchow and Nanking were rich centres which thrived on the silk, tea and salt trades; here private fortunes were made and rich families established. Away from the capital, painters and writers, often retired from public service, congregated in towns such as Suchow, in houses with marvellously designed courtyard gardens. The courtyard garden, designed to be viewed through a framed window opening, was developed into a fine art in the sixteenth and seventeenth centuries. The essential feature of this type of garden was that although it was possible to have a general view of the whole garden from a balcony, one usually walked around the garden in a covered corridor, looking through lattice windows which framed the view, often of a carefully placed rock or tree. The garden was seen, thus, as a series of colourful pictures, set in motion as one moved.

134

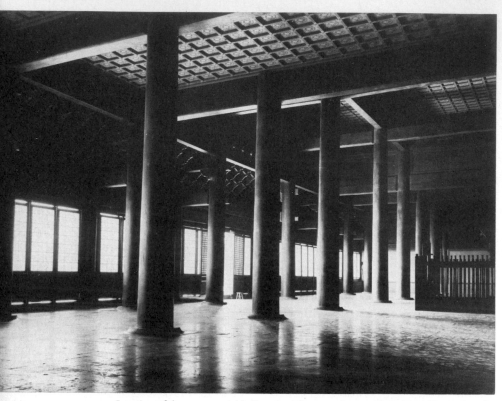

123 Interior of the ceremonial hall at the Ming tombs outside Peking. Erected in the 15th century, this massive building is one of the largest wooden structures known. Red lacquered pillars rise from a marble floor to the painted wooden ceiling; the roof is of yellow tiles.

The general effect is of being inside a painting which changes as one walks in it. The element of composition of each still is created by the frame of the lattice window, and it is magical; the lattice surface pattern within the frame further enhances the effect by fragmenting the composition enclosed and by emphasizing the contrast of surface and depth. Such contrasts were well understood by painters and indeed the ink paintings of the scholar-painter may be commentaries on the multiple compositions which the artist experienced in his own garden. Lack of colour here was no loss; it tended rather to allow the artist to emphasize line, texture and composition.

Courtyard gardens, however, were only one of many types of garden popular at this time. Large, park-like gardens were also constructed in the Nanking area while rich families with plentiful land laid out less formal, much wilder parks on their estates (such an estate was the subject of many

124 Marble camels on the Spirit Way, a road flanked by animal sculpture which leads to the Ming tombs at Nanking. The first two Ming emperors were buried at Nanking, where the tomb site, though similar, is smaller than that at Peking.

paintings by the fifteenth-century artist, Shen Chou, whose work is discussed below).

When, in 1368, the first court of the Ming Dynasty was set up by the Emperor Hung Wu in Nanking, the Emperor assembled a number of painters in an attempt to institute an Academy there. The stay of these painters at Nanking, however, was usually short, due to the factionalism and the conspiracies which were characteristic of the Hung Wu court and which extended to the artists themselves. Even after the court moved to Peking, in 1403, it did not prove to be a congenial place for many painters, and it was never again possible for an emperor to establish an Academy.

One of the greatest of the early Ming court artists in the mid-fifteenth century was Tai Chin, who came from Ch'ien T'ang, in Chekiang. He was an effortlessly fluent painter who used a large format and a style partly

derived from the thirteenth-century romantic style, but his work was also close to the fluid painting of Wu Chen. His large landscape, *Returning Home at Evening*, is constructed on the lines of a Southern Sung landscape, using wide illusions of space and a misty distance; the detail of the figures at the garden door makes a delightful small picture in itself. This picture is painted in the liquid ink style used to a similar effect by Ma Yüan, in the thirteenth century, by Wu Chen, in the fourteenth century, and by Wang Fu in the very early Ming period. Tai Chin painted only for a short time at the court, and he quickly retired to his home in Chekiang. The first syllable of the name of this province was adopted as the name of a school – the Che School – of which Tai Chin was regarded as the leader. When reference is made to painting of the Che School, it is to a general style of painting which is regarded as 'professional' and which carries with it a pejorative judgment of court artists as servants who painted to order. So, regardless of their place of origin, painters who went to court in the fifteenth century are grouped under the Che School. Although their work can be quite different in character, what they share is a fine brush style which is both flamboyant and self-assured. Wu Wei (1459–1508), from Hupei, painted mostly scrolls of fishermen in genre style. Lin Liang (last half of the fifteenth century), from Kwangtung, painted hunting birds, eagles and their prey, and was to have an influence on the Kano School in Japan. Lu Chih (last half of the fifteenth century), from Ningpo, was the most successful of all the court artists: he set up a workshop and produced a huge output of paintings of domestic birds, such as ducks and geese. These decorative Ming paintings are not only generous in scale, but also varied in style and taste. But their range of subjects is limited to kittens and puppies, well dressed little children in idyllic garden surroundings, songbirds among flowering trees, and magnificent phoenix and pheasants.

Another school of painters calling themselves Wu School grouped themselves around Shen Chou (1427–1509), who came from Wu Hsien (Suchow) where his family had an estate. His great-grandfather had been a friend of Wang Meng and it is likely that the family possessed a notable collection of paintings and calligraphy. Shen Chou was a cultivated man who never took up an official career. He was a serious painter and one of the finest eclectics in a tradition which was based upon eclecticism. As a young man he experimented with the styles of the eleventh and fourteenth centuries; he proved an interesting commentator on these styles but his own individuality was never submerged – his eclecticism was never merely archaistic. In this sense he was a true Confucian in his attitudes to his teachers, for he worked within the bounds of tradition until the moment when he felt able to break away and paint entirely in his own style. Fortunately, good

125

126

138

125 Tai Chin (1388–1452), *Returning Home at Evening* (detail). Hanging scroll, ink and slight colour on silk. The scale of this large painting imparts a new dimension to a brush style which is clearly related to the 13th century (see Pls 101, 102).

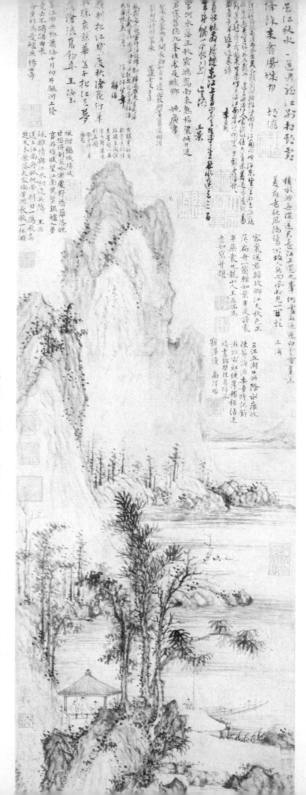

126 (*right*) Wang Fu (1362–1416), *Farewell Meeting at Feng Ch'eng*. Ink on paper. Painted in a brush style which relates both to Wu Chen (Pl. 113) and to Ni Tsan (Pl. 114), this one-sided composition is very typical of a 15th-century mode.

127 (*far right*) Shen Chou (1427–1509), *Poet on a Clifftop*. Album leaf, ink on paper. The painter/poet has projected himself, and by extension the viewer, into the painting. This is one of the earliest instances of an inscription intended as part of the composition.

156

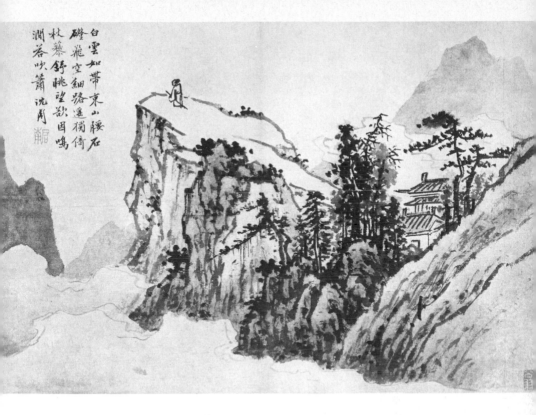

白雲如帶東山腰石

磴飛空細路遙攔倚

杖藜舒眺望欹因鳴

澗苔吹簫沈周

examples of works painted at different stages of his life have survived, so that his development as an artist can be fully traced through his actual work. This development is further confirmed by the evidence of his own writings.

Shen Chou painted many subjects; among his favourites were small landscapes of the estate on which he spent all his life. In *Walking with a Staff in the Mountains*, now in the Palace Museum, Taiwan, he used a light brush style; the landscape is constructed of bare rocks and trees reminiscent of Ni Tsan's style. However, the composition as a whole is compressed so that its 'stretch' is lost, and with it the sense of space over water. Moreover, in contrast to Ni Tsan's pure landscapes, which lack any trace of human presence, there is a figure walking in the middle distance, facing into the landscape. The figure of a man is often present in Shen Chou's paintings; its purpose is to make the viewer identify himself with the figure and so become drawn right into the picture. This is achieved by the scale of the figure and by its placing within the landscape. Figures had appeared in landscape paintings before, notably in Ma Yüan's work, but their role had never been so deliberate. In another work by Shen Chou, in the Nelson Gallery, Kansas

101

127

City, consisting of an album leaf depicting a flute player on a cliff top, the little figure draws the viewer into the painting in a similar way. Here the artist's intentions are reinforced by the accompanying poem. Since the thirteenth century explanatory notes had been written on paintings, recording the circumstances of the execution of the work and giving the date and the name of the painter; colophons also were added by owners and by other painters to enlarge upon the subject or to comment on the painting. But in the Ming Dynasty it became the custom for the artist to write a poem which was complementary to the painting. The poem for the Nelson Gallery picture reads as follows:

White clouds encircle the mountain waist like a sash,
Stone steps mount high into the void where the narrow path leads far.
Alone, leaning on my rustic staff, I gaze idly into the distance.
My longing for the notes of a flute is answered in the murmurings of the
gorge.

Shen Chou's evocation surely aims to transport the viewer into the open space high up. This little painting, quite informal and strong, epitomizes Shen Chou in his mature style, direct and vivid. He used both ink and colour with a freedom common at this time. His mature style demonstrates also the studied 'amateurism' of the scholar-painter, as he attempted to avoid the facility of brush and colour of the 'professional' decorative painters.

Shen Chou had one famous pupil, Wen Cheng-ming (1470–1559), who, although he had an official career, retired early to devote himself to painting. Wen Cheng-ming's early work was eclectic and he painted in many styles. As commentaries on the styles of old masters, his paintings are also interesting because they give clues to a general movement towards colour which seems to have been taking place at this time. Thus when he painted in Ni Tsan's wintry style, Wen Cheng-ming followed the old master's composition closely, but he changed the whole spirit of the scene by the use of atmospheric colour and by setting his picture in a different season: his landscape is of a lovely, spring day. Wen Cheng-ming was abandoning the traditional browns, greens and blues as accents to the composition and feeling his way towards the use of more realistic colours in his landscapes. This development, whose further implication was that colour might be used to create recession in landscape, was almost incompatible with traditional techniques of composition. Wen Cheng-ming was not alone in

128 Wen Cheng-ming (1470–1559), *Lofty Leisure Beneath a Sheer Cliff* (detail). Large hanging scroll, ink and colour on paper. The richness of foliage, expressed in a growing vocabulary of brush strokes, results in a striking surface texture enriched by colour.

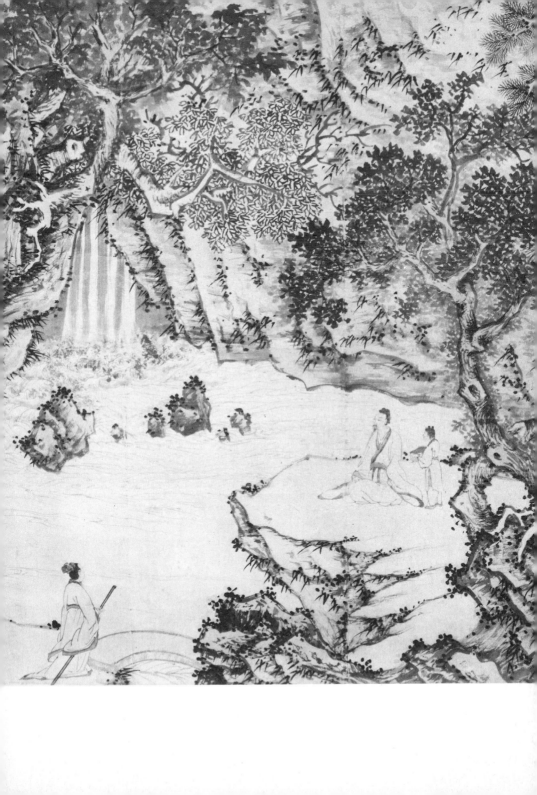

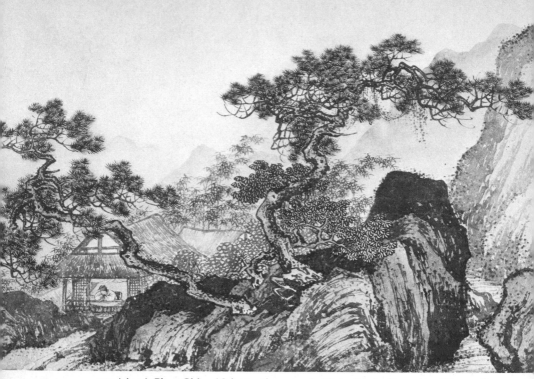

129 (*above*) Chou Ch'en (*fl*. late 15th century), *Taoist Scholar Dreaming of Immortality* (detail). Handscroll, ink and slight colour on paper. This is the beginning, right-hand, part of the scroll; the scholar's dream of himself appears in the sky to the left.

130 (*right*) Ch'iu Ying (*c*. 1494–*c*. 1552), *Fishing Boat by a Willow Bank*. Colour on silk. Using a high view and delicate composition, the artist achieves a most poetic and decorative effect.

experimenting along these lines; his descendants for the next two generations followed his example and many other artists of the sixteenth century, *129* including Chou Ch'en, explored these new areas of pictorial representation.

One of the most delightful painters who followed Wen Cheng-ming's example was Ch'iu Ying (first half of the sixteenth century), a painter from Suchow. He was a professional painter, in the sense that he trained as a decorator and painted for a living. Without having a scholarly background, *130* Ch'iu Ying was an accomplished eclectic who used an archaistic blue and green style, ink monochrome and also full colour. He had no inhibitions about subject or style, and his sheer painterly genius carried him through,

160

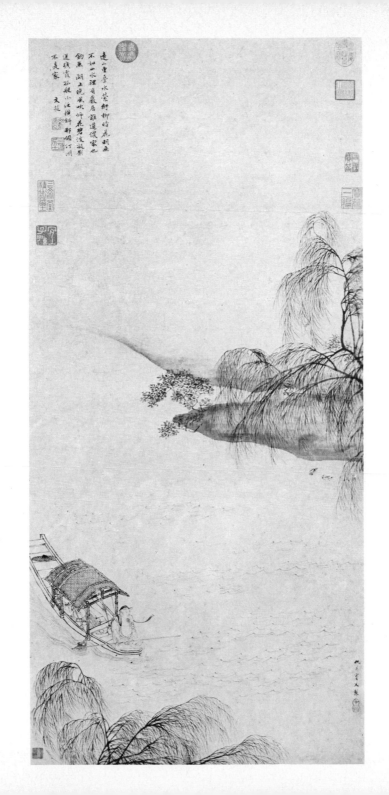

often bringing him very close to the prettiness so dreaded by the classic landscape traditionalists. Ch'iu Ying's figure paintings of courtly scenes, which are of great delicacy, have been much copied. His figures in landscapes and his pure landscape paintings are free from the constraints of his scholarly contemporaries and they demonstrate the possibilities of the Wu School when given full freedom of development. Another painter, who does not fit into a tidy category, was T'ang Yin (1470–1524), again from Suchow. A brilliant scholar, whose career was ruined at the outset by an examination scandal, T'ang Yin painted as a professional artist. Although he was not a great innovator, he was a painter of such elegance that he won the respect and admiration of his contemporaries, even if the more conservative were a little suspicious of his suave brushwork. Also renowned at this period was the painter and illustrator, Ch'en Hung-shou.

131

The sixteenth century was a period of great vitality in all the arts. Following developments in painting, colour also became a prominent feature of many of the applied arts. In ceramics, besides the rich blue and white decorated porcelains, overglaze colours brought a brightness previously known only in the low-fired burial wares. Ching-te Chen decorators used the low-fired glazes on porcelain in a secondary firing to produce all-over decoration in red, green and yellow. Ching-te Chen was a well established centre of Imperial production, but it also supplied most of the decorated porcelain of the country. As markets developed, kilns in the south-east grew rich on the export trade. Styles changed slowly through the Ming Dynasty from the delicate formalism of the fifteenth century to a greater naturalism of floral motifs. By the sixteenth century the 'picture' motif derived from woodblock prints became well known; two or three different shades of blue were being used; and it became customary to finish all decorative schemes with a selection of borders. Three-colour and five-colour polychrome styles followed the motifs already accepted in Ching-te Chen blue and white. The potters of Hopei produced Fa Hua, a stoneware with boldly drawn decoration, usually in slip trail, over which purple, turquoise and yellow glazes make a rich effect. Enamel was fired on metalwork using the *cloisonné* technique. Here opaque glaze-like material is laid in fields divided by bands of metal (*cloisons*) soldered onto the surface of the vessel. The whole object is then fired and burnished, resulting in a decoration of jewel-like richness. In some cases of great Imperial wealth, as in the tomb treasure of the Emperor Wan Li (1573–1619), semi-precious stones were set in filigree metal, and fixed over plain porcelain or jade vessels. Rich silks and rugs, opulently carved red lacquer, and heavy gilt bronze vessels all contributed to the furnishing of the houses of the collectors for whom the coloured paintings were also made.

140

132

141

137

138

162

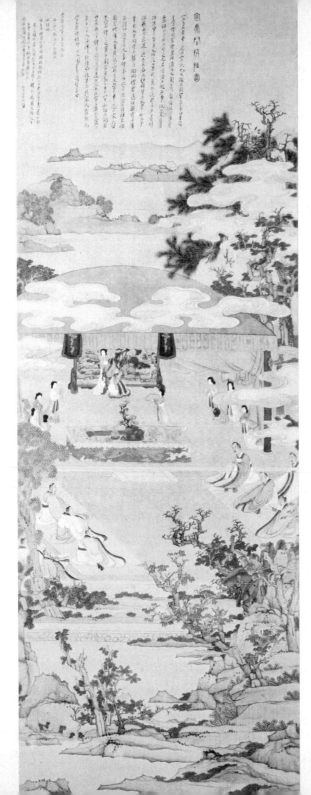

131 Ch'en Hung-shou (1599–1652), *Lady Hsuan Giving Instruction in the Classics* (detail). Colour on silk. This eccentric artist often adopted a witty archaistic style. Comparison with Pl. 68 shows some of the references.

163

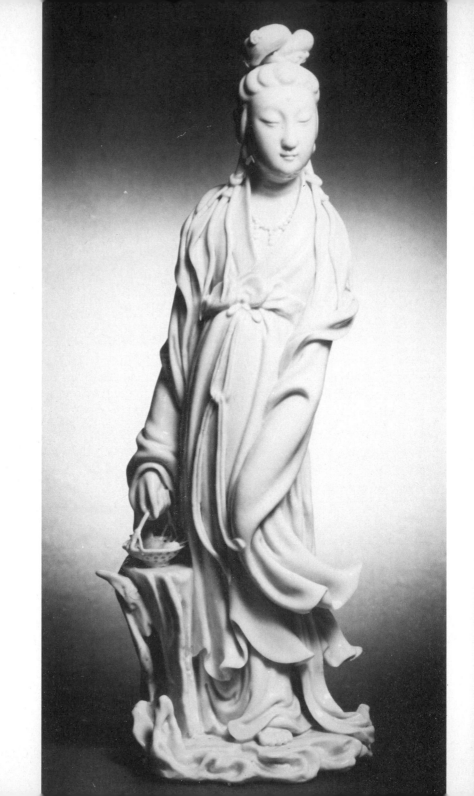

At this same time, scholars and literary men became particularly concerned with questions of aesthetics and with literary criticism. They applied themselves to reviewing the progress of literature and poetry from the T'ang period in the tenth century down to their own time, and they saw this as an orderly progression, with a classical revival occurring about 1500. They put forward criteria for quality among which *tun-wu*, a Ch'an Buddhist concept meaning 'sudden awakening', was valued above learning. Scholars interested in painting carried out a similar review. Tung Ch'i-ch'ang (1555–1636) and his colleague Mo Shih-lung (1540–1587) worked on the history of Chinese painting. Mo Shih-lung died before this work was completed, but Tung, who was a Ch'an Buddhist and a very successful official, went on to produce a critique of painting which has dominated Chinese aesthetic thinking until today. His book, *Hua Shuo* (*Talking of Painting*), contains a division of Chinese painting into historic and stylistic periods, as well as remarks on connoisseurship and on the classification of paintings.

The most distinctive part of Tung Ch'i-ch'ang's book concerns his theory according to which north and south are seen as representing diametrically opposed schools of landscape painting. This distinction, on which his whole classification of painting was based, can perhaps be most simply understood by an analogy with the northern and southern sects of Ch'an Buddhism. In the late seventh century AD, a schism occurred within the sect and one branch broke away, rejecting sutra and study, ritual and all outward show; this sect then went to the south, leaving the northern sect with the court. Tung, accordingly, divides paintings between those which are concerned with poetic insight and what he called 'transformation', and those which are superficial and decorative, classifying them respectively as southern and northern. The distinction was clear in his own time and his classification underlines a scholarly disapproval of decorative and showy art. As his sympathies clearly lay with the southern school, Tung's ideas on the nature of southern painting are more fully developed and more interesting. The concept of 'transformation' encompasses both the painter's expression of observed reality and also, within the general theory of the transmission of a tradition, the transformation of one painter's vision by another – the very essence of eclecticism. This last concept could lead to a very strict adherence to tradition. But Tung warned against such a strait-jacket in a passage entitled 'Conformity and Detachment': 'Even a great master of painting

132 Standing Kuan-yin carrying a basket of fish. White porcelain with a slightly ivory-tinted glaze from Te Hua, Fukien (Blanc de Chine ware). 17th century.

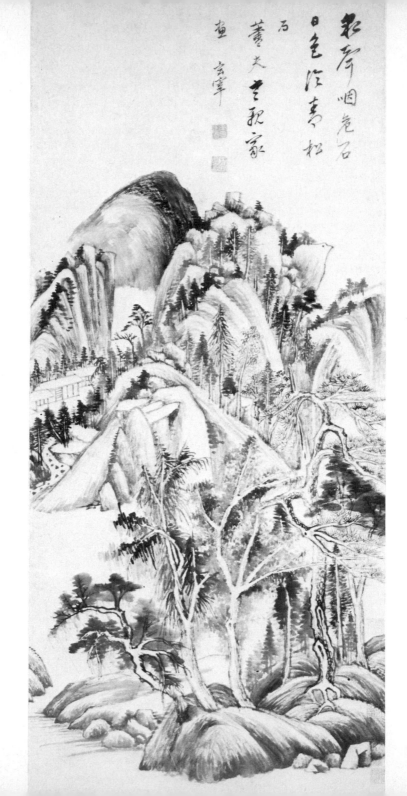

must start from imitation. In time there will be virtuosity and with virtuosity will come spontaneity. Once the method is mastered and digested by the painter he can go in and out of the method at will with his own variations and he can be completely free from his models.' And on the notion of 'transformation' between observed reality and depiction, the primary artistic transformation, he said, most vividly. 'painting is no equal to mountains and water for the wonder of scenery; but mountains and water are no equal to painting for the sheer marvels of brush and ink'. Tung predictably claimed for the southern school a direct line from Wang Wei of T'ang, through the tenth-century landscape masters, the Yüan scholars and the Wu School of Ming. As a painter himself, Tung was, in his larger works, an analyst. In his *133* dry paintings, he explored and dissected composition and brushwork. Such works seem, at least in part, to be study exercises and they comment on the work of the Yüan masters in particular. Tung's album leaves are much more direct and painted in the accomplished style of a gentleman artist of the period.

This process of analysis and classification, indeed the attempt to trace a history of painting parallel to that of literature, was to have an immense influence in succeeding centuries. Perhaps it aimed at making artists pause in the gathering momentum towards freedom and even eccentricity in style, but it also encouraged an academicism against which many artists were to react strongly.

133 Tung Ch'i-ch'ang (1555–1636), *Landscape*. Ink on paper. Such a landscape is an academic artist's comment on the work of several 14th-century and earlier painters (see Pls 112, 114).

Individualism and Eccentricity
17th–18th centuries

The growing complexity of society at the end of the sixteenth century was reflected in an enriched cultural life in which heterogeneous tastes supported a wide variety of artists and craftsmen: the presence of foreigners at court and increasing affluence, which made the merchants independent of the court and of the official class, were only two of the many factors which nurtured artistic diversity. Individuality also began to be considered an important quality in a painter; indeed, a small group of artists were even known as the 'Individualists'.

One of the best of these artists was Chu Ta, also known as Pa Ta Shan Jen (1626–1705). He was a relation of members of the Ming royal house and at the change of dynasty he retired to live in a monastery. He painted in the Ch'an School. He was something of a recluse and an eccentric, and it is said that he became dumb and may even have suffered from epilepsy. His ink paintings of birds, fish and flowers bear the stamp of his individual style; his brushwork and composition communicate directly to the twentieth-century viewer; his style is witty and requires no further explanation. Pa Ta Shan Jen's composition is in the Ch'an tradition of Mu Ch'i and Liang K'ai, subtle and yet very strong. The bravura of his work appealed to the Japanese and his style has become virtually synonymous with Zen painting in that country. However, he also painted landscapes, usually in ink on satin or coarse paper, and it is in this genre that he comes very close to Tung Ch'i-ch'ang. But whereas Tung was preoccupied with finding solutions to compositional problems, Pa Ta Shan Jen used the mass and line of a landscape to produce imaginative 'transformations' of great strength. In his day Pa Ta Shan Jen was a connoisseur's artist, and his style has been influential up to the present day in both China and Japan.

Shih T'ao or Tao Ch'i (1630–1707) was also related to the Ming royal family, and he too retired to live the quiet life of a monk, painter and scholar in the Yangchow area. He wrote a famous treatise, *Hua Yu Lu (Collection of Sayings on Paintings)*, which is a brilliant exposition of a painter's task. His work stands almost at the opposite pole to Tung Ch'i-ch'ang's and he was at some pains to counteract what he considered the older artist's academicism. He emphasized the need for clear vision and direct communication, and eschewed being categorized: he said he did not know to which school of

135

134 The Wang Shi Yüan garden, Suchow. A small courtyard garden seen from a doorway. The covered way to the right with its tile lattice windows provides different views of the trees and rocks against the white wall. 16th century. (See p. 151)

135 (*left*) Pa Ta Shan Jen (Chu Ja) (1626–1705), *Landscape in the Manner of Tung Yüan.*
Ink on paper. This hanging scroll should be compared with Pl. 133, for although
many of the references are similar, Pa Ta Shan Jen has in addition the grace and
vitality of a great Ch'an painter.

136 (*above*) Shih T'ao (1630 1707), *The Peach Blossom Spring*. This is the right-hand
end of a small handscroll, in ink on colour over paper. The traveller makes his way
out of the idyllic valley into the grey world beyond.

painting he belonged, but that he was himself the school. Basing himself on
the Yüan masters and following Shen Chou, Shih T'ao painted imaginative
landscape and genre pictures. He used colour to create atmosphere and light, *136*
particularly with his coloured *tien*, the dots used by painters as accents and
texture strokes; when these are painted in pale pink and blue over each other
they create the effect of a haze of light. He also used colour under his ink
paintings; this allowed a combination of ink and colour compositions, a
solution to the problem raised by the polychromatic works of the previous
century. Shih T'ao invented new techniques to serve his vision, so that
sometimes his brushwork seems wild and his composition eccentric. Such
was the vitality of his invention that to this day painters look to his work for
inspiration.

The third of the Individualist painters was K'un Ts'an, also a monk about
whom very little is known, and from whose work only a few landscapes and *139*
album leaves survive. His large compositions tend to be sprawling and

171

137 Red lacquer covered box carved with a design of camellia sprays. Generous composition and deep smooth cutting distinguish Ming lacquerwork. Later Ch'ing pieces become much more complex and sharp edged. First half of 15th century. (See p. 162)

138 Pien Wen-chin (*fl.* 1400–1430), *Three Friends and One Hundred Birds.* Ink and colour on silk. Generosity of decoration is evident in this large hanging scroll which is an example of the Ming development of the bird and flower tradition. (See pp. 154, 162)

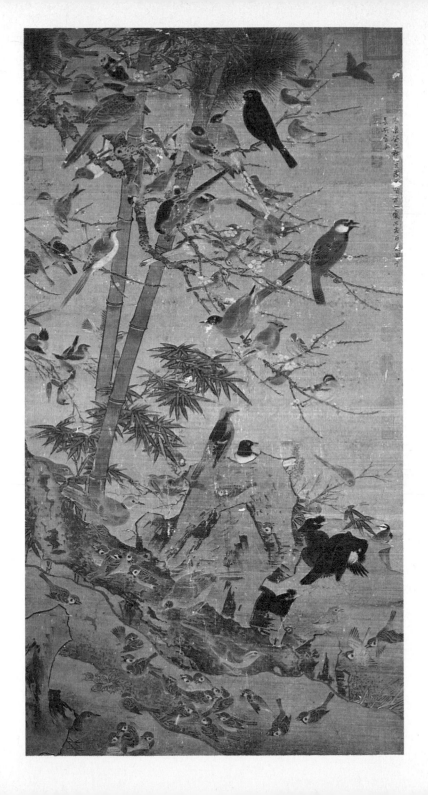

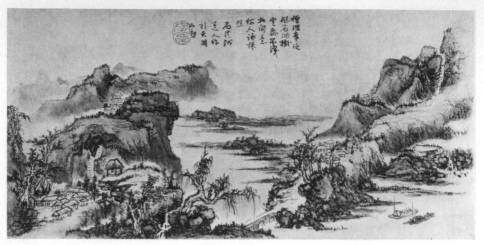

139 K'un Ts'an (*c.* 1610–1693), *Autumn Landscape*. Ink and slight colour on paper. The atmospheric effect of the distance is enhanced by the colour.

anecdotal. The structure does not have any of the tightness of other classic-style painters, and the various focal episodes of his large pictures are divided by misty, undefined passages; each focus thus becomes a small independent composition. K'un Ts'an used colour in a personal way in his landscapes: in the distance, over the hills, there is often a sunset painted in full colour, although the foreground is usually executed in greys and browns. This is a rare treatment of transient light effects and an innovation which seems to lead towards watercolour paintings of landscape, in full colours.

These three great Individualist artists initiated a movement in painting outside established modes. None of them worked in an official capacity, nor were they professional artists, although we do find Shih T'ao complaining about being required to paint on satin, which he disliked. The Individualists were regarded as connoisseurs' painters, but they were also highly regarded by court and commercial painters, although not by the court itself. Shih T'ao in particular was in correspondence and close contact with the major artists of his day.

As mentioned before, society in China at the start of the Ch'ing Dynasty was becoming more diverse, and many kinds of patronage encouraged a variety of styles. The court and the more conventional official class admired the work of a group known as the Four Wangs. These four men, all by the surname Wang, but not all related, span two generations and formed the centre of a movement which derived from the Wu School and from Tung Ch'i-ch'ang. Wang Shih-min (1592–1680) held a high official position until the fall of the Ming Dynasty, when he retired to live at T'ai Ts'ang, in

Kiangsu. The majority of his works are large, densely composed landscapes, often coloured. While not innovative, in the sense that Shih T'ao was, Wang Shih-min painted magnificent scrolls on the scale of the old masters, of whom he particularly admired Huang Kung-wang. His manipulation of eye levels and surface balance are fairly traditional, but his work is not archaistic. A follower of Tung Ch'i-ch'ang, Wang Shih-min seems to have reached the final stage in the process, described by Tung, of 'slipping in and out of the method at will'. His contemporary, but no relation, was Wang Chien (1598–1677), who also painted imposing landscapes in the same style. These two men were admired by the Manchu Ch'ing court as great exponents of a tradition and culture with which the Manchus were not yet entirely at home. Wang Chien introduced Wang Hui (1632–1717) to Wang Shih-min, who took the younger man on as a pupil. This young man, also no relation, had a naturally beautiful brush style which gave charm to his work. His compositions, although within the tradition of his teacher, are striking; he painted landscapes in an exaggeratedly tall and thin scroll format. His friends Yun Shou-p'ing and Wu Li (often included in the Four Wang group) worked in a more decorative vein, making free use of colour. Yun Shou-p'ing painted flowers in what is known as the 'boneless' style, that is, without outline. Wu Li painted idyllic summer landscapes in the style of Wen Cheng-ming. Yun Shou-p'ing and Wu Li also collaborated together on paintings, in a manner traditional amongst scholar-painters: one would paint the rocks and another the trees or bamboo. Such collaborative work became a form of social painting, and it played an important role in the scholar-painters' lives. Informally, fans and album leaves were painted during social gatherings of scholars, who would also compose poems and paint together.

The fourth of the Four Wangs, Wang Yüan-ch'i (1642–1715), also worked at the K'ang Hsi court. He was a grandson of Wang Shih-min. He held high court office and was in charge of the Imperial collections of painting and calligraphy. In spite of his court commitments, Wang Yüan-ch'i was a highly inventive painter within the landscape tradition. His distinctive feature is his manner of expressing volume and depth in almost Cubist terms within the traditional moving eye level composition. The comparison of Wang Yüan-chi's landscape with that of Pa Ta Shan Jen is interesting: the calligraphic style of the earlier painter contrasts with the painting of volume by the eighteenth-century artist. This is clear in the landscape *View of Mount Hua*, where Wang seems to reach towards his more 142 Cubist style, which, however, Chinese artists were never to develop any further. He used touches of colour as a slight indication of atmosphere and light, and also to strengthen the surface composition, in a manner reminiscent of Cézanne.

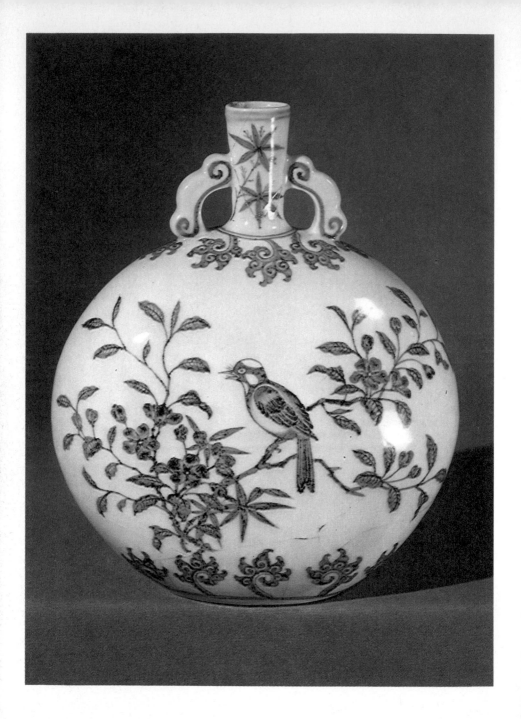

140 Moon flask of blue and white porcelain. Free and delicate painting of birds and flowers gradually superseded the heavier and more conventional motifs of the 14th century (see Pls 117, 118). From Ching-te Chen. 15th century. (See p. 162)

141 Overglaze decorated porcelain bowl. Green and red low-fired glaze colours painted over the porcelain glaze and then refired. From Ching-te Chen. 16th century. (See p. 162)

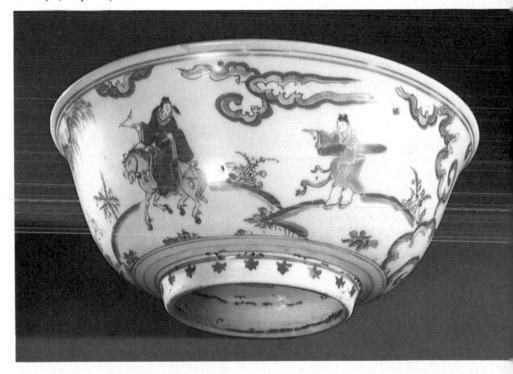

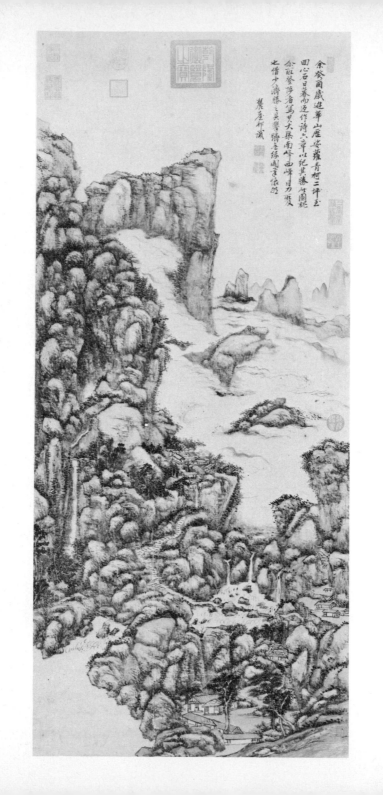

The younger group of the Four Wangs worked at the court of the K'ang Hsi Emperor, the third of the Manchu rulers of the Ch'ing Dynasty. K'ang Hsi had come to the throne as a child and was educated as a Chinese, but he retained some of the characteristic energy of a Manchu. He gathered around him a remarkable court which included painters, poets and calligraphers. These artists practised the traditional Chinese arts which were an acquired taste for the Manchus, whose own taste and traditions found expression in the decorative arts. Following these traditions, the Emperor encouraged the setting up of workshops within the palace compound to house expert craftsmen who made enamels, jade carvings, embroideries and overglaze decorated porcelain. Although drawn from the diverse major craft centres in China, these palace craftsmen did reflect something of the special taste of the Manchu court.

Ching-te Chen and the Imperial porcelain factories in Kiangsi had suffered during the disturbances caused by the change of dynasty. But by the time of the reign of the Emperor K'ang Hsi, the kilns were working again and producing fine quality blue and white wares. These were painted with *145* landscape and figure scenes, finely drawn in a manner similar to that of the late seventeenth-century and early eighteenth-century landscape painters. The pots from this period became collector's items, especially appealing to those with an academic taste. The style used developed initially from woodblock illustrations and was refined by the late seventeenth century to a calligraphic style broadly known as the 'K'ang Hsi style'. In overglaze decoration of porcelain, a more varied palette was used with the addition of the tints of the five overglaze colours of the Ming. This ware, called *famille verte* by Europeans, was decorated in the same refined manner as the blue and *143* white wares. The body of *famille verte* ware, with its clear white glaze, was treated as the equivalent to silk on which artists sometimes painted. The decorators of these pots painted on them ever more delicately in the style of contemporary bird and flower or landscape painting.

The new stylistic tendency in decorated wares, which soon included enamel on metal, was towards the use of a wider range of colours and of *146* more delicate drawing: rose-pink and white colours (pink from colloidal gold and white from arsenic) were introduced from Europe and they completed a palette known in the West as *famille rose*. Parallel with the *144* developing taste for pretty decoration was the ever-present use of archaistic

142 Wang Yüan-ch'i (1642–1715), *View of Mount Hua*. Ink and light colours on paper. Here the mist takes the place of a river, and the breakdown of the land mass into boulders gives a greater sense of volume. The high overview of the near distance allows an almost fixed eye-level.

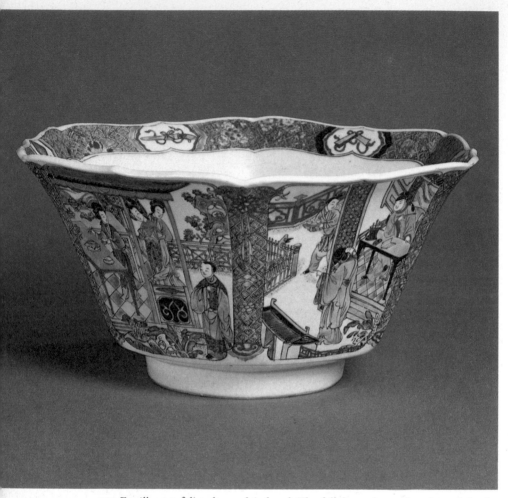

143 *Famille verte* foliated porcelain bowl. The full five-colour palette is used for the overglaze decoration of ladies in a garden. From Ching-te Chen. Early 18th century.

144 Small porcelain vase decorated in *famille rose* colours of the quality known as Ku Yüeh Hsuan. This piece is thought to have been decorated in the Palace workshops, although the body was made in Ching-te Chen. Mid-18th century.

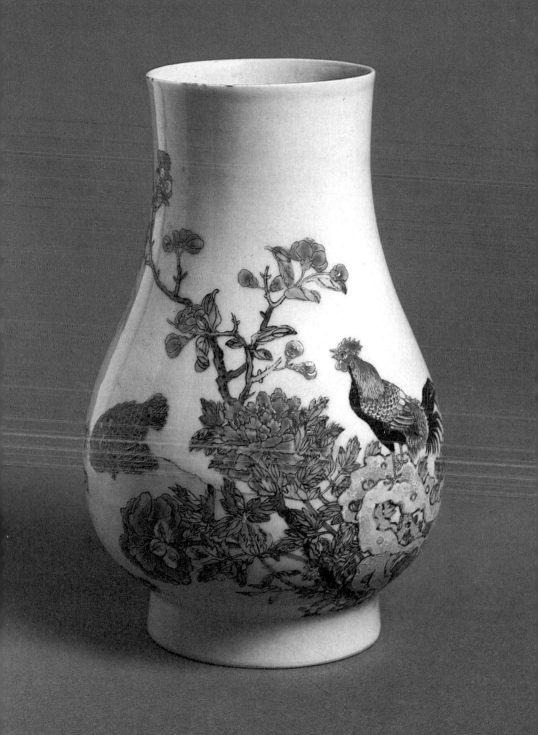

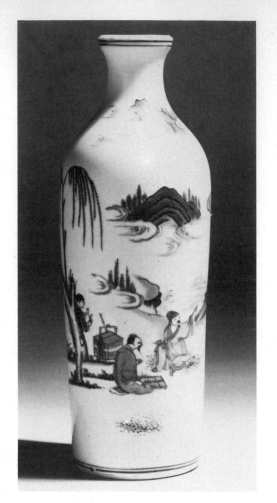

145 Porcelain vase in the form of a European glass bottle, decorated with underglaze blue. From Ching-te Chen. Mid- to late 17th century.

design. This was particularly strong during the Yung Cheng reign (1723–35) when it took the form of very fine quality Sung-style stoneware (of the Ju and Kuan type), and of inlaid bronze work. The combination of more colourful decoration and sober archaistic designs was in accord with eighteenth-century European taste. As a result, craftwork from China became part of a growing trade with Europe, where a fascination with all things Oriental led to the flowering of Chinoiserie.

The K'ang Hsi palace in Peking was rebuilt and fully painted in bright colours, as it is today, and its gardens were laid out. The Manchus loved bright colours and this influenced court costume and the development of Ch'ing styles of embroidery. Jade carving was of high quality and it became

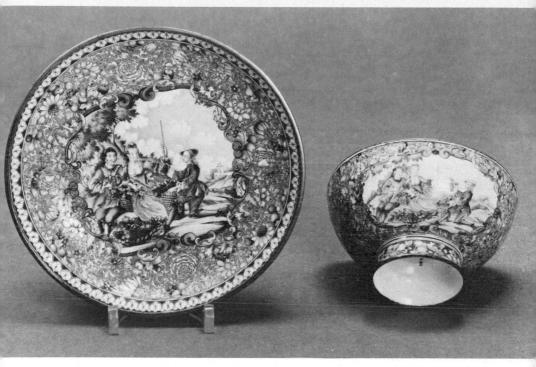

146 Bronze cup and saucer decorated with 'Canton' enamel. The technique of firing enamel painting on metal was popular both at the court and for export. Such strikingly foreign decoration, derived from a European print, reflects the contemporary court taste for the exotic. 18th century.

increasingly flamboyant towards the reign of the Ch'ien Lung Emperor (1736–95). Once again semi-precious stones were used in inlay, in a style close to that of the Mughul jade workers. Indeed, there is a tendency in all the applied arts of this period towards exoticism, either through the use of more elaborate decoration or, more subtly, through the introduction of strange and unfamiliar forms. This was perhaps the result of the introduction of European workmen to the court, who brought about a sort of Chinoiserie in reverse.

There had been Jesuits at the Chinese court since 1601, when Matteo Ricci was attached to the Wan Li court. K'ang Hsi received delegations of foreigners and allowed a group of Jesuits to settle in Peking. He showed interest in the European painted enamels and decorated articles – mirrors, clocks and trinkets – which were presented to him. And he required his own craftsmen to produce similar work in the workshops set up in the north-west of the palace compound. There were also a number of Jesuit painters at court,

the most notable of whom was Giuseppe Castiglione (1688–1766), better known by his Chinese name of Lang Shih-ning. Castiglione had trained in Italy as an architect and painter; he became a valued servant of the Peking court where, by right of the favour shown him as a painter, he had the unenviable position of acting as intercessor for the Catholic Church in China in times of persecution. Castiglione or Lang Shih-ning adopted certain Chinese characteristics in his painting: he made use of the proportions of the scroll format and in his bird and flower paintings he employed compositional techniques current at the time. His drawing, however, was
147 Italian, as was his use of colour, light and shade, modelling and linear perspective, all of which seemed exotic and fascinating to the Chinese. His style became popular at court and was adopted by several Chinese painters. The result was a new 'realism' in painting which was at odds with all that Shih T'ao, Pa Ta Shan Jen or the Four Wangs stood for. Nevertheless, this type of realism became rooted in Chinese tradition and it further generated a school of decorative painting in the eighteenth and nineteenth centuries.

Outside court circles, life was rich and independent in spirit. In flourishing districts such as Yangchow, Suchow and Nanking, artists and craftsmen found a ready market. A group of overtly commercially-minded painters, who were yet of the educated class, made their appearance in these centres. Advertising their work for sale and producing considerable quantities of small paintings, they made a good living from their work. These artists were grouped under the name of Eccentrics and were at some pains to create a memorable personal style. Although none of them was of the stature of Shih T'ao or Pa Ta Shan Jen, they were all to some extent innovators. Mei Ch'ing (1623–1697) was a friend and admirer of Shih T'ao. Using a brush stroke
148 reminiscent of the older man, he painted evocative fragments of windswept, remote landscapes. Hua Yen (1682–1755) painted horses and figures in
149 misty, windy weather, in much the same spirit. The effect of realistic immediacy, so rare in Chinese paintings, created by the evocation of weather, gives these eighteenth-century paintings a quality which is much out of character with the sense of timelessness sought by the classical painters.

147 (*above right*) Lang Shih-ning (Castiglione) (1688–1766), *Kazaks Presenting Tribute Horses to the Ch'ien Lung Emperor* (detail). Handscroll, ink and colour on paper. Another example of court taste, with its mixture of European and Chinese styles.

148 (*below right*) Mei Ch'ing (1623–1697), *Landscape in the Style of Ching Hao and Kuan T'ung*. Album leaf, ink and colour on paper. In the style of true romantic painting; all but the necessary elements are eliminated to produce a slight but vivid work.

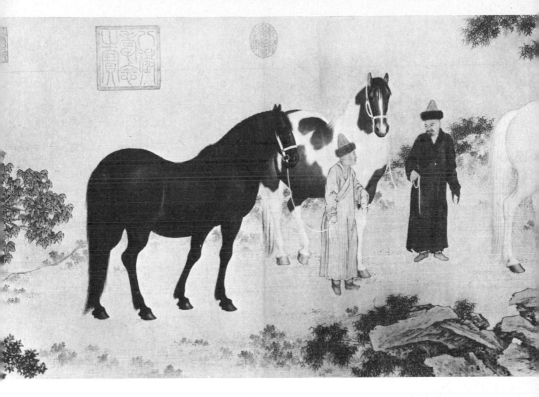

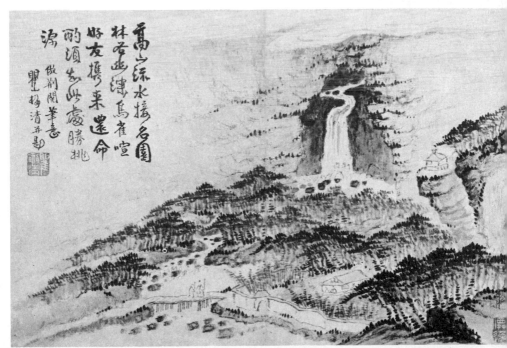

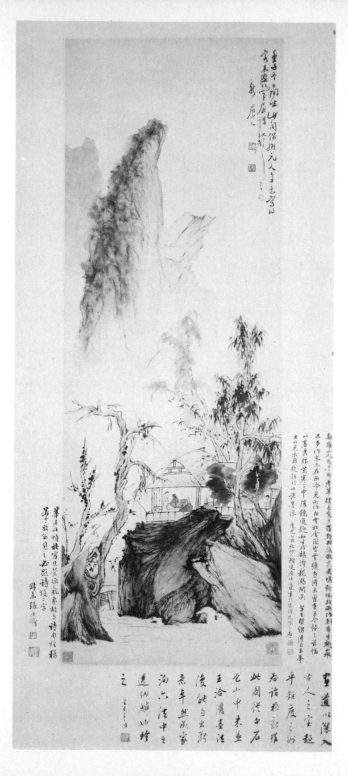

149 (*left*) Hua Yen (1682–1755), *Conversation in Autumn*. Ink and colour on paper, dated 1732. This also is a selective composition which takes the viewer back to Wang Fu (Pl. 126) and Pa Ta Shan Jen (Pl. 135), both in the composition and in the treatment of trees and rocks.

150 (*above*) Kao Ch'i-p'ei (*c.* 1672–1754), *The Four Seasons* (detail). Handscroll, ink and colour on paper. Drawn with a fingernail specially grown and used like a pen nib, a technique which Kao made his own towards the end of his life. The plum blossom and *ling-chih* fungus stand for spring.

Kao Ch'i-p'ei (*c.* 1672–1754), a Manchu who came south with the invasion, was a successful landscape painter who first worked in a meticulous, traditional style. Kao is recorded as worrying about his own originality, a quality presumably required of painters, for commercial reasons. Such unprecedented emphasis on originality makes one think that artists at this time were in a situation a little similar of that of the twentieth-century Western artist. Many other painters of the Chiang Nan area sought to break away from the old order, which had been gently eroded since the sixteenth century. Painters now exploited eccentricity of both subject and technique, while craftsmen exploited the appeal of technical pyrotechnics and weirdness of forms. In this climate, the solid scholar/patron/artist relationship, which had been the foundation of the artistic culture of China, seems to have lost its vitality and with it the capacity to create further. By the nineteenth century, as the fortunes of the state and private business declined, the position of the arts was in some disarray. By then, painters and craftsmen had become accustomed to supplying a rich but uninformed market, in which an eye-catching quality seemed all-important.

150

CHAPTER TWELVE

Conformity and Confidence

19th–20th centuries

Following the period of vitality and heightened creativity in painting and the applied arts, which was described in the previous chapter, artist and patron alike seemed to lose confidence by the beginning of the nineteenth century. The artist found himself in a situation of excessive dependence on a market or a patron. The Ch'ing court of the nineteenth century was not one of cultural distinction, and it provided little inspired patronage. Craftsmen too produced work of mixed quality and little originality; the general tendency was towards repetition, or mere elaboration. At this low ebb in the arts, even the scholar–painters seemed to lose confidence and to turn to a style of painting which, while traditional, tried too hard to conjure up some vitality by making use of emphatic brushwork and heavy ink.

There were, however, certain individuals whose work had strength and quality. One such was Jen Po-nien (1840–1895) who came from Chekiang and moved to Shanghai where he became one of the leading members of the White Lotus Society of painters. He painted bird and flower pictures in ink and colour on paper or silk. His distinctive style is recognized by a staccato brush style and by abrupt movement in his compositions. The compositions themselves are of traditional Ming style, balanced by strong diagonals and by the stabbing brushwork. Jen Po-nien's colour is rich and decorative and it gives an added appeal to his work. In lesser hands, Jen Po-nien's manner produced a bland style of spurious energy characterized by the use of bright colour and heavy ink tones.

At the end of the nineteenth century, during the reigns of the Kuang Hsu Emperor and, later, under the influence of the Empress Dowager Tzu Hsi, there was a short revival of the arts at court marked by active patronage and extensive palace building, notably the building of the present Summer Palace. The revival of decorative arts was in the style of the late eighteenth century (late Ch'ien Lung period), but lacked the finesse of the earlier period; in porcelain decoration, for instance, an emphatic black line was used, giving the polychrome overglaze decoration a heavy and sometimes garish

151 Light metal hairpin with tremblant flower decoration set with pearls, semi-precious stone and kingfisher feather. Part of a hair ornament which might have been worn with a gown in the style of Pl. 153.

157

152

152 Porcelain vase with pink, gold and black decoration. Both the shape and the decoration of this piece are characteristic of the late 19th and early 20th century. From Ching-te Chen.

appearance. Much of the Chinese art seen in English country houses dates from this period. Bronze work too was heavy, archaistic in style and often of rough workmanship, while lacquer and ivory carvings were elaborate and

153 ornate. Textiles and costumes made use of the newly introduced aniline dyes
151 and were complemented by flamboyant jewellery. Excessive attention to

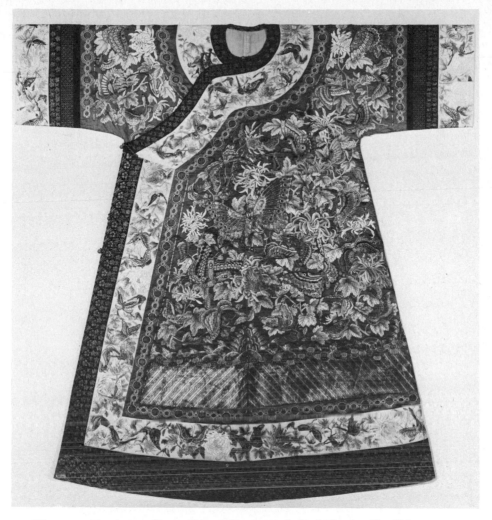

153 Silk gown with a design of butterflies and flowers, made for the Empress Tzu Hsi. This richly embroidered informal robe would have been worn over and indeed under other silk gowns and jackets. Late 19th or early 20th century.

technical accomplishment was not balanced by the discerning taste of preceding centuries, and the resulting work, while representing a technical *tour de force*, was over-executed and clumsy by comparison.

In the early twentieth century painters joined together in societies, one of the most influential being the White Lotus Society of Shanghai, mentioned

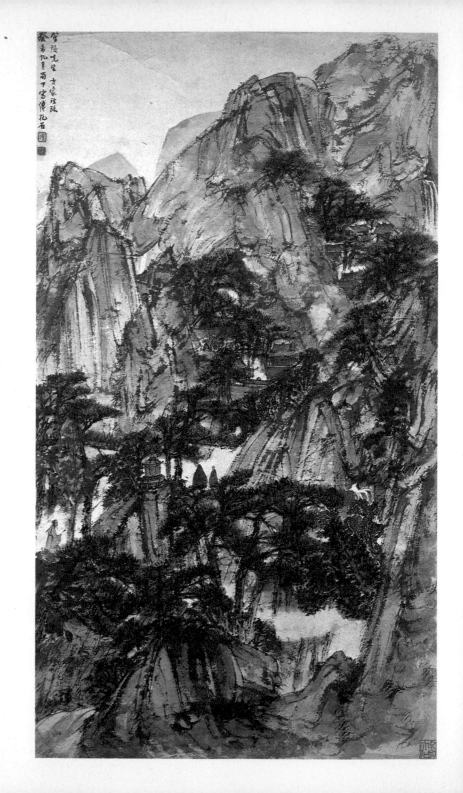

154 (*left*) Fu Pao-shih (1904–1965), *Mountain Landscape*. Ink and colour on paper, dated 1944. The surface of the paper is roughened and much of the ink texture is due to an uneven absorbency and spread. (See p. 198)

155 (*above*) An appreciation of Fu Pao-shih. Calligraphy by the writer and scholar Kuo Mo-jo (d. 1979). This is a fine example of modern calligraphy, reading from left to right horizontally. The composition of the page is considered, and the scale and weight of characters is emphasized towards the foot of the page.

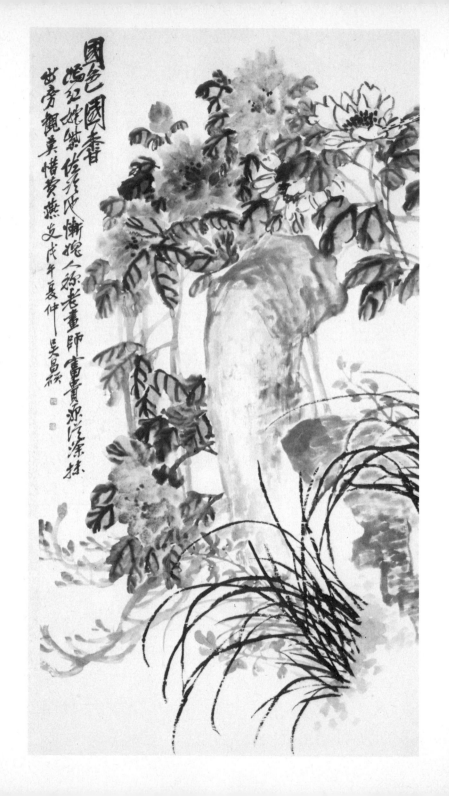

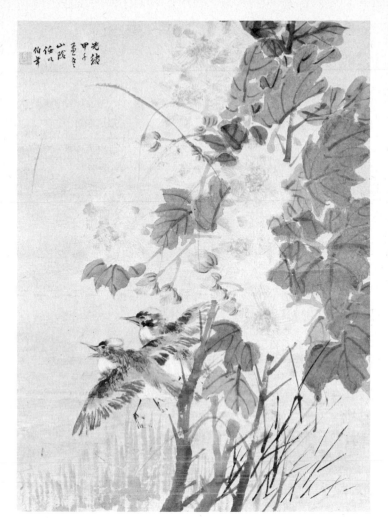

光緒
甲午
夏冬之
山陰
任頤伯年

156 Wu Ch'ang-shih (1844–1927), *Rocks and Flowers*. Ink and colour on paper, dated 1918. A somewhat over-blown composition with rich ink and bright colour in a style popular today.

157 Jen Po-nien (1840–1895), *Hibiscus and Flying Kingfishers*. Ink and colour on paper, dated 1894. A small painting in 'boneless' style, i.e. without outlines.

above. Wu Ch'ang-shih (1844–1927) was one of the leading members of the society at this time. In many ways he was a close follower of Jen Po-nien, his older contemporary. His personal style of heavy and strong brushwork, rich colour and strong calligraphy seems to epitomize the turn-of-the-century style. His use of a Ch'an style in his ink works, and his method of composition in his flower paintings, often in large format, influenced many later painters. A younger contemporary of his, Huang Ping-hung (1864–1955), came from Anhui, but moved to Shanghai in 1908. He painted

156
157

158 Ch'i Pai-shih (1863–1957), *Chrysanthemum and Bee*. An unmounted fan painted in colour on paper. Although this work dates from the artist's later years, the style is still close to that of Wu Ch'ang-shih (Pl. 156).

landscapes in ink, and in ink and colour. His work is executed in a free and self-assured manner and his composition is derived from the Wu School tradition; he often makes use in his paintings of cloud passages which break the transitions from middle to back ground. Huang seemed to be the natural successor to K'un Ts'an. These two painters generated styles which persisted through the experiments which came later. Ch'i Pai-shih (1863–1957) must also be mentioned here, as he was their contemporary and a close follower of Wu Ch'ang-shih. Ch'i came from the Changsha area and he was of very humble origins. He made his reputation as a bird and flower painter and he also painted insects, which made him a legend in his lifetime. He was a skilled professional painter by training, painting portraits and household decorations. He was self-educated and he developed his personal style after he had moved to Peking; this style was varied, sometimes combining exquisitely painted insects with bold Ch'an-style painting.

158

As the Imperial system broke down and successive political changes were taking place, many diverse influences were at work in China. Not only was Western culture imported, but Chinese artists started travelling abroad, to Japan and to the West, especially to France and Germany. Some of these painters made reputations overseas, as did Hsu Pei-hung (1896–1953), who painted in Paris under the name of Ju Peon. Most of these travellers returned home in the 1930s and many European-inspired experiments were tried out in China. Western-style art schools, where life-drawing and oil-painting were taught, were set up in Shanghai, Nanking and Peking, and still-life

159 Kuan Shan-yüeh (contemporary), *Man with Horse on Steps*. Pale colour and ink on paper, dated 1934. The picture employs a fixed perspective relieved by mist to enhance the overpowering city wall.

197

painting and huge history paintings of the Water Margin stories were undertaken. For the present, at least, this Westernizing movement must be seen as short-lived and as having left little impression. The Chinese painters who went to Japan returned with styles and techniques much closer to their own, but with a new sense of freedom in their use of papers and texture.

Ch'i Pai-shih may be taken as representative of those artists who stayed in China developing a style based partly on Ch'an, partly on more academic models, but one rooted in eighteenth- and nineteenth-century traditions of painting. Of the artists who travelled abroad, Hsu Pei-hung experimented with a hybrid style, part Western-academic, part Chinese, which, however, has not developed any further. Lin Feng-mien (born 1901), who also travelled to Paris, was more influenced by Matisse and the Western colourists; his style is also hybrid, but distinctive and personal. Fu Pao-shih (1904–1965), who went to Japan, developed a wide range of styles ranging from T'ang figure painting to a more personal landscape style evolving out of the Shih T'ao style – this is the style which has most influenced the work of the major artists of the mid-twentieth century. His great contemporary and collaborator was the Kwangtung artist, Kuan Shan-yüeh. Li K'o-jan is one of the most popular painters of the present day and his work shows many of the features of mid-twentieth-century art: the use of strong line and of a solidly balanced composition, and also of decorative colour. This style owes much to a vogue for woodblock prints in the 1920s and 1930s. At that time, societies were formed, inspired by the popular enthusiasm for the art of woodblock cutting and printing; prints became an important medium partly because of their use as political tools and partly through the rejuvenation of the craft through the introduction of a foreign woodblock style. The Chinese had a well-established and highly skilled tradition of woodblock printing, but a new style, influenced by German prints, and particularly by the work of Georg Grosz and Käthe Kollwitz, was avidly taken up during the 1930s. In the wake of this new woodblock style, certain elements of Western composition found their way into Chinese painting, changing the traditional composition completely and resulting in a four-square proportion and a static quality quite new to Chinese art.

With so much innovation and experimentation in the arts taking place everywhere else in the world, it is interesting that Chinese painting, on the whole, has remained self-sufficient within its own traditions. It has not

160 Li K'o-jan (contemporary), *Landscape Based on Chairman Mao's Poem*. Ink and slight colour on paper, 1960s. The heavy ink style is very characteristic of the artist. The blocking-in of the rectangular frame and the very high view derive from print design techniques.

198

followed, for example, the same course as Japanese painting, to which, in some ways, it is closely related: there seems, for the present, to be no place in Chinese painting for pure abstraction. Outside China, some Chinese artists have painted abstract works successfully. But the weight of a long tradition of art within the country seems to be greater than that of international art trends. Lui Shou-kwan, a traditionally trained Cantonese painter working in Hong Kong, has struggled with the problems involved in finding his own style, and he moved naturally towards abstraction; but the moment he achieved it he found that he lost impetus in his painting and he has had, repeatedly, to return to a representational theme to regain momentum. This experience serves perhaps as a general comment on a situation and a sensibility which earlier painters had confronted: Chinese painting has sought a balance between abstraction and representation for many centuries and therein lies much of its fascination.

161

161 Lui Shou-kwan (d. 1977), *Island Landscape*. Ink on paper, dated 1961. While retaining much from classical tradition, this semi-abstraction of the island landscape of Hong Kong demonstrates the balance sought by Chinese artists between abstraction and representation.

Selected Bibliography

General

R. Dawson (ed.), *The Legacy of China*, Oxford, 1964

A. Herrmann, *An Historical Atlas of China*, new ed., Edinburgh, 1966

Sherman E. Lee, *A History of Far Eastern Art*, revised ed., New York, 1974 and London, 1975

L. Sickman and A. Soper, *The Art and Architecture of China*, 3rd ed., Harmondsworth, 1968

M. Sullivan, *The Arts of China*, revised ed., Berkeley, Los Angeles and London, 1977

W. Watson, *Style in the Arts of China*, Harmondsworth and Baltimore, 1974

W. Willetts, *Foundations of Chinese Art*, London and New York, 1965

Early Periods

K.C. Chang, *The Archaeology of Ancient China*, 3rd ed., New Haven, 1977

T.K. Cheng, *Archaeology in China*, 4 vols, Cambridge and Toronto, 1959–66

J. Rawson, *Ancient China: Art and Archaeology*, London, 1980

W. Watson, *Archaeology in China*, London, 1960

—, *Early Civilisation in China*, London and New York, 1966

—, *Cultural Frontiers in Ancient East Asia*, Edinburgh, 1971

Journals: *Wen Wu*, Peking (monthly)
 Kaogu, Peking (monthly)
 Kaogu Xuebao, Peking (quarterly)

Bronzes

W. Watson, *Ancient Chinese Bronzes*, London and Vermont, 1962

Ceramics

H. Garner, *Oriental Blue and White*, London, 1954

G. St G. Gompertz, *Chinese Celadon Wares*, London, 1958

Soame Jenyns, *Ming Pottery and Porcelain*, London, 1953 and New York, 1954

—, *Later Chinese Porcelain: The Ch'ing Dynasty 1644–1912*, 4th ed., London, 1971

D. Lion-Goldschmidt, *Ming Porcelain*, London and New York, 1978

M. Medley, *The Chinese Potter*, Oxford and New York, 1976

—, *Yüan Porcelain and Stoneware*, London, 1974

S. Valenstein, *A Handbook of Chinese Ceramics*, New York, 1975

N. Wood, *Oriental Glazes*, London and New York, 1978

Painting

J. Cahill, *Chinese Painting*, Geneva, 1960

—, *Hills Beyond a River: Chinese Painting of the Yüan Dynasty*, New York and Tokyo, 1976

—, *Parting at the Shore: Chinese Painting of the Early and Middle Ming*, New York and Tokyo, 1978

M. and S. Fu, *Studies in Connoisseurship: Chinese Paintings in the Arthur M. Sackler Collection*, Princeton, 1973

O. Sirén, *Chinese Painting*, 7 vols, London and New York, 1956–58

M. Sullivan, *The Three Perfections: Chinese Painting, Poetry and Calligraphy*, London, 1974

—, *Chinese Art in the 20th Century*, Berkeley and London, 1959

Sculpture

T. Akiyama, *Arts of China*, Vol. II: *Buddhist Cave Temples*, Tokyo and Palo Alto, 1969

Lacquer and Enamel

M. Beurdeley, D. Lion-Goldschmidt, S. Jenyns and W. Watson, *Chinese Art*, 3 vols, London, 1963–65

H. Garner, *Chinese and Japanese Cloisonné Enamels*, London and Vermont, 1962

—, *Chinese Lacquer*, London, 1979

Architecture etc.

A. Boyd, *Chinese Architecture and Town Planning 1500 BC–AD 1911*, Chicago and London, 1962

M. Keswick, *The Chinese Garden*, London and New York, 1978

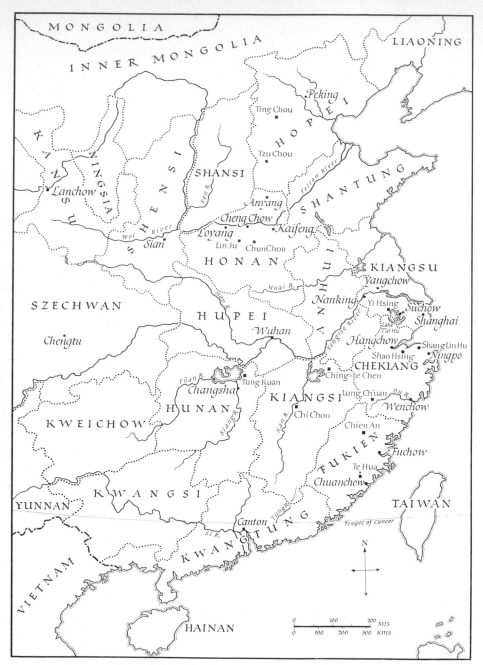

MONGOLIA

INNER MONGOLIA

LIAONING

KANSU

NINGSIA

SHENSI

SHANSI

HOPEI

SHANTUNG

Peking

Ting Chou

Tzu Chou

Lanchow

Wei River

Sian

Loyang

Anyang

Cheng Chow

Kaifeng

Lin Ju

ChunChou

Fen R.

HONAN

KIANGSU

SZECHWAN

HUPEI

Huai R.

ANHUI

Yangchow

Nanking

Yi Hsing

Suchow

Shanghai

Chengtu

Wuhan

Yangtse River

Lake T'ai Hu

Hangchow

Shao Hsing

CHEKIANG

Shang Lin Hu

Ningpo

Yüan R.

Tung Kuan

Ching-te Chen

KIANGSI

Lung Ch'uan

OU R.

Wenchow

Changsha

HUNAN

Siang R.

Kan R.

Chi Chou

KWEICHOW

Chien An

FUKIEN

Fuchow

Te Hua

Chuanchow

YUNNAN

KWANGSI

TAIWAN

VIETNAM

Canton

Tung R.

KWANGTUNG

Tropic of Cancer

SI R.

N

0 100 200 MIS
0 100 200 300 Kms

HAINAN

1 Map of China showing provinces and main kiln sites.

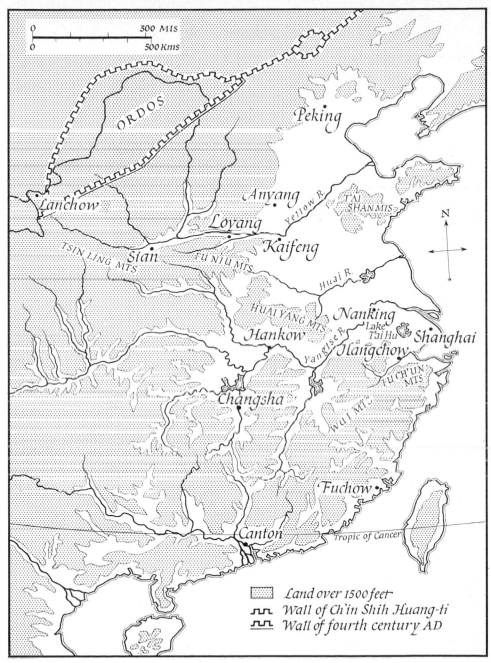

2 Relief map of China.

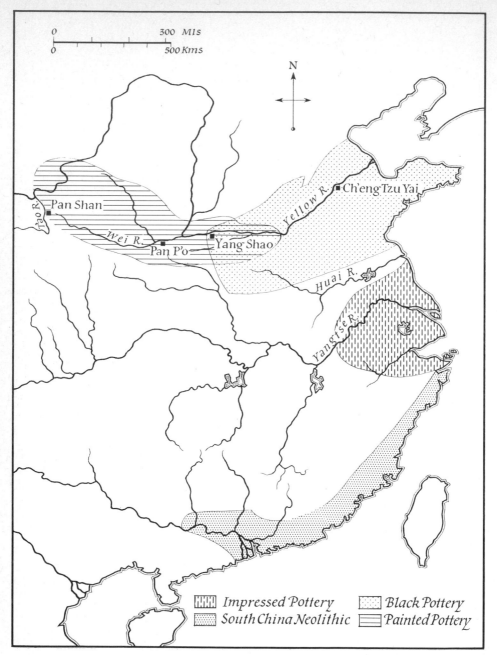

3 Map showing main areas of Neolithic settlement.

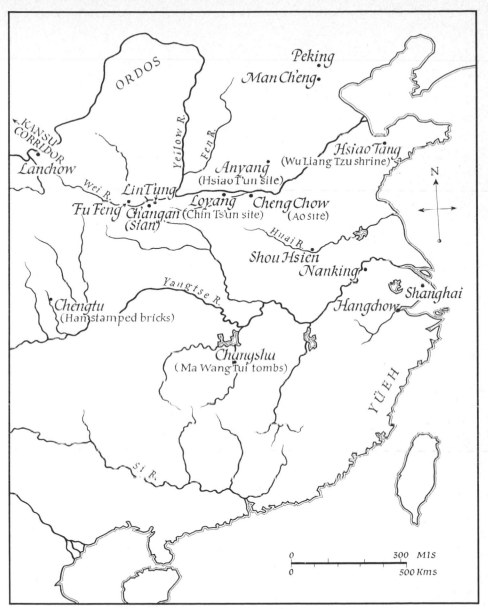

4 Map showing Bronze Age and Han Dynasty sites.

5 (*overleaf*) Map showing Buddhist cave temple sites.

Turfan

Kizil

KANSU CORRIDOR

Tun Huang

Boundary of
T'ang China c.AD 750 ———
Boundary of
present-day China ·······

0 400 MIs
0 600 Kms

LIAO

ORDOS

TaTung

Peking

Yun Kang

Yellow R.

Fen R.

Lanchow

Loyang

Kaifeng

Kung Hsien

Ch'angan
(Sian)

Lung
Men

KOREA

Yangtse R.

Hangchow

Ningpo

N

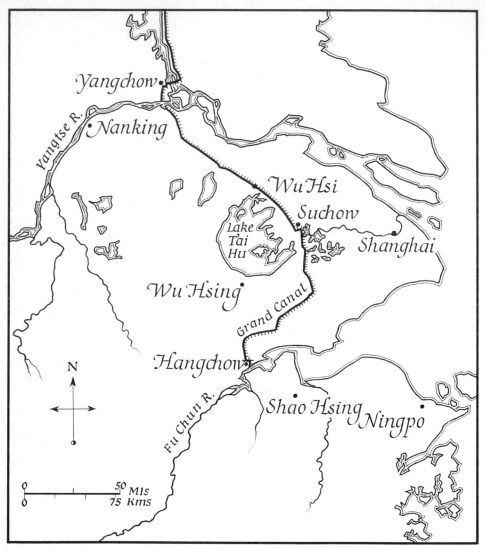

6 Map of the Chiang Nan region.

List of Illustrations

Measurements are given in inches followed by centimetres, height preceding width preceding depth, unless otherwise indicated

Frontispiece Gilt bronze Buddhist altarpiece. Wei style. 6th century AD. H. 23¼ (59). Metropolitan Museum of Art, New York (Rogers Fund, 1938).

1 Single shouldered polished stone axe head. From Ho-yin, Honan. Neolithic period. Östasiatiska Museet, Stockholm.

2 Reconstruction of Pan P'o circular hut.

3 Excavation of Pan P'o circular hut foundation. Photo courtesy Britain-China Friendship Association.

4 Buff earthenware basin with dark slip-painted decoration. From Pan P'o, Shensi. 5th–4th millennium BC. H. 6¾ (17), d. 17½ (44·5). People's Republic of China.

5 Large burial urn of burnished red earthenware, painted in black and purple slip. Pan Shan type, from Kansu. 3rd millennium BC. H. 19 (48·3). Ashmolean Museum, Oxford.

6 Footed *tazza* of burnished red earthenware, painted in black slip. From Lanchow, Kansu. Late 3rd millennium BC. H. 6½ (16·4). People's Republic of China.

7 Tall beaker of thin burnished black pottery. From Wei Fang, Shantung. 3rd or early 2nd millennium BC. H. 6¾ (16·1). People's Republic of China.

8 White pottery tripod jug. From Wei Fang, Shantung. 3rd or early 2nd millennium BC. H. 11⅝ (29·7). People's Republic of China.

9 Impressed 'double F' decorated stoneware jar. From Wu Hua, Kwangtung. Late Neolithic or Bronze Age period. H. 10¼ (26). Hong Kong Museum of History (Gift of Father Maglioni).

10 White pottery jar. From Anyang, Honan. 14th–13th century BC. H. 13 (33). Courtesy of Smithsonian Institution, Freer Gallery of Art, Washington D.C.

11 Impressed stoneware jar with high-fired glaze. From Cheng Chow, Honan. 16th–15th century BC. H. 11⅛ (28·2). People's Republic of China.

12 Bronze vessel, *li-ting*. 14th century BC. H. 8 (20·3). Ashmolean Museum, Oxford.

13 Detail of Plate 12.

14 Bronze vessel, *ku*. 14th–13th century BC. H. 13 (33). Ashmolean Museum, Oxford.

15 Bronze vessel, *ting*. From Ning-hsiang, Honan. 14th–12th century BC. H. 15¼ (38·7). People's Republic of China.

16 Bronze vessel, *kuei*. 12th–11th century BC. H. 5⅝ (14·3). Ashmolean Museum, Oxford.

17 Detail of Plate 16.

18 Bronze vessel, *yu*. 11th century BC. H. 13¾ (35). Musée Cernuschi, Paris.

19 Bronze vessel, *kuang*. 12th century BC. 9⅛ × 12¼ (23·2 × 31·2). Courtesy of Smithsonian Institution, Freer Gallery of Art, Washington D.C.

20 Bronze vessel, *tsun*. From Funan, Anhui. 14th–11th century BC. H. 18½ (47). People's Republic of China.

21 Fragment of oracle bone. From Ta Ssu K'ung, Anyang. *c.* 1500 BC. British Museum, London.

22 Stone chime with incised decoration. From a tomb at Wu-kuan-t'sun, Anyang. 14th–12th century BC. L. 27½ (70). People's Republic of China.

23 Carved jade bird plaque. 13th–11th century BC. L. 5⅛ (13). British Museum, London.

24 White jade *tsung*. 12th–11th century BC. H. 3 (7·6). Royal Ontario Museum, Toronto.

25 Bronze vessel, *yu*. 12th–11th century BC. 14¼ × 10⅝ (36·1 × 26·9). Courtesy of Smithsonian Institution, Freer Gallery of Art, Washington D.C.

26 Bronze vessel, *yu*. From Anhui. 10th–9th century BC. 9 × 9 × 6 (22·9 × 22·9 × 15·3). Courtesy of Smithsonian Institution, Freer Gallery of Art, Washington D.C.

27 Bronze vessel, *ting*. *c.* 6th century BC. H. 5¾ (14·6). Ashmolean Museum, Oxford.

28 Bronze monster mask and ring handle. From Yi Hsien, Hopei. 5th century BC. L. of mask 17⅞ (45·5), d. of ring 11½ (29). People's Republic of China.

29 Gold openwork dagger handle. 4th century BC. H. 4¾ (11·1). British Museum, London.

30 Bronze table leg inlaid with gold and silver. 6th–3rd century BC. H. 4¾ (12·1). Nelson Gallery-Atkins Museum, Kansas City, Missouri (Nelson Fund).

31 Carved green jade belt hook. 3rd century BC. L. 7·4 (19). Collection Mr and Mrs Richard C. Bull.

32 Carved jade crescent plaque. Early 10th century BC. 2⅞ × 6⅝ (7·3 × 16·8). Nelson Gallery-Atkins Museum, Kansas City, Missouri (Nelson Fund).

33 Carved green jade disc, *pi*. Perhaps 8th century BC. D. 9⅝ (24·5). Seattle Art Museum.

34 Grey stoneware jar with slightly yellowish glaze. From the north Chekiang area. 4th century BC. H. 11

(27·9). Ashmolean Museum, Oxford.

35 Ordos style bronze plaque showing tiger and tree. 4th–3rd century BC. $2\frac{1}{2} \times 3\frac{7}{8}$ (6·2 × 9·9). British Museum, London.

36 *Li* script with heavy serif, in ink on wooden strip. From Yumen, Kansu. AD. 100. $4\frac{3}{4} \times 2\frac{1}{2}$ (12 × 6·5). British Museum, London.

37 Pottery burial jars from sites in the Kansu region. 3rd–2nd millennium BC. British Museum, London.

38 Bronze vessel, *chüeh*. 13th–12th century BC. H. $8\frac{1}{2}$ (21·6). Ashmolean Museum, Oxford.

39 Painted brick from the frieze of a tomb near Loyang (detail). Han. $7\frac{1}{2} \times 13\frac{3}{4}$ (19 × 35). Museum of Fine Arts, Boston.

40 Drawing of funerary banner from the Ma Wang Tui tombs, Changsha. Mid-2nd century BC. People's Republic of China.

41 Lower portion of banner from the Ma Wang Tui tombs, Changsha. Mid-2nd century BC. People's Republic of China.

42 Bronze mirror back with cosmic motifs. Han. D. $5\frac{1}{2}$ (14). Barlow Collection, University of Sussex. Photo Jeff Teasdale.

43 Stone relief carving of a concert in a palace. From a funerary chapel at Ching Ping Hsien, Shantung. *c.* AD. 114. Metropolitan Museum of Art, New York (Rogers Fund, 1920).

44 Battle on a bridge (detail). Rubbing of a stone relief from the Wu Liang Tzu shrine, Shantung. AD. 147–168. H. $30\frac{3}{4}$ (78). Photo courtesy School of Oriental and African Studies, London.

45 Rubbing of a stamped brick from Chengtu, Szechwan, showing hunting and reaping scenes. Late Han. H. $16\frac{1}{2}$ (42). People's Republic of China.

46 Stamped brick from Chengtu, Szechwan, showing a teacher with students. Late Han. Szechwan Provincial Museum.

47 Grey earthenware standing tomb figure of a servant. Probably Han. H. 30 (76·2). Ashmolean Museum, Oxford.

48 Unglazed pottery tomb model of a farmhouse. From Canton. Han. H. $9\frac{1}{4}$ (23·5). Ashmolean Museum, Oxford.

49 Pair of cast bronze wrestlers or acrobats. Late Chou or early Han. 6 × 6 (15·3 × 15·3). British Museum, London.

50 Gilt bronze mirror box, *lien*. Han. D. of lid 7 (17·8). Victoria and Albert Museum, London.

51 Bronze hill censer with gold and silver inlays. From the tomb of Prince Liu Sheng, Man Ch'eng, Hopei. Late 2nd century BC. H. $10\frac{1}{4}$ (26). People's Republic of China.

52 Gilt bronze oil lamp in the form of a kneeling servant girl. From the tomb of Princess Tou Wan, Man Ch'eng, Hopei. *c.* 2nd century BC. H. $18\frac{7}{8}$ (48). People's Republic of China.

53 Large stoneware storage jar with incised decoration and green glaze. Han. H. 23 (58·4). Ashmolean Museum, Oxford.

54 Bronze horse poised on a flying swallow. From Wu-wei, Kansu. 2nd century BC. $13\frac{5}{8} \times 17\frac{3}{4}$ (35·4 × 45). People's Republic of China.

55 Projection and plans of the Horyuji, Nara, Japan. 7th century. From R.T. Paine and A. Soper, *The Art and Architecture of Japan*, Harmondsworth, 1974.

56 Section and elevation of the Fo Kuang Ssu hall on Mount Wu T'ai. Mid-9th century. From L. Sickman and A. Soper, *The Art and Architecture of China*, Harmondsworth, 1968.

57 Detail of bracketing and eaves of the Fo Kuang Ssu. From L. Sickman and A. Soper. *The Art and Architecture of China*, Harmondsworth, 1968.

58 Interior of cave no. 428, Tun Huang, Kansu. 5th century.

59 General view of part of the caves at Yun Kang, Shensi. Photo courtesy Lawrence Sickman.

60 Colossal red sandstone Buddha with attendant Buddha, Yun Kang. H. of colossal Buddha 45 ft (13·7 m). *c.* 460–470. Photo British Museum, London.

61 Seated Buddha with Bodhisattva at the Si Ku Ssu, Yun Kang. 460–494. Photo Werner Forman Archive.

62 Detail of a relief from cave 6, Yun Kang. Second half of 5th century. Photo Werner Forman Archive.

63 Grey limestone carving of a celestial musician. Probably from Lung Men, Honan. Early 6th century. H. $25\frac{1}{4}$ (64·1). Victoria and Albert Museum, London.

64 *The Paradise of Amitabha*. Silk painting from Tung Huang. 8th century. 54·7 × 40 (139 × 101·7). British Museum, London.

65 Detail from the murals in the tomb chamber of Princess Yung T'ai, near Ch'angan. 706. H. $75\frac{1}{2}$ (192).

66 The colossal Buddha at the Feng Hsien Ssu, Lung Men, Honan. 672 and 675. H. of Buddha 50 ft (15·2 m). Photo Werner Forman Archive.

67 Central lotus boss of the Lien Hua Tung, Lung Men. 6th century. Photo Werner Forman Archive.

68 *The Emperor Ming Huang Travelling in Shu*. Colour on silk. Later copy of 8th-century original. $21\frac{3}{4} \times 31$ (55·9 × 81). Collection of National Palace Museum, Taipei, Taiwan, Republic of China.

69 Standing Buddha with attendants at the Ping Yang Tung, Lung Men. *c.* 523. Photo Werner Forman Archive.

70 Colossal marble standing Amitabha Buddha. Found at Hsiang-pei near Ting Chou, Hopei. 585. H. 216 (548·6). British Museum, London.

71 Headless marble statue of a Bodhisattva. From Lung-yen-shan, Pao-ting, Hopei. *c.* 670. H. 73 (185·4).

72 Detail of incised carving on a limestone sarcophagus *c.* 525. 24½ × 88 (62·2 × 223·5). Nelson Gallery-Atkins Museum, Kansas City, Missouri.

73 Ku K'ai-chih (*c.* 344–*c.* 406), *The Nymph of the Lo River* (detail). Handscroll, ink and colour on silk. Later copy. H. 21⅛ (53·6). British Museum, London.

74 Ku K'ai-chih (*c.* 344–*c.* 406), *Admonitions of the Instructress to the Court Ladies* (detail). Handscroll, red and black ink on silk. 9⅞ × 136⅝ (25 × 347). British Museum, London.

75 Three-colour lead glazed earthenware dish. 8th century. D. 14 (35½). Victoria and Albert Museum, London.

76 Ju ware vase with copper rim. 12th century. H. 9¾ (25). Percival David Foundation of Chinese Art, London.

77 Chao Meng-fu (1254–1322), *Autumn Colours on the Ch'iao and Hua Mountains* (detail). Handscroll, ink and light colour on paper. 1295. H. 11⅛ (28·4). Collection of National Palace Museum, Taipei, Taiwan, Republic of China.

78 Rubbing of incised decoration from the sarcophagus of the Princess Yung T'ai tomb, Ch'angan. 706. 53½ × 31⅞ (136 × 81).

79 Bodhisattva flying on a cloud. Ink painting on hemp. 8th century. 52 × 54 (132 × 137·2). Shosoin, Nara, Japan.

80 Yüeh ware water pot. From Shang Lin Hu, Chekiang. 10th century. H. 3¼ (8·3). Ashmolean Museum, Oxford.

81 Northern white ware indented jar. Possibly from the Ting Chou region. 10th century. H 8½ (21·6). Ashmolean Museum, Oxford.

82 Pair of shallow silver bowls and covers with chased and gilt decoration. *c.* 750–850. D. 9½ (24·1). Seattle Art Museum (Eugene Fuller Memorial Collection).

83 Bronze mirror back decorated in silver and covered with a thin sheet of gold. Mid-8th century. Courtesy of Smithsonian Institution, Freer Gallery of Art, Washington D.C.

84 Stoneware pilgrim flask with brown glaze and moulded decoration. Mid-8th century. 8⅝ × 7½ (21·9 × 19). Victoria and Albert Museum, London.

85 Fragment of woven silk with a design of wine drinkers. From Astana, near Turfan, Sinkiang. 8th century. L. 5 (12·8). People's Republic of China.

86 Earthenware tomb model of a saddled camel with cream, green and yellow glazes. 8th century. H. 32½ (82·5). British Museum, London.

87 Detail of lacquer landscape painting on the face of a *p'i-pa*, a type of lute. 8th century. W. approx. 8¾ (22·2). Shosoin, Nara, Japan.

88 Tung Yüan (*fl.* 947–970), *Festival for Evoking Rain.* Ink and slight colour on silk. 61¾ × 63½ (156·8 × 161·3). Collection of National Palace Museum, Taipei, Taiwan, Republic of China.

89 Chu Jan (*fl. c.* 960–980), *Seeking the Tao in the Autumn Mountains.* Ink on silk. 61½ × 30¾ (156·2 × 74·3). Collection of National Palace Museum, Taipei, Taiwan, Republic of China.

90 Fan K'uan (*c.* 950–1050), *Travelling in Streams and Mountains.* Ink and slight colour on silk. 61 × 29¼ (154·9 × 74·3). Collection of National Palace Museum, Taipei, Taiwan, Republic of China.

91 Kuo Hsi (*c.* 1020–1090), *Early Spring.* Ink and slight colour on silk. 62¼ × 42⅝ (158·1 × 108·7). Collection of National Palace Museum, Taipei, Taiwan, Republic of China.

92 Hsu Tao-ning (*fl.* 11th century), *Fishing in a Mountain Stream* (detail). Handscroll, ink on silk. 19 × 82½ (48·3 × 209·6). Nelson Gallery-Atkins Museum, Kansas City, Missouri.

93 Su Shih (1036–1101), *Cold Provisions Day.* Ink on paper. Detail of poem composed and written by Su Shih.

94 Shallow foliated Ting ware bowl. 11th–12th century. D. 8 (20·3). Ashmolean Museum, Oxford.

95 Chun ware dish of pale-blue glazed buff stoneware. 12th century. D. 6¾ (17·1). Ashmolean Museum, Oxford.

96 Pear-shaped stoneware vase with an almost black glaze. Probably from Honan. 12th–13th century. H. 10⅝ (27). Ashmolean Museum, Oxford.

97 Tzu Chou stoneware pillow. 12th century 6 × 17 × 6¾ (15·2 × 43·2 × 17·1). Victoria and Albert Museum, London.

98 Emperor Hui Tsung (1082–1135), *Five-coloured Parakeet on a Branch of Apricot Blossom.* Handscroll, colour on silk. H. 20⅞ (53). Museum of Fine Arts, Boston (Maria Antoinette Evans Fund).

99 Chang Tse-tuan (late 11th–early 12th century), *Life Along the River on the Eve of the Ch'ing Ming Festival* (detail). Handscroll, ink and slight colour on silk. H. 10 (25·5). Collection of Palace Museum, Peking.

100 Hsia Kuei (*fl.* 1180–1230), *Pure and Remote Views of Hills and Streams* (detail). Handscroll, ink on paper. H. 18¼ (46·5). Collection of National Palace

Museum, Taipei, Taiwan, Republic of China.

101 Ma Yüan (*fl.* 1190–1225), *On a Mountain Path in Spring* (detail). Album leaf, ink and light colour on silk. H. 10¾ (27·4). Collection of National Palace Museum, Taipei, Taiwan, Republic of China.

102 Ma Lin (*fl.* early 13th century), *Waiting for Guests by Lamplight*. Album leaf, ink and colour on silk. 9¾ × 9⅞ (24·8 × 25). Collection of National Palace Museum, Taipei, Taiwan, Republic of China.

103 Mu Ch'i (active 1269), *White-robed Kuan-yin*. Ink on silk. 56 × 38 (142 × 96). Daitokuji, Kyoto. Photo courtesy School of Oriental and African Studies, London.

104 Mu Ch'i (active 1269), *Persimmons*. Ink on paper. 15 × 14¼ (36·2 × 38·1). Daitokuji, Kyoto.

105 Liang K'ai (*c.* 1140–1210), *Ch'an Priest*. Ink on paper. 19¼ × 10⅞ (48·7 × 27·6). Collection of National Palace Museum, Taipei, Taiwan, Republic of China.

106 Ying Ch'ing impressed porcelain bowl. From Ching-te Chen. 13th–14th century. D. 6¾ (17·1). Ashmolean Museum, Oxford.

107 Lung Ch'uan celadon bowl with lotus petal relief decoration. 13th–14th century. D. 5¾ (14·6). Ashmolean Museum, Oxford.

108 Temmoku ware tea bowl of the 'hare's fur' type. From Chien An, Fukien. 13th–14th century. D. 4 (10·2). Ashmolean Museum, Oxford.

109 Gilt bronze Bodhisattva. Sung. H. 7½ (19). Ashmolean Museum, Oxford.

110 Parakeet on a cherry twig. Woven silk tapestry (*k'o ssu*). 13th century. 10 × 12 (25·4 × 30·5). Museum of Fine Arts, Boston.

111 Ch'ien Hsuan (*c.* 1235–1301), *Squirrel on a Peach Bough*. Ink and colour on paper. 10¼ × 17¼ (26 × 43·8). Collection of National Palace Museum, Taipei, Taiwan, Republic of China.

112 Huang Kung-wang (1269–1354), *Wandering in the Fu Ch'un Mountains* (detail). Handscroll, ink on paper. 1350. H. 13 (33). Collection of National Palace Museum, Taipei, Taiwan, Republic of China.

113 Wu Chen (1280–1354), *Fishermen*. Handscroll, ink on paper. 1352. 12¾ × 211⅞ (32·5 × 562·2). Courtesy of Smithsonian Institution, Freer Gallery of Art, Washington D.C.

114 Ni Tsan (1301–1374), *The Jung Hsi Studio*. Ink on paper. 28¾ × 13¾ (73 × 34·9). Collection of National Palace Museum, Taipei, Taiwan, Republic of China.

115 Wang Meng (1308–1385), *Thatched Halls on Mount T'ai*. Ink and colour on paper. 43⅞ × 13¾ (111·4 × 34·8). Collection of National Palace Museum, Taipei, Taiwan, Republic of China.

116 Iron underglaze decorated stoneware dish.

Perhaps from Chi Chow, Kiangsi. 14th century. D. 18 (45·7). Ashmolean Museum, Oxford.

117 Large porcelain dish decorated in underglaze blue. From Ching-te Chen. Late 14th century. D. 18¼ (46·4). Ashmolean Museum, Oxford.

118 Pear-shaped vase with underglaze copper-red decoration. From Ching-te Chen. 14th century. H. 12 (30·5). Ashmolean Museum, Oxford.

119 Ying Ch'ing porcelain figure of a seated Kuan-yin. From Ching-te Chen. 1298 or 1299. 20¼ × 12 × 7¾ (51·4 × 30·5 × 19·7). Nelson Gallery-Atkins Museum, Kansas City, Missouri.

120 The Forbidden City, Peking. General view of one of the inner courtyards of the Palace. 15th-century foundation. Photo Werner Forman Archive.

121 The Forbidden City, Peking. View of the canal and covered way leading to the side of the main halls. 15th-century foundation. Photo Werner Forman Archive.

122 The Temple of Heaven, near Peking. Late Ch'ing period. Photo Russell A. Thompson.

123 Interior of the ceremonial hall at the Ming Tombs outside Peking. 15th-century foundation. Photo Werner Forman Archive.

124 Marble camels on the Spirit Way, a road leading to the Ming Tombs at Nanking. Photo Werner Forman Archive.

125 Tai Chin (1388–1452), *Returning Home at Evening* (detail). Hanging scroll, ink and slight colour on silk. 73⅞ × 36⅜ (187 × 92). Collection of National Palace Museum, Taipei, Taiwan, Republic of China.

126 Wang Fu (1362–1416), *Farewell Meeting at Feng Ch'eng*. Ink on paper. 36 × 12¼ (91·4 × 31). Collection of National Palace Museum, Taipei, Taiwan, Republic of China.

127 Shen Chou (1427–1509), *Poet on a Clifftop* Album leaf, ink on paper. 15¼ × 23¾ (38·7 × 60·3). Nelson Gallery-Atkins Museum, Kansas City, Missouri.

128 Wen Cheng-ming (1470–1559), *Lofty Leisure Beneath a Sheer Cliff* (detail). Large hanging scroll, ink and colour on paper. 58⅝ × 70 (148·9 × 177·9). Collection of National Palace Museum, Taipei, Taiwan, Republic of China.

129 Chou Chen (*fl.* late 15th century), *Taoist Scholar Dreaming of Immortality* (detail). Handscroll, ink and slight colour on paper. H. 11⅛ (28·3). Courtesy of Smithsonian Institution, Freer Gallery of Art, Washington D.C.

130 Ch'iu Ying (*c.* 1494–*c.* 1552), *Fishing Boat by a Willow Bank*. Colour on silk. 40½ × 18½ (102·9 × 47·2). Collection of National Palace Museum, Taipei,

Taiwan, Republic of China.

131 Ch'en Hung-shou (1599–1652), *Lady Hsuan Giving Instruction in the Classics* (detail). Colour on silk. $68\frac{3}{8} \times 21\frac{7}{8}$ (188 × 55·6). Cleveland Museum of Art (Purchase Mr and Mrs William H. Marlatt Fund).

132 White porcelain figure of a Kuan-yin carrying a basket of fish. From Te Hua, Fukien. 17th century. H. 16 (40·6). Ashmolean Museum, Oxford.

133 Tung Ch'i-ch'ang (1555–1636), *Landscape*. Ink on paper. $37\frac{7}{8} \times 16\frac{1}{4}$ (95·5 × 41·3). British Museum, London.

134 The Wang Shi Yüan garden, Suchow. Photo Peter Hayden.

135 Pa Ta Shan Jen (Chu Ja) (1626–1705), *Landscape in the Manner of Tung Yüan*. Ink on paper. $70\frac{7}{8} \times 36\frac{7}{8}$ (180 × 93·5). Östasiatiska Museet, Stockholm.

136 Shih T'ao (1630–1707), *The Peach Blossom Spring* (detail). Handscroll, ink on colour over paper. $9\frac{7}{8} \times 62\frac{1}{4}$ (25 × 157·8). Courtesy of Smithsonian Institution, Freer Gallery of Art, Washington D.C.

137 Red lacquer covered box carved with a design of camellia sprays. First half of 15th century. D. $8\frac{3}{4}$ (22·2). Victoria and Albert Museum, London.

138 Pien Wen-chin (*fl. c.* 1400–30), *Three Friends and One Hundred Birds*. Ink and colour on silk. 1413. $59\frac{5}{8} \times 30\frac{3}{4}$ (151·3 × 78·1). Collection of National Palace Museum, Taipei, Taiwan, Republic of China.

139 K'un Ts'an (*c.* 1610–1693), *Autumn Landscape*. Handscroll, ink and slight colour on paper. 1666. $12\frac{3}{8} \times 25\frac{1}{4}$ (31·4 × 64·1). British Museum, London.

140 Moon flask of blue and white porcelain. From Ching-te Chen. 15th century. H. $12\frac{1}{8}$ (30·7). Percival David Foundation of Chinese Art, London.

141 Overglaze decorated porcelain bowl. From Ching-te Chen. 16th century. D. $8\frac{3}{4}$ (22). Percival David Foundation of Chinese Art, London.

142 Wang Yüan-ch'i (1642–1715), *View of Mount Hua*. Ink and light colours on paper. 1693. $45\frac{5}{8} \times 19\frac{1}{2}$ (115·9 × 49·7). Collection of National Palace Museum, Taipei, Taiwan, Republic of China.

143 Famille verte foliated porcelain bowl. From Ching-te Chen. Early 18th century. D. $6\frac{1}{2}$ (16·5). Ashmolean Museum, Oxford.

144 Small porcelain vase decorated in *famille rose* colours. Mid-18th century. H. 7 (17·8). Ashmolean Museum, Oxford.

145 Blue and white porcelain vase in the form of a European glass bottle. From Ching-te Chen. Mid- to late 17th century. H. $9\frac{1}{2}$ (24·1). Ashmolean Museum, Oxford.

146 Bronze cup and saucer decorated with 'Canton' enamel. 18th century. D. of saucer $5\frac{3}{4}$ (14·6).

Ashmolean Museum, Oxford.

147 Giuseppe Castiglione (1688–1766), *Kazaks Presenting Tribute Horses to the Ch'ien Lung Emperor* (detail). Handscroll, ink and colour on paper. $17\frac{3}{4} \times 105\frac{1}{8}$ (45 × 267). Musée Guimet, Paris. Photo Musées Nationaux, Paris.

148 Mei Ch'ing (1623–1697), *Landscape in the Style of Ching Hao and Kuan T'ung*. Album leaf, ink and colour on paper. $11\frac{1}{4} \times 17\frac{1}{4}$ (28·6 × 44). Cleveland Museum of Art (Purchase John L. Severance Fund).

149 Hua Yen (1682–1755), *Conversation in Autumn*. Ink and colour on paper. 1732. $45\frac{3}{8} \times 15\frac{5}{8}$ (115·3 × 39·7). Cleveland Museum of Art (Purchase John L. Severance Fund).

150 Kao Ch'i-p'ei (*c.* 1672–1754), *The Four Seasons* (detail). Handscroll, ink and colour on paper. H. $8\frac{3}{4}$ (22·2). Ashmolean Museum, Oxford.

151 Light metal hairpin set with pearls, semi-precious stone and kingfisher feather. H. 3 (7·6). Ashmolean Museum, Oxford.

152 Porcelain vase with pink, gold and black decoration. From Ching-te Chen. Late 19th or early 20th century. H. $16\frac{1}{2}$ (41·9). Ashmolean Museum, Oxford.

153 Silk gown with a design of butterflies and flowers, made for the Empress Tzu Hsi. Late 19th or early 20th century. Royal Ontario Museum, Toronto.

154 Fu Pao-shih (1904–1965), *Mountain Landscape*. Ink and colour on paper. 1944. $43\frac{1}{8} \times 24\frac{1}{8}$ (109·5 × 61·3). Ashmolean Museum, Oxford.

155 An appreciation of Fu Pao-shih. Calligraphy by Kuo Mo-jo (d. 1979).

156 Wu Ch'ang-shih (1844–1927), *Rocks and Flowers*. Ink and colour on paper. 1918. $61\frac{3}{4} \times 31\frac{1}{2}$ (157 × 80). Private Collection.

157 Jen Po-nien (1840–1895), *Hibiscus and Flying Kingfishers*. Ink and colour on paper. 1894. $25\frac{7}{8} \times 18\frac{1}{8}$ (65·6 × 46). Ashmolean Museum, Oxford.

158 Ch'i Pai-shih (1863–1957), *Chrysanthemum and Bee*. Unmounted fan, colour on paper. $7\frac{1}{2} \times 22$ (19 × 55·9). Ashmolean Museum, Oxford.

159 Kuan Shan-yüeh (contemporary), *Man with Horse on Steps*. Pale colour and ink on paper. 1934. $44 \times 15\frac{1}{8}$ (111·8 × 38·4). Ashmolean Museum, Oxford.

160 Li K'o-jan (b. 1907), *Landscape Based on Chairman Mao's Poem*. Ink and slight colour on paper. 1960s. $27\frac{1}{2} \times 18\frac{1}{4}$ (70 × 46·25). C. A. Drenowatz Collection, Museum Rietberg, Zurich.

161 Lui Shou-kwan (d. 1977), *Island Landscape*. Ink on paper. 1961. $11 \times 32\frac{1}{4}$ (27·9 × 81·9). Private Collection.

Index

HUMAN INTELLIGENCE

transaction book series

HUMAN INTELLIGENCE

Edited by
J. McVicker Hunt

*trans*action *books*
New Brunswick, New Jersey
Distributed by E. P. Dutton and Company

Unless otherwise indicated, the essays in this book originally appeared in *trans*action magazine

*trans*action *books*
Rutgers University
New Brunswick, New Jersey 08903

Library of Congress Catalog Card Number: 78-164977
ISBN: 0-87855-002-X (cloth); 0-87855-502-1 (paper)

Printed in the United States of America

Contents

Preface

For the past eight years, *trans*action magazine has dedicated itself to the task of reporting the strains and conflicts within the American system. But the magazine has done more than this. It has pioneered in social programs for changing the society, offered the kind of analysis that has permanently restructured the terms of the "dialogue" between peoples and publics, and offered the sort of prognosis that makes for real alterations in social and political policies directly affecting our lives.

The work done in the pages of *trans*action has crossed disciplinary boundaries. This represents much more than simple cross-disciplinary "team efforts." It embodies rather a recognition that the social world cannot be easily carved into neat academic disciplines; that, indeed, the study of the experience of blacks in American ghettos, or the manifold uses and abuses of

agencies of law enforcement, or the sorts of overseas policies that lead to the celebration of some dictatorships and the condemnation of others, can best be examined from many viewpoints and from the vantage points of many disciplines.

Now the editors of *trans*action magazine are making available in permanent form the most important work done in the magazine, supplemented in some cases by additional materials edited to reflect the tone and style developed over the years by *trans*action. Like the magazine, this series of books demonstrates the superiority of starting with real world problems and searching out practical solutions, over the zealous guardianship of professional boundaries. Indeed, it is precisely this approach that has elicited enthusiastic support from leading American social scientists, many of whom are represented among the editors of these volumes.

The subject matter of these books concerns social changes and social policies that have aroused the long-standing needs and present-day anxieties of us all. These changes are in organizational lifestyles, concepts of human ability and intelligence, changing patterns of norms and morals, the relationship of social conditions to physical and biological environments, and in the status of social science with respect to national policy making. The editors feel that many of these articles have withstood the test of time, and match in durable interest the best of available social science literature. This collection of *trans*action articles, then, attempts to address itself to immediate issues without violating the basic insights derived from the classical literature in the various fields of social science.

As the crises of the sixties have given way to the economic crunch of the seventies, the social scientists

involved as editors and authors of this series have gone beyond observation of critical areas, and have entered into the vital and difficult tasks of explanation and interpretation. They have defined issues in a way that makes solutions possible. They have provided answers as well as asked the right questions. These books, based as they are upon the best materials from *trans*action magazine, are dedicated not to the highlighting of social problems alone, but to establishing guidelines for social solutions based on the social sciences.

THE EDITORS
*trans*action

Introduction

J. MCVICKER HUNT

Few conceptions of the behavioral and social sciences have been undergoing more rapid change than that of intelligence and its role in human competence. Few conceptions of these sciences are more intimately intertwined with social policy as such policy influences social change for better or worse. In the eight years that *trans*action magazine has been dedicated, as the editors have put it, "to the task of reporting the strains and conflicts in the American system," it has published a number of articles which have illuminated various aspects of this highly important domain. Taken individually, each sheds its light over but a limited portion of the whole. Taken together, these vignettes illuminate and contribute significantly to dialogue; and in these ways they influence social policy decisions regarding early childhood education and various aspects of education which foster or hamper the development of

1

competence and its utilization in society. The impact of these essays becomes more significant as they are brought together in a single book.

The essays comprising this anthology fall roughly into the four categories indicated in the table of contents. Part I, comprised of three subsections, is concerned with whether the heritability indices of intelligence test performance have anything to say about the educability of individuals, with the implications of plasticity in psychological development and the role of experience in the development of competence, and with the two kinds of intelligence. Part II concerns various aspects of social class and education in the development of competence. Part III is concerned with the differences between and similarities of creativity and intelligence. Part IV contains suggestions for improving the status quo. One is concerned with improving the treatment of the retarded, another with using techniques of reinforcement to change the climate of the classroom, a third suggests an improvement on the practice of tracking in high schools, and the final one makes a plea for criteria of hiring which are more relevant to competence on the job.

This anthology should be of interest to a wide variety of people. It could well serve as a readable introduction to the changing conceptions of intelligence for laymen generally and for those with political responsibility. It should be of interest to teachers. It could well serve as supplementary reading for courses in intelligence or intelligence testing, in child development, in educational psychology, and perhaps even in personnel selection and in labor relations.

Such anthologies have taken on new importance for both laymen and students in recent years. As they face

moments of decision on social policies, many laymen find need to become informed through accurate but nontechnical presentations of the matters concerned. Seldom can they take the time for a library search or even a search through the issues of a magazine like *trans*action. For them, having the relevant articles assembled in an inexpensive book is a great time-saving boon. Anthologies have also acquired new importance in the colleges. Since World War II when the GIs returned to the campuses, the reserve desks at college libraries have become frustrating bottlenecks for students seeking the readings which have been assigned to supplement the textbooks. Again, inexpensive anthologies which supplement textbooks are a time-saving boon for students.

No claim of comprehensive coverage is made for this work, yet, taken together, the articles in this anthology will shed light on a great deal of the domain of human intelligence and competence and the factors which influence it. Moreover, the supplementary readings both extend the coverage and supply leads to the basic investigative literature which, if followed, can open the whole field in relatively rapid order.

BACKGROUND FACTORS

Part I.

Genetics and Competence: Do Heritability Indices Predict Educability?

JERRY HIRSCH

Over the past two decades the case against extreme behaviorism has been spelled out in incontrovertible detail. The behaviorists committed many sins: they accepted the mind at birth as Locke's *tabula rasa,* they advocated an empty-organism psychology, they asserted the uniformity postulate of no prenatal individual differences; in short, they epitomized typological think- ing. Many times we have heard quoted the famous boast by the first high priest of behaviorism, John B. Watson:

> Give me a dozen healthy infants, well-formed, and my own specified world to bring them up in, and I'll guarantee to take any one at random and train him to become any type of specialist I might select— doctor, lawyer, artist, merchant-chief and yes, even beggar-man and thief, regardless of his talents, penchants, tendencies, abilities, vocations, race of his ancestors.

7

However, it is only when we read the next sentence, which is rarely, if ever, quoted, that we begin to understand how so many people might have embraced something intellectually so shallow as radical behaviorism. In that all-important next sentence Watson explains: "I am going beyond my facts and I admit it, but so have the advocates of the contrary and they have been doing it for many thousands of years."

Who were the advocates of the contrary, and what had they been saying? It is difficult to establish the origins of racist thinking, but certainly one of its most influential advocates was Joseph Arthur de Gobineau, who published a four-volume *Essay on the Inequality of the Human Races* in the mid-1850s. De Gobineau preached the superiority of the white race, and among whites it was the Aryans who carried civilization to its highest point. In fact, they were responsible for civilization wherever it appeared. Unfortunately, de Gobineau's essay proved to be the major seminal work that inspired some of the most perverse developments in the intellectual and political history of our civilization. Later in his life, de Gobineau became an intimate of Richard Wagner. Houston Stewart Chamberlain, an Englishman who emigrated to the Continent, became a devoted admirer of both de Gobineau and Wagner. In 1908, after Wagner's death, Chamberlain married Wagner's daughter during World War I, becoming a naturalized German citizen in 1916.

In the summer of 1923, an admirer of Chamberlain's writings, Adolf Hitler, visited Wahnfried, the Wagner family home in Bayreuth where Chamberlain lived. After their meeting, Chamberlain wrote to Hitler: "My faith in the Germans had never wavered for a moment, but my hope . . . had sunk to a low ebb. At one stroke

you have transformed the state of my soul!" We all know the sequel to that unfortunate tale. I find that many of my scientific colleagues, whether they be biological or social scientists, for the most part, do not know the sad parallel that exists for the essentially political tale I have so far recounted. The same theme can be traced down the mainstream of biosocial science.

Today not many people know the complete title of Darwin's most famous book: *On the Origin of Species by Means of Natural Selection or the Preservation of Favored Races in the Struggle for Life.* I find no evidence that Darwin had the attitudes we now call racist. Unfortunately, many of his admirers, his contemporaries and his successors were not as circumspect as he. In Paris in 1838, J.E.D. Esquirol first described a form of mental deficiency later to become well known by two inappropriate names unrelated to his work. Unhappily, one of these names, through textbook adoption and clinical jargon, puts into wide circulation a term loaded with race prejudice. Somewhat later (1846 and 1866), E. Seguin described the same condition under the name "furfuraceous cretinism," but his account has only recently been recognized as "the most ingenious description of physical characteristics," as C.E. Benda puts it.

This most promising scientific beginning was ignored, however, and in 1866, John Langdon Haydon Down published the paper entitled "Observations on an Ethnic Classification of Idiots."

...making a classification of the feeble-minded, by arranging them around various ethnic standards—in other words, framing a natural system to supplement the information to be derived by an inquiry into the history of the case.

I have been able to find among the large number
of idiots and imbeciles which comes under my
observation, both at Earlswood and the outpatient
department of the Hospital, that a considerable
portion can be fairly referred to one of the great
divisions of the human family other than the class
from which they have sprung. Of course, there are
numerous representatives of the great Caucasian
family. Several well-marked examples of the Ethio-
pian variety have come under my notice, presenting
the characteristic malar bones, the prominent eyes,
the puffy lips, and retreating chin. The woolly hair
has also been present, although not always black nor
has the skin acquired pigmentary deposit. They have
been specimens of white negroes, although of Euro-
pean descent.

Some arrange themselves around the Malay vari-
ety, and present in their soft, black, curly hair, their
prominent upper jaws and capacious mouths, types
of the family which people the South Sea Islands.

Nor have there been wanting the analogues of the
people who with shortened foreheads, prominent
cheeks, deep-set eyes, and slightly apish nose, origin-
ally inhabited the American Continent.

The great Mongolian family has numerous repre-
sentatives, and it is to this division, I wish, in this
paper, to call special attention. A very large number
of congenital idiots are typical Mongols. So marked is
this, that when placed side by side, it is difficult to
believe that the specimens compared are not children
of the same parents. The number of idiots who
arrange themselves around the Mongolian type is so
great, and they present such a close resemblance to
one another in mental power, that I shall describe an

idiot member of this racial division, selected from the large number that have fallen under my observation.

The hair is not black, as in the real Mongol, but of a brownish colour, straight and scanty. The face is flat and broad, and destitute of prominence. The cheeks are roundish, and extended laterally. The eyes are obliquely placed, and the internal canthi more than normally distant from one another. The palpebral fissure is very narrow. The forehead is wrinkled transversely from the constant assistance which the levatores palpebrarum derive from the occipito-frontalis muscle in the opening of the eyes. The lips are large and thick with transverse fissures. The tongue is long, thick, and is much roughened. The nose is small. The skin has a slight dirty yellowish tinge and is deficient in elasticity, giving the appearance of being too large for the body.

The boy's aspect is such that it is difficult to realize that he is the child of Europeans, but so frequently are these characters presented, that there can be no doubt that these ethnic features are the result of degeneration.

And he means degeneration from a higher to a lower race. The foregoing represents a distasteful but excellent example of the racial hierarchy theory and its misleadingly dangerous implications. That was how the widely used terms "mongolism" and "mongolian idiocy" entered our "technical" vocabulary. For the next century, this pattern of thought would persist and occupy an important place in the minds of many leading scientists.

In 1884, Francis Galton, Darwin's half cousin, founder of the eugenics movement and respected contributor to many fields of science, wrote to the distinguished Swiss botanist Alphonse de Candolle: "It strikes me that

the Jews are specialized for a parasitical existence upon other nations, and that there is need of evidence that they are capable of fulfilling the varied duties of a civilized nation by themselves." Karl Pearson, Galton's disciple and biographer, echoed this opinion 40 years later during his attempt to prove the undesirability of Jewish immigration into Britain: "for such men as religion, social habits, or language keep as a caste apart, there should be no place. They will not be absorbed by, and at the same time strengthen the existing population; they will develop into a parasitic race."

Beginning in 1908 and continuing at least until 1928, Karl Pearson collected and analyzed data in order to assess "the quality of the racial stock immigrating into Great Britain." He was particularly disturbed by the large numbers of East European Jews, who near the turn of the century began coming from Poland and Russia to escape the pogroms. Pearson's philosophy was quite explicitly spelled out:

> Let us admitthat the mind of man is for the most part a congenital product, and the factors which determine it are racial and familial; we are not dealing with a mutable characteristic capable of being moulded by the doctor, the teacher, the parent or the home environmentThe ancestors of the men who pride themselves on being English today were all at one time immigrants; it is not for us to cast the first stone against newcomers, solely because they are newcomers. But the test for immigrants in the old days was a severe one; it was power physical and mental to retain their hold on the land they seized. So came Celts, Saxons, Norsemen, Danes and Normans in succession and built up the nation of which we are proud. Nor do we criticize the alien Jewish

[handwritten margin note: problem in U.S. immigration too!]

immigration simply because it is Jewish; we took the alien Jews to study, because they were the chief immigrants of that day and material was readily available.

His observations led him to conclude: "Taken *on the average,* and regarding both sexes this alien Jewish population is somewhat inferior physically and mentally to the native population." Pearson proclaimed this general Jewish inferiority despite his own failure to find any differences between the Jewish and non-Jewish boys when comparisons (reported in the same article) were made for the sexes separately.

Quite recently there has appeared a series of papers disputing whether or not black Americans are, in fact, genetically inferior to white Americans in intellectual capacity. In 1969 a discussion of heredity, race and intelligence reasserting the old fallacious white supremacist point of view was published in the *Harvard Educational Review* by the notorious A.R. Jensen of the University of California at Berkeley. The claims and counterclaims have been given enormous publicity in the popular press in America. Some of those papers contain most of the fallacies that can conceivably be associated with this widely misunderstood problem.

This dispute leads to an intellectual cul-de-sac, and a series of steps marked by fallacious assumptions that can be listed as follows: 1) a trait called intelligence is defined, and an instrument for measuring the expression of this trait is devised and used; 2) the heritability of the trait is estimated; 3) races (populations) are compared with respect to their performance on the test of trait expression; 4) when the races (populations) differ on the test whose heritability has now been measured, the one with the lower score is genetically inferior, Q.E.D.

The foregoing argument can be applied to any single trait or to as many traits as one might choose to consider. Therefore, analysis of this general problem does *not* depend upon the particular definition and test used for this or that trait. For my analysis I shall pretend that an acceptable test exists for some trait, be it height, weight, intelligence or anything else. For without an acceptable test, discussion of the "trait" remains unscientific.

In order even to consider comparisons between races, the following concepts must be recognized: 1) the mosaic nature of the genome or hereditary endowment of the species; 2) development as the expression of one out of many alternatives in the norm of reaction (see below) of the genotype or hereditary endowment of the individual; 3) a population as a gene pool or reservoir of possible genetic combinations; 4) heritability (a measure of the amount of genetic variation in a population associated with variation in the expression of some trait) is not instinct (an inherited stereotyped behavior pattern like the nest-building activities of a bird); 5) traits as distributions of scores; and 6) distributions as moments or the mathematical descriptions of their major features, such as average, scatter, asymmetry and peakedness.

Since genetic inheritance comes to us in bits and pieces, as it were, not in a lump, the hereditary endowment of each individual is a unique mosaic—an assemblage of factors many of which are independent. Because of the lotterylike nature of fertilization and even of the way egg and sperm are formed, no two individuals other than identical twins share the same genotypic mosaic.

The ontogeny of an individual's phenotype (the

observable outcome of development) has a norm or range of reaction not predictable in advance. In most cases the norm of reaction remains largely unknown, but the concept is nevertheless of fundamental importance, because it saves us from being taken in by glib and misleading textbook cliches such as "heredity sets the limits, but environment determines the extent of development within those limits." Even when, as in plants and some animals, an individual genotype can be replicated many times and its development studied over a range of environmental conditions, we can only get an approximate estimate of what the range of the genotype's reaction might be. The more varied the conditions, the more varied might be the end product. Of course, different genotypes should not be expected to have the same norm of reaction (the same seed develops into quite a different plant at sea level and above the timberline). Unfortunately, psychology's attention was diverted from appreciating this basic fact of biology by a half century of misguided environmentalism. Just as we see that, except for twins born of the same egg, no two human faces are alike, so we must expect norms of reaction to show genotypic uniqueness. That is one reason why the heroic but ill-fated attempts of experimental learning psychologists to write the "laws of environmental influence" were grasping at shadows. Those "limits set by heredity" in the textbook cliche can never be specified. They are plastic within each individual and differ between individuals. Extreme environmentalists were wrong to hope that one law or set of laws would be found that could describe universally how genetic endowment is modified. Extreme hereditarians were wrong to ignore the norm of reaction.

Individuals occur in populations, and then only as temporary attachments, so to speak, each to particular combinations of genes. The population, however, can endure indefinitely as a pool or reservoir of genes, maybe forever recombining to generate new individuals.

What is heritability? How is heritability estimated for intelligence or any other trait? Is heritability related to instinct? In 1872, Douglas Spalding demonstrated that the ontogeny of a bird's ability to fly is simply maturation and not the result of practice, imitation or any demonstrable kind of learning. He confined immature birds and deprived them of the opportunity either to practice flapping their wings or to observe and imitate the flight of older birds; in spite of this, they developed the ability to fly. For some ethologists this deprivation experiment became the paradigm for proving the innateness or instinctive nature of a behavior by demonstrating that it appears despite the absence of any opportunity for it to be learned. Remember two things about this approach: first, the observation involves experimental manipulation of the conditions of experience during development, and second, such observation can be made on the development of one individual. For some people the results of a deprivation experiment now constitute the operational demonstration of the existence (or nonexistence) of an instinct in a particular species.

Are instincts heritable, that is, are they determined by genes? But what is a gene? A gene is an inference from a breeding experiment. It is recognized by the measurement of individual differences—the recognition of the segregation of distinguishable forms of the expression of some trait among the progeny of appropriate matings. For example, when an individual of blood

type AA mates with one of type BB, their offspring are uniformly AB. If two of the AB offspring mate, it is found that the A and B gene forms, or alleles as they are called technically, have segregated during reproduction and recombined in their progeny to produce all combinations of A and B: AA, AB and BB. Note that the only operation involved in such a study is *breeding* of one or more generations and then, at an appropriate time of life, observation of the separate individuals born in each generation—controlled breeding with experimental material or pedigree analysis of the appropriate families. In principle, only one (usually brief) observation is required. Thus we see that genetics is a science of *differences,* and the breeding experiment is its fundamental operation. The operational definition of the gene, therefore, involves observation in a breeding experiment of the segregation among several individuals of distinguishable differences in the expression of some trait from which the gene can be inferred; that is, in contrast to the study of instinct, a genetic study requires more than one subject, whose development is studied. Moreover, all discussions of genetic analysis presuppose sufficiently adequate control of environmental conditions so that all observed individual differences have developed under the same environmental conditions—conditions never achieved in any human studies.

How does heritability enter the picture? At the present stage of knowledge, many features (traits) of animals and plants have not yet been related to genes that can be recognized individually. But the role of large number of genes, often called polygenes and in most organisms still indistinguishable one from the other, has been demonstrated easily (and often) by selective breeding or by appropriate comparisons between dif-

ferent strains of animals or plants. Selection and strain
crossing have provided the basis for many advances in
agriculture, and among the new generation of research
workers they are becoming standard tools for the
experimental behaviorist. Heritability often summarizes
the extent to which a particular population has respond-
ed to a regimen of being bred selectively on the basis of
the expression of some trait, as is done for milk
production in cattle and egg production in poultry.
Heritability values vary on a continuum between zero
and plus one. If the distribution of trait expression
among progeny remains the same no matter how their
parents might be selected, then heritability has zero
value. If parental selection does make a difference,
heritability exceeds zero, its exact value reflecting the
parent-offspring correlation.

A heritability estimate, however, is a far more limited
piece of information than most people realize. As was so
well stated by J.L. Fuller and W.R. Thompson, "herita-
bility is a property of populations and not of traits." In
its strictest sense, a heritability measure provides for a
given population an estimate of the proportion of the
variance it shows in trait (phenotype) expression which
is correlated with the segregation of the alleles of
independently acting genes; that is, milk yield might
have a high heritability in one heterogeneous herd of
cattle and a very low heritability in some other
relatively homogeneous herd. There are other more
broadly conceived heritability measures which estimate
this correlation and also include the combined effects of
genes that are independent and of those that interact.
Therefore, heritability estimates the proportion of
individual differences shown by a trait that can be
attributed to genetic variation (narrowly or broadly

interpreted) in some particular population at a single generation under one set of conditions.

This description contains three fundamentally important limitations that have rarely been accorded sufficient attention. In the first place, the importance of limiting any statement about heritability to a specific population is evident when we realize that a gene, which shows variation in one population because it is represented there by two or more different forms of expression, might show no variation in some other population because it is uniformly represented there by only a single allele. Remember that initially such a gene could never have been detected by genetic methods in the second population. Once it has been detected in some population carrying two or more of its segregating alleles, the information thus obtained might permit us to recognize it in populations carrying only a single allele. Note how this is related to heritability: the trait will show a greater-than-zero heritability in the segregating population but zero heritability in the nonsegregating population. This does *not* mean that the trait is determined genetically in the first population and environmentally in the second!

Up to now my discussion has been limited to a single gene. The very same argument applies for every gene of the polygenic complexes involved in continuously varying traits like height, weight and intelligence. Also, only *genetic* variation has been considered—the presence or absence of segregating alleles at one or more loci in different populations.

Next let us consider the ever-present environmental sources of variation. Usually from the Mendelian point of view, except for the genes on the segregating chromosomes, everything inside the cell and outside the

organism is lumped together and can be called environmental variation—cytoplasmic constituents, the maternal effects now known to be so important, the early experience effects studied in so many psychological laboratories and so on. None of these can be considered unimportant or trivial. They are ever present. Let us now perform what physicists call a Gedanken, or thought, experiment. Imagine Aldous Huxley's *Brave New World* or Skinner's *Walden II* organized in such a way that every individual is exposed to precisely the same environmental conditions. In other words, consider the extreme, but *un*realistic, case of complete environmental homogeneity. Under these circumstances the heritability value would approach plus one, because only genetic variation would be present. Don't forget, however, that even under these conditions, there are over 70 trillion potential human genotypes—no two of us share the same genotype no matter how many ancestors we happen to have in common. Since our unique genotype is in the nucleus, or executive, of every cell in our bodies, the individuality that is so obvious in the human faces we see around us must also characterize the unseen components. Let the same experiment be imagined for any number of environments. Since every genotype has a unique norm of reaction, they can develop differently in the different possible environments, and the rank ordering of their phenotypes will not necessarily remain the same in the different environments because the shift from one environment to another must not be expected to have the same effect on every genotype; for example, the change from hypothetical environment A to B might raise the score on some measure for one individual and lower that of another individual whereas the reverse might happen for

the same two individuals with the change from hypothetical environment A to C.

The third limitation refers to the fact that because gene frequencies can and do change from one generation to the next, so will heritability values or the magnitude of the genetic variance.

Now let us shift our focus to the entire genotype or at least to those of its components that might co-vary at least partially with the phenotypic expression of a particular trait. Early in this century, Woltereck, a German zoologist, called to our attention the norm-of-reaction concept: the same genotype can give rise to a wide array of phenotypes depending upon the environment in which it develops. This is most conveniently studied in plants where genotypes are easily replicated. Later R.B. Goldschmidt, a German-American geneticist, was to show in the fruit fly that, by careful selection of the environmental conditions at critical periods in development, various phenotypes ordinarily associated with specific gene mutations could be produced from genotypes that did not include the mutant form of those genes. Descriptively, Goldschmidt called these events *phenocopies* environmentally produced imitations of gene mutants or phenotypic expressions only manifested by the "inappropriate" genotype if unusual environmental influences impinge during critical periods in development, but regularly manifested by the "appropriate" genotype under the usual environmental conditions.

In 1946, the brilliant British geneticist J.B.S. Haldane analyzed the interaction concept and gave quantitative meaning to the foregoing. For the simplest case but one, that of two genotypes in three environments, or for its mathematical equivalent, that of three genotypes in two

environments, he showed that there are 60 possible kinds of interaction. Ten genotypes in ten environments generate 10^{144} possible kinds of interaction. In general, m genotypes in n environments generate $(mn)!/m!n!$ kinds of interaction. Since the characterization of genotype-environment interaction can only be ad hoc (is unpredictable and therefore only can be described after it has happened) and the number of possible interactions is effectively unlimited, it is no wonder that the long search for general laws has been so unfruitful.

For genetically different lines of rats that had been bred to be "bright" or "dull" in the preformance of a given task, by so simple a change in environmental conditions as increasing the interval of the time allowed between practice trials, J.U. McGaugh, R.D. Jennings and C.W. Thompson found that the so-called dulls moved right up to the scoring level of the so-called brights. In a recent study of the open-field behavior of mice, J.P. Hegmann and J.C. DeFries found that heritabilities measured repeatedly in the same individuals were unstable over two successive days. In surveying earlier work, they commented: "Heritability estimates for repeated measurements of behavioral characters have been found to increase (Broadhurst and Jinks, 1961), decrease (Broadhurst and Jinks, 1966), and fluctuate randomly (Fuller and Thompson, 1960) as a function of repeated testing." Therefore, to the limitations on heritability due to population, situation and breeding generation, we must now add developmental stage, or, many people might say, just plain unreliability! The late and brilliant Sir Ronald Fisher, whose authority Jensen cites, indicated how fully he had appreciated such limitations when he commented: "the so-called co-efficient of heritability, which I regard as

one of those unfortunate short-cuts which have emerged in biometry for lack of a more thorough analysis of the data." The plain facts are that in the study of man a heritability estimate turns out to be a piece of "knowledge" that is both deceptive and trivial.

The other two concepts to be taken into account when racial comparisons are considered involve for each population (race) the description by a distribution of the scores obtained by individuals when some trait (like intelligence) has been measured and the use of statistical measures (like moments) to describe those distributions. Populations should be compared only with respect to one trait at a time, and comparisons should be made in terms of the moment statistics of their trait distributions. Therefore, for any two populations, on each trait of interest, a separate comparison should be made for every moment of their score distributions. If we consider only the first four moments, from which are derived the familiar statistics for mean, variance, skewness and kurtosis, then there are four ways in which populations or races may differ with respect to any single trait. Since we possess 23 independently assorting pairs of chromosomes, certainly there are at least 23 uncorrelated traits with respect to which populations can be compared. Since comparisons will be made in terms of four (usually independent) statistics, there are $4 \times 23 = 92$ ways in which races can differ. Since the integrity of chromosomes is *not* preserved over the generations, because they often break apart at meiosis and exchange constituent genes, there are far more than 23 independent hereditary units. If instead of 23 chromosomes we take the 100,000 genes man is now estimated to possess, and we think in terms of their phenotypic trait correlates, then there may be as many

as 400,000 comparisons to be made between any two populations or races.

A priori, at this time we know enough to expect no two populations to be the same with respect to most or all of the constituents of their gene pools. Mutations and recombinations will occur at different places, at different times and with differing frequencies. Furthermore, selection pressures will also vary. So the number and kinds of differences between populations now waiting to be revealed in "the more thorough analysis" recommended by R. A. Fisher literally stagger the imagination. It does not suggest a linear hierarchy of inferior and superior races.

Why has so much stress been placed on comparing distributions only with respect to their average values? There is so much evidence that many distributions of observations differ with respect to other features besides their averages. The source of our difficulty traces back to the very inception of our statistical tradition.

There is an unbroken line of intellectual influence from Quetelet through Galton and Pearson to modern psychometrics and biometrics. Adolphe Quetelet (1796-1874), the Belgian astronomer-statistician, introduced the concept of "the average man"; he also applied the normal distribution, so widely used in astronomy for error variation, to human data, biological and social. The great Francis Galton followed Quetelet's lead, and then Karl Pearson elaborated and perfected their methods. I know of nothing that has contributed more to impose and perpetuate the typological way of thought on present-day psychology than the feedback from these methods for describing observations in terms of group averages.

There is a technique called composite photography to the perfection of which Sir Francis Galton contributed in an important way. Some of Galton's best work in this field was done by combining—literally averaging—the separate physiognomic features of many different Jewish individuals into his composite photograph of "the Jewish type." Karl Pearson, his disciple and biographer, wrote: "There is little doubt that Galton's Jewish type formed a landmark in composite photography." The part played by typological thinking in the development of modern statistics and the way in which such typological thinking has been feeding back into our conceptual framework through our continued careless use of these statistics are illuminated by Galton's following remarks:

> The word generic presupposes a genus, that is to say, a collection of individuals who have much in common, and among whom medium characteristics are very much more frequent than extreme ones. The same idea is sometimes expressed by the word typical, which was much used by Quetelet, who was the first to give it a rigorous interpretation, and whose idea of a type lies at the basis of his statistical views. No statistician dreams of combining objects into the same generic group that do not cluster towards a common centre; no more can we compose generic portraits out of heterogeneous elements, for if the attempt be made to do so the result is monstrous and meaningless.

The basic assumption of a type, or typical individual, is clear and explicit. They used the normal curve, and they permitted distributions to be represented by an average because, even though at times they knew better, far too

often they tended to think of races as discrete, even homogeneous, groups and individual variation as error.

It is important to realize that these developments began before 1900, when Mendel's work was still unknown. Thus at the inception of biosocial science there was no substantive basis for understanding individual differences. After 1900, when Mendel's work became available, its incorporation into biosocial science was bitterly opposed by the biometricians under Pearson's leadership. Galton had promulgated two "laws": his law of ancestral heredity (1865) and his law of regression (1877). When G.U. Yule, a British statistician, and W.E. Castle, an American geneticist, pointed out how the law of ancestral heredity could be explained in Mendelian terms, Pearson stubbornly denied it. Mendel had chosen for experimental observation seven traits, each of which, in his pea plant material, turned out to be a phenotypic correlate of a single gene with two segregating alleles. For all seven traits one allele was dominant. Unfortunately, Pearson assumed the universality of dominance and based his disdain for Mendelism on this assumption. Yule then showed that without the assumption of dominance, Mendelism becomes perfectly consistent with the kind of quantitative data on the basis of which it was being rejected by Pearson. It is sad to realize that Pearson never appreciated the generality of Mendelism and seems to have gone on for the next 32 years without doing so.

Now we can consider the recent debate about the meaning of comparisons between the "intelligence" of different human races. We are told that intelligence has a high heritability and that one race performs better than another on intelligence tests. In essence we are

presented with a racial hierarchy reminiscent of that pernicious "system" which John Langdon Haydon Down used when he misnamed a disease entity "mongolism."

The people who are so committed to answering the nature-nurture pseudoquestion "Is heredity or environment more important in determining intelligence?" make two conceptual blunders. Like Spalding's question about the instinctive nature of bird flight, which introduced the ethologists's deprivation experiment, their question about intelligence is, in fact, being asked about the development of a single individual. Unlike Spalding and the ethologists, however, they do not study development in single individuals. Usually they test groups of individuals at a single time of life. The weights being assigned to heredity and to environment refer to the relative amounts of the variance between individuals comprising a population, not how much of whatever enters into the development of the observed expression of a trait in a particular individual has been contributed by heredity and by environment, respectively. They want to know how instinctive is intelligence in the development of a certain individual, but instead they measure differences between large numbers of fully, or partially, developed individuals. If we now take into consideration the norm-of-reaction concept and combine it with the facts of genotypic individuality, then there is no general statement that can be made about the assignment of fixed proportions to the contributions of heredity and environment either to the development of a single individual, because we have not even begun to assess his norm of reaction, or to the differences that might be measured among members of a

population, because we have hardly begun to assess the
range of environmental conditions under which its
constituent members might develop!

Their second mistake—an egregious error—is related
to the first one. They assume an inverse relationship
between heritability magnitude and improvability by
training and teaching. If heritability is high, little room
is left for improvement by environmental modification.
If heritability is low, much more improvement is
possible. Note how this basic fallacy is incorporated
directly into the title of Jensen's article "How Much
Can We Boost IQ and Scholastic Achievement?" To that
question he gave a straightforward, but fallacious,
answer: "The fact that scholastic achievement is consid-
erably less heritable than intelligence . . . means there is
potentially much more we can do to improve school
performance through environmental means than we can
do to change intelligence." Commenting on the herita-
bility of intelligence and "the old nature-nurture contro-
versy," one of Jensen's respondents makes the same
mistake in his rebuttal: "This is an old estimate which
many of us have used, but we have used it to determine
what could be done with the variance left for the
some of the implications of environmental variance for
education and child rearing."

The trouble with this is that high or low heritability
tells us absolutely nothing about how a given individual
might have developed under conditions different from
those in which he actually did develop. Heritability
provides no information about norm of reaction. Since
the characterization of genotype-environment interac-
tion can only be ad hoc and the number of possible
interactions is effectively unlimited, no wonder the
search for general laws of behavior has been so

unfruitful—and *the* heritability of intelligence or of any other trait must be recognized as still another of those will-o'-the-wisp general laws. And no magic words about an interaction component in a linear analysis-of-variance model will make disappear the reality of each genotype's unique norm of reaction. Such claims by Jensen or anyone else are false. Interaction is an abstraction of mathematics. Norm of reaction is a developmental reality of biology in plants, animals and people.

In Israel, the descendants of those Jews Pearson feared would contaminate Britain are manifesting some interesting properties of the norm of reaction. According to B.S. Bloom, children of European origin have an average IQ of 105 when they are brought up in individual homes. Those brought up in a kibbutz on the nursery rearing schedule of 22 hours per day for four or more years have an average IQ of 115. In contrast, the Middle-Eastern Jewish children brought up in individual homes have an average IQ of only 85, Jensen's danger point. However, when brought up in a kibbutz they also have an average IQ of 115; that is, they perform the same as the European children with whom they were matched for education, the occupational level of parents and the kibbutz group in which they were raised. There is no basis for expecting different overall results for any population in our species.

The Role of Experience in the Development of Competence

J. McVICKER HUNT

What determines human intelligence? What determines
the competence of people? Is it fixed and immutable at
a child's birth? Or does it change with time and
circumstance? If it does, then what circumstances will
best foster its maximum growth?

These questions once agitated only a small group of
scholars and scientists. No longer. Today they have
acquired urgent social and political significance. The
fates of vast programs and many a career may hinge on
the conclusions of the most recondite social-
psychological study. A scholarly paper, a thicket of
statistical tables, becomes an object of burning interest
for journalists, politicians and others concerned to find
"the" answer to why the children of the poor don't
seem to learn as much in school as their own children
do.

I had thought, though, that at least in the years since

World War II we had learned something about most of these matters. I had thought we had learned that it was no longer tenable to conceive of intelligence tests as indicators of fixed capacity or innate potential in children. I had thought we had learned that it was quite wrong to think we could predict an adult's intellectual competence from his score on a test taken as a child without specifying the circumstances he would encounter in the interim.

In fact our political and educational leaders do seem to have gotten this message. The circumstances that affect a child's experiences in the course of growing up *are* believed to play an important role in affecting intelligence and the motivation for achievement and competence. This notion has been used in formulating solutions to the crisis of the cities created by the heavy migration of the poor from the South. Only a little imagination and goodwill has been needed to infer that the children of lower socioeconomic backgrounds, once very widely considered to be innately stupid and lazy, may instead be viewed as children who have been cheated of that equality of opportunity which our forefathers considered to be the birthright of all.

Unfortunately, however, these changing conceptions of intelligence and growth appear to have reached the leaders even before they have been fully appreciated among those of us trained in the psychological sciences. I say "unfortunately" because the newer conceptions may have led to excessive hopes among politicians and the administrators of our educational systems. Too many of them have a tendency to confuse the perfectly justifiable expectation that there can be significant improvement in the competence of the children of the poor with the basic scientific know-how required to

carry out, or even to plan, the broad educational programs needed to do the job. What I am worried about is that the confusion and excessive hopes may have created an "oversell" that will now be followed by an "overkill" of support for the efforts to develop and deploy effective educational programs. One has only to recall the recent vicissitudes of the Head Start program.

Moreover, the possibility of an overkill is made all the more dangerous by the revival of interest and belief in the notion that races differ in inherited potential for competence. People so persuaded are far from extinct. We all witnessed the great flurry of attention given by the national press to Arthur Jensen's recent paper on the relative immutability of the IQ. Although one cannot with certainty rule out the possibility of racial differences in potential for competence, the whole issue is of very little import so long as the great majority of black, Puerto Rican and Indian children grow up in poverty with extremely limited opportunities to acquire the language and number abilities and the motivation that underlie full participation in our society.

But I am no less fearful that the failure of some of our most expensive and publicized efforts to improve dramatically the learning potential of poor children may lead to an unjustified discouragement on the part not only of politicians but of the public that must pay for these efforts. I am afraid that our ignorance of how to proceed effectively may now deprive us, for an indefinite period, of the opportunity to do what I am confident ultimately can be done to meet these challenges. What we need is the opportunity to innovate and evaluate, to fail, to correct our misinterpretations and our failures, and gradually to develop programs of

educational technology, beginning even at birth, that *are* effective in fostering development.

It is these concerns that have prompted me to review here the evidence for the crucial importance of life's circumstances for the development of the cognitive skills and the attitudes that comprise competence.

It should have been obvious from the beginning that scores on tests of intelligence could not possibly serve as indicators of hereditary capacity or potential. It is a truism to say that one's genetic endowment sets limits on intellectual potential and also that it greatly influences what happens when we encounter any given series of circumstances. As a scientific statement, however, this is basically meaningless, as Alfred Binet, the developer of the most widely used IQ test, recognized as early as 1909 when he struck out against

... some recent philosophers [who] appear to have given their moral support to this deplorable verdict that the intelligence of an individual is a fixed quantity ... we must protest and act against this brutal pessimism ... (for) a child's mind is like a field for which an expert farmer has advised a change in the methods of cultivation, with the result that in the place of a desert land, we now have a harvest. It is in this particular sense, the one which is significant, that we say that the intelligence of children may be increased. One increases that which constitutes the intelligence of a school child, namely the capacity to learn, to improve with instruction.

Although the complex tests of Binet and Theodore Simon remained pre-eminent in the intelligence-testing movement, the conceptual framework built up around their use was developed by the students of Francis

Galton and G. Stanley Hall, rather than by Binet. This framework emphasized from the beginning the role of heredity as a fixer of intelligence and a predeterminant of development in the interpretation of test scores.

Moreover, throughout more than the first four decades of this century, American textbooks on genetics tended to emphasize the work of Gregor Mendel on the hereditary transmission of traits and to neglect the work of Walter Johannsen on the crucial role of the interaction of the *genotype* (the constellation of genes received by an organism from its progenitors) with the environment in determining the *phenotype* (the observable characteristics of an organism).

To be sure, some of the early evidence did seem to confirm the notion of intelligence tests as indicators of adult capacity. For instance, the IQs of groups of children showed great constancy (which was a consequence of the way the tests were constructed) and also considerable individual constancy once a child got into school. Moreover, efforts at training children directly on the intellectual functions tested turned out to have but short-lived effects. Furthermore, the IQs of persons closely related to a child proved to be more similar than the IQs of persons less closely related or unrelated.

Since World War II, however, evidence has been accumulated that is so out of keeping with the belief that the tests indicated fixed innate capacity or potential that the belief is no longer tenable.

Perhaps the most incontrovertible of this evidence is that of rising intelligence in the face of predicted deterioration. The prediction of deterioration came from combining two observations. First, it has been obvious since the seventeenth century that poor families have more children than families of the middle and

upper classes. Second, many studies have shown that people from low socioeconomic background typically average about 20 points of IQ below people in the upper-middle class. In 1937, R. B. Cattell multiplied the number of people at each IQ level by the reproduction rate at that level and computed the new mean to estimate the IQ of the next generation. From this procedure, he estimated a drop of a little over three points a generation, or about one point a decade. This he characterized as a "galloping plunge toward intellectual bankruptcy."

But Cattell's dire prediction has been repeatedly contradicted by rising IQs in those populations where the children of a given age have been tested and retested after intervals of a decade or more. Thirteen years after his own forecast, Cattell himself published a study comparing ten-year-old children living in the city of Leicester, England in 1949 with the ten-year-old children living in that same city in 1936. In the place of the predicted drop of something slightly more than one point in IQ, Cattell acutally found an increase of 1.28 points. Although small, this increase was highly significant from the statistical standpoint.

In other studies, the predicted drop in IQ has been proven wrong by gains substantially larger than these. S. Smith reported a growth of around 20 points between the scores of children in various Honolulu schools in 1924 and the scores of children in those same schools in 1938. Lester Wheeler reported a ten-point increase in the mean IQ of children from a single group of families in the ten-year period before and after the great changes brought about in that community by the Tennessee Valley Authority. When Frank Finch compared the IQs of all students in a sample of high schools in the 1920s

and again in those same high schools in the 1940s, he found the average gains ranging between 10 and 15 points. But perhaps the most dramatic evidence of an upward shift came when the test performances of soldiers in World War II were compared with those of World War I soldiers. Clearly, if the tests measure fixed intellectual capacity or innate potential, and if the majority of each new generation comes from parents in the lowest third in tested intelligence, something very, very strange is happening.

It has long been customary to differentiate intelligence tests from achievement tests. Some differences do exist. All are differences in degree, however, rather than in kind.

First, intelligence tests tend to tap a wider variety of experience, both in and out of school, than do achievement tests. Most achievement tests are closely tied to specific courses of study. Intelligence tests are not. School experience still contributes, however, to performance on more broadly based tests of intelligence. Moreover, experiences in the home and in social groups contribute to performance on achievement tests. Second, achievement tests are aimed at relatively new learning, while intelligence tests depend typically on older learning.

Intelligence tests and achievement tests, then, are measures of current capacity depending directly upon previously acquired skills and information and motivation. Binet saw this at the turn of the century, but he had escaped the "advantages" of the tutelage of men with strong theoretical beliefs in intelligence fixed by heredity.

Semantics can often have unfortunate consequences. The terms "dimensions" and "scale" when applied to

such matters as intelligence are a case in point. These terms were borrowed from measurement in the physical world where scales are instruments for measuring unvarying dimensions. When these terms are applied to the behavior of people, we tend also to apply notions of concreteness and constancy derived from the world of physical objects. Thus, calling intelligence a dimension of behavior and speaking of tests as scales tends to obscure reality. This becomes especially unfortunate when the semantics sap the motivation of teachers to change their approaches to promote increased development in children who resist their standard approaches and curricula.

Let me turn next to those propositions concerning development that I believe are no longer tenable and that I believe are highly unfortunate in their influence upon those working in programs of early childhood education.

Fallacy: the rate of development is predetermined. I am confident that belief in a predetermined rate of human development is quite untenable. In the history of our thinking about psychological development, the constant IQ was the epitome of this notion. But it got support from the widely cited work of G. E. Coghill in the 1920s which related developmental sequences in the behavior of salamander larvae from head to tail and from trunk to limbs to microscopic histological evidences of neuromuscular maturation. Support also came from various other observations that I cannot take time to review here. Suffice it to say that maturation and learning were seen as two distinctly separate processes with maturation predetermined by heredity and learning controlled by the circumstances encountered.

Evidence contradicting the notion of a predetermined rate of development also appeared. Wendell Cruze reported that chicks allowed to peck for only 15 minutes a day failed to improve in the accuracy of their pecking. Moreover, the early longitudinal studies of intellectual development in children uncovered individual growth curves with changes in IQ as large as 60 points. Several students in the 1930s found increases in the IQs of young children associated with nursery schooling.

At the time, however, the credibility of these observations of change in the rate of development was questioned by other observers who posited differing inherited patterns of growth or found methodological weaknesses in the studies. Differences of more than 20 points of IQ were found between identical twins reared apart under differing kinds of circumstances, but, because such instances were rare, they were considered to be merely examples of errors of measurement.

One of the most impressive of the early studies to cast doubt on the notion of a predetermined rate of development is that of Harold M. Skeels and Murlon H. Dye. This study was prompted by a "clinical surprise." Two residents of a state orphanage, one aged 13 months With a Kühlmann IQ of 46 and the other aged 16 months with an IQ of 35, were committed to an institution for the retarded. After six months there, where the mentally retarded women doted on them, these two children showed a remarkably rapid rate of development. Coupled with change from apathy to liveliness was an improvement of 31 points of IQ in one and 52 points in the other. After this, a group of 13 infants—ranging in age from 7 months to 30 months and in IQs from 36 to 89, with a mean of 64—were

transferred from the orphanage (but not committed) to these wards for moron women. After being there for periods ranging from 6 months for the seven-month-old child to 52 months for the 30-month-old child, every one of these infants showed a gain in IQ. The minimum gain was 7 points; the maximum was 58 points, and all but four showed gains of over 20 points.

On the other hand, 12 other infants—ranging in age from 12 to 22 months and in IQ from 50 to 103, with a mean IQ of 87—were left in the orphanage. When these infants were retested after periods varying from 20 to 43 months, all but one of them showed decreases in IQ that ranged from eight to 45 points, and five of the decreases exceeded 35 points. These findings suggested strongly that the effects of these two institutional environments differed greatly, but the idea that children's IQs had been improved by moving them from an orphanage to a school for the mentally retarded was merely ridiculed, and the ridicule deprived the findings of their highly suggestive import.

In the light of the evidence accumulated since World War II, this study of Skeels and Dye has acquired the status of a classic, and the notion of a predetermined rate of development has become almost incredible.

Fallacy: maturation is independent of circumstances. Locomotor development has long been considered to be predetermined, but in 1957 Wayne Dennis discovered an orphanage in Tehran where 60 percent of those infants in their second year were still not sitting up alone and where 84 percent of those in their fourth year were still not walking. When one considers that nearly all family-reared infants are sitting alone at eight months and nearly all such infants are walking alone by 20 months

of age, it becomes clear that locomotor development cannot be independent of circumstances.

In the 1940s, the theorizing of Donald Hebb prompted investigators to rear animals under circumstances varying in complexity, especially in perceptual complexity. In the first such study, Hebb himself found the adult ability of rats reared as pets to be superior in solving maze problems to that of litter-mates reared in laboratory cages. Other investigators have found that dogs reared freely in complex environments are better as adults at learning mazes than their litter-mates reared in the monotony of laboratory cages.

The neuropsychological theorizing of Hebb and the theorizing of Holger Hydén, a Swedish biochemist, have prompted investigators to rear animals in the dark and in environments of various levels of complexity to determine the effects of such variations in rearing on both behavioral development and neuroanatomical maturation. Dark-reared chimpanzees, cats, rabbits, rats and mice have all shown deficiencies of both nerve cells and glial cells of their retinal ganglia when compared with animals or litter-mates reared in the light of laboratory cages. More recent investigations have extended these neuroanatomical deficiencies associated with dark-rearing to the appropriate nuclei of the thalamus and even to the striate area of the occipital lobe of the brain. These highly exciting finds indicate that even neuroanatomical maturation can no longer be considered to be independent of the circumstances in which animals develop.

Fallacy: longitudinal prediction is possible. Despite such an accumulation of evidence as I have indicated (and there is much more), the belief in a constant IQ has

given us the habit of thinking of the validity of tests in longitudinal terms. We have used and still use the scores based on the performance of children on tests administered at one age to predict what their school or test performances will be at later ages.

Yet, if even neuroanatomic maturation can be influenced by circumstances, and if psychological development is as plastic as this evidence implies, longitudinal prediction is impossible from test scores alone. The plasticity that appears to exist in the rate at which human organisms develop renders longitudinal prediction basically impossible unless one specifies the circumstances under which this development is to take place. In fact, trying to predict what a person's IQ will be at 20 on the basis of his IQ at age one or two is like trying to predict how heavy a two-week-old calf will be when he is a two-year-old without knowing whether he will be reared in a dry pasture, in an irrigated pasture or in a feed lot.

To be sure, longitudinal prediction improves with age. This results from the fact that test-retest validities involve part-whole relationships. Thus, if one is predicting IQ at 20, the older the child is at the time of the initial test, the larger becomes the predictor part of the criterion whole. Moreover, in actual situations, individuals tend to remain within sets of social, economic and educational circumstances that are relatively stable. Thus, a very large share of whatever constancy individual IQs have had can be attributed to a combination of the increasingly congruent part-whole relationship and with the sameness of circumstances.

Belief in a predetermined rate of development and in the possibility of predicting performance over time has had very unfortunate consequences for educational

practice. When children fail to learn and are found to have low scores on intelligence tests, teachers are prompt to feel that "these children are doing as well as can be expected." Such an attitude dampens any inclination teachers may have to alter their approach to such children. Consequence? The tutelage that the child encounters remains essentially stable, and the child continues in his rut of failure.

An important corollary of the finding that the rate of development depends upon the circumstances encountered is a needed change in the conception of "readiness." The notion that children are ready for certain kinds of experiences and not for others had validity. On the other hand, the notion that this "readiness" is a matter of predetermined maturation, as distinct from learning or past encounters with circumstances, is basically wrong and potentially damaging. What is involved is what I have been calling "the problem of the match." If encountering a given set of circumstances is to induce psychological development in the child, these circumstances must have an appropriate relationship to the information and skills already accumulated by the child. This is no easy matter. Ordinarily, the best indicators of an appropriate match are to be found, I now believe, in emotional behavior. They are evidences of interest and of mild surprise. If the circumstances are too simple and too familiar, the child will fail to develop and he is likely to withdraw into boredom. If the circumstances demand too much of a child, he will withdraw in fear or explode in anger. So long as the child can withdraw from the circumstances without facing punishment, loss of love, fear of disapproval, or what-not, I believe it is impossible to overstimulate him.

The challenge in such a conception of "readiness" as that involved in the "problem of the match" is basically the problem of preparing the environment to foster development. We are a long way from solid knowledge of how to do this, but I believe we do have some sensible suggestions about how to proceed.

One more point about development and its implications. Order has always been obvious in behavioral development. In locomotor development, for instance, it is obvious that the infant is at first rooted to a given spot, that he learns to wheel and twist before he sits up, that he sits up alone before he can creep, that he creeps or scoots before he stands, that he stands before he cruises, that he cruises while holding on to things before he toddles, that he toddles before he walks, and that he walks before he runs. Arnold Gesell and his collaborators at Yale devoted their total normative enterprise to describing the order in the various domains of behavioral development that take place with advancing age. Jean Piaget and his collaborators have also been concerned with describing the order in intelligence and in the construction of such aspects of reality as object permanence, as constancy of quantity, of shape, and of color, and causality, space and time. Ina Uzgiris and I have been using these orderly landmarks in development as a basis for our ordinal scales of psychological development in infancy. In short, order in development is an obvious fact.

Although Gesell gave occasional lip service to the interaction between child and environment in behavioral development, all but one of his various principles of growth (that of "individuating maturation") described predetermined processes. Moreover, in 1954 Gesell

explicitly said that "the so-called environment, whether internal or external, does not generate the progressions of development. Environmental factors support, inflect and specify; but they do not engender the basic forms and sequences of ontogenesis."

Similarly, Mary Shirley saw evidence of Coghill's head-to-tail principle when she wrote that "motor control begins headward and travels toward the feet beginning with the eye muscle and progressing through stages in which the head and neck muscles are mastered, arms and upper trunk come under control . . . the baby at last achieves mastery of his whole body. . . ."

Yet such an interpretation is not a necessary implication of the observed fact of orderliness in development. While Piaget, like Gesell, has found order in psychological development, he, unlike Gesell, has emphasized the role of interaction. According to Piaget, development occurs in the course of adaptive interaction between the child and the environment. This interaction involves two complimentary and invariant processes: *assimilation* and *accommodation*. Piaget conceives these processes as basically common to the physiological as well as the psychological domain. Assimilation occurs whenever an organism utilizes something from the environment and incorporates it into its own structures. Accommodation, the complement of assimilation, operates whenever encounters with the environment evoke a change in the existing structure of the central processes that mediate the interpretation of events and control action. Thus, accommodation is another term for adaptive learning.

Although I cannot here go into Piaget's ideas, they have definitely influenced my own thinking about learning. Attempting to understand them has opened my own eyes to the fact that circumstances influence

development in ways quite other than those within the traditional rubrics under which we have studied learning.

Learning in poverty. As I have already noted, the factors controlling the development of competence in early childhood are no longer purely an academic topic. These factors have acquired both social and political significance from the fact that our advancing technology is rapidly decreasing the economic opportunities for those without linguistic and mathematical abilities, the motivation to solve problems and the inclination to carry social responsibility, and from the fact that a large number of black people, coming from a background of poverty and limited opportunity, lack these skills and motives. In the light of these challenges, what are the implications of the foregoing argument?

The intellectual capacity that underlies competence in substantial part is not fixed. In this connection, various lines of evidence suggest strongly that being reared in conditions of poverty and cultural deprivation deprives a child of opportunities to learn. The children of poor families have typically encountered many fewer kinds of objects than children of the middle class. As infants, the children of poverty often have inadequate diets and they live in crowded circumstances which expose them to a continuous vocal racket to which they become habituated. This habituation may account for the inadequacies in hearing other people speak that was found by Cynthia Deutsch and by Deutsch and Brown. Too often, the verbal interaction of children of the poor with their elders is limited to commands to stop whatever the child is doing without explanations as to why. Seldom are these children invited to note what is

going on around them or to formulate their observations in their own language. These children are especially unlikely to learn the syntactical rules of the standard language. Seldom is their ingenuity rewarded except when they learn to avoid the punishment that comes when they get caught at something arbitrarily prohibited. In such circumstances, the low test scores repeatedly observed in the children of poverty are to be expected.

With respect to motivation, moreover, the children of poverty, black or white, have little opportunity to learn to take initiative, to give up present satisfactions for larger satisfactions in the future, or to take pride in problem-solving achievement. Seldom have the poor acquired such motives. Thus, their responses to their children's demands are dictated largely by their own immediate impulses and needs, not the children's. To these parents, a good child is typically a quiet child who does not bother them.

Regarding conduct, finally, these children of the poor are exposed to circumstances and standards that are hardly those prescribed by the demands of the dominant society. The models of behavior for these children often make them unfit for adaptation to either schools or marketplace. So long as a large percentage of black people are reared in poverty under these conditions of childrearing it is not tenable to attribute to race the existing deficiency in competence as measured by intelligence tests.

From such evidence as has been accumulating on the matter of class differences in child-rearing, it is becoming clearer and clearer that the accident of being born in poverty serves to deprive children of that equality of

opportunity which our founding fathers considered to be the right of all Americans.

What is to be done? These relatively new findings concerning the role of circumstances in the development of competence suggest that corrective efforts should be focused upon the young, and preferably upon the very young—even beginning with birth. These findings suggest that early childhood education can have tremendous social significance if we learn how to do it effectively. It is a long step, however, from justifiable hopes to the development of the educational technology in workable form and to its broad-scale deployment in America. The question is, can we extend these findings into programs of early childhood education fast enough?

Project Head Start was a fine step in the right direction. The danger is that it may have been taken with hopes too high before an adequately effective technology of early childhood education for the children of the poor had been developed. All too often, the Head Start programs have merely supplied poor children with an opportunity to play in traditional nursery schools that were designed chiefly to exercise large muscles and to enable middle-class children to escape from their overly strict and solicitous mothers. Such opportunities are unlikely to be very effective in overcoming the deficient skills and motives to be found in the children of the poor.

Nursery schools were invented originally for the purposes of compensatory education. Shortly after the turn of the century, Maria Montessori developed a program for the poor children of the San Lorenzo

district of Rome which appeared to be highly successful. She provided a practical solution to what I am calling the "problem of the match" by breaking the lock-step in education and permitting each child to follow his own interests in working with a variety of materials that she had found to be stimulating to children. She arranged these materials in sequences that would lead to conceptual skills. Moreover, in her classes she combined children ranging in age from three to six and thereby provided the younger with a graded series of models for imitation and the older ones with opportunities to learn by helping to teach the younger. Somewhat later, Margaret McMillan established her nursery schools in the slums of England to give these children, whom she considered to be environmentally handicapped, an opportunity to learn many of the abilities and motives that children of the middle class learn spontaneously. When the nursery schools were brought to the United States, however, it was only the well-to-do who could pay for them. Our traditional belief that class differences in ability are the inevitable consequence of heredity left Americans with little inclination to provide nursery schools for children of the poor. Thus, the schools got adapted to what were conceived to be the needs of the middle-class children. When the decision to mount Project Head Start was made, only these programs were widely available for deployment on a large scale. It should be no surprise, then, if the success of Project Head Start in improving the future academic success of children of the poor is highly limited.

In consequence of this unfortunate history, we have no ready-made technology of compensatory early childhood education designed to foster in children of the poor those abilities and motives underlying competence

in the dominant society which circumstances prevented their acquiring.

This is beginning to be recognized. With the recognition is coming a tremendous explosion in new curricula for young children. My impression is that these achieve little unless they focus on the fostering of the ability to handle language and number concepts, and, with regard to motivation, on extending the time interval in which these children operate psychologically, and on developing pride in achievement. I see no substitute for a painstaking investigation of what works and what does not work coupled with a theoretical synthesis calculated to give us a more accurate picture of the various kinds of deficits to be found in children of the slums and more effective ways either to compensate for these deficits or to prevent them.

I am inclined to believe that we shall have to extend our programs to include children of ages less than four. I believe we shall have to involve the help of parents in these programs. Attempts to influence the child-rearing of parents of the lowest socioeconomic status by means of psychotherapy-like counseling have regularly failed. On the other hand, involving parents first as observers and then as aides in nursery schools, where they get an opportunity to see the effects of new (to them) ways of dealing with children and where these techniques are explained and tried out first in school and then in home demonstrations, all this appears to be highly promising. Here the investigations of Rupert Klaus and Susan Gray and their colleagues at the George Peabody College for teachers in Nashville, Tennessee, of Ira Gordon at the University of Florida, of Merle Karnes at the University of Illinois, and of David Weikart at Ypsilanti, Michigan appear to be showing the way. In a summer nursery

school for children of poverty in Nashville, for instance, Klaus and Gray have developed a curriculum that aimed at teaching language and number skills and the attitudes and motives required to cope with elementary schools. Home visitors brought each mother to observe and later to participate in the teaching at the nursery school. The home visitors interpreted for the mothers what they saw the teachers doing. Then, during the period between summer sessions of the nursery school, the home visitors saw each of the mothers every other week. During these visits, they demonstrated for the mothers such matters as how to read a story with enthusiasm, how to reinforce children for new abilities, and how to talk with children about such homemaking operations as peeling potatoes while in the process.

This effort has been evaluated by means of gains in scores on standard tests of intelligence and will be evaluated in terms of the later progress of these children in the schools. Tests given before and after the summer nursery school have shown spurts in scores of the nursery schoolers that do not appear in the test performances of the children who did not go to the nursery school.

The test results of this program also show two other highly promising phenomena. First, the younger siblings of the children going to nursery school whose mothers saw the home visitors regularly have turned out to be significantly superior in test performance to the younger siblings of the four-year-old children in two contrast groups who got neither nursery school nor the home visits. This finding suggests that the mother must have been learning something about child-rearing that generalized to their management of their younger children.

Second, the younger children of the mothers in the

contrast group who lived in the same neighborhood as those receiving the home visits got higher test scores than did the children of mothers in a contrast group living some 60 miles away. This finding suggests that mothers who learn new child-rearing practices from their observations at the nursery school and from the home visitor were somehow communicating them to their neighbors with whom they had face-to-face relationships.

The evidence is highly promising from these new efforts in compensatory education. But after Head Start we should beware of the flush of too-high hopes. I fear that the very limited success to be expected from the deployment of nursery schools designed chiefly for the children of the middle class may lead to an unjustified discouragement on the part of both political leaders and the public. I fear a fading out of support for efforts in the domain of early childhood education. At this stage of history, it is extremely important that both political leaders and voters understand the limited nature of our knowledge about how to foster competence in the young, that they understand the basis for our justified hopes, and that they comprehend the need for the continued support of fundamental research and of the process of developing an adequate technology of early childhood education. Only with continued support for research and development in this domain can we expect to create effective means of compensating for and/or preventing the deficiencies of early experience required to meet the twin challenges of racial discrimination and poverty.

June 1969

FURTHER READING:

The Disadvantaged Child: Studies of the Social Environment and the Learning Process by Martin Deutsch (New York: Basic Books, 1967) is an anthology of many of the pioneering developments in early childhood education.

Studies in Cognitive Development: Essays in the Honor of Jean Piaget edited by David Elkind and John H. Flavell (New York: Oxford University Press, 1969). This anthology is primarily concerned with the investigations and theorizing of Piaget, whose work has inspired at least in part many of the recent developments.

Revolution in Learning: The Years from Birth to Six by Maya Pines (New York: Harper and Row, 1967). The nontechnical survey presented many of the developments in early childhood education before the investigators themselves had published their findings.

The Nature of Human Intelligence by J. P. Guilford (New York: McGraw Hill, 1967) describes the structure of intellect as this has been revealed by studies employing the method of factor analysis.

Experience, Structure, and Adaptability edited by O. J. Harvey (New York: Springer Publishing Co., 1966). This anthology includes a variety of investigations of the role of early experience in the development of flexibility and adaptability.

Intelligence and Experience by J. McV. Hunt (New York: Ronald Press, 1961). This heavily documented book describes in detail the evidence which is forcing a change in the conception of intelligence and of the degree of plasticity in early psychological development.

The Challenge of Incompetence and Poverty by J. McV. Hunt (Urbana: University of Illinois Press, 1969). This book, also well-documented, contains seven papers which describe the interconnection between poverty and lack of competence, gives the basis for preschool enrichment, and describes the results of the experimental attempts to intervene in the lives of the poor with preschool education and with parent education.

Intelligence — Why It Grows, Why It Declines

JOHN L. HORN

One of the oldest and most thoroughly studied concepts in psychology is the concept of intelligence. Yet the term "intelligence" still escapes precise definition. There are so many different kinds of behavior that are indicative of intelligence that identifying the essence of them all has seemed virtually impossible. However, some recent research indicates that much of the diversity seen in expressions of intelligence can be understood in terms of a relatively small number of concepts. What's more, this research has also given us insight into understanding where intelligence originates; how it develops; and why and when it increases or decreases.

Studies of the interrelationships among human abilities indicate that there are two basic types of intelligence: fluid intelligence and crystallized intelligence. Fluid intelligence is rather formless; it is relatively independent of education and experience; and it can

"flow into" a wide variety of intellectual activities. Crystallized intelligence, on the other hand, is a precipitate out of experience. It results when fluid intelligence is "mixed" with what can be called "the intelligence of the culture." Crystallized intelligence increases with a person's experience, and with the education that provides new methods and perspectives for dealing with that experience.

These two major kinds of intelligence are composed of more elementary abilities, called "primary" mental abilities. The number of these primaries is small. Only about 30 can be accepted as really well established. But with just these 30 primaries, we can explain much of the person-to-person variation commonly observed in reasoning, thinking, problem-solving, inventing and understanding. Since several thousand tests have been devised to measure various aspects of intelligence, this system of primaries represents a very considerable achievement in parsimony. In much the same way that the chemical elements are organized according to the Periodic Law, these primary mental abilities fall into the patterns labeled fluid and crystallized intelligence.

What follows are some examples of the kinds of abilities that define fluid intelligence—and some of the tests that measure this kind of intelligence.

☐ *Induction* is the ability to discover a general rule from several particular incidents and then apply this rule to cover a new incident.

For example, if a person observes the characteristics of a number of people who are members of a particular club or lodge, he might discover the rule by which membership is determined (even when this rule is highly secret information). He might then apply this rule to obtain an invitation to membership!

Among the tests that measure induction ability is the letter series. Given some letters in a series like

A C F J O —

the task is to provide the next letter. Of course, the test can be used only with people who know the alphabet, and this rules out illiterates and most children. We can't eliminate the influence of accumulated learning from even the purest examples of fluid intelligence.

□ *Figural Relations* refers to the ability to notice changes or differences in shapes and use this awareness to identify or produce one element missing from a pattern.

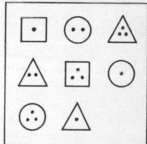

What figure fits into the lower right? (Answer: a square with two dots.)

An everyday example of intelligence in figural relations is the ability to navigate cloverleaf and expressway turnoff patterns—an ability that may mean as much for adequate adjustment today as skill in finding one's way through a virgin forest had in the days of Daniel Boone. This ability also has ready application in interior decorating and in jobs where maps (or aerial views) must be compared a good deal—as by cartographers, navigators, pilots, meteorologists and tourists.

□ *Span of Apprehension* is the ability to recognize and retain awareness of the immediate environment. A simple test is memory span: Several digits or other symbols are presented briefly, and the task is to

reproduce them later, perhaps in reverse order. Without this ability, remembering a telephone number long enough to dial it would be impossible.

Other primary abilities that help define fluid intelligence include:

□ *General Reasoning* (example: estimating how long it would take to do several errands around town);

□ *Semantic Relations* (example: enjoying a pun on common words);

□ *Deductive Reasoning,* or the ability to reason from the general to the particular (example: noting that the wood of fallen trees rots and concluding that one should cover—for example, paint—wooden fence posts before inserting them into the ground);

□ *Associative Memory,* or the ability to aid memory by observing the relationships between separate items (example: remembering the way to grandmother's house by associating various landmarks en route, or remembering the traits of different people by association with their faces).

Most of what we call intelligence—for example, the ability to make good use of language or to solve complex technical problems—is actually crystallized intelligence. Here are some of the primary abilities that demonstrate the nature of this kind of intelligence:

□ *Verbal Comprehension.* This could also be called general information, since it represents a broad slice of knowledge. Vocabulary tests, current-events tests and reading-comprehension tests all measure verbal comprehension, as do other tests that require a person to recall information about his culture. The ability is rather fully exercised when one quickly reads an article like this one and grasps the essential ideas. Verbal comprehension is also called for when a person reads news items about

foreign affairs, understands their implications, and relates them to one another and to their historical backgrounds.

☐ *Experiential Evaluation* is often called "common sense" or "social intelligence." Experiential evaluation includes the ability to project oneself into situations, to feel as other people feel and thereby better understand interactions among people. Everyday examples include figuring out why a conscientious foreman is not getting good results from those under him, and why people disobey traffic laws more at some intersections than at others.

One test that measures experiential evaluation in married men is the following:

Your wife has just invested time, effort and money in a new hairdo. But it doesn't help her appearance at all. She wants your opinion. You should:

1. try to pretend that the hairdo is great;

2. state your opinion bluntly;

3. compliment her on her hairdo, but add minor qualifications; or,

4. refuse to comment.

Answer 3 is considered judged correct—on the grounds that husbands can't get away with answers 1 and 4, and answer 2 is likely to provoke undue strife.

☐ *Formal Reasoning* is reasoning in ways that have become more or less formalized in Western cultures. An example is the syllogism, like this one:

No Gox box when in purple socks.

Jocks is a Gox wearing purple socks,

Therefore: Jocks does not now box.

The task is to determine whether or not the conclusion is warranted. (It is.)

An everyday example of formal reasoning might be to

produce a well-reasoned analysis of the pros and cons of an issue presented to the United Nations. Formal reasoning, to a much greater extent than experiential evaluation or verbal comprehension, depends upon dealing with abstractions and symbols in highly structured ways.

□ *Number Facility,* the primary ability to do numerical calculations, also helps define crystallized intelligence, since to a considerable extent it reflects the quality of a person's education. In a somewhat less direct way, this quality is also represented in the primary abilities called mechanical knowledge, judgment and associational fluency.

□ *Semantic Relations* and *General Reasoning,* listed as primary aspects of fluid intelligence, are also—when carrying a burden of learning and culture—aspects of crystallized intelligence. This points up the fact that, although fluid and crystallized intelligence represent distinct patterns of abilities, there is some overlap. This is what is known as *alternative mechanisms* in intellectual performance. In other words, a given kind of problem can sometimes be solved by exercise of different abilities.

Consider the general-reasoning primary, for example. In this, typical problems have a slightly mathematical flavor:

> There are 100 patients in a hospital. Some (an even number) are one-legged, but wearing shoes. One-half of the remainder are barefooted. How many shoes are being worn?

We may solve this by using a formal algebraic equation. Set x equal to the number of one-legged patients, with 100-x then being the number of two-legged patients, and $x+\frac{1}{2}(100-x)2$ being the number of

shoes worn. We don't have to invent the algebraic techniques used here. They have been passed down to us over centuries. As Keith Hayes very nicely puts it, "The culture relieves us of much of the burden of creativity by giving us access to the products of creative acts scattered thinly through the history of the species." The use of such products is an important part of crystallized intelligence.

But this problem can also be solved by a young boy who has never heard of algebra! He may reason that, if half the two-legged people are without shoes, and all the rest (an even number) are one-legged, then the shoes must average one per person, and the answer must be 100. This response, too, represents learning—but it is not so much a product of education, or of the accumulated wisdom passed from one generation to the next, as is the typical product of crystallized intelligence. Fluid intelligence is composed of such relatively untutored skills.

Thus the same problem can be solved by exercise of *either* fluid intelligence *or* crystallized intelligence. We can also see the operation of such alternative mechanisms in these two problems.

ZEUS—JUPITER· ARTEMIS—?

Answer: Phidias Coria *Diana*

HERE—NOW: THERE—?

Answer: Thus Sometimes *Then*

The first problem is no harder to solve than the second, *provided* you have acquired a rather sophisticated knowledge of mythology. The second problem requires learning too, but no more than simply learning the language—a fact that puts native-born whites and Negroes on a relatively equal footing in dealing with

problems of this sort, but places Spanish-speaking Puerto Ricans or Mexican-Americans at a disadvantage. As measures of fluid intelligence, both items are about equally good. But the first involves, to a much greater extent, crystallized intelligence gleaned from formal education or leisure reading.

Because the use of alternative mechanisms is natural in the play of human intelligence, most intelligence tests provide mixed rather than pure measures of fluid or crystallized abilities. This only reflects the way in which we usually go about solving problems—by a combination of natural wit and acquired strategies. But tests can be devised in which one type of intelligence predominates. For example, efforts to devise "culture fair" intelligence tests that won't discriminate against people from deprived educational or cultural backgrounds usually focus on holding constant the effect of crystallized capabilities—so that fluid capabilities can be more fully represented.

Now that we have roughly defined what fluid and crystallized intelligence are, let us investigate how each of them develops over time.

The infant, whose reasoning powers extend little beyond the observation that a determined howl brings food, attention or a dry diaper, becomes the man who can solve legal problems all day, execute complicated detours to avoid the five o'clock traffic on his way home and deliver a rousing speech to his political club in the evening. But how? To understand the intertwined development of the fluid and crystallized abilities that such activities require, we need to consider three processes essential to the development of intelligence: anlage function, the acquisition of aids and concept formation.

Anlage function, which includes the complex work-ings of the brain and other nervous tissue, provides the physical base for all of the infant's future mental growth. ("Anlage" is a German word meaning "rudi-ment.") The second two factors—the aids and concepts the child acquires as he grows up—represent the building blocks that, placed on the anlage base, form the structure of adult intelligence.

The anlage function depends crucially and directly upon physiology. Physiology, in turn, depends partly on heredity, but it can also be influenced by injury, disease, poisons, drugs and severe shocks. Such influences can occur very early in life—often even in the womb. Hence it is quite possible that an individual's anlage function-ing may have only a remote relationship to his heredi-tary potential. All we can say for sure is that the anlage process *is* closely tied to a physiological base.

A good everyday measure of a person's anlage functioning is his memory span (provided we can rule out the effects of anxiety, fatigue or mental distur-bance). Given a series of letters or numbers, most adults can immediately reproduce only about six or seven of them in reverse order. Some people may be able to remember 11, others as few as four, but in no case is the capacity unlimited or even very great. Memory span increases through childhood—probably on account of the increasing size and complexity of the brain—but it is not much affected by learning. This is generally true of other examples of anlage functioning.

Aids are techniques that enable us to go beyond the limitations imposed by anlage functioning. An aid can, for example, extend our memory span. For example, we break up a telephone or social-security number with dashes, transforming long numbers into short, more

easily recalled sets, and this takes the strain off immediate memory.

Some aids, like the rules of algebra, are taught in school. But several psychologists (notably Jean Piaget) have demonstrated that infants and children also invent their own aids in their untutored explorations of the world. In development, this process probably continues for several years.

Concepts are categories we impose on the phenomena we experience. In forming concepts, we find that otherwise dissimilar things can be regarded as "the same" in some sense because they have common properties. For instance, children learn to distinguish the features associated with "bike"—two wheels, pedaling, riding outside, etc.—from those associated with "car." Very early in a child's development, these categories may be known and represented only in terms of his own internal symbols. In time, however, the child learns to associate his personal symbols with conventional signs—that is, he learns to use language to represent what he "knows" from direct experience. Also, increased proficiency in the use of language affords opportunities to see new relations and acquire new concepts.

The concepts we possess at any time are a residue of previous intellectual functioning. Tests that indicate the extent of this residue may, therefore, predict the level of a person's future intellectual development. A large vocabulary indicates a large storehouse of previously acquired concepts, so verbal ability itself is often taken as a good indication of ability to conceptualize. Many well-known tests of intelligence, especially of crystallized intelligence, are based on this rationale.

However, language is really only an indirect measure

of concept awareness. Thus verbally oriented tests can be misleading. What about the child raised in an environment where language is seldom used, but which is otherwise rich in opportunity to perceive relationships and acquire concepts (the backwoods of Illinois, or by a pond in Massachusetts)? At the extreme, what about a person who never hears the spoken word or sees the written word? He does not necessarily lack the awareness that we so glibly represent in language. Nor does he necessarily lack intelligence. A child who doesn't know the spoken or written word "key" surely understands the concept if he can distinguish a key from other small objects and use it to open a lock.

What is true of conventional language is also true of conventional aids. Lack of facility or familiarity with aids does not mean that a child has failed to develop intellectually, even though it may make him appear mentally slow on standard intelligence tests. Just as verbally oriented tests penalize the child who has not had the formal schooling or proper environment to develop a large vocabulary, many tests of so-called mathematical aptitude rely heavily on the use of conventional aids taught in school—on algebraic formulas, for example. Someone who has learned few of these conventional aids will generally do poorly on such tests, but this does not mean that he lacks intelligence.

We cannot overlook the fact that an intelligent woodsman may be just as intelligent, in one sense of this term, as an intelligent college professor. The particular combination of primary abilities needed to perform well may differ in the two cases, but the basic wherewithal of intellectual competence can be the same—adequate anlage functioning, plus an awareness of the concepts and a facility with the aids relevant to dealing with the

environment at hand. Daniel Boone surely needed as much intelligence to chart the unexplored forests of the frontier as today's professor needs to thread his way through the groves of academe.

It is obvious, then, that formal education is not essential to the development of important aspects of intelligence. Barring disruption of anlage functioning by accident or illness, the child will form concepts and devise aids to progressively expand his mental grasp as he grows up, and this will occur whether he goes to school or not.

Where formal instruction *is* significant is in making such development easier—and in passing along the concepts and aids that many people have deposited into the intelligence of a culture. The schools give children awareness of concepts that they may not have had the opportunity to gain from first-hand experience—the ability to recognize an Australian platypus, for example, without ever having seen one, or a knowledge of how the caste system works in India. Aids, too, are taught in school. A child well-armed with an array of mathematical formulas will likely be able to solve a problem faster and more accurately than one who must work it out completely on his own. Indeed, some problems simply cannot be solved without mathematical aids. Since the acquisition of both concepts and aids is cumulative, several years of formal education can put one child well ahead of another one, unschooled, who has roughly the same intellectual potential.

Education can thus play a powerful role in developing intelligence. Too often, however, it doesn't. Even in school, some children in perfectly good health and physical condition fail to develop, or develop slowly. Some even seem to be mentally stunted by their school

experience. Why? What sorts of experiences can foster—
or retard—the developmental processes of concept-
formation and aid-formation in the school environment?

Even though we are only beginning to find answers in
this area, it is already clear that learning can be speeded
up, slowed down or brought almost to a dead halt by a
variety of school experiences. On the favorable side,
abilities improve by *positive transfer.* Learning one skill
makes it easier to learn a related one. A student who
already knows Spanish, for example, will find it easier
to learn Portuguese. And positive transfer also works in
less obvious ways. There is even evidence to suggest that
new learning is facilitated simply by having learned
before—by a sort of learning how to learn.

But other factors too can affect the course of
learning, and these factors are particularly prominent in
the context of our formal educational system. For
example, merely having the opportunity to learn may
depend on both previous learning and previous oppor-
tunity to learn. Thus, even if his native potential and
level of self-education are good, the person who has not
had the opportunity to finish high school has a poor
chance of going on to college.

Labeling operates in a similar way. If a person is
labeled as lacking in ability, he may receive no further
chance to develop. Kenneth B. Clark states this very
well:

> If a child scores low on an intelligence test because he
> cannot read and then is not taught to read because he
> has a low score, then such a child is being imprisoned
> in an *iron circle* and becomes the victim of an
> educational self-fulfilling prophecy.

Avoidance-learning is similar. This is learning not to
learn. Punishment in a learning situation—being humili-

ated in school, for example—may make a child "turn off." Problem-solving may become such a threat that he will avoid all suggestion of it. Since an active, inquiring curiosity is at the root of mental growth, avoidance-learning can very seriously retard intellectual development. Moreover, since a child typically expresses avoidance by aggression, lack of attention, sullenness and other behavior unacceptable to educators and parents, they—being human—may react by shutting the child out of further learning situations, and thus create another kind of iron circle.

Labeling, lack of opportunity, and avoidance-learning affect the development of both fluid and crystallized intelligence. Both depend upon acculturational influences—the various factors that provide, or block, chances for learning. And both depend upon anlage function and thus upon physiological influences as well. However, fluid intelligence depends more on physiological factors, and crystallized intelligence more on acculturational ones. It is the interplay of these factors throughout a child's development that produces the fact that fluid and crystallized intelligence can be separated in adult intellectual performances. But how does this separation arise?

In many respects, the opportunities to maintain good physiological health are the same for all in our society. The climate, air pollution, water, the chances of injury and other hazards in the physical environment do not vary greatly. Even the social environments are similar in many ways. We acquire similar language skills, go to schools that have similar curricula, have a similar choice of television programs and so on. In this sense, the most advantaged and the most disadvantaged child have some

of the same opportunities to develop anlage functioning, and to acquire concepts and aids.

Moreover, we should be careful about how we use the term "disadvantaged." We do not yet know what is superior in all respects, at every age level, for the development of all the abilities that go into intelligence. At one stage, what seems a "bad" home may give intelligence a greater impetus than an apparently "good" home. It may be, for instance, that in early childhood "lax" parents allow more scope for development. In later development, "stimulating" and "responsible" (but restrictive?) parents might be better. Some of the intellectual leaders of every period of history and of every culture have developed in environments that, according to many definitions, would have to be classified as "disadvantaged."

It is clear, however, that favorable conditions for the development of intelligence are not the same for all. To avoid the iron circle, to gain opportunities to go on, children have to display the right abilities at the right times. To some extent, this depends on early and basic endowment. Intelligent parents may provide good heredity, good environmental conditions for learning and good stimulation and encouragement. But the opportunities a child gets, and what he meets them with, can also be quite independent of his own characteristics. His opportunities depend on such haphazard factors as the neighborhood in which he lives, the kind of schooling available, his mother's interests and his father's income, the personality qualities of the teachers he happens to get, and the attitudes and actions of his playmates.

Thus, through a child's years of growth and education, societal influences can produce an effect that is

largely independent of those produced by physiological
influences. In an infant, cultural influences could not
have accumulated independently of the physiological.
But as children pass through preschool and school, their
awareness of concepts and use of aids becomes more
evident, and the influence of acculturation is felt and
exhibited. The probable shape of future learning and
opportunity becomes more clear. The child who has
already moved ahead tends to be ready to move farther
ahead, and to be accepted for such promotion. Crystal-
lized intelligence feeds the growth of crystallized intelli-
gence. By contrast, the child who has not moved ahead,
for whatever reasons, tends to be less ready and to be
viewed as such. His acquisition of the lore of the culture
proceeds at a decelerating rate. This is how two children
with roughly the same hereditary potential can grow
apart in their acquisition of crystallized intelligence.
Among adults, then, we should expect to find great
variation in the crystallized pattern of abilities—and we
do!

The cultural influences that can produce this kind of
inequality operate almost independently of physio-
logical factors, however. Thus, the child who fails to
progress rapidly in learning the ever-more-abstruse con-
cepts and aids of crystallized intelligence may still
acquire many concepts and aids of a more common
type. And if he is lucky in avoiding accidents and
maintaining good health, this kind of development can
be quite impressive. His intellectual growth may even
surpass that of a seemingly more favored child who is
slowed down by illness or injury. Thus, two children
with about the same hereditary makeup can grow apart
in fluid intelligence, too. The result is a wide range of
variation in adult fluid intelligence—a range even wider

than we would expect to be produced by differences in heredity alone.

Both fluid and crystallized intelligence, as we have just seen, develop with age. But intelligence also declines with age. This is especially true of the fluid kind. Looked at in terms of averages, fluid intelligence begins to decline before a person is out of his 20s. Crystallized intelligence fares better, however, and generally continues to increase throughout life. Because crystallized intelligence usually increases in this fashion, the decline in fluid abilities may not seriously undermine intellectual competence in people as they mature into middle age and even beyond. But let us look at these matters more analytically.

The graph below represents results from several studies, each involving several hundred people. Notice, first, that the curves representing fluid intelligence (FI) and crystallized intelligence (CI) are at first indis-

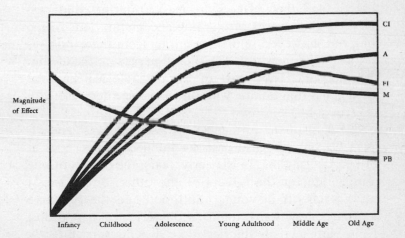

Development of Fluid Intelligence (FI) and
Crystallized Intelligence (CI) in relation to effects produced by Maturation (M),
Acculturation (A), and loss of Physiological Base (PB) due to injury.

tinguishable, but become separate as development proceeds. This represents the fact that both are products of development. It also illustrates the fact that it is easier to distinguish between fluid intelligence and crystallized intelligence in adults than in children.

The maturation curve (M) summarizes evidence that the physical structures and processes that support intellect (the brain, for instance) grow and increase in complexity until the late teens or the early 20s. Development is rapid but decelerating. Since both fluid and crystallized intelligence depend on maturation, their curves more or less follow it.

But maturation accounts for only part of the change in the physical structures that support intelligence. They are also affected by injuries, such as birth complications, blows to the head, carbon-monoxide poisoning, intoxication and high fever. Such injuries are irreversible and thus cumulative. In the short run, they are difficult to discern, and their effects are masked during childhood by the rising curves of learning and maturation. In the long run, however, injuries resulting from the exposures of living take their toll. The older the person, the greater the exposure. Thus, part of the physiological base for intellectual functioning will, on an average decrease with age (curve PB).

The sum of the influences represented by M and PB form the physiological base for intellectual processes at any particular time. In the early years, the effects of one compensate for the effects of the other. But as the M curve levels off in young adulthood and the PB curve continues downward, the total physiological base drops. Those intellectual abilities that depend very directly upon physiology must then decline.

The effects of brain-tissue loss are variable, however.

At the physiological level, an ability is a complex network of neurons that "fire" together to produce observable patterns of behavior. Such networks are overdetermined—not all of the neurons in the network need to "fire" to produce the behavior. And some networks are much more overdetermined than others. This means that when a loss of brain tissue (that is, a loss of neurons) occurs, some networks, and hence some abilities, will be only minimally affected. Networks that are not highly overdetermined, though, will become completely inoperative when a critical number of neurons cease to fire.

The crystallized abilities apparently correspond to highly overdetermined neural networks. Such abilities will not be greatly affected by moderate loss of neurons. The fluid abilities, on the other hand, depend much more significantly upon anlage functions, which are represented by very elementary neural networks. These abilities will thus "fall off" with a loss of neurons.

Curve A in the graph shows how, potentially at least, the effects of acculturation and positive transfer may accumulate throughout a lifetime. On this basis alone, were it not for neural damage, we might expect intelligence to increase, not decline, in adulthood.

Whether intellectual decline occurs or not will depend upon the extent of neuron loss, and upon whether learning new aids and concepts can compensate for losing old skills. For example, the anlage capacity to keep six digits in immediate awareness may decline with loss of neurons. But the individual, sensing this loss, may develop new techniques to help him keep a number in mind. Thus the overall effect may be no loss of ability. What the evidence does indicate, however, is that, with increasing age beyond the teens, there is a

steady, if gentle, decline in fluid intelligence. This suggests that learning new aids and concepts of the fluid kind does not quite compensate for the loss of anlage function and the loss of previously learned aids and concepts.

On a happier note, and by way of contrast, the evidence also shows that crystallized intelligence *increases* throughout most of adulthood. Here alternative mechanisms come into play. Compensating for the loss of one ability with the surplus of another, the older person uses crystallized intelligence in place of fluid intelligence. He substitutes accumulated wisdom for brilliance, while the younger person does the opposite.

A word of caution about these results. They represent averages, and averages can be affected by a relatively few extreme cases. For example, if only a relatively few individuals experience brain damage, but the effect is rather pronounced in each case, this will show up in the averages. If such damage occurs more frequently with older people than with younger people, a corresponding decline of abilities with age will show up—even though such decline may not be an inevitable aspect of aging for everyone. But even though these cautions must be kept in mind, we should not lose track of the fact that the FI curve parallels the PB in adulthood.

Intelligence tests that measure mixtures of fluid and crystallized intelligence (and most popular ones do) show varying relationships between aging and intelligence in adulthood. If fluid tests predominate, decline is indicated. If crystallized intelligence is well represented, then there is no apparent decline.

Intellectual performance in important jobs in life will depend on both kinds of intelligence, and may be represented by a composite curve (FI and CI in the

graph below). Notice that the peak of this curve occurs later than the peak of the FI curve below it. If fluid intelligence reaches its peak in the early 20s, intelligence in overall performance, influenced by the cultural accretion, may peak in the 30s. The evidence indicates that the greatest intellectual *productivity* tends to occur in the 30s or early 40s, although the most *creative* work often is accomplished earlier. For example, half of the 52 greatest discoveries in chemistry (as judged by chemists) were made before the innovator had reached age 29, and 62 percent were made before he was 40. It

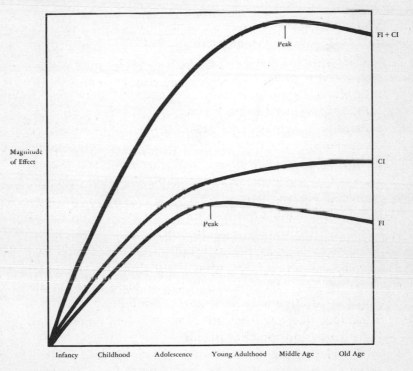

Fluid intelligence, crystallized intelligence, and the effect of the two added together.

would seem that creativity and productivity represent somewhat different combinations of fluid and crystallized intelligence, with productivity being relatively more affected by cultural factors.

The age at which the combined FI and CI function peaks varies from one person to another, depending on the development of new concepts and aids, the amount of brain damage, and other factors such as diet and general health.

Perhaps the most interesting result of all this recent work lies in the questions it provokes. What are the factors producing the apparent decline in fluid intelligence? Are they intrinsic to aging, or do they merely reflect the hazards of living? Are they associated with the hazards of different occupations? Do auto mechanics, for example, who are repeatedly exposed to carbon monoxide, show more decline in fluid intelligence than cement finishers, who work in the open air?

Most important of all, what experiences in infancy and childhood have favorable or unfavorable effects on the future growth of fluid intelligence? Of crystallized intelligence? Of both? Do experiences that affect fluid intelligence always affect crystallized intelligence, too? We are still far from finding firm and comprehensive answers to these questions, but they very clearly hold massive implications for our child-rearing practices, for our educational system and for the whole complex of fields that bear on the development and management of human potential.

November 1967

OF SOCIAL CLASS
AND EDUCATION

Part II.

The Demographic Context
of Metropolitan Education

KARL E. TAEUBER

The American educational system is beset with anachronisms. Like the American political system and many associated administrative systems the educational system splits the nation into states, states into districts, and districts into neighborhoods. Implicit in this scheme is an ideological romanticism, harking back to the good old rural past when the countryside was dotted with villages each of which linked the surrounding farm families to a core of community institutions and services. Add to the picture a New England town meeting, and you have the prototype of rural American democracy.

Twentieth-century events have made the preceding picture impractical for an understanding of present-day educational problems. Instead we need a geography that considers the relationship of populations to populations: that discusses urbanization and suburbanization;

77

migration and population movement within urban areas, and the resulting age patterns and numbers of school age children; and racial residential segregation and its relationship to school segregation. In this chapter I shall attempt to outline the ways in which such geographic analyses might be made.

Urbanization and Suburbanization

Imagine an ordinary relief map of the United States. A mountain peak projecting 10,000 feet above the surface of the earth is represented on the map by a peak of one or two inches. Now, redraw the map, letting height represent the number of people per square mile. In this new map, both Death Valley and the Rocky Mountains are represented as valleys. Various coastal locations, virtually at sea level, are sites of enormous peaks. The entire map is a series of greater and lesser peaks, with steep slopes and highly variegated plateaus separating the peaks.

If a series of our special relief maps were constructed, one for each census date, we could visualize the process of urbanization of the United States. At the first census in 1790 there would be an eastern plateau, sloping off to the west, representing the inhabited portion of the new nation. The plateau would be studded with small peaks. Even the few large peaks would be smaller than dozens of those on the 1960 map. Let us jump to 1910. Not only had the number and size of urban peaks greatly increased, but the farm population was more numerous than before or since. In recent decades, most counties in the nation have lost population; the general level of the plateau was lower in 1960 than in 1910. There were more high peaks, and many of the high ones had become much broader or fatter. In fact, for a

number of the highest ones the principal change in recent years has been an increase in breadth rather than height.

The principal topographic features of our map are the mountains, the metropolitan areas. But although the peaks are clearly distinguishable, it is not clear precisely where the base of each peak ends and where the next begins. This is particularly true of certain sectors: the northeastern seaboard, for example, or along the southern edge of the Great Lakes.

The federal government has developed a compromise solution to this problem, at least for purposes of data-gathering. This approach, used since the 1950 census, merges our relief map with the standard political map. Mixing practicality and scholarly idealism, counties are taken as the building blocks. Around each large city (each nodal point on our map) a metropolitan area is defined, consisting of the county containing the city and, if appropriate, contiguous counties which (according to patterns of commuting, telephone calls and the like) are socially and economically integrated with the city.

From 1910 to 1970 "metropolitan mountains" pushed upward all over the map. By 1970 two-thirds of the United States population was metropolitan. This metropolitan concentration embraces both races; indeed, the nationwide figure for Negroes is now a bit higher than that for whites, even though in some Southern areas the Negro population has grown more slowly than the white population.

Where has the added population been housed? The principal source of additional housing is new construction. (Subdivision of existing units was prevalent during the tight housing market of the 1940s, but is inherently

limited in magnitude.) Given the market system that prevails in the United States, new housing tends to be moderately expensive. It has tended to be single-family units, owner occupied, with a private yard. This housing pattern gobbles up space, and space has been available mainly at the edges of the built-up area. In the past, cities tended to annex areas as they were initially built up and occupied. Hence the growth of the expanding metropolis was in large part contained within the growth of the city. During the last 50 years, however, annexation has become much less frequent, and much metropolitan growth occurs outside city limits. In great measure, therefore, the much-ballyhooed process of suburbanization is simply the old process of urbanization. The difference is largely the differential use of the political annexation process rather than a fundamental change in the process of metropolitan expansion. Suburbanization is simply the continued outward growth of the metropolis.

This view of suburbanization does not deny the very real differences between middle-class suburb and lower-class ghetto. With respect to types of housing, these differences reflect not so much differences between suburbanization and urbanization as between urbanization in the 1880s and urbanization in the 1950s and 1960s. Changing consumer preferences together with changes in technology, financing and organization of the construction industry have led to major changes in styles of housing. Rather than compare single-family home with tenement, it suffices to compare current central-city high-density apartment developments with old tenement patterns, or new suburban homes with old. Changes in settlement patterns result also from the larger number of families with more real income.

Widespread automobile ownership and freeway construction have permitted new housing to spread over the landscape rather than concentrate along mass transportation routes.

Many central cities are now losing population while the suburbs continue to grow rapidly. This loss of central city population need not be taken as a radical sign of urban decay. It is more appropriate to envision every neighborhood as having a normal life cycle. An area is likely to be platted and opened to residential development as the transportation of the era—rail or surface—makes the location accessible and as other sites more attractive by contemporary standards are occupied. (The relevant measures of attractiveness of an area are not only the whims of potential residents but also the views of potential builders who are subject to numerous technological and financial constraints.) At first the housing is new, but the passage of time wreaks a toll in two ways. Housing which was new and up-to-date very soon lags behind newer housing in fashion and technological convenience. In addition, maintenance costs increase with the passage of time, both from aging of the building and from rising costs of labor. In some neighborhoods the residents or owners have the inclination and the resources continually to maintain and upgrade the housing; in others they do not.

Typically, the initial period of settlement is followed by a period of consolidation, as the remaining vacant lots are occupied and other opportunities to add to the housing supply are utilized. After a period of relative stability, the neighborhood may begin to decline in its attractiveness to the kind of residents originally there. This may lead to substantial conversion to a denser

residential pattern, but in the long run it leads to an
absolute decline in marketability, to high vacancy rates,
to displacement for urban renewal or highway construc-
tion, and to declining population.

The two world wars and the great depression were
periods of little home construction. The 1920s, 1950s
and 1960s were periods of rapid home construction. But
they were also periods of rapid population growth and
new household formation. In many metropolitan areas,
much of the total housing stock antedates the first
world war. This is particularly true of housing within
city limits, the more so if those limits were expanded
around the turn of the century to embrace most of the
built-up area but have changed little since. With a slow
rate of replacement of existing housing, this old housing
is very old indeed. The decline in city populations
reflects a decline in use of this ancient housing. It
contributes to the improvement of the housing of the
bulk of the population, and from this perspective is a
cause for celebration rather than despair. To be sure
declining city populations create problems, but these
take a far different shape from a national or even a
metropolitan perspective than they do from the vantage
point of a mayor's office or a board of education.

I shall return to the topic of city-suburban differ-
ences, but I'd like to approach it in terms of processes
rather than as a static picture. Hence it will be necessary
first to talk a bit about the process of migration—people
moving from one place to another, from farm to city,
from city to suburb, from suburb to city and so forth.

Patterns of Migration

When the oldest members of our population were
born, the nation was predominantly rural. Already,

however, we were in the midst of rapid urbanization based on our own rural surplus and on the immigration of millions of Europeans. Today we are a nation of cities, and the predominant pattern of movement is from city to city. The farm population continues to send migrants to cities, but the numbers involved are small and growing smaller. In the contemporary scene, the new migrant that attracts the attention of welfare agencies and reformers is not the foreigner or the Okie but the rural Negro. I shall begin with a discussion of Negro migration and then move to a separate discussion of white migration and suburbanization.

Most southern cities have always had a sizeable representation of Negroes in the population, but for many northern cities the period from about 1919 to 1925 produced the first large influx of Negro population. The fragmentary sources upon which we base most of what is known about the early period of large-scale Negro migration are in general agreement that Negro in-migrants to cities were of lower social and economic status than the resident Negro and white populations. Increased racial tensions were blamed upon the heavy influx of Negroes of low socioeconomic status. Even the old Negro residents are reported to have shared in resentment of the new in-migrants:

Inevitably many of them were inclined to hold the migrants responsible for these increasing social restrictions and tended to resent the influx of other blacks, many of whom were inferior in education and culture to the northern Negroes and many of whom were unaccustomed to northern standards of living and modes of conduct.

This early migration was brought to a halt by economic crisis and the depression. Migration resumed

with the industrial boom of the early 1940s. Through
the late 1940s and early 1950s there was a continued
shift of Negroes from the rural South to the urban
North and South. An extensive literature, both popular
and scholarly, paints and repaints the same picture that
was painted in 1917 and 1927. Whites are presumed to
be abandoning cities to a Negro population increasing
daily through the addition of low-status migrants who
burden schools, welfare agencies, police and other
public agencies. The extreme portrait in this painting is
that of the urban newcomer so unsophisticated in the
mysteries of urban life that he throws his garbage out
the window unaware that no pigs feed in the alley
below. I'm sure that welfare workers and teachers have
encountered occasional families of this type, and in that
sense there is the inevitable kernel of truth to the
picture. But the degree of truth is less than in the
typical racial stereotype. A study of the characteristics
of the in-migrants and their growth replaces the stereo-
type with a picture of men and women working hard to
achieve a better life for themselves and their children.

First I wish to emphasize that massive migrations are
necessarily limited in duration. A shift from migration
to natural increase as the principal source of growth is
typical for migrant populations. After an early period of
migration, the resident population is large enough to
produce a significant natural increase. As the resident
base increases, a steady rate of migration produces a
smaller and smaller relative rate of growth. This shift is
augmented by the tendency for migrants to be concen-
trated in the young adult ages, so that family formation
is rapid and birth rates are high. It is also quite natural
for the migration itself to diminish. Although in many
northern cities the volume of Negro in-migration has

continued to be high its character has changed and its proportionate share of metropolitan growth has declined. There are hardly any more Negro sharecroppers; the rural Negro population has been declining; and there is an increasing number of cities in both North and South to which Negroes now move.

Many discussions of migration rely, most unfortunately, on data on *net* migration. A net migration of 10,000 may result from an in-migration of 10,000 and an out-migration of zero, or from a in-migration of 100,000 and an out-migration of 90,000. Knowing the net balance really tells us very little about migration. Furthermore, we are usually interested in the characteristics of the migrants, and this makes it necessary to identify individual migrants. After all, there is no such creature as a "net migrant." Without a population register identification of migrants requires surveys. We can learn much from the largest survey of all, the decennial census. The relevant 1970 census results are not yet available. In the 1960 census each person in a sample was asked where he lived five years before. If not at the same address, he was classified as a local-mover if still in the same city, or as a migrant if he had moved from elsewhere. Census data for the period 1955-60 reveal the following features of Negro migration to northern and border cities:

Contrary to the popular stereotype, Negro in-migrants ... were not of lower average socio-economic status than the resident Negro population. Indeed, in educational attainment Negro in-migrants ... were equal to or slightly higher than the resident white population. Comparisons with limited data for earlier periods suggest that, as the Negro population has changed from a disadvantaged rural

population to a metropolitan one of increasing
socioeconomic levels, its patterns of migration have
changed to become very much like those of the white
population.

A portion of the Negro migrants to each city
formerly lived in the nonmetropolitan South. This
portion tends to be of low socioeconomic status, though
not as low as the stereotype suggests. The significant
unrecognized factor is that this portion is relatively
small compared to the total volume of migration. There
is much movement of Negroes from city to city within
the North, and from southern cities to northern cities. It
takes a person with at least a modicum of ambition,
money and knowledge of opportunities at the destina-
tion to move a long distance to a radically new type of
job and community. Hence, long-distance migration
tends to be selective of the more successful rather than
the less successful.

Long-distance migration is not the only option
available to a Negro farm-laborer dispossessed by a new
minimum wage law or to a Negro teenager who knows
rural life isn't for him. There is probably a nearby town
or city to which relatives and friends have gone, which
he has visited previously, and which offers an easier
refuge than the big city up North. Each southern
metropolis carries on an exchange of poorly educated,
unskilled Negroes with an extensive rural hinterland.
The flow is both ways, and by now there are few rural
people so isolated as to have no meaningful contacts
with the urban way of life.

In 1885, a Britisher named Ravenstein published an
article on "The Laws of Migration." His laws are really
generalizations based on his study of the limited
migration data then available for a few countries, but

they have stood the test of time and hold up remarkably well in other places at other times. One of these laws is that most migrants are young adults. It is youth who lead the redistribution of population, who abandon old ways of life and try out the new. In recent decades in the United States, even in the rural South, nearly all children attended school, and through time there has been a tendency for the amount of schooling to increase. Hence, each new generation of youthful migrants is better educated than the last. Not only does long-distance migration tend to select the better educated, but it selects from among the best-educated age group in society.

A second of Ravenstein's laws concerns the prevalence of stage migration. Although we talk of the shift of people from farms to giant cities, actual movements tend to be in stages, with farm-reared youth moving to towns, town-reared youth moving to the nearest city, and city-reared youth moving to more distant cities. Despite spectacular examples of direct migration from backwoods farm to modern metropolis, there is much evidence that stage migration is the more typical pattern. People change their life styles gradually, and the migrant to St. Louis or Chicago who has never before seen a large city is a rare individual, no matter how dramatic his personal situation.

A generalization that emerges from the preceding but does not have the universality of Ravenstein's law is that selective migration can lower the status of both the sending and receiving populations. Rural counties that lose all of their Negro grade school graduates to the nearby cities have their average educational level lowered. But these migrants may be poorly educated by the standards of urban Negroes, thus lowering the

average educational level of the city. Similarly, many of the urban southern Negroes who move to the urban North are well educated by the standards of their home communities, but not so by the standards prevailing in the northern cities. This paradox points to the community problems created by migration patterns which, on an individual level, may be highly beneficial.

The redistribution of white population has obeyed the same general "laws." I shall skip over the massive rural to urban migration of whites, and only briefly summarize a study of white migration between cities and suburbs.

Within the twelve largest metropolitan areas, there has been a substantial flow of persons in both directions—from city to suburb and from suburb to city. Indeed, Ravenstein once again hit the mark by postulating that each principal current of migration generates a countercurrent. Hence, there has long been a "back-to-the-city" movement, which accounts for the ease with which Sunday supplements find cases to illustrate that the central city is attracting back those frustrated suburbanites. Of course cities attract some suburbanites. But cities continue to lose to suburbs faster than they gain back. In this circulation of migrants, the general socioeconomic status tends to be higher than for nonmigrants. The principal migrants are single men and women and young families. They seek new housing not so much for status as for the space and style they always wanted but couldn't afford or which they could get along without because their kids were small.

Some metropolitan migrants are of low economic status. They are likely to find housing in older neighborhoods and hence in the central city. Migrants of higher status are likely to seek newer housing, and hence to

locate in the suburbs. Persons of really low status are unlikely to do much moving except between apartments within a neighborhood. The problem of city poverty and suburban wealth is only in small part a result of poor people flooding into the cities and rich people moving out. Rather, large cities contribute to suburbs and to other metropolitan areas more high-status migrants than they receive, whereas suburban rings receive more high-status migrants than they lose. The net effect of this circulation is to diminish the socioeconomic level of central city populations and augment the socioeconomic level of suburban populations. The process of population redistribution within the metropolis is much more complicated than public discussion would suggest.

The analyses underlying the preceding discussion of migration have concentrated on large cities. Current evidence suggests that newer and smaller cities are heading in the direction of these older and larger places, but they have not all reached the same point. In many of these places, the suburban populations are not superior to city populations in average levels of education, occupation or income. Even where the average levels are in the expected direction of higher suburban status, the magnitude of the difference is small. There are college graduates in the cities and high school dropouts in the suburbs.

Many persons read popular essays on suburbia and forget their own observations. Many delightful suburban-type areas lie within city limits, and many places outside city limits are really slums. Suburban squalor in the South is obvious in the rural villages and enclaves of shacks that have been brought into the urban sphere by its outward growth. We are so

accustomed to a mental picture of suburbia that we tend to feel that these are nonsuburban places. If the definition of suburbs is restricted to certain "nice" residential neighborhoods, it is still obvious that suburbs may be found in the city as well as outside. The number and size of such neighborhoods are nowhere near as great as the simple city-suburb population figures would suggest. Carefully zoned half-acre developments impress us, and lead us to ignore the much greater number of families housed in denser and less luxurious settlement patterns.

Differences between cities and suburbs are more often exaggerated than minimized. My effort here is not to deny differences, but to call attention to similarities. The U.S. Commission on Civil Rights in its recent report on school segregation noted that 55 percent of college graduates in metropolitan areas live in suburbs contrasted with 55 percent of those without a high school diploma living in central cities. The figures may be presumed correct, but for present purposes I would turn them around to change the emphasis: 45 percent of metropolitan college graduates live in central cities, while 45 percent of the poorly educated live in suburbs. Central cities are not lacking in middle-class residents, nor are suburbs lacking in working-class residents.

Changing Age Composition

I studied the changes 1950-60 for the aggregate population of the 24 largest metropolitan areas, and have checked preliminary 1970 census results to be sure the major patterns still obtain. Obviously such an aggregate does not perfectly represent any one area, but the pattern is typical of most large and many small metropolitan areas. It only takes a glance to see the

paucity of suburban nonwhites. Although the suburban nonwhite population increased in every age group, the numbers involved are small. The large percentage increases sometimes cited to prove that Negroes are suburbanizing are clearly misleading if not put in the context of the small numbers.

In the absence of suburbanization, the white population in central cities should have increased at most ages. In fact, there were only small increases at the main school ages, and very large decreases at ages 20-29. The suburbs showed tremendous gains in numbers of school-age whites.

The patterns become more complex when the city and suburban figures for whites and nonwhites are examined for specific age groups in specific areas. The data cannot be interpreted sensibly without keeping in mind the way in which they are affected by national fertility trends. For the total United States, the number of people in a given age group depends mainly on the number of births during the approporate earlier period. For more than a decade, the United States has had about 3,500,000 births a year, and this has led to a national stability in the numbers entering each elementary grade each year. But as the baby-boom children form families of their own, these numbers will increase even if birth rates decline. Hence, new fluctuating waves will eventually be rippling through the school systems. At the local level, migration patterns may augment the national waves, or produce counter currents.

Projections of school enrollment are very difficult, as many school administrators have learned through bitter experience. It is possible to keep track of the national demographic waves, and to anticipate their impact. It is harder, but not impossible, to project past suburbaniza-

tion trends into the future. The census data cited earlier indicate that metropolitan population is still growing, that this growth is mainly in the suburbs, and that the suburbs remain largely closed to Negroes. Another complication is the existence of private school systems alongside the public system. Negroes make up a much greater percentage of public than of private school enrollment. Rarely do private school systems have a large percentage enrollment of Negroes. Suburban private schools typically have only a token Negro enrollment, and even suburban public schools confront a small Negro enrollment. With some exceptions, it is the public school systems in central cities that have large Negro enrollments, and it is only for these school systems that it is inherently difficult even to design a desegregation program.

Residential Segregation

There are many types of residential segregation, but it is racial segregation that currently poses the most difficult problems for education. It is helpful at the very start of a discussion of segregation to present an objective definition. If there were no racial residential segregation, white and Negro families would be similarly distributed among the housing of a city. Every residential neighborhood—a block or a cluster of blocks—would have about the same proportion of whites and Negroes as every other neighborhood. To the extent that there is a dissimilarity in the territorial distribution of white and Negro families, there is residential segregation. By this approach, segregation is simply observed fact. The processes by which the segregation came about may include prejudice, discrimination, income differences, choice and so forth, and there may be dispute about the

relative importance of each of these causes. But the fact itself cannot reasonably be disputed.

The decennial censuses give the racial population of each city block. With these data I have calculated segregation indexes—measures of the dissimilarity in territorial distribution of whites and nonwhites—for all large cities in the United States. These indexes show that racial residential segregation is everywhere pronounced—in the North and in the South, in the recent past and in the present. This segregation by race is greater than the segregation of European immigrant groups ever was, and is much greater than the segregation of rich from poor of each race. The long-run trend in both North and South has been for racial residential segregation to increase. In the 1950s, this trend seems to have been (temporarily) halted in the North, as a result of the relatively loose housing market, rapid growth of urban Negro populations and increasing economic status of many Negro families. Speculation that the 1950s represented the beginnings of a general process of residential desegregation remains, so far, speculation. For a dozen or so cities which had special censuses in the mid-1960s, there is no indication of continued or accelerating declines in racial segregation since 1960. In many cities, an increasing supply of good housing is opening up to Negroes, and individual Negroes may be finding it easier to obtain housing in predominantly white neighborhoods. But the total picture continues to be one of very pronounced segregation, with no clear signs that fair housing legislation, educational campaigns, improved Negro economic status or any other factor has yet had a decisive impact.

These facts about residential segregation cannot, in my view, reasonably be disputed. There is more room

for argument about the causes and prospects. With
respect to causes, I am convinced that discrimination in
the housing market is the principal cause, and that
"choice" and "Negro poverty" are vastly overrated as
contributing factors. Perhaps Negroes prefer to live in
Negro neighborhoods, perhaps not. Consider the other
side of the coin: the preference of whites for white
neighborhoods. Such a preference, if it exists to any
great extent, can hardly be considered apart from the
prevalent prejudice and discrimination in our society. So
long as any Negroes who move into white neighbor-
hoods are threatened with physical violence or even
simply social ostracism, it is hardly an expression of free
choice for Negroes to prefer Negro neighborhoods.

The poverty argument is similarly easy to dispute. In
the first place, Negro poverty itself is a result of
prejudice and discrimination. But the real estate indus-
try tends to argue that it cannot be responsible for that.
All it can do is operate on the free market principle of
selling to anyone who can afford the price. But it is
patent nonsense to argue that the housing market in any
large city in the country functions that way. Wealthy
Negroes do not have the same housing options as
wealthy whites. Poor Negroes do not live interspersed
with poor whites.

This perspective on the causes of residential segrega-
tion does not permit any magic insights into the future.
It is clear that a rapid increase in Negro incomes would
not of itself lead to residential desegregation. Negroes of
higher incomes are just as segregated as those of lower
incomes. The impact of fair housing laws is difficult to
foresee. Clearly, in the short run, there is likely to be
little effect. Even federal regulations and laws seem to
be enforced with the deliberate speed of the Supreme

Court school decision. Local ordinances already in existence in many states and cities have thus far failed to effect major changes in segregated residential patterns.

In the longer perspective, it is clear that the situation is changing, and changing rather rapidly compared to the pace of many deep-seated social revolutions. The degree of token integration has clearly increased; many neighborhoods have proved their tolerance by "allowing" a Negro family or two to live amongst them. The number of neighborhoods with a substantial degree of racial intermixture, stable over several years, is probably increasing. Once such patterns are shown to be not only possible, but profitable, not only utopian, but practical and just, will this innovation spread rapidly? Will the diffusion follow the accelerating curve of color television ownership or use of the birth control pill? Or will it diffuse more slowly, as seems to have been the case with religious and ethnic tolerance in general?

Whatever the answer, the short-run prospect is one of extreme racial residential segregation, and desegregation at a snail's pace (to the extent it occurs at all). Many cities already have a Negro majority in their public school systems. Many more cities will soon reach this point. The housing stock of central cities grows older. The white population, especially young families with children, continues to favor suburban over city residence, while similar Negro families continue to be confined to the cities. Private school systems augment th racial imbalance still further. The racial composition of city schools is becoming more homogeneously Negro. This occurs whether or not the pattern of segregated public schools changes, simply because the relative number of Negroes increases. As Negro children replace

white children in a public school system, administrators, even if they attempt to utilize the available repertoire of desegregation techniques, are likely to find the number of Negroes in predominantly Negro schools increasing. In other words, the demographic composition of public school children is changing so rapidly that even if the all-white schools are integrated, the other schools will simultaneously become more predominantly Negro.

A recent Office of Education study demonstrated that Negro educational achievement, controlling for various relevant factors, is lower as the percentage of Negroes in a school increases. It argued further that most kinds of financial investment in schools had relatively little demonstrable payoff in terms of educational achievement. The United States Commission on Civil Rights drew from these findings a policy implication for the federal government to push for school desegregation nationwide. Compensatory educational schemes and additional investment in ghetto schools may be necessary stopgaps, the Commission argued, but they should not be allowed to divert money, time or energy from the desegregation move. The *New York Times,* among other editorial voices, countered that rapid school desegregation in our major metropolitan areas is a utopian dream. Children currently in school should not be shortchanged of urgently needed funds in the hopes of eventual salvation by federally imposed desegregation.

Educational administrators cannot embrace both positions wholeheartedly. The resources simply aren't available, and moves in one direction today may constrain future moves in another direction. It is clear that no decision can be made on educational grounds alone. Rather it is necessary to view the changing

educational system in the context of a changing society. I have sketched a demographer's perspective on several aspects of our changing society—urbanization and suburbanization, migration, the movement of successive birth cohorts through the school system, and the awesome tenacity of racial residential segregation. The demography of education cannot be divorced from the general social demography of the nation. Similarly, I suggest, the resulting problems for the educational system should be viewed (by educators and by the public) neither as solely within the domain of the school systems nor as constraints to which we can only adapt. Study of population trends, especially migration and residential relocation, should be prominent on the nation's social policy agenda.

FURTHER READING:

Louise V. Kennedy, *The Negro Peasant Turns Cityward* (New York: Columbia University Press, 1930).

Karl E. Taeuber and Alma F. Taeuber, "The Changing Character of Negro Migration," *American Journal of Sociology*, (January, 1965).

E. G. Ravenstein, "The Laws of Migration," *Journal of the Royal Statistical Society*, (1885).

Karl E. Taeuber and Alma F. Taeuber, "White Migration and Socio-Economic Differences between Cities and Suburbs," *American Sociological Review*, (October, 1964).

U.S. Commission on Civil Rights, *Racial Isolation in the Public Schools*, Vol. 1 (Washington: U.S. Government Printing Office, 1967).

Karl E. Taeuber and Alma F. Taeuber, *Negroes in Cities* (Chicago: Aldine Publishing Co., 1965).

James S. Coleman *et al., Equality of Educational Opportunity* (Washington: U.S. Government Printing Office, 1966).

Of Achievement, Hope and Time in Poverty

JULES HENRY

Among the children of the very poor survival must take precedence over every other consideration. But current motivational theory tends to downgrade immediate and physical motives. It turns its eagle vision instead, like a rising young executive, on "goal-striving," "status-seeking" and "planning." By such elite and middle-class standards the poor must be said to have little or no motivation.

Under a grant from the National Institute of Mental Health we have been studying a large St. Louis housing development inhabited almost exclusively by very poor Negroes. We middle-class observers have noted the pronounced tendency of the tenants toward "random-like" and unrealistic behavior. Their attitudes toward space, time, objects and persons lack our patterns of organization, lack our predictability—even sometimes seem to lack sense . . . to us. How do they seem to the

project dwellers themselves? After more than a year of field work with about 50 families we have the strong impression that they are well aware of the differences.

For instance, they make a strong distinction between C.P. (colored people's) time and W.P. (white people's) time. According to C.P. time a scheduled event may occur at any moment over a wide spread of hours—or perhaps not at all. They believe, however, that in the highly organized world of the whites it occurs when scheduled.

The housing project is so isolated from the social and economic life of the city and the white community that the occupational classes of the census bureau scarcely apply to it. The tenants work as domestics, or in the nooks and cracks of our economy; employment is uncertain, pay is poor, resources are scarce. Yet unemployed men talk of jobs they do not have, and the women in this "city of women" speak of husbands dead, fled or who never existed.

Illusion is thus a way of life. Young and old spend money they do not have for expensive clothes and cars. People with no power and status brag of influence and position and concentrate on getting the better of each other. The illusion of middle-class success settles invisibly over them. Thus a white school teacher working with Negro children remarks that they are not interested in solid accomplishment but only in showing off. Obviously such short-cutting must interfere with learning and with facing school and life realistically.

Casting out the poor and the Negro from white society has resulted in a social life so saturated by illusion that the fancy soon becomes the only possible achievement.

Disorganization and a life of dreams fit into the social

dynamic of the school room to create educational
under-achievement.

The children of disorganization cannot create class-
room organization; and the teacher can only work with
those who have somehow managed to acquire enough of
the necessary motivation. Often we have seen a harassed
teacher working with a very few children in a class and
trying to ignore the disorder and uproar the others are
creating. Here are some notes made in one such sixth
grade classroom, with both Negro and white children:

The teacher was leaning over Paul's desk helping him
with arithmetic. Irv and Mike were watching. Alice
was talking to Jane and Joan to Edith. Nearby Alan,
Ed and Tom were pushing and shoving. Tom got out
of his seat, made a wad of notebook paper and tossed
it into the air several times. Tom and Ed suddenly
slammed their desks shut, got up and walked out
noisily, Lila and Alice followed. Alan grinned at the
observer, waved his hand, and said, "Hi." The teacher
took no notice. . . .

This process of *partial withdrawal*—whereby the
teacher simply withdrew to those few students she
could handle—may occur anywhere an individual tries to
cope with a disturbed environment; I have also seen it in
mental hospitals. It reflects not so much the relationship
between authority and client but the total social
situation.

In school pupils have the choice of building status
either with their teacher or their friends; to many,
reputation among friends may be much more important.
The pressure of peer-groups is very strong, and self-
destructive status choice can occur in any such conflict
between the demands of authority figures and the
demands of the group. What usually tips the balance

toward teacher and self-preservation is a measure of hope in the future. Disorganization can tip the balance the other way.

This is especially true if the disorganization has unique attractions for the children. In integrated classrooms, the approval of white students may become so attractive to Negro children that they gladly risk official displeasure, punishment or failure. In coeducational classes, attracting the attention and getting the approval of the opposite sex can become much more important than "teacher's dirty looks." All such "split" situations introduce disturbing and competing elements. Students can make status choices that ruin their whole future lives.

Very, very poor children, both by feeling and understanding, lack the structure on which conventional education can build. Their background does not have the elements of order necessary to achieve. Their homes are crowded, full of disturbance, physically and personally disorganized; they do not operate on schedules that pay much attention to school concepts of time. They lack both belief in achievement and fear of no achievement.

When 30 to 50 such children are in a class supposed to be run by one teacher, disorganization must result. From it the teacher in sheer self-defense may select only those elements suited to her task—she will teach those considered teachable and let the others go. But even the children most willing and able to learn are under tremendous pressure from their classmates to give up and join them. By pleasing the teacher they can buy success in a vague and distant future only at the probable expense of making their present life lonely, unhappy and even dangerous.

The poor motivation of the low-achiever is not therefore a demon somehow arising from and locked up inside himself but one effect of a whole sea of pressure and pain which has surrounded him since birth; and in which he himself seldom knows why he gasps.

But why all this disorder, illusion and destruction? Does it come about because, as some moralists believe, the poor lack an essential fiber, so that they tack and waver in the wind against which *we* advance?

This view is actually not far wrong. The poor do lack a fundamental vitamin that we others absorb with the smell of food, with the promise of gifts at Christmas, with plans for graduation. *They lack the essential strength of hope.*

Hope is not a simple nutrient. It goes straight to the heart of organization and makes it work.

Among lower animals organization occurs largely through in born genetic factors. With man, things are not so direct, and the word "culture" has been chosen to designate the complex learnings that determine his behavior.

But "culture" varies between societies and even between groups within societies. For the middle and upper classes in our society, achievement and security are major determinants. They organize behavior—or our behavior is organized around them. They act as carrots; the fear of their opposites—failure and insecurity—acts as a goad. When people do not see success and failure as we do, their behavior will appear to us random and purposeless; and we disapprove of it. But those who cannot hope for achievement or security can have no concept of the organization of behavior through time towards goals.

The culture of the middle class itself has been superficially charted. How, for instance, does the middle class handle hope, time and the self? Achievement depends on hope—and hope rests on time. Some time in the future we hope to achieve something. Even to say "Billy has stopped wetting the bed" means that desired change has occurred through time: Billy used to wet the bed but does so no longer.

But the parent with no hope can have only partial understanding of his child's having stopped bed-wetting. He can have no fruitful conception of the conscious movement through time toward desired goals. Relative to large social goals, his actions are undirected.

Though the poor have little hope for life, they do not wish to die. According to comparative suicide rates they have less taste for final voluntary quietus than any other class. Therefore, they concentrate on those factors that keep them alive—now—that make direct, obvious and strong contributions to present life. The culture of the very poor is a *flight from death*.

In this setting, the very disregard of common methods of looking at things and objects—such as how to arrange a house—can become institutionalized, a way of life. Such disregard in objects we call disorder; in behavior we call it randomness.

Martin Heidegger in *Being and Time* relates perception of self to existence through time. When people think of themselves they seem to say, he argues, "That is the way I was, this is how I am now, and in the future, I hope to be something else." These perceptions of self have past, present and future; and it is from them, he believes, that we conceive time. They presuppose change during time—movement from what used to

be toward what will be. Self must therefore exist at least partly as a function of time; it must include organization through time.

But what happens to a person who has no expectations or hopes for himself or his children? His behavior, having neither background nor direction, is disorganized. What is left of him in the irreducible ash—the survival self—the flight from death.

The survival self has no real sublimation or higher displacement—nothing but physical life—in a very limited but very intense form. The survival self must concentrate on those experiences which give it continual and vivid reassurance that it is alive—heightened perhaps and smoothed by drugs or alcohol. It must, literally, keep *feeling* its life. Sociologists of middle-class background contemptuously refer to this state as "hedonism"—living for pleasure. It is not—it is flight from death.

The famous second law of thermodynamics states, in paraphrase, that disorder within an isolated system can only increase. Life is not pure physics; but there is a useful parallel. Consider a middle-class neighborhood or suburb. It is not an isolated system. Its members go out into the community, and the community comes in at the door and the mind. The resources of the community are known to and used by it, and it is subject to steady cultural and economic stimulation—which it in turn affects. The interaction brings adjustment and regulation; the disorder or randomness—"entropy" in the language of physics—is low.

The slum or lower-class housing project does not have access to these sources of support and stimulation. A paradox—or vicious circle—exists: because of their disorganization and lack of hope the very poor cannot

or do not get to the major sources of economic and cultural stimulation; and their disorganization and hopelessness came in the first place from lack of access to these resources. Cut off from hope, stimulation and change, the poor neighborhood is an isolated human thermodynamic system, and its disorganization can only increase.

Many middle-class selves are also in flight from death; but they are trained to look at life through the lens of achievement, sustained by hope and expectation, and they can fly along this path—perhaps even to greater achievement. This sustenance is not available to the great majority from the slum and housing project.

Our conclusion then must be that hope is a boundary: it separates the free from the slave, the determined from the drifting—and the very poorest from almost all those above it. A corollary conclusion—even more surprising—follows: time, space and objects really exist for us only when we have hope.

Short of reforming his world, how can we stimulate the slum child to greater school achievement? Certainly it will not be enough to merely improve teaching methods and curricula. We must improve the school as a social system.

Some proposals are in order:

☐ *Building up perceptions.* Children whose central milieu involves so much disorganization and disorder cannot master mathematics, or any other discipline involving order and direction. I would urge that these children be given pre-school training in which the basic perceptions that other children acquire without apparent effort be deliberately taught. For instance, a child must learn fundamental shapes and categories—

insideness and outsideness, roundness, straightness, flex-
ibility, rigidity, transparency, opacity, motion in a
straight line, motion in a circle, rocking motion and
many other basic perceptions. A child should have this
perceptual competence before he starts school.

□ *Calming down.* Poor children often come to school
unfed, after wretched nights torn by screaming, fighting,
bed-wetting; often they cannot sleep because of cold
and rats. They come to class hungry, sleepy and
emotionally upset. To start routine schoolwork effec-
tively at once is impossible. I propose that teachers be
specially trained—as they are in the Youth Development
Project of the greater Kansas City Mental Health
Foundation—to deal with such children, and that they
eat breakfast with them in school. The school should, of
course, furnish the food, perhaps out of government
surplus. School breakfast would accomplish two things:
it would feed hungry children, otherwise unable to
concentrate adequately on their work; and it would
bring teacher and pupil together in an informal and
friendly atmosphere, associated with satisfaction, before
the strain of classroom constriction and peer-group
pressures dictate that teacher become an enemy. It is
essential, therefore, that the teacher be present. A
program like this suggested by me in Kansas City
brought about immediate and sharp improvement in
attendance, behavior and in schoolwork. The more the
teachers know about the emotional management of
these children, the better.

□ *Expansion of participation.* The frequently pro-
claimed immediate goal of instruction—more personal-
ized attention—is especially important with low-
achievers. This can be done by reducing class size or by
increasing the number of teachers. The extra teachers, if

not as highly qualified as the regulars, should neverthe-
less be trained and familiar with the lessons. They can
be substitutes, teachers in training or even members of
the domestic counterpart of the Peace Corps whenever
that is established. They should be able to help with
routine tasks, with keeping order—and with seeing to it
that each child has more time, attention, care and
opportunity to learn.

Very poor children need hope in order to achieve. So
do those who work with them.

March/April 1965

How Teachers Learn
to Help Children Fail

ESTELLE FUCHS

Ideally, public schools exist to educate the child. But a high percentage of pupils fail as early as the fifth or sixth grade, especially in the urban slums. For many children, the educational process bogs down at a time when it has barely begun. Now, educators and social scientists have proposed a number of theories to explain this high rate of failure among slum-school children. One of them is that the slum-school system's tacit belief that social conditions outside the school make such failures inevitable *does* make such failures inevitable.

How this expectation of failure affects the instruction of lower-class children and becomes a self-fulfilling prophecy is suggested in data collected by Hunter College's Project TRUE (Teacher Resources for Urban Education), a study that focused on the experiences of 14 fledgling teachers in New York's inner-city elementary schools. As part of the study, several new

teachers tape-recorded accounts of their first-semester teaching experiences in "special service" schools— schools that invariably had high Negro or Puerto Rican enrollments, retarded reading levels among the students, and constant discipline problems.

The following excerpts from one teacher's account show how the slum school gradually instills, in even the best-intentioned teacher, the prevailing rationale for its own failure: the idea that in the slum, it is the child and the family who fail, but never the school.

October 26

Mrs. Jones, the sixth-grade teacher, and I were discussing reading problems. I said, "I wonder about my children. They don't seem too slow; they seem average. Some of them even seem to be above average. I can't understand how they can grow up to be fifth- and sixth-graders and still be reading on the second-grade level. It seems absolutely amazing."

Mrs. Jones [an experienced teacher] explained about the environmental problems that these children have. "Some of them never see a newspaper. Some of them have never been on the subway. The parents are so busy having parties and things that they have no time for their children. They can't even take them to a museum or anything. It's very important that the teacher stress books."

Mrs. Jones tells her class, "If anyone asks you what you want for Christmas, you can say you want a book." She told me that she had a 6-1 class last year, and it was absolutely amazing how many children had never even seen a newspaper. They can't read Spanish either. So she said that the educational problem lies with the parents. They are the ones that have to be educated.

It's just a shame that the children suffer. This problem will take an awful lot to straighten it out. I guess it won't take one day or even a year; it will take time.

December 14

Here I am, a first-grade teacher. I get a great thrill out of these children being able to read but I often wonder, "Am I teaching them how to read or are they just stringing along sight words that they know?" I never had a course in college for teaching phonetics to children. In this school we have had conferences about it, but I really wish that one of the reading teachers would come in and specifically show me how to go about teaching phonetics. I have never gotten a course like this and it is a difficult thing, especially when there is a language barrier and words are quite strange to these children who can't speak English. How can they read English? We have a great responsibility on our shoulders and teachers should take these things seriously.

January 4

Something very, very important and different has happened to me in my school. It all happened the last week before the vacation on Tuesday. Mr. Frost, our principal, came over to me and asked if I would be willing to take over a second-grade class starting after the vacation. Well, I looked at him and I said, "Why?"

He told me briefly that the registers in the school have dropped and according to the board of education the school must lose a teacher. Apparently he was getting rid of a second-grade teacher and he wanted to combine two of the first-grade classes. The registers on the first grade were the lowest in the school, I believe. Anyway, he told me that he was going to all the

afternoon first-grade teachers asking if any of them would be willing to change in the middle of the term. He said he thought perhaps someone would really want it and, instead of his just delegating a person, it would be better if he asked each one individually.

I was torn between many factors. I enjoyed my class very, very much and I enjoyed teaching the first grade. But because I was teaching afternoon session (our school runs on two different sessions), I was left out of many of the goings-on within the school as my hours were different and it also sort of conflicted with my home responsibilities. Well, with these two points in mind, I really felt that I would rather stay with my class than to switch over in the middle of the term.

But he explained further that some of the classes would not remain the same because there would be many changes made. So, being the type of person that I am, I felt that, even though I did want to stay with my class and the children and the first grade, if something had to be done in the school, there was no way of stopping it and I might as well do it. I explained to Mr. Frost that even though I wouldn't want to change in the middle—after all it would be a whole new experience, two classes of children would be suffering by the change—but if it had to be done I would be willing to take on the new responsibility.

With that, Mr. Frost said, "Thank you," and said he would go around to the other teachers to see if anyone really wanted to change. Well, already I felt that it was going to be me, but I wasn't sure.

A little later on in the day I was taking my class to recess, and we were lining up in the hall. I spoke to Miss Lane, another teacher, and she said that he had also spoken to her. At that point Mr. Frost came over and

told me that he was sorry but that I had been the one elected. Well, I said that I hoped that I would be able to do a good job, and that was that.

From that point on, there was an awful lot of talk in the school. Everybody was talking about it, at least, everyone who knew something about the matter. So all the afternoon first-grade teachers and all the morning first-grade teachers knew, and many of the new teachers (those that I came into the school with), and apparently there was a lot of business going on that I can't begin to describe because I don't know how the whole thing started in the first place. However, from the office I did find out that it wasn't Mr. Frost's fault or anything that the second-grade teacher was going to be dismissed. It was a directive from higher up that stated he would lose a teacher. How he chose this particular teacher to let go I really can't say. I understand that they really didn't get along too well and neither of them were too happy in the school working together.

Everything went so quickly and everybody was talking to me. Mrs. Parsons spoke to me. She is my assistant principal. She was supervisor of the first grade and she will be in charge of the second grade also. I was told that I would have to take over the new class on January 2, the first day that we return from the vacation. I really felt terrible about my children, but it was something that had to be done and I did it.

Thursday, Mr. Frost talked to the other afternoon teachers and myself. He referred to me as the hero and he said, "Now it's your turn to be heroes also." He asked the afternoon first-grade teachers if they would be willing to have their registers become higher by having my 27 children split up among the four remaining afternoon classes, or did they think he should have them

split up among all the first-grade classes, some of which met in the morning.

He was straightforward, saying that he didn't think it would be a good idea for the children to be split up among all the first-grade teachers. I agreed with him. He felt that it would be trying on the parents and on the children to have a whole new schedule worked out. After all, if you're used to going to school from 12 to 4, coming to school from 7:30 to 12 is quite a difference. It would be very, very hard on the parents. Especially in this neighborhood where sometimes they have a few children in the same grade, a few in different grades. So I agreed with Mr. Frost. The other teachers didn't seem too happy about the idea, but they said they would go along with it.

Mr. Frost and Mrs. Parsons worked out a plan whereby the 1-1 class register would go up to 35 which is generally what a 1-1 class has. The 1-3 class register would go up to 32 or 33. And so forth down the line. 1-5 (my class) would be erased. The teachers didn't think it was so bad then, but we all did have added responsibilities.

Mr. Frost then added that if we had any children in our classes that we felt did not belong, this was our chance to have them changed, since there would be many interclass transfers in order to make more homogeneous classes. So we all had to sit down and think—"Who belongs? Who doesn't belong?" I, of course, had to decide where 27 children would belong.

I went through my class and divided them into groups to the best of my ability. In the 1-1 class, I put Joseph R., who scored the highest on the reading-readiness test. As a result of his score and his work in class, I felt Joseph did belong in the 1-1 class. Lydia A., who I

believe is a very smart girl and who wasn't really working as well as she could in my class, I felt belonged in the 1-1 class. Lydia scored second highest on the reading-readiness test. In the 1-1 class, I also put Anita R. Anita is a bit older than the rest of the children but she has caught on most beautifully to most phases of school work even though she just came to the United States last March. Also, she scored the same as Lydia on the reading-readiness test.

Then I decided that I would put Robert M. in the 1-1 class. I felt strongly that Robert was by far the best child in my class. Robert did every bit of the work ever assigned. He caught on very, very quickly to all phases of work besides doing his work well, quickly, efficiently and neatly. Even though on reading-readiness he only scored in the 50th percentile, I felt he really stood out and I also felt that once you're in a "1" class, unless you really don't belong, you have a better chance. The "1" class is really the only class that you would term a "good" class. So those four children I recommended for the 1-1 class.

Then I went down the line and for the 1-3 class, I picked nine children, really good children who, on the whole, listened and did their work. Most of them scored in the 50th and 40th percentile on reading-readiness, and they were coping with school problems very, very well. In the 1-7 class, I put the slower children and in the 1-9 class, of course, which is Mrs. Gould's, I put all the children that really weren't doing well in school work at all. First, Alberto S. Alberto who is still not able to write his name. Then I put Beatrice L., Stella S., Pedro D., and several others, who really were not working well, in the 1-9 class.

I know that the other teachers do have a big job

before them because whichever class these children are placed in will not have been doing exactly the same work. The children either have much to catch up on or they might review some of the work, and the teachers will have to be patient either way. I really don't think anyone will have serious discipline problems, except perhaps in the 1-1 class where Lydia and Anita have been placed.

The time came when I had to tell the children that I would not be their teacher anymore. Well, as young as they are, I think that many of them caught on immediately, and before I could say anything, faces were very, very long and the children were mumbling, "But I wanted you for a teacher."

That was all I needed! I felt even worse than I felt when I found out that I wouldn't be with them anymore. So I continued talking and I told them that it's just something that happens and that I would still be in the school and maybe next year they would get me when they go to the second grade. I told them that I would miss them all, that they would have a lot of fun in their new classes, and they would learn a lot. And, of course, I said, "You know all the other teachers. Some of you will get Mrs. Lewis. Some will get Miss Lane, some will get Miss Taylor, and some will get Mrs. Gould.

To my astonishment Anita kept saying over and over, "But I want you for a teacher. But I want you for a teacher."

I looked around the room. Most of the children were sitting there with very, very long faces. Joseph C. was sitting there with the longest face you could imagine, Robert G. said he didn't want another teacher, and all of a sudden Joseph started crying and just didn't stop. He cried all the way out into the hall when we got

dressed to go home. I spoke to him softly and said, "Joseph, wouldn't you like Miss Lane for a teacher?" She was standing right near me, and finally he stopped crying.

I said goodbye to them and that I would see them all. And that was the end of my class

Good schools. Poor schools. What is a good school? Is a good school one that is in a good neighborhood, that has middle-class children? Is a poor school one in a depressed area where you have Negro and Puerto Rican children? These are common terms that people refer to all the time. They hear your school is on Wolf Street—"Oh, you must be in a bad school."

I don't really think that that is what a good or a bad school is. I think a good school is a school that is well run, has a good administration, has people that work together well, has good discipline and where the children are able to learn and also, of course, where there are numerous facilities for the children and the teachers. In my estimation a poor or a bad school would be one in which the administration and the teachers do not work together, are not working in the best interests of the children and where learning is not going on. Also, a poor school is one where you don't have proper facilities. I am not acquainted with many of the public schools, and I really can't say that the ones that I know are better or worse.

I believe my school is a pretty good school. It isn't in the best neighborhood. There are many, many problems in my school but on the whole I think that the teachers and the administration work together and I do believe that they are doing the best they can with the problems that are around.

You have to remember that in a school such as ours

the children are not as ready and willing to learn as in schools in middle-class neighborhoods.

When a new teacher enters the classroom, she must learn the behavior, attitudes and skills required in the new situation. Much of this learning is conscious. Some of it is not. What is significant is that, while on the job, the teacher is socialized to her new role—she is integrated into the society of the school, and learns the values, beliefs, and attitudes that govern its functioning.

The saga of class 1-5 shows the subtle ways in which one new teacher is socialized to her job. In just a few months, she accepts the demands of the school organization and its prevailing rationale for student failure.

The new teacher of class 1-5 in a slum school begins her career with a warm, friendly attitude toward her students. She respects and admires their abilities and is troubled by what the future holds for them: by the sixth grade in her school, educational failure is very common.

Very early in her teaching career, however, a more experienced teacher exposes this new teacher to the belief, widely held, that the children come from inferior backgrounds and that the deficits in their homes—expressed here as lack of newspapers and parental care—prevent educational achievement. That the teachers and the school as an institution contribute to the failure of the children is never even considered as a possible cause. The beginning teacher, in her description of what happens to class 1-5, then provides us with a graphic account of the ways in which this attitude can promote failure.

First, let us examine the actual instruction of the children. Early in her career, this new, very sincere

teacher is painfully aware of her own deficiencies. Unsure about her teaching of so fundamental a subject as reading, she raises serious questions about her own effectiveness. As yet, she has not unconsciously accepted the notion that the failure of children stems from gaps in their backgrounds. Although no consensus exists about reading methodology, the teacher tells us that there are serious weaknesses in feedback evaluation—and that she is unable to find out what the children have been taught or what they have really learned.

By the end of the term, all this has changed. By that time, the eventual failure of most of class 1-5 has been virtually assured. And the teacher has come to rationalize this failure in terms of pupil inadequacy.

In the particular case of class 1-5, the cycle of failure begins with a drop in the number of students registered in the school. The principal loses a teacher, which in turn means dissolving a class and subsequently distributing its children among other classes. The principal and the teachers have no control over this event. In the inner-city schools, education budgets, tables of organization, and directions from headquarters create conditions beyond the control of the administrators and teachers who are in closest touch with the children.

A drop in pupil registers would seemingly provide the opportunity for a higher adult-pupil ratio and, consequently, more individualized instruction and pedagogical supports for both youngsters and teachers. In a suburban school, this is probably what would have occurred. But in this slum school, the register drop leads to the loss of a teacher, larger classes, and—perhaps most important—increased time spent by the administrator and his staff on the mechanics of administration rather

than on the supervision of instruction. (Why *this* particular teacher is released is unclear, though her substitute status and low rank in the staff hierarchy probably contribute to her release.) As a result many classes are disrupted, several first-grade class registers grow larger, time for instruction is lost, and concern is felt by teachers and pupils alike.

An even more significant clue to the possible eventual failure of the children is described in poignant detail— when the teacher tells how the youngsters in her class are to be distributed among the other first-grade classes. Educators now know that children mature at different rates; that they have different rates of learning readiness; and that developmental differences between boys and girls are relevant to learning. To forecast the educational outcome of youngsters at this early state of their development, without due provision for these normal growth variations, is a travesty of the educational process. Yet here, in the first half of the first grade, a relatively inexperienced young teacher, herself keenly aware of her own deficiencies as an educator, is placed in the position of literally deciding the educational future of her charges.

A few are selected for success—"I felt that once you're in a '1' class, unless you really don't belong, you have a better chance. The '1' class is really the only class that you would term a 'good' class." Several children are placed in a class labeled "slow." And the remaining youngsters are relegated to a state of limbo, a middle range that does not carry the hope of providing a "better chance."

Thus, before these youngsters have completed a full four months of schooling, their educational futures have been "tracked": all through the grades, the labels of

their class placement will follow them, accompanied by teacher attitudes about their abilities. Some youngsters are selected very early for success, others written off as slow. Because differential teaching occurs and helps to widen the gap between children, the opportunity to move from one category to another is limited. In addition, the children too become aware of the labels placed upon them. And their pattern for achievement in later years is influenced by their feelings of success or failure in early school experiences.

The teacher, as she reflects upon what a "good" or a "bad" school is, continues to include how well the children learn as a significant criterion, together with good relations between staff and administration. But the children in her school do not achieve very well academically, so when describing her school as "good," she stresses the good relations between the administration and the teachers. The fact that the children do not learn does not seem so important now: "the children are not as ready and willing to learn as in schools in middle-class neighborhoods."

How well our teacher has internalized the attitude that deficits of the children themselves explain their failure in school! How normal she now considers the administrative upheavals and their effects upon teachers and children! How perfectly ordinary she considers the "tracking" of youngsters so early in their school years!

The teacher of class 1-5 has been socialized by the school to accept its structure and values. Despite her sincerity and warmth and obvious concern for the children, this teacher is not likely to change the forecast of failure for most of these children—because she has come to accept the very structural and attitudinal factors that make failure nearly certain. In addition,

with all her good intentions, she has come to operate as an agent determining the life chances of the children in her class—by distributing them among the ranked classes in the grade.

This teacher came to her job with very positive impulses. She thought highly of her youngsters and was disturbed that, with what appeared to be good potential, there was so much failure in the school in the upper grades. She looked inward for ways in which she might improve her efforts to forestall retardation. She was not repelled by the neighborhood in which she worked. There is every indication that she had the potential to become a very effective teacher of disadvantaged youngsters.

Her good impulses, however, were not enough. This young teacher, unarmed with the strength that understanding the social processes involved might have given her and having little power within the school hierarchy, was socialized by the attitudes of those around her, by the administration, and by the availability of a suitable rationale to explain her and the school's failure to fulfill their ideal roles. As a result she came to accept traditional slum-school attitudes toward the children—and traditional attitudes toward school organization as the way things have to be. This teacher is a pleasant, flexible, cooperative young woman to have on one's staff. But she has learned to behave and think in a way that perpetuates a process by which disadvantaged children continue to be disadvantaged.

The organizational structure of the large inner-city school and the attitudes of the administrators and teachers within it clearly affect the development of the children attending. No theory proposed to explain the academic failure of poor and minority-group children

can ignore the impact of the actual school experience and the context in which it occurs.

September 1968

The Self-Fulfilling Prophecy in Ghetto Education

RAY C. RIST

Teacher-student relationships and the dynamics of interaction between teacher and students are far from uniform. For any child within the classroom, variations in the experience of success or failure, praise or ridicule, freedom or control, creativity or docility, comprehension or mystification may ultimately have significance far beyond the classroom. This chapter will explore what is generally regarded as a crucial aspect of the classroom experience for the children involved—the process whereby expectations and social interactions give rise to the social organization of the class. During this process, out of a large group of children and an adult unknown to one another prior to the beginning of the school year, emerges patterns of behavior, expectations of performance, and a mutually accepted stratification system delineating those doing well from those doing poorly.

A number of studies have sought to determine what effect on children a teacher's values, beliefs, attitudes and expectations may have. Many researchers have noted that how a teacher expects a pupil to perform may have a strong influence on his actual academic performance. They have sought to validate a type of educational self-fulfilling prophecy: if the teacher expects high performance she receives it, and vice versa. But few if any of these studies have explained either the basis upon which such differential expectations are formed or how they are manifested within the classroom. Here we shall attempt to answer these questions, by describing both the factors that are critical in the teacher's development of expectations for various groups of her pupils and the process by which such expectations influence the classroom experience.

Data for this study were collected by means of twice weekly one and one-half hour observations of a single group of black children in an urban ghetto school who began kindergarten in September of 1967. Formal observations were conducted throughout the year while the children were in kindergarten and again in 1969 when these same children were in the first half of their second-grade year. The children were also visited informally four times in the classroom during their first-grade year. The difference between the formal and informal observations consisted in the fact that during formal visits, a continuous handwritten account was taken of classroom interaction and activity as it occurred. The informal observations did not include the taking of notes during the classroom visit, but comments were written after the visit. Additionally, a series of interviews were conducted with both the kindergarten and the second-grade teachers. No mechanical

devices were utilized to record classroom activities or interviews.

The particular school which the children attend was built in the early part of the 1960s. It has classes from kindergarten through the eighth grade and a single special education class. The enrollment fluctuates near the 900 level while the teaching staff consists of 26 teachers, in addition to a librarian, two physical education instructors, the principal and an assistant principal. There are also at the school, on a part time basis, a speech therapist, social worker, nurse and doctor, all employed by the Board of Education. All administrators, teachers, staff and pupils are black. (The author is Caucasian.) The school is located in a blighted urban area that has 98 percent black population within its census district. Within the school itself, nearly 500 of the 900 pupils (55 percent) come from families supported by funds from Aid to Dependent Children. I do not believe that this school and the classrooms within it are atypical from others in urban black neighborhoods.

The school in which this study occurred was selected by the District Superintendent as one of five available to the research team. All five schools were visited during the course of the study and detailed observations were conducted in four of them. The principal at the school reported upon in this study commented that I was very fortunate in coming to his school since his staff (and kindergarten teacher in particular) were equal to "any in the city."

The Kindergarten Class

Prior to the beginning of the school year, the teacher possessed several different kinds of information regarding the children that she would have in her class. The

first was the preregistration form, which gave the name of the child, his age, the name of his parents, his home address, his phone number and whether he had had any preschool experience. The second source of information was a tentative list of all children enrolled in the kindergarten class who lived in homes that received public welfare funds, and was provided by the school social worker.

Third, an interview was held with the mother and child during the registration period in the few days prior to the beginning of school or during the first days of school. Medical information and any specific paternal concern related to the child were gathered. This latter information was noted on the "Behavioral Questionnaire" where the mother was to indicate her concern, if any, on 28 different items. Such items as thumbsucking, bed-wetting, loss of bowel control, lying, stealing, fighting and laziness were included on this questionnaire.

The fourth source of information was the teachers' experiences with older siblings. A rather strong informal norm had developed among teachers in the school such that pertinent information, especially that related to discipline matters, was passed on to the next teacher of the student. Frequently, during the first days of the school year, there were admonitions to a specific teacher to "watch out" for a child believed to be a "troublemaker." Teachers would also relate techniques of controlling the behavior of a student who had been disruptive in the class. Thus a variety of information concerning students in the school was shared, whether that information regarded academic performance, behavior in class or the parents and their interest in the student and the school.

When the kindergarten teacher made the permanent seating assignments on the eighth day of school, not only had she the above four sources of information concerning the children, but she had also had time to observe them within the classroom setting. Thus the behavior, degree and type of verbalization, dress, mannerisms, physical appearance and performance on the early tasks assigned during class were available to her as she began to form opinions concerning the capabilities and potential of the various children. There seems to be little doubt that such evaluation of the children by the teacher was beginning. Within a few days, only a certain group of children were continually being called on to lead the class in the Pledge of Allegiance, read the weather calendar each day, come to the front for "show and tell" periods, take messages to the office, count the number of children present in the class, pass out materials for class projects, be in charge of equipment on the playground, and lead the class to the bathroom, library or on a school tour. This one group of children, that continually were physically close to the teacher and had a high degree of verbal interaction with her, she placed at Table 1.

As one progressed from Table 1 to Table 2 and Table 3, there was an increasing dissimilarity between each group of children at the different tables on at least four major criteria. The first criterion appeared to be the physical appearance of the child. While the children at Table 1 were all dressed in clean clothes that were relatively new and pressed, most of the children at Table 2, and with only one exception at Table 3, were all quite poorly dressed. The clothes were old and often quite dirty. The children at Tables 2 and 3 also had a noticeably different quality and quantity of clothes to

wear, especially during the winter months. Whereas the children at Table 1 would come on cold days with heavy coats and sweaters, the children at the other two tables often wore very thin spring coats and summer clothes. The single child at Table 3 who came to school quite nicely dressed came from a home in which the mother was receiving welfare funds, but was supplied with clothing for the children by the families of her brother and sister.

An additional aspect of the physical appearance of the children related to their body odor. While none of the children at Table 1 came to class with an odor of urine on them, there were two children at Table 2 and five children at Table 3 who frequently had such an odor. There was not a clear distinction among the children at the various tables as the the degree of "blackness" of their skin, but there were more children at the third table with very dark skin (five in all) than there were at the first table (three). There was also a noticeable distinction among the various groups of children as to the condition of their hair. While the three boys at Table 1 all had short hair cuts and the six girls at the same table had their hair "processed" and combed, the number of children with either matted or unprocessed hair increased at Table 2 (two boys and three girls) and eight of the children at Table 3 (four boys and four girls). None of the children in the kindergarten class wore their hair in the style of a "natural."

A second major criteria which appeared to differenti-ate the children at the various tables was their inter-action, both among themselves and with the teacher. The several children who began to develop as leaders within the class by giving directions to other members,

initiating the division of the class into teams on the playground, and seeking to speak for the class to the teacher ("We want to color now"), all were placed by the teacher at Table 1. This same group of children displayed considerable ease in their interaction with her. Whereas the children at Tables 2 and 3 would often linger on the periphery of groups surrounding the teacher, the children at Table 1 most often crowded close to her.

The use of language within the classroom appeared to be the third major differentiation among the children. While the children placed at the first table were quite verbal with the teacher, the children placed at the remaining two tables spoke much less frequently with her. The children placed at the first table also displayed a greater use of Standard American English within the classroom. Whereas the children placed at the last two tables most often responded to the teacher in black dialect, the children at the first table did so very infrequently. In other words, the children at the first table were much more adept at the use of "school language" than were those at the other tables. The teacher utilized Standard American English in the classroom and one group of children was able to respond in a like manner. The frequency of a "no response" to a question from the teacher was recorded at a ratio of nearly three to one for the children at the last two tables as opposed to Table 1. When questions were asked, the children who were placed at the first table most often gave a response.

The final apparent criterion by which the children at the first table were quite noticeably different from those at the other tables consisted of a series of social factors which were known to the teacher prior to her

seating the children. Though it is not known to what degree she utilized this particular criterion when she assigned seats, it does contribute to developing a clear profile of the children at the various tables. Table 1 gives a summary of the distribution of the children at the three tables on a series of variables related to social and family conditions. Such variables may be considered to give indication of the relative status of the children within the room, based on the income, education and size of the family.

Believing, as I do, that the teacher did not randomly assign the children to the various tables, it is necessary to indicate the basis for the seating arrangement. I would contend that the teacher developed, utilizing some combination of the four criteria outlined above, a series of expectations about the potential performance of each child and then grouped the children according to perceived similarities in expected performance. The teacher herself informed me that the first table consisted of her "fast learners" while those at the last two tables "had no idea of what was going on in the classroom." What becomes crucial in this discussion is to ascertain the basis upon which the teacher developed her criteria of "fast learner" since there had been no formal testing of the children as to their academic potential or capacity for cognitive development. She made evaluative judgements of their expected capacities to perform academic tasks after eight days of school.

Certain criteria became indicative of expected success and others became indicative of expected failure. Those children who closely fit the teacher's "ideal type" of the successful child were chosen for seats at Table 1. Those children that had the least "goodness of fit" with her ideal type were placed at the third table. The criteria

TABLE 1: Distribution of Socioeconomic Status Factors by Seating Arrangement at the Three Tables in the Kindergarten Classroom.

Factors	Seating Arrangement*		
	Table 1	Table 2	Table 3
Income			
1) Families on welfare	0	2	4
2) Families with father employed	6	3	2
3) Families with mother employed	5	5	5
4) Families with both parents employed	0	3	2
5) Total family income below $3,000./yr *=	5	4	7
6) Total family income above $12,000./yr.**	2	0	0
Education			
1) Father ever grade school	6	3	2
2) Father ever high school	5	2	1
3) Father ever college	1	0	0
4) Mother ever grade school	9	10	8
5) Mother ever high school	7	6	5
6) Mother ever college	4	0	0
7) Children with pre-school experience	1	1	0
Family Size			
1) Families with one child	3	1	0
2) Families with six or more children	2	6	7
3) Average number of siblings in family	3-4	5-6	6-7
4) Families with both parents present	6	3	2

*There are nine children at Table 1, eleven at Table 2, and ten children at Table 3.

**Estimated from stated occupation.

upon which a teacher would construct her ideal type of the successful student would rest in her perception of certain attributes in the child that she believed would make for success. To understand what the teacher considered as "success," one would have to examine her perception of the larger society and whom in that larger society she perceived as successful. I believe that the reference group utilized by Mrs. Caplow to determine what constituted success was a mixed black-white, well-educated middle class. (The names of all staff and students are pseudonyms.) Those attributes most desired by educated members of the middle class became the basis for her evaluation of the children. Highly prized middle-class status for the child in the classroom was attained by demonstrating ease of interaction among adults; high degree of verbalization in Standard American English; the ability to become a leader; a neat and clean appearance; coming from a family that is educated, employed, living together and interested in the child; and the ability to participate well as a member of a group.

The kindergarten teacher appeared to have been raised in a home where the above values were emphasized as important. Her mother was a college graduate, as were her brother and sisters. The family lived in the same neighborhood for many years, and the father held a responsible position with a public utility company in the city. The family was devoutly religious and those of the family still in the city attend the same church. She and other members of her family were active in a number of civil rights organizations in the city. The attributes indicative of "success" among those of the educated middle class had been attained by the teacher. She was a college graduate, held positions of respect and

responsibility in the black community, lived in a comfortable middle-class section of the city in a well-furnished and spacious home, together with her husband earned over $20,000 per year, was active in a number of community organizations, and had parents, brother and sisters similar in education, income and occupational positions.

The teacher's preferential treatment of a select group of children appeared to be derived from her belief that certain behavioral and cultural characteristics are more crucial to learning in school than are others. In a similar manner, those children who appeared not to possess the criteria essential for success were ascribed low status and described as "failures" by the teacher. They were relegated to positions at Table 2 and 3. The placement of the children then appeared to result from their possessing or lacking the certain desired cultural characteristics perceived as important by the teacher.

The organization of the kindergarten classroom became the basis for the differential treatment of the children for the remainder of the school year. From the day that the class was assigned permanent seats, the activities in the classroom perceivably changed. The fundamental division of the class into those expected to learn and those expected not to permeated the teacher's orientation to the class.

The teacher's rationalization for narrowing her attention to selected students was that the majority of the remainder of the class (in her words) "just had no idea of what was going on in the classroom." Her reliance on the few students of ascribed high social status reached such proportions that on occasion, the teacher would use one of these students as an exemplar that the remainder of the class would do well to emulate.

(It is Fire Prevention Week and the teacher is trying
to have the children say so. The children make a
number of incorrect responses, a few of which
follow:) Jim who had raised his hand, in answer to
the question, "Do you know what week it is?" says,
"October." The teacher says "No, that's the name of
the month. Jane, do you know what special week this
is?" and Jane responds, "It cold outside." Teacher
says, "No, that is not it either. I guess I will have to
call on Pamela. Pamela, come here and stand by me
and tell the rest of the boys and girls what special
week this is." Pamela leaves her chair, comes and
stands by the teacher, turns and faces the rest of the
class. The teacher puts her arm around Pamela, and
Pamela says, "It fire week." The teacher responds,
"Well Pamela, that is close, actually it is Fire
Prevention Week."

On another occasion, the Friday after Hallowe'en, the
teacher informed the class that she would allow time for
all the students to come to the front of the class and tell
of their experiences. She, in reality, called on six
students, five of whom sat at Table 1 and the sixth at
Table 2. Not only on this occasion, but on others, the
teacher focused her attention on the experiences of the
higher status students.

(The students are involved in acting out a skit
arranged by the teacher on how a family should come
together to eat the evening meal.) The students acting
the roles of mother, father and daughter are all from
Table 1. The boy playing the son is from Table 2. At
the small dinner table set up in the center of the
classroom, the four children are supposed to be
sharing with each other what they had done during
the day—the father at work, the mother at home and

the two children at school. The Table 2 boy makes
few comments. (In real life he has no father and his
mother is supported by ADC funds.) The teacher
comments, "I think that we are going to have to let
Milt (Table 1) be the new son. Sam, why don't you
go and sit down. Milt, you seem to be one who would
know what a son is supposed to do at the dinner
table. You come and take Sam's place."

In this instance, the lower-status student was penalized,
not only for failing to have verbalized middle-class table
talk, but more fundamentally for lacking middle-class
experiences. He had no actual father to whom he could
speak at the dinner table, yet he was expected to speak
fluently with an imaginary one.

Though the blackboard was long enough to extend
parallel to all three tables, the teacher wrote such
assignments as arithmetic problems and drew all illustra-
tions on the board in front of the students at Table 1. A
rather poignant example of the penalty the children at
Table 3 had to pay was that they often could not see
the board material.

Lilly stands up out of her seat. Mrs. Caplow asks Lilly
what she wants. Lilly makes no verbal response to the
question. Mrs. Caplow then says rather firmly to
Lilly, "Sit down." Lilly does. However, Lilly sits
down sideways in the chair (so she is still facing the
teacher) Mrs. Caplow instructs Lilly to put her feet
under the table. This Lilly does. Now she is facing
directly away from the teacher and the blackboard
where the teacher is demonstrating to the students
how to print the letter, "O."

The realization of the self-fulfilling prophecy within
the classroom was in its final stages by late May of the
kindergarten year. Lack of communication with the

teacher, lack of involvement in the class activities and infrequent instruction all characterized the situation of the children at Tables 2 and 3. During one observational period of an hour in May, not a single act of communication was directed towards any child at either Table 2 or 3 by the teacher except for twice commanding "sit down." The teacher devoted her attention to teaching those children at Table 1. Attempts by the children at Table 2 and 3 to elicit the attention of the teacher were much fewer than earlier in the school year.

In June, after school had ended for the year, the teacher was asked to comment on the children in her class. Of the children at the first table, she noted:

I guess the best way to describe it is that very few children in my class are exceptional. I guess you could notice this just from the way the children were seated this year. Those at Table 1 gave consistently the most responses throughout the year and seemed most interested and aware of what was going on in the classroom.

Of those children at the remaining two tables, the teacher commented:

It seems to me that some of the children at Table 2 and most all the children at Table 3 at times seem to have no idea of what is going on in the classroom and were off in another world all by themselves. It just appears that some can do it and some cannot. I don't think that it is the teaching that affects those that cannot do it, but some are just basically low achievers.

The students in the kindergarten classroom did not sit passively, internalizing the behavior the the teacher directed towards them. Rather, they responded to the stimuli of the teacher, both in internal differentiations

within the class itself and also in their response to the teacher.

For the high-status students at Table 1, the response to the track system of the teacher appeared to be at least three-fold. One such response was the directing of ridicule and belittlement towards those children at Tables 2 and 3. At no point during the entire school year was a child from Table 2 or 3 ever observed directing such remarks at the children at Table 1.

Jim starts to say out loud that he is smarter than Tom. He repeats it over and over again, "I smarter than you. I smarter than you." (Jim sits at Table 1, Tom at Table 3.)

Milt came over to the observer and told him to look at Lilly's shoes. I asked him why I should and he replied, "Because they so ragged and dirty." (Milt is at Table 1, Lilly at Table 3.)

When I asked Lilly what it was that she was drawing, she replied, "A parachute." Gregory interrupted and said, "She can't draw nothin'."

The problems of those children who were of lower status were compounded, for not only had the teacher indicated her low esteem of them, but their peers had also turned against them. The implications for the future schooling of a child who lacks the desired status credentials in a classroom where the teacher places high value on middle-class "success" values and mannerisms are tragic.

It must not be assumed, however, that though the children at Tables 2 and 3 did not participate in classroom activities and were systematically ignored by the teacher, they did not learn. I contend that in fact they did learn, but in a fundamentally different way from the way in which the high-status children at Table

1 learned. The children at Table 2 and 3 who were unable to interact with the teacher began to develop patterns of interaction among themselves whereby they would discuss the material that the teacher was present- ing to the children at Table 1. Thus I have termed their method of grasping the material "secondary learning" to imply that knowledge was not gained in direct inter- action with the teacher, but through the mediation of peers and also through listening to the teacher though she was not speaking to them. That the children were grasping, in part, the material presented in the class- room, was indicated to me in home visits when the children who sat at Table 3 would relate material specifically taught by the teacher to the children at Table 1. It is not that the children at Table 2 and 3 were ignorant of what was being taught in the class, but rather that the patterns of classroom interaction estab- lished by the teacher inhibited the low-status children from verbalizing what knowledge they had accumulated. From the teacher's terms of reference, those who could not discuss must not know. Her expectations continued to be fulfilled, for though the low-status children had accumulated knowledge, they did not have the opportu- nity to verbalize it and, consequently, the teacher could not know what they had learned.

A second response of the higher status students to the differential behavior of the teacher towards them was to seek solidarity and closeness with the teacher and urge Table 2 and 3 children to comply with her wishes.

The teacher is out of the room. Pamela says to the class, "We all should clean up before the teacher comes." Shortly thereafter the teacher has still not returned and Pamela begins to supervise other chil- dren in the class. She says to one girl from Table 3,

"Girl, leave that piano alone." The child plays only a short time longer and then leaves.

The teacher has instructed the students to go and take off their coats since they have come in from the playground. Milt says, "OK y'all, let's go take off our clothes."

When the teacher tells the students to come from their desks and form a semicircle around her, Gregory scoots up very close to Mrs. Caplow and is practically sitting in her lap.

Not only would the Table 1 students attempt to control and ridicule the Table 2 and 3 students, but they also perceived and verbalized that they, the Table 1 students, were better students and were receiving differential treatment from the teacher.

The children are rehearsing a play, Little Red Riding Hood. Pamela tells the observer, "The teacher gave me the best part." The teacher overheard this comment, smiled, and made no verbal response.

The children are preparing to go on a field trip to a local dairy. The teacher has designated Gregory as the "sheriff" for the trip. Mrs. Caplow stated that for the field trip today Gregory would be the sheriff. Mrs. Caplow simply watched as Gregory would walk up to a student and push him back into line saying, "Boy, stand where you suppose to." Several times he went up to students from Table 3 and showed them the badge that the teacher had given to him and said, "Teacher made me sheriff."

The children seated at the first table were internalizing the attitudes and behavior of the teacher towards those at the remaining two tables. That is, as the teacher responded from her reference group orientation as to which type of children were most likely to succeed and

which type most likely to fail, she behaved towards the two groups of children in a significantly different manner. The children from Table 1 were also learning through emulating the teacher how to behave towards other black children who came from low-income and poorly educated homes. The teacher, who came from a well-educated and middle-income family, and the children from Table 1 who came from a background similiar to the teacher's, came to respond to the children from poor and uneducated homes in a strikingly similar manner.

The lower-status students in the classroom from Tables 2 and 3 responded in significantly different ways to the stimuli of the teacher. The two major responses of the Table 2 and 3 students were withdrawal and verbal and physical in-group hostility. The withdrawal took the form of physical withdrawal, but most often it was psychological.

Betty, a very poorly dressed child, had gone outside and hidden behind the door. . . . Mrs. Caplow sees Betty leave and goes outside to bring her back, says in an authoritative and irritated voice, "Betty, come here right now." When the child returns, Mrs. Caplow seizes her by the right arm, brings her over to the group and pushes her down to the floor. Betty begins to cry. . . . The teacher now shows the group a large posterboard with a picture of a white child going to school.

The teacher is demonstrating how to mount leaves between two pieces of wax paper. Betty leaves the group and goes back to her seat and begins to color. The teacher is instructing the children in how they can make a "spooky thing" for Hallowe'en. James turns away from the teacher and puts his head on his

desk. Mrs. Caplow looks at James and says, "James, sit up and look here."

The teacher has the children seated on the floor in front of her asking them questions about a story that she had read to them. The teacher says, "June, your back is turned. I want to see your face." (The child had turned completely around and was facing away from the group.)

The verbal and physical hostility that the children at Tables 2 and 3 began to act out among themselves in many ways mirrored what the Table 1 students and the teacher were also saying about them. There are numerous instances in the observations of the children at Tables 2 and 3 calling one another "stupid," "dummy," or "dumb dumb." Racial overtones were noted on two occasions when one boy called another a "nigger," and on another occasion when a girl called a boy an "almond head." Threats of beatings, "whoppins," and even spitting on a child were also recorded among those at Tables 2 and 3. Also at Table 2, two instances were observed in which a single child hoarded all the supplies for the whole table. Similar manifestations of hostility were not observed among those children at the first table. A popular "folk myth" of American society is that children are inherently cruel to one another and that this tendency towards cruelty must be socialized into socially acceptable channels. The evidence from this classroom would indicate that much of the cruelty displayed was a result of the social organization of the class. Those children at Tables 2 and 3 who displayed cruelty appeared to have learned from the teacher that it was acceptable to act in an aggressive manner towards those from low-income and poorly educated backgrounds. Their cruelty was not diffuse, but rather

focused on a specific group—the other poor children. Likewise, the incidence of such behavior increased over time. The children at Tables 2 and 3 did not begin the school year ridiculing and belittling each other. The children from the first table were also apparently socialized into a pattern of behavior in which they perceived that they could direct hostility and aggression towards those at Table 2 and 3, but not towards one another. The children in the class learned who was vulnerable to hostility and who was not through the actions of the teacher. She established the patterns of differential behavior which the class adopted.

First Grade

Though Mrs. Caplow had anticipated that only 12 of the children from the kindergarten class would attend the first grade in the same school, 18 of the children were assigned during the summer to the first-grade classroom in the main building. The remaining children either were assigned to a new school a few blocks north, or were assigned to a branch school designed to handle the overflow from the main building, or had moved away. Mrs. Logan, the first-grade teacher, had had more than 20 years of teaching experience in the city public school system, and every school in which she had taught was more than 90 percent black.

In the first-grade classroom, Mrs. Logan also divided the children into three groups. Those children whom she placed at "Table A" had all been Table 1 students in kindergarten. No student who had sat at Table 2 or 3 in kindergarten was placed at Table A in the first grade. Instead, all the students from Table 2 and 3—with one exception—were placed together at "Table B." At the third table, which Mrs. Logan called "Table C," she

placed the nine children repeating the grade plus Betty who had sat at Table 3 in the kindergarten class. Of the six new students, two were placed at Table A and four at Table C. Thus the totals for the three tables were nine students at Table A, ten at Table B, and 14 at Table C.

The seating arrangement that began in the kindergarten emerged in the first grade as a caste phenomenon in which there was absolutely no mobility upward. That is, of those children whom Mrs. Caplow had perceived as potential "failures" and thus seated at either Table 2 or 3 in the kindergarten, not one was assigned to the table of the "fast learners" in the first grade.

The initial label given to the children by the kindergarten teacher had been reinforced in her interaction with those students throughout the school year. When the children were ready to pass into the first grade, their ascribed labels from the teacher as either successes or failures assumed objective dimensions. The first-grade teacher no longer had to rely on merely the presence or absence of certain behavioral and attitudinal characteristics to ascertain who would do well and who would do poorly in the class. Objective records of the "readiness" material completed by the children during the kindergarten year were available to her. Thus, upon the basis of what material the various tables in kindergarten had completed, Mrs. Logan could form her first-grade tables for reading and arithmetic.

The kindergarten teacher's disproportionate allocation of her teaching time had resulted in the Table 1 students' having completed more material at the end of the school year than the remainder of the class. As a result, the Table 1 group from kindergarten remained intact in the first grade, as they were the only students prepared for the first-grade reading material. Those

children from Tables 2 and 3 had to spend the first weeks of the first-grade year finishing kindergarten level lessons. The criteria established by the school system as to what constituted the completion of the necessary readiness material to begin first-grade lessons insured that the Table 2 and 3 students could not be placed at Table A.

It would be somewhat misleading, however, to indicate that there was absolutely no mobility for any of the students between the seating assignments in kindergarten and those in the first grade. All of the students save one who had been seated at Table 3 during the kindergarten year were moved "up" to Table B in the first grade. The majority of Table C students were those having to repeat the grade level. As a tentative explanation of Mrs. Logan's rationale for the development of the Table C seating assignments, she may have assumed that within her class there existed one group of students who possessed so very little of the perceived behavioral patterns and attitudes necessary for success that they had to be kept separate from the remainder of the class. (Table C was placed by itself on the opposite side of the room from Tables A and B.) The Table C students were spoken of by the first-grade teacher in a manner reminiscent of the way in which Mrs. Caplow spoke of the Table 3 students the previous year.

A basic tenet in explaining Mrs. Logan's seating arrangement is, of course, that she shared a similar reference group and set of values as to what constitutes "success" with Mrs. Caplow in the kindergarten class. Both women were well educated, were employed in a professional occupation, lived in middle-income neighborhoods, were active in a number of charitable and civil rights organizations and expressed strong

religious convictions and moral standards. Both were educated in the city teacher's college and had also attained graduate degrees. Their backgrounds as well as the manner in which they described the various groups of students in their classes would indicate that they shared a similar reference group and set of expectations as to what constituted the indices of the "successful" student.

Second Grade

Of the original 30 students in kindergarten and 18 in first grade, ten students were assigned to the only second-grade class in the main building. Of the eight original kindergarten students who did not come to the second grade from the first, three were repeating first grade while the remainder had moved. The teacher in the second grade also divided the class into three groups, though she did not give the number or letter designations. Rather, she called the first group the "Tigers." The middle group she labeled the "Cardinals," while the second-grade repeaters plus several new children assigned to the third table were designated by the teacher as "Clowns." The names were not given to the groups until the third week of school, though the seating arrangement was established on the third day.

In the second-grade seating scheme, no student from the first grade who had not sat at Table A was moved "up" to the Tigers at the beginning of second grade. All those students who in first grade had been at Table B or Table C and returned to the second grade were placed in the Cardinal group. The Clowns consisted of six second-grade repeaters plus three students who were new to the class. Of the ten original kindergarten students who came from the first grade, six were Tigers

were Cardinals. Table 2 illustrates that the
on of socioeconomic factors from the kinder-
ear remained essentially unchanged in the
second grade.

By the time the children came to the second grade,
their seating arrangement appeared to be based not on
the teacher's expectations of how the child might
perform, but rather on the basis of past performance of
the child. Available to the teacher when she formulated
the seating groups were grade sheets from both kinder-
garten and first grade, IQ scores from kindergarten,
listing of parental occupations for approximately half of
the class, reading scores from a test given to all students
at the end of the first grade, evaluations from the speech
teacher and also the informal evaluations from both the
kindergarten and first-grade teachers.

The single most important data utilized by the
teacher in devising seating groups were the reading
scores indicating the performance of the students at the
end of the first grade. The second-grade teacher indi-
cated that she attempted to divide the groups primarily
on the basis of these scores. The Tigers were designated
as the highest reading group and the Cardinals the
middle. The Clowns were assigned a first-grade reading
level, though they were, for the most part, repeaters
from the previous year in second grade. The caste
character of the reading groups became clear as the year
progressed, in that all three groups were reading in
different books and it was school policy that no child
could go on to a new book until the previous one had
been completed. Thus there was no way for the child,
should he have demonstrated competence at a higher
reading level, to advance, since he had to continue at the
pace of the rest of his reading group. The teacher never

TABLE 2: Distribution of Socioeconomic Status Factors by Seating Arrangement in the Three Reading Groups in the Second-Grade Classroom.

Factors	Seating Arrangement*		
	Tigers	Cardinals	Clowns
Income			
1) Families on welfare	2	4	7
2) Families with father employed	8	5	1
3) Families with mother employed	7	11	6
4) Families with both parents employed	7	5	1
5) Total family income below $3,000./yr**	1	5	8
6) Total family income above $12,000./yr**	4	0	0
Education			
1) Father ever grade school	8	6	1
2) Father ever high school	7	4	0
3) Father ever college	0	0	0
4) Mother ever grade school	12	13	9
5) Mother ever high school	9	7	4
6) Mother ever college	3	0	0
7) Children with pre-school experience	1	0	0
Family Size			
1) Families with one child	2	0	1
2) Families with six or more children	3	8	5
3) Average number of siblings in family	3-4	6-7	7-8
4) Families with both parents present	8	6	1

*There are twelve children in the Tiger group, fourteen children in the Cardinal group, and nine children in the clown group.

**Estimated from stated occupation.

allowed individual reading in order that a child might
finish a book on his own and move ahead. No matter
how well a child in the lower reading groups might have
read, he was destined to remain in the same reading
group. This is, in a sense, another manifestation of the
self-fulfilling prohpecy in that a "slow learner" had no
option but to continue to be a slow learner, regardless
of performance or potential. Initial expectations of the
kindergarten teacher two years earlier as to the ability
of the child resulted in placement in a reading group,
whether high or low, from which there appeared to be
no escape. The child's journey through the early grades
of school at one reading level and in one social grouping
appeared to be pre-ordained from the eighth day of
kindergarten.

The expectations of the kindergarten teacher ap-
peared to be fulfilled by late spring. Her description of
the academic performance of the children in June had a
strong "goodness of fit" with her stated expectations
from the previous September. For the first- and second-
grade teachers alike, there was no need to rely on
intuitive expectations as to what the performance of the
child would be. They were in the position of being able
to base future expectations upon past performance. At
this point, the relevance of the self-fulfilling prophecy
again is evident, for the very criteria by which the first-
and second-grade teachers established their three reading
groups were those manifestations of performance most
affected by the previous experience of the child. That is,
which reading books were completed, the amount of
arithmetic and reading readiness material that had been
completed and the mastery of basic printing skills all
became the significant criteria established by the Board
of Education to determine the level at which the child

would begin the first grade. A similar process of standard evaluation by past performance on criteria established by the Board appears to have been the basis for the arrangement of reading groups within the second grade. Thus, again, the initial patterns of expectations and her acting upon them appeared to place the kindergarten teacher in the position of establishing the parameters of the educational experience for the various children in her class. The parameters, most clearly defined by the seating arrangement at the various tables, remained intact through both the first and second grades.

When the second-grade teacher was asked to evaluate the children in her class by reading group, she responded in terms reminiscent of the kindergarten teacher. Though such a proposition would be tenuous at best, the high degree of similarity in the responses of both the kindergarten and second-grade teachers suggests that there may be among the teachers in the school a common set of criteria as to what constitutes the successful and promising student. If such is the case, then the particular individual who happens to occupy the role of kindergarten teacher is less crucial. For if the expectations of all staff within the school are highly similar, then with little difficulty there could be an interchange of teachers among the grades with little or no noticeable effect upon the performance of the various groups of students. If all teachers have similar expectations as to which types of students perform well and which types perform poorly, the categories established by the kindergarten teacher could be expected to reflect rather closely the manner in which other teachers would also have grouped the class.

Throughout the length of the study in the school, it

was evident that both the kindergarten and second-grade teachers were teaching the groups within their classes in a dissimilar manner. Variations were evident, for example, in the amount of time the teachers spent teaching the different groups, in the manner in which certain groups were granted privileges which were denied to others, and in the teacher's proximity to the different groups. Two additional considerations related to the teacher's use of reward and punishment.

When observations were being conducted in the second grade, it appeared that there was on the part of Mrs. Benson a differentiation of reward and punishment similar to that displayed by Mrs. Caplow. In order to examine more closely the degree to which variations were present over time, three observational periods were totally devoted to the tabulation of each of the individual behavioral units directed by the teacher towards the children. Each observational period was three and one-half hours in length, lasting from 8:30 A.M. to 12:00 noon.

A mechanism for evaluating the varieties of teacher behavior was developed. Behavior on the part of the teacher was tabluated as "behavioral unit" when there was clearly directed towards an individual child some manner of communication, whether it be verbal, non-verbal or physical contact. When, within the interaction of the teacher and the student, there occurred more than one type of behavior, i.e., the teacher spoke to the child and touched him, a count was made of both variations. The following is a list of the nine variations in teacher behavior that were tabulated within the second-grade classroom. Several examples are also included with each of the alternatives displayed by the teacher within the class.

1) Verbal Supportive—"That's a very good job." "You are such a lovely girl." "My, but your work is so neat."

2) Verbal Neutral—"Laura and Tom, let's open our books to page 34." "May, your pencil is on the floor." "Hal, do you have milk money today?"

3) Verbal Control—"Lou, sit on that chair and shut up." "Curt, get up off that floor." "Mary and Laura, quit your talking."

4) Non-verbal Supportive—Teacher nods her head at Rose. Teacher smiles at Liza. Teacher claps when Laura completes her problem at the board.

5) Non-verbal Neutral—Teacher indicates with her arms that she wants Lilly and Shirley to move farther apart in the circle. Teacher motions to Joe and Tom that they should try to snap their fingers to stay in beat with the music.

6) Non-verbal Control—Teacher frowns at Lena. Teacher shakes finger at Amy to quit tapping her pencil. Teacher motions with hand for Rose not to come to her desk.

7) Physical Contact Supportive—Teacher hugs Laura. Teacher places her arm around Mary as she talks to her. Teacher holds Trish's hand as she takes out a splinter.

8) Physical Contact Neutral—Teacher touches head of Nick as she walks past. Teacher leads Rema to new place on the circle.

9) Physical Contact Control—Teacher strikes Lou with stick. Teacher pushes Curt down in his chair. Teacher pushes Hal and Doug to the floor.

Table 3 presents all forms of control, supportive and neutral behavior grouped together within each of the three observational periods. Since the categorization of

the various types of behavior was decided as the interaction occurred and there was no cross-validation checks by another observer, all behavior was placed in the appropriate neutral category which could not be clearly distinguished as belonging to one of the established supportive or control categories. This may explain the large percentage of neutral behavior tabulated in each of the three observational periods.

The picture of the second-grade teacher, Mrs. Benson, that emerges from analysis of these data is of one who distributes rewards quite sparingly and equally, but who utilizes somewhere between two and five times as much control-oriented behavior with the Clowns as with the Tigers. With the Tigers the combination of neutral and supportive behavior never dropped below 93 percent of the total behavior directed towards them by the teacher in the three periods; the lowest figure for the Cardinals was 86 percent and for the Clowns, 73 percent. It may be assumed that neutral and supportive behavior would be conducive to learning while punishment or control-oriented behavior would not. Thus for the Tigers, the learning situation was one with only infrequent units of control, while for the Clowns, control behavior constituted one-fourth of all behavior directed towards them on at least one occasion.

Studies have indicated that children within an authoritarian classroom display a decrease in both learning and retention and performance, while those within the democratic classroom do not. In extrapolating these findings to the second-grade classroom of Mrs. Benson, one cannot say that she was continually "authoritarian" as opposed to "democratic" with her students, but that with one group of students there occurred more control-oriented behavior than with other groups. On at

TABLE 3: Variations in Teacher-Directed Behavior for Three Second Grade Reading Groups During Three Observational Periods Within a Single Classroom.

Item	Variations in Teacher-Directed Behavior		
	Control	Supportive	Neutral
*Observational Period 1**			
Tigers	5%—(6)**	7%—(8)	87%—(95)
Cardinals	10%—(7)	8%—(5)	82%—(58)
Clowns	27%—(27)	6%—(6)	67%—(67)
Observational Period 2			
Tigers	7%—(14)	8%—(16)	85%—(170)
Cardinals	7%—(13)	8%—(16)	85%—(157)
Clowns	14%—(44)	6%—(15)	80%—(180)
Observational Period 3			
Tigers	7%—(15)	6%—(13)	86%—(171)
Cardinals	14%—(20)	10%—(14)	75%—(108)
Clowns	15%—(36)	7%—(16)	78%—(188)

*Forty-eight (48) minutes of unequal teacher access (due to one group of children's being out of the room) was eliminated from the analysis.

**Value within the parentheses indicates total number of units of behavior within that category.

least one occasion Mrs. Benson utilized nearly five times the amount of control-oriented behavior with the Clowns as with her perceived high-interest and high-ability group, the Tigers. For the Clowns, who were most isolated from the teacher and received the least amount of her teaching time, the results noted above would indicate that the substantial control-oriented behavior directed towards them would compound their difficulty in experiencing significant learning and cognitive growth.

Here discussion of the self-fulfilling prophecy is relevant: given the extent to which the teacher utilized control-oriented behavior with the Clowns, data from the leadership and performance studies would indicate that it would be more difficult for that group to experience a positive learning situation. The question remains unanswered, though, as to whether the behavior of uninterested students necessitated the teacher's resorting to extensive use of control-oriented behavior, or whether that to the extent to which the teacher utilized control-oriented behavior, the students responded with uninterest. If the prior experience of the Clowns was in any way similar to that of the students in kindergarten at Table 3 and Table C in the first grade, I am inclined to opt for the latter proposition.

A very serious and, I believe, justifiable consequence of this assumption of student uninterest related to the frequency of the teacher's control-oriented behavior is that the teachers themselves contribute significantly to the creation of the "slow learners" within their classrooms. Over time, this may help account for the phenomenon noted in the Coleman Report (1966) that the gap between the academic performance of the disadvantaged students and national norms increased the

longer the students remained in the school system. During one of the three and one-half hour observational periods in the second grade, the percentage of control-oriented behavior directed toward the entire class was about 8 percent. Of the behavior directed toward the Clowns, however, 27 percent was control-oriented behavior—more than three times the amount of control-oriented behavior directed to the class as a whole.

On another level, the teacher's use of control-oriented behavior is directly related to the expectations of the ability and willingness of "slow learners" to learn the material she teaches. That is, if the student is uninterested in what goes on in the classroom, he is more apt to engage in activities that the teacher perceives as disruptive. Activities such as talking out loud, coloring when the teacher has not said it to be permissible, attempting to leave the room, calling other students' attention to activities occurring on the street, making comments to the teacher not pertinent to the lesson, dropping books, falling out of the chair and commenting on how the student cannot wait for recess, all prompt the teacher to employ control-oriented behavior towards that student. The interactional pattern between the uninterested student and the teacher literally becomes a "vicious circle" in which control-oriented behavior is followed by further manifestations of uninterest, followed by further control behavior and so on. The stronger the reciprocity of this pattern of interaction, the greater one may anticipate the strengthening of the teacher's expectation of the "slow learner" as being either unable or unwilling to learn.

The placement of the children within the various classrooms into different reading groups was ostensibly done on the promise of future performance in the

kindergarten and on differentials of past performance in later grades. However, the placement may rather have been done from purely irrational reasons that had nothing to do with academic performance. The utilization of academic criteria may have served as the rationalization for a more fundamental process occurring with the class whereby the teacher served as the agent of the larger society to ensure that proper "social distance" was maintained between the various strata of the society as represented by the children.

Within the context of this analysis there appear to be at least two interactional processes that may be identified as having occurred simultaneously within the kindergarten classroom. The first was the relation of the teacher to the students placed at Table 1. The process appeared to occur in at least four stages. The initial stage involved the kindergarten teacher's developing expectations regarding certain students as possessing a series of characteristics that she considered essential for future academic "success." Second, the teacher reinforced through her mechanisms of "positive" differential behavior those characteristics of the children that she considered important and desirable.

Third, the children responded with more of the behavior that initially gained them the attention and support of the teacher. Perceiving that verbalization, for example, was a quality that the teacher appeared to admire, the Table 1 children increased their level of verbalization throughout the school year. Fourth, the cycle was complete as the teacher focused even more specifically on the children at Table 1 who continued to manifest the behavior she desired. A positive interactional scheme arose whereby initial behavioral patterns of the student were reinforced into apparent

permanent behavioral patterns, once he had received support and differential treatment from the teacher.

The actual academic potential of the students was not objectively measured prior to the kindergarten teacher's evaluation of expected performance. The students may be assumed to have had mixed potential. However, the common positive treatment accorded to all within the group by the teacher may have served as the necessary catalyst for the self-fulfilling prophecy whereby those expected to do well did so.

A concurrent behavioral process appeared to occur between the teacher and those students placed at Tables 2 and 3. The student came into the class possessing a series of behavioral and attitudinal characteristics that within the frame of reference to the teacher were perceived as indicative of "failure." Second, through mechanisms of reinforcement of her initial expectations as to the future performance of the student, it was made evident that he was not perceived as similar or equal to those at the table of fast learners. In the third stage, the student responded to both the definition and actual treatment given to him by the teacher which emphasized his characteristics of being an educational "failure." Given the high degree of control-oriented behavior directed towards the "slower" learner, the lack of verbal interaction and encouragement, the disproportionally small amount of teaching time given to him, and the ridicule and hostility, the child withdrew from class participation. The fourth stage was the cyclical repetition of behavioral and attitudinal characteristics that led to the initial labelling as an educational failure.

As with those perceived as having high probability of future success, the academic potential of the failure group was not objectively determined prior to evalua-

tion by the kindergarten teacher. This group also may be assumed to have come into the class with mixed potential. Some within the group may have had the capacity to perform academic tasks quite well, while others perhaps did not. Yet the reinforcement by the teacher of the characteristics in the children that she had perceived as leading to academic failure may, in fact, have created the very conditions of student failure. With the "negative" treatment accorded to the perceived failure group, the teacher's definition of the situation may have ensured its emergence. What the teacher perceived in the children may have served as the catalyst for a series of interactions, with the result that the child came to act out within the class the very expectations defined for him by the teacher.

As an alternative explanation, however, the teacher may have developed the system of caste segregation within the classroom, not because the groups of children were so dissimilar they had to be handled in an entirely different manner, but because they were, in fact, so very close to one another. The teacher may have believed quite strongly that the ghetto community inhibited the development of middle-class models. Thus, it was her duty to "save" at least one group of children from the "streets." Those children had to be kept separate who could have had a bad influence on the children who appeared to have a chance to make it in the middle class of the larger society. Within this framework, the teacher's actions may be understood not only as an attempt to keep the slow learners away from those fast learners, but to ensure that the fast learners would not so be influenced that they themselves become enticed with the streets and lose their apparent opportunity for future middle-class status.

Given the extreme intercomplexity of the organizational structure of this society, the institutions that both create and sustain social organization can neither be held singularly responsible for perpetuating the inequalities nor for eradicating them. The public school system, I believe, is justifiably responsible for contributing to the present structure of the society, but the responsibility is not its alone. The picture that emerges from this study is that the school strongly shares in the complicity of maintaining the organizational perpetuation of poverty and unequal opportunity. This, of course, is in contrast to the formal doctrine of education in this country to ameliorate rather than aggravate the conditions of the poor.

The teachers' reliance on a mixed black-white middle class for their normative reference group appeared to contain assumptions of superiority over those of lower-class and status positions. For they and those members of their reference group, comfortable affluence, education, community participation and possession of professional status may have afforded a rather stable view of the social order. The treatment of those from lower socioeconomic backgrounds within the classrooms by the teachers may have indicated that the values highly esteemed by them were not open to members of the lower groups. Thus the lower groups were in numerous ways informed of their lower status and were socialized for a role of lower self expectations and also for respect and deference towards those of higher status. The social distance between the groups within the classrooms was manifested in its extreme form by the maintenance of patterns of caste segregation whereby those of lower positions were not allowed to become a part of the peer group at the highest level. The value system of the

teachers appeared to necessitate that a certain group be ostracized due to "unworthiness" or inherent inferiority. The very beliefs which legitimated exclusion were maintained among those of the higher social group which then contributed to the continuation of the pattern of social organization itself.

It has not been a contention of this study that the teachers observed could not or would not teach their students. They did, I believe, teach quite well. But the high quality teaching was not made equally accessible to all students in the class. For the students of high socioeconomic background who were perceived by the teachers as possessing desirable behavioral and attitudinal characteristics, the classroom experience was one where the teachers displayed interest in them, spent a large proportion of teaching time with them, directed little control-oriented behavior towards them, held them as models for the remainder of the class and continually reinforced statements that they were "special" students. If the classrooms observed had contained only those students perceived by the teachers as having a desirable social status and a high probability of future success outside the confines of the ghetto community, the teachers could be assumed to have continued to teach well, and under these circumstances, to the entire class.

Though this analysis has focused on the early years of schooling for a single group of black children attending a ghetto school, the implications are far-reaching for those situations where there are children from different status backgrounds within the same classroom. When a teacher bases her expectations of performance on the social status of the student and assumes that the higher the social status, the higher the potential of the child, those children of low social status suffer a stigmatiza-

tion outside of their own choice or will. Yet there is a greater tragedy than being labeled as a slow learner, and that is being treated as one. The differential amounts of control-oriented behavior, the lack of interaction with the teacher, the ridicule from one's peers and the caste aspects of being placed in lower reading groups all have implications for the future life style and value of education for the child.

The success of an educational institution and any individual teacher should not be measured by the treatment of the high-achieving students, but rather by the treatment of those not achieving. As is the case with a chain, ultimate value is based on the weakest member. So long as the lower-status students are treated differently in both quality and quantity of education, there will exist an imperative for change.

It should be apparent, of course, that if one desires this society to retain its present social class configuration and the disproportional access to wealth, power, social and economic mobility, medical care and choice of life styles, one should not disturb the methods of education as presented in this study. This contention is made because what develops as "caste" within the classrooms appears to emerge in the larger society as "class." The low-income children segregated as a caste of "unclean and intellectually inferior" persons may very well be those who in their adult years become the car washers, dishwashers, welfare recipients and participants in numerous other un- or underemployed roles within this society. The question may quite honestly be asked, "Given the treatment of low-income children from the beginning of their kindergarten experience, for what class strata are they being prepared other than that of the lower class?" It appears that the public school

system not only mirrors the configurations of the larger society, but also significantly contributes to maintaining them. Thus the system of public education in reality perpetuates what it is ideologically committed to eradicate—class barriers which result in inequality in the social and economic life of the citizenry.

FURTHER READING:

The Disadvantaged Child edited by M. Deutsch, *et al* (New York: Basic Books, 1967).

Life in Classrooms by P. Jackson, (New York: Holt, Rinehart & Winston, 1968).

Teaching and Learning in City Schools by E. Leacock, (New York: Basic Books, 1969).

Pygmalion in the Classroom by Lenore Jacobson and R. Rosenthal, (New York: Holt, Rinehart & Winston, 1968).

The Complexities of an Urban Classroom by W. Geoffrey and L. Smith, (New York: Holt, Rinehart & Winston, 1968).

This chapter is a shorter version of "Student Social Class and Teacher Expectations: the Self-fulfilling Prophecy in Ghetto Education," published by the *Harvard Educational Review* in August 1970. Copyright © 1970 by the President and Fellows of Harvard College.

CREATIVITY
AND INTELLIGENCE

Part III.

Creativity and Intelligence
in Children

MICHAEL A. WALLACH and NATHAN KOGAN

While there has been a great deal of discussion in recent years concerning the importance of fostering "creativity" in our children, there is little solid evidence to support the claim that creativity can be distinguished from the more familiar concept of intelligence. To be sure, the word "creativity" has caught the fancy of the culture—frequent reference is made to creativity in contexts as diverse as education, industry and advertising. Time and time again, however, the "proof" offered to support the existence of a type of cognitive excellence different from general intelligence has proven to be a will-o-the-wisp.

The logical requirements for such a proof can be put as follows. The psychological concept of *intelligence* defines a network of strongly related abilities concerning the retention, transformation and utilization of verbal and numerical symbols: at issue are a person's

memory storage capacities, his skill in solving problems, his dexterity in manipulating and dealing with concepts. The person high in one of these skills will tend to be high in all; the individual who is low in one will tend to be low in all. But what of the psychological concept of *creativity*? If the behavior judged to be indicative of creativity turns up in the same persons who behave in the ways we call "intelligent," then there is no justification for claiming the existence of any kind of cognitive capacity apart from general intelligence. We would have to assert that the notion of greater or lesser degrees of *creativity* in people simply boils down, upon empirical inspection, to the notion of greater or lesser degrees of general *intelligence*. On the other hand, in order to demonstrate that there are grounds for considering creativity to be a kind of cognitive talent that exists in its own right, another kind of proof would be required. It would be necessary to demonstrate that whatever methods of evaluation are utilized to define variations in creativity from person to person result in classifications that are different from those obtained when the same individuals are categorized as to intelligence.

When we reviewed the quantitative research on creativity, we were forced to conclude that these logical requirements were not met. Despite frequent use of the term "creativity" to define a form of talent that was independent of intelligence, examination of the evidence indicated that the purported measures of creativity tended to have little more in common with each other than they had in common with measures of general intelligence. If one could do about the same thing with an IQ measure as one could with the creativity measures (regarding who should be considered

more creative and who should be considered less creative), it was difficult to defend the practice of invoking a new and glamorous term such as "creativity" for describing the kind of talent under study.

While varying conceptions of the meaning of creativity had been embodied in the measures used, they all shared one thing in common: they had been administered to the persons under study as *tests*. From the viewpoint of the person undergoing assessment, the creativity procedures, no less than an intelligence test, carried the aura of school examinations. They were carried out with explicit or implicit time limits in classroom settings where many students underwent the assessment procedures at the same time. Indeed, we even found that the creativity procedures had been described to the students as "tests" by the psychologists who gave them.

We were suspicious that such a test-like context was inimical to the wholehearted display of cognitive characteristics which could be correctly referred to as being involved in creativity. Hence we believed that creativity had not yet been given a fair chance to reveal itself as a different form of excellence than intelligence. These suspicions were reinforced when we considered what creative artists and scientists have said concerning creative moments in their own work.

In their introspections one finds an emphasis upon the production of a free flow of ideas—the bubbling forth of varieties of associations concerning the matter at hand. Einstein, for example, refers to the need for "combinatory play" and "associative play" in putting ideas together. Dryden describes the process of writing as involving "a confus'd mass of thoughts, tumbling over one another in the dark." Poincaré talks about ideas as

having "rose in crowds" immediately prior to his obtaining a significant mathematical insight. These associations, moreover, range with high frequency into the consideration of unique, unusual possibilities, but ones which are nevertheless relevant to the issue rather than just bizarre. When we look into the conditions under which an abundant flow of unique ideational possibilities has been available, the artists and scientists indicate that the most conducive attitude is one of playful contemplation—if you will, of permissiveness. Creative awareness tends to occur when the individual—in a playful manner—entertains a range of possibilities without worry concerning his own personal success or failure and how his self-image will fare in the eyes of others.

With this in mind we formulated a research program that involved the extensive study of 151 fifth-grade children. They were of middle-class socioeconomic status, and boys and girls were about equally represented in our sample. The work, which was supported in part by the Cooperative Research Program of the United States Office of Education, has been described in detail in our book, *Modes of Thinking in Young Children: A Study of the Creativity-Intelligence Distinction.*

From the introspections of scientists and artists arose some ground rules concerning what creativity might rightfully signify if in fact it constitutes a type of excellence different from intelligence. These ground rules might be put in terms of the following two injunctions:

☐ First, study the flow of ideas—consider how unique and how abundant are the kinds of ideas that a child can provide when contemplating various sorts of tasks. One is talking here, of course, about relevant ideas, not

about ideas that might earn the status of being unique only because they are so bizarre as to have no relevance at all to the task.

☐ Second, provide an atmosphere that convinces the child that he is not under test—that the situation is one of play rather than one where his intellectual worthiness is under evaluation by others. This second injunction may be a particularly difficult one to fulfill on the American educational scene, where testing and the feeling of undergoing personal evaluation are ubiquitous. Yet if our considerations were correct, it obviously was essential to fulfill it if creativity was to receive a fighting chance to display itself.

Accordingly, we mustered every device possible to place the assessment procedures in a context of play rather than in the typical context of testing with which the children were all too familiar. There were no time limits on the procedures. They were administered to one child at a time rather than to groups of children seated at their classroom desks. The adults who worked with the children, moreover, had already established relationships in the context of play activities. We even took pains to avoid the customary vocabulary of tests and testing in connection with the research enterprise as a whole—in our talk with the children we described the work as oriented to the study of children's games for purposes of developing new games children would like.

The procedures involved such matters as requesting the child to suggest possible uses for each of several objects, or to describe possible ways in which each of several pairs of objects are similar to each other. For example, in one procedure the child was to suggest all the different ways in which we could use such objects as a newspaper, a cork, a shoe, a chair. "Rip it up if angry"

was a unique response for "newspaper," while "make paper hats" was not unique. In another, he was to indicate similarities between, for example, a potato and a carrot, a cat and a mouse, milk and meat. "They are government-inspected" was a unique response for "milk and meat," while "they come from animals" was not unique. In yet another, he was to indicate all the things that each of a number of abstract drawings might be—such as the drawings shown in the illustrations. For the triangle with three circles around it, "three mice eating a piece of cheese" was a unique response, while "three people sitting around a table" was not unique. For the two half-circles over the line, "two haystacks on a flying carpet" was a unique response, while "two igloos" was not unique.

Our interests were in the number of ideas that a child would suggest, and the uniqueness of the suggested ideas—the extent to which a given idea in response to a given task belonged to one child alone rather than being an idea that was suggested by other children as well. In addition, we used a variety of traditional techniques for assessing general intelligence with the same children.

When the results of the creativity assessment procedures were compared with the results of the intelli-

Left: Unique: "Lollipop bursting into pieces"
 Common: "Flower"
Right: Unique: "Two haystacks on a flying carpet"
 Common: "Two igloos"

CHILDREN'S RESPONSES TO ABSTRACT DRAWINGS

Left:	Unique:	"Foot and Toes"
	Common:	"Table with things on top"
Right:	Unique:	"Three mice eating a piece of cheese"
	Common:	"Three people sitting around a table"

gence measures, a definite divergence was obtained—the kind that had not been found in earlier studies. They had already shown, and so did our study, that a child who scores at the high intelligence end of one intelligence test will tend to score that way in other intelligence tests as well. In addition, however, our research revealed two further facts which tended to be different from earlier studies:

☐ The various measures of creativity that we utilized had a great deal in common with one another: a child who scored at the high creativity end of one of our creativity measures tended to score at the high creativity end of all the rest of these measures.

☐ Of particular importance, the indices of creativity and the indices of intelligence tended to be independent of each other. That is to say, a child who was creative by our measures would just as likely be of low intelligence as of high intelligence. Likewise, a child who was relatively low in creativity by our measures would as likely be of high intelligence as of low intelligence.

In short, the obtained facts *did* support the view that

in school children creativity is a different type of
cognitive excellence than general intelligence. Such an
outcome was especially striking in light of the fact that
our procedures for assessing creativity of necessity
called upon the child's verbal ability in some degree—
and verbal ability is known to contribute substantially
to performance on IQ tests. Despite this possible source
of commonality, the chances that a child of high
intelligence would also display high creativity by our
measures were no more than about 50-50.

What are some of the characteristics, then, of children
in our four categories: intelligent and creative; neither
intelligent nor creative; intelligent but low in creativity;
and creative but low in regard to intelligence? The
composite pictures that emerged from the experiments
and observations that we carried out are composites in
the sense that some portions of the evidence upon
which they are based were more clear for the boys,
while other parts of the evidence were more clear for
the girls. However, the general pictures that emerged for
the two sexes tended to suggest the same underlying
characteristics.

High creativity—High intelligence: In many respects
these children earn the most superlatives of any of the
four groups. For example, when they are observed in
the classroom they tend to be particularly high in degree
of attention span and concentration upon academic
work. At the same time, their academic bent does not
put them at a social disadvantage. Quite to the contrary,
they are observed to be the most socially "healthy" of
the four groups: they have the strongest inclination to
be friends with others, and others also have the
strongest inclination to be friends with them. (These

observations were made during play periods as well as during class sessions.)

These children, in addition, are the least likely of all four groups to behave in ways that suggest disapproval or doubt concerning oneself, one's actions and one's work. However, this isn't merely a question of behaving in a manner most in harmony with the society's expectations, for these children also demonstrate a strong inclination to engage in various sorts of disruptive activities in the classroom. It's as if they are bursting through the typical behavioral molds that the society has constructed.

What are some of the underpinnings of the general behaviors just described for this group? For one thing, they are likely to see possible connections between events that do not have too much in common. The members of this group, in other words, are more willing to posit relationships between events that are in many respects dissimilar. For another thing, these children are particularly good at reading the subtle affective or expressive connotations that can be carried by what goes on in the environment. These two matters are not entirely separate—a sensitive, aesthetic "tuning" to the possible expressive meanings conveyed by human gesture or by abstract design forms involves seeing possible linkages between quite different kinds of objects and events. The children high in both creativity and intelligence seemed to be most capable of all the groups regarding this kind of aesthetic sensitivity.

To illustrate how we studied the child's ability to read subtle expressive connotations, consider the following example. We confronted the child with a picture of a straight line and asked him to imagine that he was

looking down from above at a path that someone had made. The child was to tell us what sort of person made this trail. Our interest was in determining whether the child's response conveyed information about the kinds of emotional experience that might characterize the person in question, or on the other hand conveyed information only about the superficial character of what the person did. An example of a response showing sensitivity to possible expressive meanings was: "Someone very tense; because if he were relaxed he might wander all over; somebody mad." On the other hand, here is an example of a response that did not show expressive sensitivity: "Man was traveling on a highway; he met people in a huge car; it had a lot of people and it was crowded; they traveled together and got food in restaurants; when they got where they were going, they had a nice vacation."

Turning finally to the way these children describe their own feeling states, we find a tendency for them to admit to experiencing some anxiety, some disturbance—neither a great deal nor very little It may be that experiencing some anxiety serves an energizing function for them: it is not so much anxiety as to cripple them, and not so little anxiety as to leave them dormant. Also, their total mode of adaptation does not minimize the experience of anxiety for them.

Low creativity—High intelligence: In what respects are the children who are high with regard to general intelligence but low in creativity different from those who are high in both? Let us return first to behavior observed in classroom and play settings. While the high intelligence-low creativity children resembled the high creativity-high intelligence children in possessing strong capacities for concentration on academic work and a

long attention span, in other respects they were quite different. Those of high intelligence but low creativity were least likely of all four groups to engage in disruptive activities in the classroom and tended to hesitate about expressing opinions. In short, these children seemed rather unwilling to take chances.

Parallel behavior was observed in their social relations with other children; while others had a strong inclination to be friends with them, they in turn tended to hold themselves aloof from interaction with other children. The high intelligence-low creativity children, therefore, seemed to be characterized by a coolness or reserve in relations with their peers. Others would seek out the high intelligence-low creativity children for companionship, possibly because of this group's high academic standing. The children in question, however, tended not to seek out others in return. Perhaps this group felt themselves to be on top of the social mountain, as it were—in a position where they could receive homage from others without any need for requital.

The observations regarding a tendency toward caution and reserve on the part of the high intelligence-low creativity children receive further corroboration in other areas of their functioning. For example, when asked to make arrangements and groupings of pictures of everyday objects in whatever ways they considered most suitable, they preferred to make groupings that were more conventional in nature. They tended to avoid making free-wheeling, unconventional arrangements in which there would be greater free play for evolving unique combinations of objects. For instance, a more conventional grouping would be assembling pictures of a lamppost, a door and a hammer, and calling them "hard

objects." A more unconventional grouping, on the other hand, would be putting together pictures of a comb, a lipstick, a watch, a pocketbook and a door, and describing them as items that concern "getting ready to go out." It is as if a greater fear of error characterizes these children, so that when left to their own devices, they tend to gravitate toward ways of construing the world that are less open to criticism by others.

We also found out that if you request these children to try to behave in a manner that involves establishing more free-wheeling linkages among objects, they are capable of doing so. It is not that they lack the ability to look at the world in this manner, but the inclination. When an adult in their environment comes along and makes it clear that they are expected to consider unusual and possible bizarre ways in which objects can be linked, they are able to conform to this task demand with skill. But most of the time, their environment tells them that the more unconventional ways of proceeding are more likely to lead them into error and be criticized as wrong. Since the possibility of error seems particularly painful to these children, their typical behavior is to proceed in a manner that is less likely, on the average, to bring them criticism.

Another example of the same sort of process is provided when we consider how the high intelligence-low creativity group reads the possible affective meanings that can be possessed by the behavior of others. As in the case of arranging objects into groups, one can contrast more conventional, expected ways and more unconventional, unusual ways of construing what the behavior of others may signify. For example, an angry figure can be described as "angry" with little risk of error. It requires acceptance of unconventional possibili-

ties, on the other hand, for the child to admit the idea that this figure might be "peaceful" or might be "searching." It turns out that the group in question is least likely to entertain the possibility of the more unconventional, unusual kinds of meanings. They seem locked, therefore, in more conventional ways of interpreting their social world as well as their physical world. Again, fear of possible error seems to be at work.

Since the high intelligence-low creativity children seem to behave in a manner that should maximize correctness and minimize error, we can expect them to be in particularly good standing in their classroom environment. Given their apparent tendency to conform to expectations, their mode of functioning should be maximally rewarding and minimally punishing for them. In short, there should be a high degree of fit between customary environmental expectations and their way of conducting themselves. We find, in fact, that this group admits to little anxiety or disturbance when asked to describe their own feeling states. Their self-descriptions indicate the lowest levels of anxiety reported by any of the four creativity-intelligence groups. Since this group behaves in a manner that should minimize worry or concern for them, their minimal level of reported anxiety probably represents an an accurate description of how they feel. But at a cost, as we have noted, of functioning in a constricted manner.

High creativity—Low intelligence: Turning to the group characterized by high creativity but relatively low intelligence, we find, first of all, that they tend to exhibit disruptive behavior in the classroom. This is about the only respect, however, in which their observable conduct in the usual school and play settings resembles that of the group high in both creativity and

intelligence. Of all four groups, the high creativity-low intelligence children are the least able to concentrate and maintain attention in class, the lowest in self-confidence and the most likely to express the conviction that they are no good. It is as if they are convinced that their case is a hopeless one. Furthermore, they are relatively isolated socially; not only do they avoid contact with other children, but in addition their peers shun them more than any other group. Perhaps, in their social withdrawal, these children are indulging fantasy activities. At any rate, they are relatively alone in the school setting, and in many respects can be characterized as worse off than the group low in both creativity and intelligence.

It should be borne in mind that the high creativity-low intelligence children nevertheless give evidence of the same kind of creative thinking capacities as are found in the high creativity-high intelligence group. Again, for example, we find a greater likelihood of seeing possible connections between events that do not share much in common. The high creativity children, whether high or low regarding intelligence, are more willing to postulate relationships between somewhat dissimilar events.

Apparently, the kinds of evaluational pressures present in the case of intelligence and achievement testing as well as in the typical classroom environment serve to disrupt cognitive powers which can come to the fore when pressure is reduced. An interesting complementarity seems to exist with regard to the psychological situations found for the high creativity-low intelligence group and the low creativity-high intelligence group: while members of the former seem to perform more effectively when evaluational pressures are absent, mem-

bers of the latter seem to work more adequately when evaluational pressures are present. It is as if the former children tend to go to pieces if questions of personal competence and achievement enter the picture, while the latter children have difficulty if they are denied a framework of standards within which they can evaluate what is required of them if they are to seem competent in the eyes of adults.

Low creativity—Low intelligence: While the children in this group show the greatest cognitive deprivation of the four groups under study, they seem to make up for it at least to some degree in the social sphere. From observations of their behavior in school and at play they are found to be more extroverted socially, less hesitant, and more self-confident and self-assured than the children of low intelligence but high creativity. The members of the low-low group are particularly poor regarding the kinds of aesthetic sensitivity that were mentioned earlier—for example, they show the weakest tendencies to respond to the possible expressive meanings that abstract line forms may convey. Despite such deficiencies, however, this group does not seem to be the maximally disadvantaged group in the classroom. Rather, the low-low children seem to have worked out a *modus vivendi* that puts them at greater social ease in the school situation than is the case for their high creativity-low intelligence peers.

Now that we have characterized the four groups of children, let us finally consider the implications of the relative roles played by ability and by motivational factors in a child's thinking. The only group that looks like it is in difficulty with regard to ability—and even in their case we cannot be sure—is the group low in both intelligence and creativity. In the cases of the two

groups that are low regarding one cognitive skill and high regarding the other—the low intelligence-high creativity group and the high intelligence-low creativity group—our evidence suggests that, rather than an ability deficiency, the children in question are handicapped by particular motivational dispositions receiving strong environmental support. For the low intelligence-high creativity children, the difficulty seems to concern excessive fear of being evaluated; hence they perform poorly when evaluational standards are a prominent part of the setting. For the high intelligence-low creativity children, on the other hand, the difficulty seems to concern a fear of not knowing whether one is thought well of by significant others. The possibility of making mistakes, therefore, is particularly avoided. Further, if evaluational standards are not a clear part of the setting, so that the child does not know a right way of behaving in order to fulfill the expectations of others, performance will deteriorate because the problem of avoiding error becomes of prime importance.

In theory, at least, these kinds of motivational hindrances could be rectified by appropriate training procedures. If one could induce the low intelligence-high creativity children to be less concerned when evaluational standards are present, and the high intelligence-low creativity children to be less concerned when evaluational standards are absent, their thinking behavior might come to display high levels of both intelligence and creativity.

January/February 1967

FURTHER READING:

Creativity and Intelligence: Explorations With Gifted Students,

by Jacob W. Getzels and Philip W. Jackson (New York: Wiley, 1962).

Guiding Creative Talent, by E. Paul Torrance (Englewood Cliffs, N.J.: Prentice-Hall, 1962).

Modes of Thinking in Young Children: A Study of the Creativity-Intelligence Distinction, by Michael A. Wallach and Nathan Kogan (New York: Holt, Rinehart and Winston, 1965).

The Talented Student, by M.A. Wallach and C.W. Wing, Jr. (New York: Holt, Rinehart and Winston, 1969).

"Creativity" by M.A. Wallach, in P.H. Mussen (Ed.), *Carmichael's Manual of Child Psychology,* 3rd ed., Vol. 1. (New York: Wiley, 1970).

College Admissions and the Psychology of Talent, by C.W. Wing, Jr., and M.A. Wallach (New York: Holt, Rinehart and Winston, 1971).

The Creative Artist
as an Explorer

JACOB W. GETZELS
and
MIHALY CSIKSZENTMIHALYI

"All good things which exist," said John Stuart Mill, "are the fruits of originality." An overstatement perhaps, but an accurate reflection of the special value that Western man since the Renaissance has placed on creative imagination. Few qualities have been so widely praised; and few have been so little understood. Popular mythology has alternately endowed the creative man with the muse, divine inspiration, pathological excesses of temperament, and, occasionally, an uncommon supply of intelligence and good sense.

What do we know about creativity itself? So far, most of the answers have been indirect. Researchers have concentrated on describing creativity in terms of the common personality characteristics the creative person possesses: Is he outgoing, or introverted? Is he easygoing, or tense? Are his values the same as those of most

people, or different? The answers to questions of this sort have helped us develop at least a fragmentary and tentative model of what the creative man is like. But they told us almost nothing about what he does when he is creating—what actually happens when he sits down at the piano, or the typewriter or the sketch pad.

We have now begun to find some of the answers, specifically for the artist, by observing him in the act of creation. We studied 200 young artists who were, for the most part, still students at one of the leading art schools in the country. Some of them were already winning prizes in competitive shows, exhibiting in professional galleries, or supporting themselves on the proceeds of their illustrating skills. (We felt that our subjects deserved to be called "artists" because of their success in an art school of the highest professional standards and for their perseverance in pursuit of an artistic career, sometimes at considerable personal sacrifice.)

With the exception of those few whose work becomes fashionable among wealthy patrons and collectors, most artists, because they make so little money, are failures by the standards of society as a whole. What compensation does the artist get to make this precarious life worthwhile and even compelling? Part of the answer is in his values.

We compared our 200 art students with a cross-section of the college population to see how the value orientations of the two groups might differ on six standard dimensions: the economic, aesthetic, social, political, theoretical and religious. The results were striking. While economic values were close to the top for the average male college student, the art student ranked

them close to the bottom. The only value for which the art students had less apparent respect, in fact, was the social.

But before expanding on this point, let us consider the positive side of the artist's value orientation. The most notable was the artist's extreme adherence to the aesthetic value. This in itself was not surprising—we had expected the art students to show a much stronger interest in aesthetic values than the other students did. But what startled us was the single-mindedness of this commitment. Nothing but art really seemed to matter to them. The point is not that artists' aesthetic values were so high—the religious values of clergymen are also high—but that they were so high in proportion to all other values.

Second to the aesthetic—and considerably below it in importance—came the theoretical. The aesthetic and theoretical value orientations were once thought to be mutually exclusive. The dominant interest of the theoretical man is the discovery of truth. He divests himself of judgments regarding the beauty of objects, and seeks only to observe and to reason. The aesthetic attitude is, in a sense, diametrically opposed to the theoretical. The former is concerned with the diversity, the latter with the identity of experience. The aesthetic man either equates beauty with truth, or may hold that beauty is more important than truth. Recent studies have shown, however, that creative persons in several other professions, like our artists, hold both high aesthetic and high theoretical values, and the conjunction of these values may well provide us with a useful clue as to the nature of the creative process itself.

When we categorized the art students by their fields of specialization, definite differences in the value

pattern appeared. The fine arts students showed markedly different value patterns from the students planning to go into commercial and advertising art. The fine arts group showed the most extreme and exclusive adherence to aesthetic values, while the advertising art students showed value patterns more like those of the average college student. There is a great difference in values between people whose main goal is to produce work satisfying their own requirements and those whose goal is to satisfy the demands imposed by an advertising agency or a design studio.

Returning to the artists' (and particularly those in the fine arts) lack of interest in economic and social values, we can see that these students are psychologically well prepared for the conditions that their chosen career will offer. Artists are likely to be poor, at least until they get their "break" and perhaps permanently if that break never comes; they are likely to be lonely because so few people will share their interests, attitudes and values; and they are likely to be disapproved or even rejected by the people of the larger society simply because they are "different." Does all this matter to them? Apparently not. In fact, to stand outside the distracting scramble of everyday business may even be an asset if a man is to devote his energies almost entirely to producing a work of art. Perhaps it is even essential. This is clearly a deviant pattern in our age, but we might keep in mind that this was not always so: the young artist's value system duplicates quite closely the prescription for the "good life" outlined by Aristotle.

Turning to the broader personality characteristics of the artist, does rejection of social values mean that artists are not interested in other people? That they are perhaps even actively cold and unfriendly? There is

some support for this interpretation. We have evidence that they tend to be withdrawn and cool in their social contacts. They are serious and introspective rather than exuberant and outgoing. Self-sufficiency and the habit of making their own decisions without seeking or relying upon the advice of others round out the characteristic pattern of social withdrawal.

All this suggests that artists dislike other people. But our impression after talking with these students at some length, is that this is simply not the case. They are not misanthropes. They do not reject other people; they reject a social pattern—the casual, self-selling gregariousness accepted as normal behavior by the larger society.

We emerge, then, with a personality profile of the artist as self-sufficient, introspective, and socially withdrawn by the prevailing standards of American society. But how much does this really have to do with creativity? Is there any justification for saying that these are characteristics of a creative personality? The same personality test given to the artists had been administered in another study to 300 eminent scientists—researchers in physics, psychology and biology—and the composite profile obtained bore a striking resemblance to that of the young artists. This strong similarity in personality structure among persons working in such vastly different fields is suggestive, since they are linked only by the element of creative achievement.

Again, it has long been debated whether creativity is related to intelligence. Our art students, when given various IQ type tests, turned out to be no more or less bright than college students. Thus the widespread differences between artists and other students with respect to values and personality were conspicuously

lacking in the area of intelligence. It seems, then, that
superior IQ may not be essential in art in the way that it
is in certain other creative disciplines. We can imagine a
man or woman being a highly successful artist without
possessing spectacular intellectual powers as indicated
by a very high IQ; but it is difficult to imagine a
Nobel-prize-winning physicist not having such intel-
lectual powers. It appears that creativity and intelligence
may represent different processes and that intelligence is
required in widely different degrees in different fields of
creative endeavor.

Thus, we began to have some elements of the young
artists' profile. We knew the ways in which they were
different from "other" people—in their values and
personalities—and we knew the many other ways in
which they were more nearly similar, notably in
intelligence. But all this still told us nothing about what
actually happened when they were engaging in the act
of artistic creation. What was the process itself like? We
decided to find out by watching.

We arranged to have 31 male fine arts students
prepare a drawing under realistic studio conditions. We
furnished a number of objects to be drawn; the artist
could select as many or as few as he wanted and arrange
them according to his own preference before beginning
to draw. A detailed account of the artist's behavior was
kept, both before he began to draw and while he was
actually working at the easel. After the drawing was
completed, a prolonged interview was held to re-
construct as closely as possible, the conscious mental
process of which the artist had been aware while
engaged in the experiment. Of the great amount of
information collected by these methods, we want to
focus here on three very simple points observed for each

artist before he began to draw:

☐ the number of objects picked up and examined;

☐ the extent to which he either chose to draw the same objects that everyone else did, or chose more unusual ones;

☐ the extent to which he explored the objects by stroking, weighing, moving their parts, etc.

Now, what was all this supposed to show? We were, of course, looking for something in particular. Our point of view was to conceive of creativity as a special kind of problem-solving process. Problems can be classified according to answers to the following six questions: Has the problem ever been formulated before by the problem-solver? By anyone else? Is the correct method of solution known to the problem-solver? To anyone else? Is the correct solution itself known to the problem-solver? To anyone else? There are certain problems for which the answer is "no" to all six questions. That is, they have never been formulated before, and, once formulated, there is no available method for their solution, nor is there a single correct answer to be reached. It is the formulation and solution of these problems that requires creativity. Actually, these are only potential problems, since they do not exist as problems until someone formulates them as such. Thus, in the case of this special sort of problem, the central question becomes "How are new problems discovered?" rather than the more usual question "How are existing problems solved?" The first step in creative activity involves the discovery, or formulation, of the problem itself.

Returning to our drawing experiment, we can now see why the artist's pre-drawing behavior was important. In picking up, manipulating, exploring and rearranging

the objects to be drawn, the artist was trying to formulate an artistic problem. He might pose a problem in form by exploring how the intricate convolutions of a carburetor are related to the equally intricate rhythms of a bunch of grapes. He might formulate a problem of texture by placing a smooth steel shaft next to a battered baseball glove; or he might pose a problem of color—for example, how to give a relatively mono-chromatic drawing color variation—by choosing all his objects in a limited yellow-brown color range. Or he might formulate a problem of spatial relationship by rearranging several objects with little textural or color interest—say, three optical lenses in an unusual, ap-parently unbalanced or asymmetrical pattern. More likely, his problem would be a complex one, involving some combination of these basic elements of form, texture, color and spatial relationship. And of course the drawings were problematic on a meta-visual dimen-sion as well. One artist, for instance, drew a solitary white sphere in one corner of the paper, and a congeries of other objects in the opposite corner. In the interview he disclosed that on one level the drawing tried to resolve the feeling of loneliness when confronted with a group of people.

As the artist drew, photographs were quietly taken of the drawing as it developed on the paper. The students were not required to stick to the problem as originally formulated; they were allowed to alter or rearrange the objects as they went along, or ignore the objects altogether if, after the beginning, a more interesting problem developed within the confines of the drawing itself. The only requirement we placed on the drawings was that they should satisfy the students' own stan-dards. The completed drawings were then reviewed by a

group of established, well-known painters; this panel of experts judged the students' work to be generally of high professional quality.

Now to relate creativity to the drawing process. If creativity lies in the artist's ability to discover and formulate a fresh problem, then his behavior in manipulating, exploring and selecting the elements of his problem—in this case, the objects to be drawn—should have been closely related to the creativity displayed in his finished drawing. This we found to be true. The drawings rated most original and artistically most valuable by the panel of established painters were the ones produced by students who had handled the most objects, explored the objects they handled most closely, and selected the most unusual objects to work with during the pre-drawing, problem-formulating period. These students were not necessarily the ones with the greatest technical skill or "craftsmanship" as rated by the same judges. Here, in what we have labelled "discovery-oriented behavior," seemed to lie a key to the creative process. We interpreted this and similar behavior observed during the execution of the drawing itself as the outward manifestations of a specific cognitive attitude, "concern for discovery." The meaning we inferred from our observations was supported by the interview statements, which revealed that the artist himself was consciously pursuing discovery as opposed to, for instance, expression of feeling or reproduction of beauty alone. This concern with discovery set apart those who were interested in formulating and solving new artistic problems from those who were content merely to apply their technical skill to familiar problems capable of more or less pat solutions.

The most skillful drawings, then, were not always the

Table 1

Correlations Between Discovery Process Variables at the Stage of Problem Formulation and Evaluation of the Artistic Products by Five Artist-Critics (N = 31)

Process Variables	Over-all Aesthetic Value (Total 5 Raters)	Dimensions of Evaluation Originality (Total 5 Raters)	Craftsmanship (Total 5 Raters)
Problem Formulation			
A. Number of objects examined	.48d	.52d	.16
B. Unusualness of objects chosen	.35a	.42c	.22
C. Exploration of objects	.44c	.58e	.34a
Total (ABC)	.40b	.54d	.28

Level of significance = a p < .05
b p < .025
c p < .01
d p < .005
e p < .0005

most original. We are all familiar with this distinction. Contemporary painters have stressed the idea that technical skill without a fresh approach, a new vision, is tedious and dead. Both originality and technical skill are desirable, but without the former there is no progress, there can be no change, whether in the field of art, or of science and technology.

By directly observing the artists' exploratory actions as they worked out new relationships between the problematic elements of their drawings, we learned that such activities may be quite reliable predictors of the creativity displayed in the finished product. And as usual, a research finding poses a further question: Is this process of measurable discovery also involved in the wider range of human creativity, in the more memorable "fruits of originality"?

September/October 1966

FURTHER READING

Daedalus, "Creativity and Learning" Volume 94, No. 3, Summer 1965

The Art of Creation, Arthur Koestler, The Macmillan Company, New York, 1964

Scientific Creativity: Its Recognition and Development, Calvin W. Taylor and Frank Barron, John Wiley and Sons, New York, 1963

THE DEVELOPMENT
AND
UTILIZATION
OF COMPETENCE

Part IV.

A Revolution in Treatment
of the Retarded

GEORGE W. ALBEE

Nearly 6,000,000 Americans are mentally handicapped. By 1970, the number will reach almost 6,500,000. A retarded child is born every four minutes; 126,000 will be born this year.

Largely because of the deep personal interest of President Kennedy, in recent years there has been considerable activity to help the retarded. Since 1963, Federal funds for research and training have increased at an unprecedented rate. Unfortunately, most of these funds are not being used to help the majority of the retarded those who are normally slow, not victims of inherited or acquired diseases. Instead, money is being poured into costly biomedical research centers and "treatment" clinics to help a minority—those who are retarded because of organic reasons, like injuries, trauma, infections and biochemical imbalances.

The majority of the retarded need, not medical

treatment, but rehabilitative training—so they can use their maximum potential. While every promising research lead should be pursued, and every significant effort in the whole field of retardation should be supported, a truly generous part of the new federal funds ought to be invested in research aimed at helping the retarded lead lives as normal as possible. And more funds should be spent to train people who will, in turn, help train the majority of the retarded.

At the root of this error in priorities is a tragic misconception—namely, that mental retardation is an inherited or acquired disease. Recently, for example, the National Institute of Child Health and Human Development announced that it was allocating new funds for research centers whose purpose will be to 1) discover organic causes of retardation and 2) mount medical efforts to reduce its incidence. The Institute's press release went on: "Inherited diseases are among the leading causes of mental retardation." On May 16, 1967, the U.S. Public Health Service announced a grant for the construction of a $2.2 million center for medical research at a Midwestern university. Its press release stated:

> Several research studies will be aimed at identifying metabolic abnormalities in patients with unknown causes of mental retardation. Through biochemical studies of the urine, blood, and tissues of retarded patients, defects or absences of necessary biologic metabolic enzymes may be uncovered, paving the way for new attacks on mental retardation.

Between the lines of both statements is the promise that the incidence of retardation, because of such medically oriented research, may be significantly reduced. This

promise is based on ignorance—or on a distortion of reality.

The truth is that most retardation is *not* an inherited disease. Quite correctly, President Kennedy's Panel on Mental Retardation emphasized the fact that

... about 75 percent to 85 percent of those now diagnosed as retarded show no demonstrable gross brain abnormality. They are, by and large, persons with relatively mild degrees of retardation Unfavorable environmental and psychological influences are thought to play an important contributory role among this group. Such influences include interference with normal emotional and intellectual stimulation in early infancy, unfavorable psychological or emotional experiences in early childhood, and lack of normal intellectual and cultural experiences during the entire developmental period.

More basically, brightness and dullness are a reflection of inherited capacities—the result of the interaction of a large number of genes operating in a perfectly normal, nonpathological way. While intelligence is thus genetically determined, so is a person's height—and neither stature *nor* mental retardation is an illness.

People are born retarded simply because intelligence is distributed normally throughout the entire population. A certain percentage of all children—slightly more than 2 percent, as it happens—will be born without defect and yet have I.Q.s below 70. Similarly, a certain percentage—also 2 percent—will be born with an I.Q. as high as that of the average graduate student.

Edward Zigler of Yale put it this way:

We need simply to accept the generally recognized

fact that the gene pool of any population is such that there will always be variations in the behavioral . . . expression of virtually every measurable trait or characteristic of man. From the polygenic model advanced by geneticists, we deduce that the distribution of intelligence is characterized by a bisymmetrical bell-shaped curve

Once one adopts the position that the familial mental retardate is not defective or pathological but is essentially a normal individual of low intelligence, then the familial retardate no longer represents a mystery but, rather, is viewed as a particular manifestation of the general developmental process.

This point has crucial implications. It illuminates the inappropriateness of our present priorities, whereby 90 to 95 percent of the federal construction funds for retardation centers will be used to house research and training on biomedical approaches. It says the large majority of retarded children and adults are *not* retarded because of an acquired physiological abnormality, or because of a defect in their metabolism, or because of brain injury, or because their mothers had German measles, or because of the effects of any other infectious disease, or because of any other discovered or undiscovered exogenous or biomedical defects.

Rather, the majority of retarded children and adults are produced from the more or less accidental distribution of polygenic factors present in the entire human race. Each parent transmits—often untouched—a large and varied set of genetic potentials from his myriad ancestors to his descendants. Thus each human is potentially the parent or grandparent or great-grandparent of a retarded child. Because of various forms of gene linkage, "familial" retardation is some-

what less common in bright families than in dull families. It occurs most commonly in "average" families—because there are many more of them.

The cold, but realistic, fact must be faced: It is no more likely that medical research findings will raise the intelligence of most retardates than it is that research will raise the intelligence of college students.

Let me make it very clear that I am not opposing medical research, or deprecating the triumphs of biology and medicine in uncovering the causes of several (albeit rare) forms of retardation in the past decade or so. What I am arguing against is the almost exclusive investment of federal monies in medically-oriented research. For the plain truth is that, even after all the post-conception organic causes and all the metabolic and chromosomal defects are discovered and prevented or corrected, at least 2 percent of the general population will *still* be born retarded. And this situation will prevail for the indefinite future.

I believe, therefore, that it is not only unfair but unreasonable that almost every new federally funded, university-affiliated center to train people and to engage in research in this field is in a medically-dominated and biomedically-oriented center. Even in the Mental Retardation Research Centers being funded by the new National Institute of Child Health and Human Development, the major efforts are biomedical. Instead, at least half of these centers should be designed for research in special educational methods and rehabilitation; others should be designed primarily for research in the social and behavioral-science approaches to helping the retarded.

Why is the emphasis, both in research and in treatment, on organic approaches to retardation? One

reason: the academic medical institutions' insatiable need for research money. Because of the enormous federal funds recently made available for constructing research and training facilities in the area of retardation, medicine—particularly psychiatry and pediatrics—has discovered and promulgated compelling arguments why these research centers should be placed in medical settings. Almost exclusive emphasis has been on all of the external causes of retardation—the metabolic, the infectious, the undiscovered causes of brain damage. In addition, by controlling the advisory committees that rule on applications for construction funds to build the university-affiliated facilities, the doctors have controlled the character of these centers still further.

Another reason: The powerful citizens' committees in the field of retardation are composed largely of well-informed parents of retarded children. But in these families, normal garden-variety retardation is relatively rare. These parents, from the numerically small but politically advantaged upper-middle classes and upper classes, are more likely to have children who are retarded because of *exogenous* damage than because of normal polygenic inheritance. Their retarded children are more likely to be represented in the below-50 I.Q. group of the seriously-handicapped than among the much more common 50-70 I.Q. group. As a consequence, these citizens' committees militate for biomedical discoveries that will prevent, or cure, exogenous retardation. Their aspirations coincide with the eagerness of academic medicine to have large, expensive research labs. Both groups push legislation—and the rules implementing legislation—in the direction of an overwhelming emphasis on biomedical research.

There are still other reasons to explain the over-

emphasis on biological or injury explanations of retardation.

In child-worshipping American society, and particularly in the great sprawling suburban areas, parents are gravely concerned about the academic success of their children. Their children's scores on intelligence tests are therefore exceedingly important to these parents. And when a parent is told that his child tests at the 135-I.Q. level, his response is a feeling of pride, even elation. It means that Johnny can go far, that a society that rewards intellectual success (not necessarily achievement) will eventually be at his feet.

But consider the parent who is told that his child is functioning at a 65-I.Q. level and must be placed in a special class for slow-learners. After his original shock and panic have subsided somewhat, the parent begins to cast about for an explanation. What could have happened? What accident, injury or disease could have caused this terrible thing?

Now, two currently popular diagnoses for mentally deficient children are *minimal brain damage,* or *maturational lag.* The trouble is that the neurological and psychological tests upon which these diagnoses are based leave much to be desired. Nevertheless, one or the other of these diagnoses is made with increasing frequency, perhaps because they are very useful to give to parents who somehow feel personally responsible for a retarded child and seize upon such a diagnosis as an exculpation.

It is difficult for a pediatrician, a psychiatrist or a consulting psychologist to tell parents their child is just slow mentally, and not because of illness, disease or exogenous damage. Similarly, one of the most difficult diagnoses for parents in our society to accept is that

their child is normal and has a limited intellectual capacity. No special explanation is required for a child who is bright—he "just comes by that naturally." But when a child is slow intellectually, something must have happened. Thus the diagnosis of minimal brain damage, or maturational lag, has great psychological appeal. Most parents can recall an illness or accident at some point in the child's life, or in the expectant mother's. This is certainly an easier explanation to accept, in an extremely painful situation, than garden-variety, normal retardation. Nor is it hard to understand that such a parent's desire to "do something" leads to still more support of biomedical research.

Whatever the reasons for its origin, the imbalance in the field of mental retardation should be remedied swiftly—if our society truly believes that everyone should have the opportunity to develop his potential to the maximum. We need social and educational research into retardation as much—or more—than we need biological and medical research. What follows is just one example of a recent significant study involving teachers, children and intelligence (Robert Rosenthal and Lenore Jacobsen, 1967).

At the beginning of the school year, intelligence tests were given to children in a city school of 18 classrooms (three at each grade level from first to sixth). By pre-arranged plan, the teachers in the school were told that the tests measured potential for "intellectual blooming." One child in five—chosen at random—in each classroom was said to have scored high on the test. This child, the teacher was told, very probably would show marked intellectual improvement within the next several months.

Eight months later, at the end of the school year,

another intelligence test was given. The specially-identified children in the first and second grades had made dramatic improvements. In first grade, the average gain was more than 15 points; in the second grade, more than ten points. In actuality, these children had been randomly chosen for identification. Yet, by some mysterious alchemy, the teachers had behaved in such a way toward these young children, who were designated as special, as to elicit more of their basic potential.

This study illustrates how research can clarify a point that is of crucial importance in planning educational experiences for intellectually handicapped youngsters. The point made in the study is that teachers with the right attitudes and expectations are of critical importance—and can have a significant effect on the development of the child's capacity to its fullest. This is the sort of research we need more of!

Too often we approach the task of teaching retarded children with the expectation that they will not, or cannot, learn. We have not yet begun to tap much of the potential of these children, a potential that might be unlocked not only with new techniques but with new expectations. Such insights and progress, of course, will *not* result from our exclusive reliance on biological research.

But it is not only research efforts that are out of balance. So are efforts at rehabilitation.

For example, the Children's Bureau of the Department of Health, Education and Welfare has struggled painfully—for 11 years—to develop 134 clinics across the nation for the retarded. These clinics ostensibly are operated to demonstrate the value of biomedically-oriented treatment that uses a so-called multi-disciplinary approach. As J. William Oberman (technical

adviser on Medical Aspects of Mental Retardation for the Children's Bureau) notes somewhat plaintively, these 134 clinics are able to offer only a very small fraction of the amount of care needed by the retarded and their families. He estimates that each year some 30,000 individuals are served by these clinics and that perhaps "other multidisciplinary clinics under medical direction" provide care for an additional 10,000 retarded children. But this is a trifle compared with the needs of the 6 million retarded children and adults in the United States. Dr. Oberman notes that even 2,500 new clinics (as impossible to staff as 2,500 new major-league baseball teams!) could barely handle the present demand. And the demand keeps increasing. Unmet needs grow. Of what profit is it to demonstrate that an expensive treatment clinic, expertly staffed with high-priced professionals, can see a handful of children a year with modest effectiveness, when it is impossible ever to duplicate such clinics? How long will Congress stand still for this nonsense?

The justification for these clinics having medical direction and treatment (largely unavailable full-time) rests on two highly emotional arguments. One, as we have seen, stresses the pathological or accidental—and theoretically preventable—causes of a high percentage of the severely retarded. The second stresses the concomitant additional physical handicaps, which are alleged to require continuing diagnostic follow-up and medical care.

The truth is that 85 percent of the retarded, after thorough medical evaluation, ordinarily require no more medical care than many other handicapped groups in society. The associated physical complications that are correctable, in a majority of cases, are visual and

auditory—outside the competence of the ordinary psychiatrist or pediatrician. A significant number of retardates also have speech problems, and these demand the special skills of a speech therapist rather than a physician.

The kind of professional manpower required for effective and functional care of the retarded is not more physicians, nurses and psychologists with highly specialized training in this field. These people do not spend any significant amount of their professional time working with the retarded anyway. More than anything else, we need teachers and vocational-guidance specialists.

According to the President's Panel, a very large majority of the retarded "can, with special training and assistance, acquire limited job skills and achieve a high measure of independence; they represent 85 percent of the retarded group." Yet many states even now do not provide any classes for the "trainable" retarded, and no state has enough classes for the "educable" retarded. Only one of every five retarded children is now being reached by any kind of special-education program. The President's Panel found 20,000 special-education teachers across the nation, many of them poorly trained, where 55,000 were needed. The panel predicted that by 1970 the need for special teachers will reach 90,000. And state vocational agencies that provide urgently-needed vocational rehabilitation for the mildly retarded are currently reaching only 3 percent of them.

In one investigation in Massachusetts, Simon Olshansky studied over 1,000 children whose families were receiving aid for dependent children. He found that 6.7 percent were retarded. Virtually none were getting any significant help. The mothers were "too immobilized" to recognize the problem, or to seek help. Social

agencies, as is frequently the case, had no workers to reach out and seek cases that would add to their excessive caseloads.

To provide adequate help to the 110,000 children born each year with mild but handicapping retardation, and to provide care and rehabilitation for the other 5,500,000 mildly retarded people in our society, we need teachers, teachers and more teachers—and then taxes to support a massive educational effort. Among teachers in this context I include all those specially trained and devoted professional people willing to spend hours and hours in daily and patient interaction with retarded children, unlocking and strengthening whatever skills and abilities are in them. Also included are the vocational-rehabilitation workers and those in occupational therapy, in recreational therapy and in non-professional but patient and warm interaction therapies that the retarded yearn for.

Needed desperately, in addition to teachers, are skilled caseworkers, sheltered-workshop personnel, vocational-guidance counselors, speech therapists, and all of the range of other people who have chosen careers that make them their handicapped brother's keeper. Many of these people could be trained in bachelor's or even two-year junior-college programs.

But, first and foremost, it is essential to escape the biomedical orientation that controls our efforts. Fourteen university-affiliated facilities for the retarded, all devoted to research and training, have now been approved for construction with federal funds. The federal government already has allocated the millions of dollars to build these research centers. Every last one of them is in a medical setting where most of the research, the research training, and the education of

professionals will be relevant to a small minority of retarded children. What have these huge new research centers to do with training special-education teachers and vocational counselors? The answer: next to nothing.

There *is* a place where medical care is truly needed to prevent retardation, and where it has not been available—in the prenatal and perinatal care of "medically indigent" expectant mothers in our large cities. A significant number of their children are born prematurely, and the prematurity rate is two to three times greater in low-income families where prenatal care is haphazard. Almost 500,000 indigent mothers deliver babies each year in our tax-supported city hospitals. At least 100,000 of these need special medical services for complications in pregnancy and birth. Most of them do not get it.

Here is an area for good medical research and action, because mental retardation that may well have an organic base is associated with prematurity and low birth weight. Among infants who weigh below three pounds at birth, nearly three-quarters subsequently develop physical or mental defects. In an average big-city hospital, the baby girl born to a Negro mother on the "staff service" (free service) weighs nearly a pound less than the baby born to a suburban white mother on the private service of the general hospital. A large percentage of urban indigent Negro mothers are "walk-ins" who receive little or no prenatal care, no special instructions on diet, and no medical guidance until labor pains begin. The retardation rate in infants born to these indigent mothers is ten times the white rate.

If American medicine were to turn its massive

resources to the solution of these problems—adequate medical care for the poor—many more cases of retardation could be prevented than will result from the present emphasis on research into esoteric causes. Unfortunately, the growing shortage of physicians, the fee-for-service philosophy of American medicine, and the high prestige of complex research activities in academia all combine to make this significant prevention-effort unlikely.

At the root of our double standard of care and intervention with the retarded is the fact that the nice people—the people who do the planning, the governing, the writing, the reading and the decision-making in our society—are members of the economically favored group. Most of them have arranged their lives in such a way as to be sealed off—geographically and socially— from the have-not groups, the disadvantaged and the dispossessed.

But parents of the retarded—parent-citizen groups in particular—are, for the most part, prosperous, and they at least have the advantage of some special insights into some of the darker social forces in our society. Most of them know from personal experience the hardships and heartaches that are the lot of the child or adult in our society who has limited intellectual capacity. Such citizen groups must take the lead in demanding that at least half of the tax dollars be spent for educational and rehabilitative approaches for all our intellectually-handicapped children and adults.

Our efforts are out of balance and out of joint. It is only an informed citizenry that can study the facts and act on them. The retarded cannot speak for themselves.

January/February 1968

FURTHER READING:

A Proposed Program for National Action to Combat Mental Retardation (U.S. Public Health Service, 1962). Report of the President's Panel on Mental Retardation. A good overview of the problem and of the recommendations to President Kennedy.

Intelligence and Experience by J. McV. Hunt (New York: The Ronald Press, 1961). While somewhat technical and research-oriented, this is an excellent treatise on factors influencing intelligent behavior.

The Wild Boy of Aveyron by J.M.G. Itard (New York: Appleton-Century-Crofts, 1932). This report of the attempt of a nineteenth-century physician to teach a mentally retarded boy is a classic.

Psychopathology of Childhood by Jane W. Kessler (Englewood Cliffs, N.J.: Prentice-Hall, 1966). This excellent textbook has chapters summarizing historical and contemporary approaches to mental subnormality and to learning problems.

Early Education of the Mentally Retarded by S. Kirk (Urbana, Ill.: University of Illinois Press, 1958). All of Dr. Kirk's writings must be on any required-reading list in this field.

Psychological Problems in Mental Deficiency (Third Edition) by S. Sarason (New York: Harper & Row, 1958). Dr. Sarason has pioneered in the development of a psychoeducational clinic at Yale that is a model for a meaningful approach to the problem discussed in this article.

Changing the Game from "Get the Teacher" to "Learn"

ROBERT L. HAMBLIN, DAVID BUCKHOLDT
DONALD BUSHELL, DESMOND ELLIS
and DANIEL FERRITOR

Almost any educator of experience will assure you that it is next to impossible—and often actually impossible—to teach normal classroom subjects to children who have extreme behavior problems, or who are "too young." Yet at four experimental classrooms of the Central Midwestern Regional Educational Laboratories (CEMREL), we have been bringing about striking changes in the behavior and learning progress of just such children.

In the 18 months of using new exchange systems and working with different types of problem children, we have seen these results:

☐ Extraordinarily aggressive boys, who had not previously responded to therapy, have been tamed.

☐ Two-year-olds have learned to read about as fast and as well as their five-year-old classmates.

☐ Four ghetto children, too shy, too withdrawn to talk,

210

have become better than average talkers.

□ Several autistic children, who were either mute or could only parrot sounds, have developed functional speech, have lost their bizarre and disruptive behavior patterns, and their relationships with parents and other children have improved. All of these children are on the road to normality.

Our system is deceptively simple. Superficially, in fact, it may not even seem new—though, in detail, it has never been tried in precisely this form in the classroom before. In essence, we simply reinforce "good" behavior and nonpunitively discourage "bad" behavior. We structure a social exchange so that as the child progresses, we reinforce this behavior—give him something that he values, something that shows our approval. Therefore, he becomes strongly motivated to continue his progress. To terminate bizarre, disruptive or explosive patterns, we stop whatever has been reinforcing that undesirable behavior—actions or attention that teachers or parents have unwittingly been giving him in exchange, often in the belief that they were punishing and thus discouraging him. Study after study has shown that whenever a child persists in behaving badly, some adult has, perhaps inadvertently, been rewarding him for it.

"Socialization" is the term that sociologists use to describe the process of transforming babies—who can do little but cry, eat and sleep—into adults who can communicate and function rather effectively in their society. Socialization varies from culture to culture, and while it is going on all around us, we are seldom aware of it. But when normal socialization breaks down, "problems" occur—autism, nonverbal or hyperaggressive behavior, retardation, delinquency, crime and so on.

The authors, after years of often interesting but by

and large frustrating research, realized that the more common theories of child development (Freudian, neo-Freudian, the developmental theories of Gesell and Piaget, and a number of others) simply do not satisfactorily explain the socialization process in children. Consequently in desperation we began to move toward the learning theories and then toward the related exchange theories of social structure. Since then, working with problem children, our view has gradually been amplified and refined. Each experimental classroom has given us a different looking glass. In each we can see the child in different conditions, and can alter the conditions which hinder his socialization into a civilized, productive adult capable of happiness.

By the time they become students, most children love to play with one another, to do art work, to cut and paste, to play with Playdoh, to climb and swing on the playground, and so on. Most pre-schools also serve juice and cookie snacks, and some have television sets or movies. There is, consequently, no dearth of prizes for us to reward the children for good behavior. The problem is not in finding reinforcers, but in managing them.

One of the simpler and most effective ways, we found, was to develop a token-exchange system. The tokens we use are plastic discs that children can earn. A child who completes his arithmetic or reading may earn a dozen tokens, given one by one as he proceeds through the lessons. And at the end of the lesson period comes the reward.

Often it is a movie. The price varies. For four tokens, a student can watch while sitting on the floor; for eight, he gets a chair; for 12, he can watch while sitting on the table. Perhaps the view is better from the table—

anyway, the children almost always buy it if they have enough tokens. But if they dawdled so much that they earned fewer than four, they are "timed out" into the hall while the others see the movie. Throughout the morning, therefore, the children earn, then spend, then earn, then spend.

This token-exchange system is very powerful. It can create beneficial changes in a child's behavior, his emotional reactions and ultimately even his approach to life. But it is not easy to set up, nor simple to maintain.

At the beginning the tokens are meaningless to the children; so to make them meaningful, we pair them with M&M candies, or something similar. As the child engages in the desired behavior (or a reasonable facsimile), the teacher gives him a "Thank you," an M&M and a token. At first the children are motivated by the M&Ms and have to be urged to hold on to the tokens; but then they find that the tokens can be used to buy admission to the movie, Playdoh or other good things. The teacher tells them the price and asks them to count out the tokens. Increasingly, the teacher "forgets" the M&Ms. In two or three days the children get no candy, just the approval and the tokens. By then, they have learned.

There are problems in maintaining a token exchange. Children become disinterested in certain reinforcers if they are used too frequently, and therefore in the tokens that buy them. For instance, young children will work very hard to save up tokens to play with Playdoh once a week; if they are offered Playdoh every day, the charm quickly fades. Some activities—snacks, movies, walks outdoors—are powerful enough to be used every day.

As noted, the children we worked with had different

behavior problems, reflecting various kinds of break-downs in the socialization process. Each experiment we conducted concentrated on a particular type of malad-justment or a particular group of maladjusted children to see how a properly structured exchange system might help them. Let us look at each experiment, to see how each problem was affected.

Unfortunately, our world reinforces and rewards aggressive behavior. Some cultures and some families are open and brazen about it—they systematically and consciously teach their young that it is desirable, and even virtuous, to attack certain other individuals or groups. The child who can beat up the other kids on the playground is sometimes respected by his peers, and perhaps by his parents; the soldier achieves glory in combat. The status, the booty or the bargaining advantages that come to the aggressor can become reinforcement to continue and escalate his aggressions.

In more civilized cultures the young are taught not to use aggression, and we try to substitute less harmful patterns. But even so, aggression is sometimes reinforced unintentionally—and the consequences, predictably, are the same as if the teaching was deliberate.

In the long run civilized cultures are not kind to hyperaggressive children. A recent survey in England, for instance, found that the great majority of teachers felt that aggressive behavior by students disturbed more classrooms than anything else and caused the most anxiety among teachers. At least partly as a result, the dropout rates for the hyperaggressives was two and one-half times as great as for "normals," and dispropor-tionate numbers of hyperaggressives turned up in mental clinics.

The traditional treatment for aggressive juveniles is

punishment—often harsh punishment. This is not only of dubious moral value, but generally it does not work.

We took seriously—perhaps for the first time—the theory that aggression is a type of exchange behavior. Boys become aggressive because they get something for it; they continue to be aggressive because the rewards are continuing. To change an aggressive pattern in our experimental class at Washington University, therefore, we had to restructure appropriately the exchange system in which the boys were involved.

As subjects we (Ellis and Hamblin) found five extraordinarily aggressive four-year-old boys, all referred to us by local psychiatrists and social workers who had been able to do very little with them. Next, we hired a trained teacher. We told her about the boys and general nature of the experiment—then gave her her head. That is, she was allowed to use her previous training during the first period—and this would provide a baseline comparison with that followed after. We hoped she would act like the "typical teacher." We suspect that she did.

The teacher was, variously, a strict disciplinarian, wise counselor, clever arbitrator and sweet peacemaker. Each role failed miserably. After the eighth day, the average of the children was 150 sequences of aggression per day! Here is what a mere four minutes of those sequences were like:

Mike, John and Dan are seated together playing with pieces of Playdoh. Barry, some distance from the others, is seated and also is playing with Playdoh. The children, except Barry, are talking about what they are making. Time is 9:10 AM. Miss Sally, the teacher, turns toward the children and says, "It's time for a lesson. Put your Playdoh away." Mike says,

"Not me." John says, "Not me." Dan says, "Not me." Miss Sally moves toward Mike. Mike throws some Playdoh in Miss Sally's face. Miss Sally jerks back, then moves forward rapidly and snatches Playdoh from Mike. Puts Playdoh in her pocket. Mike screams for Playdoh, says he wants to play with it. Mike moves toward Miss Sally and attempts to snatch the Playdoh from Miss Sally's pocket. Miss Sally pushes him away. Mike kicks Miss Sally on the leg. Kicks her again, and demands the return of his Playdoh. Kicks Miss Sally again. Picks up a small steel chair and throws it at Miss Sally. Miss Sally jumps out of the way. Mike picks up another chair and throws it more violently. Miss Sally cannot move in time. Chair strikes her foot. Miss Sally pushes Mike down on the floor. Mike starts up. Pulls over one chair. Now another, another. Stops a moment. Miss Sally is picking up chairs, Mike looks at Miss Sally. Miss Sally moves toward Mike. Mike runs away.

John wants his Playdoh. Miss Sally says "No." He joins Mike in pulling over chairs and attempts to grab Playdoh from Miss Sally's pocket. Miss Sally pushes him away roughly. John is screaming that he wants to play with his Playdoh. Moves toward phonograph. Pulls it off the table; lets it crash onto the floor. Mike has his coat on. Says he is going home. Miss Sally asks Dan to bolt the door. Dan gets to the door at the same time as Mike. Mike hits Dan in the face. Dan's nose is bleeding. Miss Sally walks over to Dan, turns to the others, and says that she is taking Dan to the washroom and that while she is away, they may play with the Playdoh. Returns Playdoh from pocket to Mike and John. Time: 9:14 AM.

Wild? Very. These were barbarous little boys who

enjoyed battle. Miss Sally did her best but they were just more clever than she, and they *always* won. Whether Miss Sally wanted to or not, they could always drag her into the fray, and just go at it harder and harder until she capitulated. She was finally driven to their level, trading a kick for a kick and a spit in the face for a spit in the face.

What Miss Sally did not realize is that she had inadvertently structured an exchange where she consistently reinforced aggression. First, as noted, whenever she fought with them, she *always lost.* Second, more subtly, she reinforced their aggressive pattern by giving it serious attention—by looking, talking, scolding, cajoling, becoming angry, even striking back. These boys were playing a teasing game called "Get the Teacher." The more she showed that she was bothered by their behavior, the better they liked it, and the further they went.

These interpretations may seem far-fetched, but they are borne out dramatically by what happened later. On the twelfth day we changed the conditions, beginning with B1 (see Figure 1). First, we set up the usual token exchange to reinforce cooperative behavior. This was to develop or strengthen behavior that would replace aggression. Any strong pattern of behavior serves some function for the individual, so the first step in getting rid of a strong, disruptive pattern is substituting another one that is more useful and causes fewer problems. Not only therapy, but simple humanity dictates this.

First, the teacher had to be instructed in how *not* to reinforce aggression. Contrary to all her experience, she was asked to turn her back on the aggressor, and at the same time to reinforce others' cooperation with tokens. Once we were able to coach her and give her immediate

feedback over a wireless-communication system, she structured the exchanges almost perfectly. The data in Figures 1 and 2 show the crucial changes: a gradual increase in cooperation—from 56 to about 115 sequences per day, and a corresponding decrease in aggression from 150 to about 60 sequences!

These results should have been satisfactory, but we were new at this kind of experimentation, and nervous. We wanted to reduce the frequency of aggression to a "normal" level, to about 15 sequences a day. So we restructured the exchange system and thus launched A2.

In A2, we simply made sure that aggression would

Figure 1. Frequency of aggressive sequences by days for five 4-year-old boys. In A1, A2 and A3 the teacher attempted to punish aggression but inadvertently reinforced it. In B1, B2 and B3 she turned her back or otherwise ignored aggression and thus did not reinforce it.

always be punished. The teacher was told to *charge* tokens for any aggression.

To our surprise, the frequency of cooperation remained stable, about 115 sequences per day; but aggression *increased* to about 110 sequences per day! Evidently the boys were still playing "Get the Teacher," and the fines were enough reinforcement to increase aggression.

So, instead of fining the children, the teacher was again told to ignore aggression by turning her back and giving attention and tokens only for cooperation. The

Figure 2. Frequency of cooperative sequences. In A1, A2 and A3 the teacher structured a weak approval exchange for cooperation and a disapproval exchange for noncooperation. In B1, A2, B2 and B3, she structured a token exchange for cooperation.

frequency of aggression went down to a near "normal" level, about 16 sequences per day (B2), and cooperation increased to about 140 sequences.

Then, as originally planned, the conditions were again reversed. The boys were given enough tokens at the beginning of the morning to buy their usual supply of movies, toys and snacks, and these were not used as reinforcers. The teacher was told to do the best she could. She was not instructed to return to her old pattern, but without the tokens and without our coaching she did—and with the same results. Note A3 in Figures 1 and 2. Aggression increased to about 120 sequences per day, and cooperation decreased to about 90. While this was an improvement over A1, before the boys had ever been exposed to the token exchange, it was not good. The mixture of aggression and coopera- tion was strange, even weird, to watch.

When the token exchange was restructured (B3) and the aggression no longer reinforced, the expected changes recurred—with a bang. Aggression decreased to seven sequences on the last day, and cooperation rose to about 181 sequences. In "normal" nursery schools, our observations have shown that five boys can be expected to have 15 aggression sequences and 60 cooperation sequences per day. Thus, from extremely aggressive and uncooperative, our boys had become less aggressive and far more cooperative than "normal" boys.

Here is an example of their new behavior patterns, taken from a rest period—precisely the time when the most aggressive acts had occurred in the past:

All of the children are sitting around the table drinking their milk; John, as usual, has finished first. Takes his plastic mug and returns it to the table. Miss Martha, the assistant teacher, gives him a token. John

goes to the cupboard, takes out his mat, spreads it out by the blackboard, and lies down. Miss Martha gives him a token. Meanwhile, Mike, Barry, and Jack have spread their mats on the carpet. Dan is lying on the carpet itself since he hasn't a mat. Each of them gets a token. Mike asks if he can sleep by the wall. Miss Sally says "Yes." John asks if he can put out the light. Miss Sally says to wait until Barry has his mat spread properly. Dan asks Mike if he can share his mat with him. Mike says "No." Dan then asks Jack. Jack says, "Yes," but before he can move over, Mike says "Yes." Dan joins Mike. Both Jack and Mike get tokens. Mike and Jack get up to put their tokens in their cans. Return to their mats. Miss Sally asks John to put out the light. John does so. Miss Martha gives him a token. All quiet now. Four minutes later—all quiet. Quiet still, three minutes later. Time: 10:23 AM. Rest period ends.

The hyperaggressive boys actually had, and were, double problems; they were not only extremely disruptive, but they were also washouts as students. Before the token system (A1), they paid attention to their teacher only about 8 percent of the lesson time (see Figure 3). The teacher's system of scolding the youngsters for inattention and taking their attention for granted with faint approval, if any, did not work at all. To the pupils, the "Get the Teacher" game was much more satisfying.

After the token exchange was started, in B1, B2, B3 and B4, it took a long, long time before there was any appreciable effect. The teacher was being trained from scratch, and our methods were, then, not very good. However, after we set up a wireless-communication system that allowed us to coach the teacher from behind a one-way mirror and to give her immediate

feedback, the children's attention began to increase. Toward the end of B3, it leveled off at about 75 percent—from 8 percent! After the token exchange was taken out during A2, attention went down to level off at 23 percent; put back in at B4, it shot back up to a plateau of about 93 percent. Like a roller coaster: 8 percent without, to 75 with, to 23 without, to 93 with.

These results occurred with chronic, apparently hopeless hyperaggressive boys. Would token exchange also help "normal," relatively bright upper-middle-class children? Sixteen youngsters of that description—nine boys and seven girls, ranging from 2 years 9 months to 4

Figure 3. Percentage of scheduled time spent in lessons by days for five hyperaggressive boys. In A1 and A2, teacher structured approval exchange for attendance, disapproval for non-attendance. In B1 and B2, a token exchange for attendance was structured, but not effectively until B2 and B4.

Figure 4. Sixteen upper-middle-class pre-schoolers. In A1, A2 and A3 the token exchange was used; in B, only approval.

years 9 months—were put through an experimental series by Bushell, Hamblin and Denis Stoddard in an experimental pre-school at Webster College. All had about a month's earlier experience with the token-exchange system. The results are shown in Figure 4.

At first, the study hour was broken up into 15-minute periods, alternating between the work that received tokens, and the play or reward that the tokens could be used for. Probably because the children were already familiar with token exchange, no great increase in learning took place. On the 22nd day, we decided to try to increase the learning period, perhaps for the whole hour. In A2 (Figure 4), note that the time spent in studying went up rapidly and dramatically—almost doubling—from 27 to level off at 42 minutes.

During B, the token exchange was taken out completely. The teachers still gave encouragement and prepared interesting lessons as before. The rewards—the nature walks, snacks, movies and so on—were retained. But, as in a usual classroom, they were given to the children free instead of being sold. The children continued at about the same rate as before for a few days. But after a week, attention dropped off slowly, then sharply. On the last day it was down to about 15 minutes—one-third the level of the end of the token period.

In A3, the token exchange was reinstituted. In only three days, attention snapped back from an average of 15 minutes to 45 minutes. However, by the end of A3, the students paid attention an average of 50 of the available 60 minutes.

A comparison of the record of these normals with the record of the hyperaggressive boys is interesting. The increase in attention brought by the token exchange,

from about 15 minutes to 50, is approximately three-fold for the normal children; but for the hyperaggressive boys—who are disobedient and easily distracted—it is about eleven-fold, from 8 percent to 93 percent of the time. The increase was not only greater, but the absolute level achieved was higher. This indicates strongly, therefore, that the more problematic the child, the greater may be the effect of token exchange on his behavior.

The high rates of attention were not due to the fact that each teacher had fewer children to work with. Individualized lessons were not enough. Without the token exchange, even three teachers could not hold the interest of 16 children two to four years old—at least not in reading, writing and arithmetic.

Praise and approval were not enough as rewards. The teachers, throughout the experiment, used praise and approval to encourage attention; they patted heads and said things like "Good," "You're doing fine," and "Keep it up"; yet, in B, when the token exchange was removed, this attention nevertheless ultimately declined by two-thirds. Social approval is important, but not nearly so powerful as material reinforcers.

Finally, it is obvious that if the reinforcers (movies, snacks, toys or whatever) do not seem directly connected to the work, they will not sustain a high level of study. To be effective with young children, rewards must occur in a structured exchange in which they are given promptly as recompense and thus are directly connected to the work performed.

According to accepted educational theory, a child must be about six and a half before he can comfortably learn to read. But is this really true, or is it merely a convenience for the traditional educational system?

After all, by the time a normal child is two and a half he has learned a foreign language—the one spoken by his parents and family; and he has learned it without special instruction or coaching. He has even developed a feel for the rules of grammar, which, by and large, he uses correctly. It is a rare college student who becomes fluent in a foreign language with only two and a half years of formal training—and our college students are supposed to be the brightest of our breed. Paul Goodman has suggested that if children learned to *speak* by the same methods that they learn to *read*, there might well be as many nonspeakers now as illiterates.

What if the problem is really one of motivation? If we structured an exchange that rewarded them, in ways they could appreciate, for learning to read, couldn't they learn as readily as five-year-olds?

We decided that for beginners, the number of words a child can read is the best test of reading ability. In an experiment designed by Hamblin, Carol Pfeiffer, Dennis Shea and June Hamblin, and administered at our Washington University pre-school, the token-exchange system was used to reward children for the number of words each learned. The results are given in Figure 5. Note that the two-year-olds did about as well as the five-year-olds; their sight vocabularies were almost as large.

There was an interesting side effect: at the end of the school year, all but one of these children tested at the "genius" level. On Stanford-Binet individual tests, their IQ scores increased as much as 36 points. It was impossible to compute an average gain only because three of the children "topped out"—made something in excess of 149, the maximum score possible.

In general, the lower the measured IQ at the start, the

Figure 5. Number of sight-words learned through time by five 4- and 5-year-olds, and four 2- and 3-year-olds. Note that the younger children did about as well as the older ones—except for one boy whose IQ was somewhat lower than the others in the group. (Gaps indicate absences.)

greater the gain—apparently as a result of the educational experience.

What happens when ghetto children are introduced into a token-exchange system? At our Mullanphy Street pre-school, 22 Afro-American children—age three to five—attend regularly. All live in or near the notorious Pruitt-Igoe Housing Project, and most come from broken homes. When the school began, the teachers were unenthusiastic about a token exchange, so we let them proceed as they wished. The result was pandemonium. About half of the children chased one another around the room, engaged in violent arguments and fought. The others withdrew; some would not even communicate.

After the third day, the teachers asked for help. As in the other experimental schools, we (Buckholdt and Hamblin) instructed them to ignore aggressive-disruptive behavior and to reward attention and cooperation with social approval and the plastic tokens, later to be exchanged for such things as milk, cookies, admission to the movies and toys. The children quickly caught on, the disruptions diminished, and cooperation increased. Within three weeks of such consistent treatment, most of the children took part in the lessons, and disruptive behavior had become only an occasional problem. All of this, remember, without punishment.

Our attention was then focused upon the children with verbal problems. These children seldom started conversations with teachers or other students, but they would sometimes answer questions with a word or perhaps two. This pattern may be unusual in the middle classes, but is quite common among ghetto children. Our research has shown that children so afflicted are usually uneducable.

As we investigated, we became convinced that their problem was not that they were unable to talk as much as that they were too shy to talk to strangers—that is, to nonfamily. In their homes we overheard most of them talking brokenly, but in sentences. Consequently, we set up a token exchange for them designed specifically to develop a pattern of talking with outsiders, especially teachers and school children.

As it happened, we were able to complete the experiment with only four children (see Figure 6). During A1, the baseline period (before the tokens were used), the four children spoke only in about 8 percent of the 15-second sampling periods. In B1, the teachers gave social approval and tokens *only* for speaking; nonverbalisms, like pointing or headshaking, would not be recognized or reinforced. Note the increase in verbalization, leveling out at approximately 48 percent.

In A2 we reversed the conditions by using a teacher new to the school. The rate of talking dropped off immediately, then increased unevenly until it occurred in about 23 percent of the sample periods.

In B2 the new teacher reintroduced the token exchange for talking, and once more there was a dramatic rise: The speaking increased much more rapidly than the first time, ending up at about 60 percent. (This more rapid increase is known as the Contrast Effect. It occurs in part, perhaps, because the children value the token exchange more after it has been taken away.)

In the final test, we again took out the token exchange, and introduced yet another new teacher. This time the drop was small, to 47 percent.

We followed the children for three months after the end of the experiment. Their speech level remained at

48 percent, with little dropoff. This compares with the 40 percent talking rate for our other ghetto children, and the 42 percent rate for upper-middle-class children at the Washington University pre-school.

Frequency of speech, however, was not the only important finding. At the end of B1, the children spoke more often but still in a hesitant and broken way. By the end of B2, they spoke in sentences, used better syntax, and frequently started conversations.

Mothers, teachers and neighbors all reported that the children were much more friendly and assertive. But some claimed that the children now talked too much! This could reflect individual bias; but there was little doubt that at least one child, Ben, had become an almost compulsive talker. He was given to saying hello to everyone he met and shaking their hands. So we terminated the experiment—what would have happened to Ben had we started *another* exchange?

This experiment shows that token exchange can bring on permanent behavior change, but that the culture must reinforce the new behavior. Talking is important in our culture, and so is reading; therefore they are reinforced. But other subjects—such as mathematics beyond simple arithmetic—are not important for most people. For behavior to change permanently it must be reinforced at least intermittently.

The problems of autistic children usually dwarf those of all other children. To the casual observer, autistic children never sustain eye contact with others but appear to be self-contained—sealed off in a world of their own. The most severe cases never learn how to talk, though they sometimes echo or parrot. They remain dependent upon Mother and become more and more demanding. They develop increasingly destructive

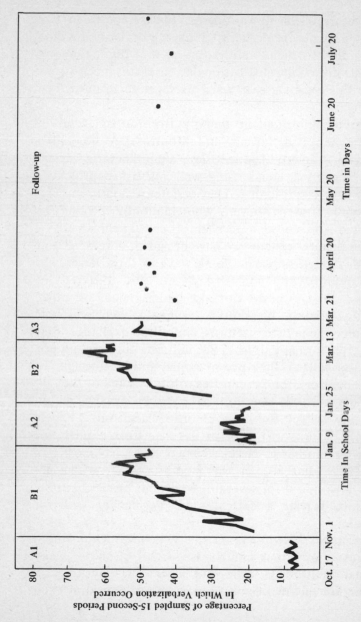

Figure 6. Percentage of sampled periods in which talking occured through time for four non-verbal "culturally deprived" children, and through five experimental conditions. In each of the A conditions a new teacher was introduced, and she structured a token exchange for participation in lessons. In the B conditions, the teacher then structured a token exchange for talking. The follow-up was similar to the A conditions.

and bizarre behavior problems. Finally, between five and ten years old, autistic children ordinarily become unbearable to their families and at that point they are almost invariably institutionalized. Until recently, at least, this meant a rear ward to vegetate in until they died.

The breakthrough in therapy from autism came in 1964 when Ivar Lovaas and Montrose Wolfe and a graduate student, Todd Risley, simultaneously developed therapy systems using well-established principles of operant conditioning. They were particularly successful with those children who randomly echoed or imitated words or sentences (this is called echolalia).

The therapy systems we have designed, developed and tested, though similar in some ways to those developed by Lovaas, Wolfe and Risley, are quite different in others. First, we do not use punishment, or other negative stimuli. We simply terminate exchanges that reinforce the autistic patterns, and set up exchanges that reinforce normal patterns. Second, our children are not institutionalized; they live at home, and are brought to the laboratory for 20 minutes to three hours of therapy per day. Third, as soon as possible—usually within months—we get the children into classrooms where a therapist works with four or five at a time. Fourth, we train the mother to be an assistant therapist—mostly in the home, but also in the laboratory. These changes were introduced for several reasons, but primarily in the hope of getting a better, more permanent cure for autism.

Is autism hereditary, as many believe? Our studies indicate that this is not the important question. Many mental faculties, including IQ, have some physiological base. But the real issue is how much physiologically

based potential is socially realized, for good or bad. As far as we can tell, the exchanges that intensify autism get structured inadvertently, often by accident; but once started, a vicious cycle develops that relentlessly drives the child further into autism.

When autism starts, the mother often reacts by babying the child, trying to anticipate his every need before he signals. Thus normal communication is not reinforced, and the child never learns to work his environment properly. But even if he doesn't know how to get what he wants through talking, he does learn, through association, that his oversolicitous and anxious mother will always respond if he acts up violently or bizarrely enough. And she must, if only to punish. He thus learns to play "Get Mother's attention"; and this soon develops into "Get Mother exasperated, but stop just short of the point where she punishes and really hurts." Here is an example (observed by Ferritor in the first of a series of experiments by the Laboratory's staff, not reported here):

Larry is allowed to pick out his favorite book. His mother then attempts to read it to him, but he keeps turning the pages so she can't. He gets up and walks away from the table. The mother then yells at him to come back. He *smiles* (a sign of pleasure usually, but not always, accompanies reinforcement). Mother continues to talk to the child to try to get him back for the story. Finally, he comes over to the table and takes the book away from her. She lets him and goes back to the bookcase for another book. He then sits down and she begins to read. He tries to get up, but his mother pulls him back. Again. Again. She holds him there. He gets away and starts walking around the room. Goes to the toy cabinet. Mother gets up to

go over and take a toy away from him. He sits on the
floor. The mother comes over and sits down by him.
He gets up and goes over by the door and opens it
and tries to run out. She tells him he has to stay. He
smiles. She resumes reading. He gets up and starts
walking around the table. She grabs him as he comes
by. He *smiles*.

A clinical psychologist who had tested Larry did not
diagnose him as autistic, but as an educable mental
retardate with an IQ of perhaps 30. Yet he had gaze
aversion and we suspected that Larry, like other
autistics, was feigning inability as a way of getting what
he wanted from his mother, and then from other adults.
He began to respond to the attractive exchanges that we
structured for him, and as we did, he began to tip his
hand. For example, at one point when his mother was
being trained to be an assistant therapist, the following
incident occurred:

Mrs. C. told Larry that as soon as he strung some
beads he could have gum from the gum machine that
was across the room. For about ten minutes he
fumbled, he whined, all the time crying, saying "I
can't." Finally, he threw the beads at his mother.
Eventually, the mother had the good sense to leave
the room, saying, "As soon as you string those beads,
you can have your gum." With his mother out of the
room, according to our observers he sat right down
and, in less than 30 seconds, filled a string with beads
with no apparent trouble.

Just two weeks later, after the mother had been through
our ten-day training program, they again had a "story
time."

The mother begins by immediately asking Larry
questions about this book (the same book used a few

weeks before). He responds to every question. She gives approval for every correct answer. Then she tries to get him to say, "That is a duck." He will not say it intelligibly, but wants to turn the page. Mother says, "As soon as you say 'duck,' you may turn the page. Larry says "Duck" and turns the page. He *smiles*.

After seven minutes, Larry is still sitting down. They have finished one book and are beginning a second.

Most autistic children play the game "Look at me, I'm stupid," or "Look at me, I'm bizarre." These are simply attention-getting games that most adults repeatedly reinforce. Man is not a simple machine; he learns, and as he develops his abilities, he develops stronger and stronger habits. Thus, once these inadvertent exchanges get established, the child becomes more and more dependent, more and more disruptive, more and more bizarre, more and more alienated from the positive exchanges that are structured in his environment. What is sad is that the parents and the others in the child's life sense that something is terribly wrong, but the more they do, the worse the situation becomes.

It seems to those of us who have been involved in these experiments from the beginning that the exchange techniques and theories we have used have without question demonstrated their effectiveness in treating and educating problem children. Watching these children as they go peacefully and productively about their lessons toward the end of each experimental series is both an exhilarating and humbling experience. It is almost impossible to believe that so many had been written off as "uneducable" by professionals, that without this therapy and training—or something similar—most would have had dark and hopeless futures.

But it is not inevitable that so many hyperaggressive or environmentally retarded ghetto children become dropouts or delinquents; it is not inevitable that so many autistic children, saddest of all, must vegetate and die mutely in the back wards of mental hospitals.

January 1969

FURTHER READING:

The Analysis of Human Operant Behavior by Ellen P. Reese (Dubuque Iowa: William C. Brown Company, 1966).

The Emotionally Disturbed Child in the Classroom by Frank Hewett (Boston: Allyn and Bacon, Inc., 1968).

Early Childhood Autism edited by J.K. Wing (London: Pergamon Press, Ltd., 1966).

Case Studies in Behavior Modification by Leonard P. Ullman and Leonard Krasner (New York: Holt, Rinehart and Winston, Inc., 1965).

Note: The work reported here was done by the Central Midwestern Regional Educational Laboratory, a private, non-profit corporation supported in part as a Regional Educational Laboratory by funds from the U.S. Office of Education, Department of Health, Education and Welfare. The opinions expressed here do not necessarily reflect the position or policy of the Office of Education, and no official endorsement by the Office of Education should be inferred.

Programmed for Social Class: Tracking in American High Schools

WALTER E. SCHAEFER
CAROL OLEXA and KENNETH POLK

If, as folklore would have it, America is the land of opportunity, offering anyone the chance to raise himself purely on the basis of his or her ability, then education is the key to self-betterment. The spectacular increase in those of us who attend school is often cited as proof of the great scope of opportunity that our society offers: 94 percent of the high school age population was attending school in 1967, as compared to 7 percent in 1890.

Similarly, our educational system is frequently called more democratic than European systems, for instance, which rigidly segregate students by ability early in their lives, often on the basis of nationally administered examinations such as England's "11-plus." The United States, of course, has no official national policy of educational segregation. Our students, too, are tested and retested throughout their lives and put into faster or

Start

slower classes or programs on the basis of their presumed ability, but this procedure is carried out in a decentralized fashion that varies between each city or state.

However, many critics of the American practice claim that, no matter how it is carried out, it does not meet the needs of the brighter and duller groups, so much as it solidifies and widens the differences between them. One such critic, the eminent educator Kenneth B. Clark, speculates: "It is conceivable that the detrimental effects of segregation based upon intellect are similar to the known detrimental effects of schools segregated on the basis of class, nationality or race."

Patricia Cayo Sexton notes that school grouping based on presumed ability often reinforces already existing social divisions:

Children from higher social strata usually enter the "higher quality" groups and those from lower strata the "lower" ones. School decisions about a child's ability will greatly influeence the kind and quality of education he receives, as well as his future life, including whether he goes to college, the job he will get, and his feelings about himself and others.

And Arthur Pearl puts it bluntly:

... "special ability classes," "basic track," or "slow learner classes" are various names for another means of systematically denying the poor adequate access to education.

In this chapter we will examine some evidence bearing on this vital question of whether current educational practices tend to reinforce existing social class divisions. We will also offer an alternative aimed at making our public schools more effective institutions for keeping open the opportunities for social mobility.

Since the turn of the century, a number of trends have converged to increase enormously the pressure on American adolescents to graduate from high school: declining opportunity in jobs, the upgrading of educational requirements for job entry, and the diminishing need for teenagers to contribute to family income. While some school systems, especially in the large cities, have adapted to this vast increase in enrollment by creating separate high schools for students with different interests, abilities or occupational goals, most communities have developed comprehensive high schools serving all the youngsters within a neighborhood or community.

In about half the high schools in the United States today, the method for handling these large and varied student populations is through some form of tracking system. Under this arrangement, the entire student body is divided into two or more relatively distinct career lines, or tracks, with such titles as college preparatory, vocational, technical, industrial, business, general, basic and remedial. While students on different tracks may take some courses together in the same classroom, they are usually separated into entirely different courses or different sections of the same course.

Schoolmen offer several different justifications for tracking systems. Common to most, however, is the notion that college-bound students are academically more able, learn more rapidly, should not be deterred in their progress by slower, non-college-bound students, and need courses for college preparation which non-college-bound students do not need. By the same token, it is thought that non-college-bound students are less bright, learn more slowly, should not be expected to progress as fast or learn as much as college-bound

students, and need only a general education or work-oriented training to prepare themselves for immediate entry into the world of work or a business or vocational school.

In reply, the numerous critics of tracking usually contend that while the college-bound are often encouraged by the tracking system to improve their performance, non-college-bound students, largely as a result of being placed in a lower-rated track, are discouraged from living up to their potential or from showing an interest in academic values. What makes the system especially pernicious, these critics say, is that non-college-bound students more often come from low-income and minority group families. As a result, high schools, through the tracking system, inadvertently close off opportunities for large numbers of students from lower social strata, and thereby contribute to the low achievement, lack of interest, delinquency and rebellion which schoolmen frequently deplore in their noncollege track students.

If these critics are correct, the American comprehensive high school, which is popularly assumed to be the very model of an open and democratic institution, may not really be open and democratic at all. In fact, rather than facilitating equality of educational opportunity, our schools may be subtly denying it, and in the process widening and hardening existing social divisions.

During the summer of 1964, we collected data from official school transcripts of the recently graduated senior classes of two midwestern three-year high schools. The larger school, located in a predominantly middle-class, academic community of about 70,000, had a graduating class that year of 753 students. The smaller school, with a graduating class of 404, was located

nearby in a predominantly working-class, industrial community of about 20,000.

Both schools placed their students into either a college prep or general track. We determined the positions of every student in our sample by whether he took tenth grade English in the college prep or the general section. If he was enrolled in the college prep section, he almost always took other college prep sections or courses, such as advanced mathematics or foreign languages, in which almost all enrollees were also college prep.

Just how students in the two schools were assigned to—or chose—tracks is somewhat of a mystery. When we interviewed people both in the high schools and in their feeder junior highs, we were told that whether a student went into one track or another depended on various factors, such as his own desires and aspirations, teacher advice, achievement test scores, grades, pressure from parents and counselor assessment of academic promise. One is hard put to say which of these weighs most heavily, but we must note that one team of researchers, Cicourel and Kitsuse, showed in their study of *The Educational Decision-Makers* that assumptions made by counselors about the character, adjustment and potential of incoming students are vitally important in track assignment.

Whatever the precise dynamics of this decision, the outcome was clear in the schools we studied: socio-economic and racial background had an effect on which track a student took, quite apart from either his achievement in junior high or his ability as measured by IQ scores. In the smaller, working-class school, 58 percent of the incoming students were assigned to the college prep track; in the larger, middle-class school, 71

percent were placed in the college prep track. And, taking the two schools together, whereas 83 percent of students from white-collar homes were assigned to the college prep track, this was the case with only 48 percent of students from blue-collar homes. The relationship of race to track assignment was even stronger: 71 percent of the whites and only 30 percent of the blacks were assigned to the college prep track. In the two schools studied, the evidence is plain: Children from low income and minority group families more often found themselves in low ability groups and non-college-bound tracks than in high ability groups or college-bound tracks.

Furthermore, this decision-point early in the students' high school careers was of great significance for their futures, since it was virtually irreversible. Only 7 percent of those who began on the college prep track moved down to the noncollege prep track, while only 7 percent of those assigned to the lower, noncollege track, moved up. Clearly, these small figures indicate a high degree of rigid segregation within each of the two schools. In fact, greater mobility between levels has been reported in English secondary modern schools, where streaming—the British term for tracking—is usually thought to be more rigid and fixed than tracking in this country. (It must be remembered, of course, that in England the more rigid break is between secondary modern and grammar schools.)

As might be expected from the schoolmen's justification for placing students in separate tracks in the first place, track position is noticeably related to academic performance. Thirty-seven percent of the college prep students graduated in the top quarter of their class (measured by grade point average throughout high

school), while a mere 2 percent of the noncollege group achieved the top quarter. By contrast, half the non-college prep students fell in the lowest quarter, as opposed to only 12 percent of the college prep.

Track position is also strikingly related to whether a student's academic performance improves or deteriorates during high school. The grade point average of all sample students in their ninth year—that is, prior to their being assigned to tracks—was compared with their grade point averages over the next three years. While there was a slight difference in the ninth year between those who would subsequently enter the college and noncollege tracks, this difference had increased by the senior year. This widening gap in academic performance resulted from the fact that a higher percentage of students subsequently placed in the college prep track improved their grade point average by the senior year, while a higher percentage of noncollege prep experienced a decline in grade point average by the time they reached the senior year.

Track position is also related strongly to dropout rate. Four percent of the college prep students dropped out of high school prior to graduation, as opposed to 36 percent of the noncollege group.

Track position is also a good indication of how deeply involved a student will be in school, as measured by participation in extracurricular activities. Out of the 753 seniors in the larger school, a comparatively small number of college prep students—21 percent—did not participate in any activities, while 44 percent took part in three or more such activities. By contrast, 58 percent, or more than half of the noncollege group took part in no extracurricular activities at all, and only 11 percent of this group took part in three or more activities.

Finally, track position is strikingly related to delinquency, both in and out of school. Out of the entire student body of the larger school who committed one or more violations during the 1963-1964 school year, just over one-third were college-bound, while just over one-half were non-college-bound. (The track position of the remaining one-tenth was unknown.) Among those who committed three or more such violations, 19 percent were college-bound, compared with 70 percent who were non-college-bound. Among all those suspended, over one-third were college-bound, while just over one-half were non-college-bound. In short, the non-college-bound students were considerably more often caught and sanctioned for violations of school rules, even though they comprised less than one-third of the student body.

Furthermore, using juvenile court records, we find that out of the 1964 graduating class in the larger school, 6 percent of the college prep, and 16 percent of the non-college-bound groups, were delinquent while in high school. Even though 5 percent of those on the noncollege track had already entered high school with court records, opposed to only 1 percent of the college prep track, still more non-college-bound students became delinquent during high school than did college prep students (11 percent compared with 5 percent). So the relation between track position and delinquency is further supported.

We have seen, then, that when compared with college prep students, noncollege prep students show lower achievement, great deterioration of achievement, less participation in extracurricular activities, a greater tendency to drop out, more misbehavior in school, and more delinquency outside of school. Since students are

assigned to different tracks largely on the basis of presumed differences in intellectual ability and inclination for study, the crucial question is whether assignment to different tracks helped to meet the needs of groups of students who were already different, as many educators would claim, or actually contributed to and reinforced such differences, as critics like Sexton and Pearl contend.

The simplest way to explain the differences we have just seen is to attribute them to characteristics already inherent in the individual students, or—at a more sophisticated level—to students' cultural and educational backgrounds.

It can be argued, for example, that the difference in academic achievement between the college and non-college groups can be explained by the fact that college prep students are simply brighter; after all, this is one of the reasons they were taken into college prep courses. Others would argue that non-college-bound students do less well in school work because of family background: they more often come from blue-collar homes where less value is placed on grades and college, where books and help in schoolwork are less readily available, and verbal expression limited. Still others would contend that lower track students get lower grades because they performed less well in elementary and junior high, have fallen behind, and probably try less hard.

Fortunately, it was possible with our data to separate out the influence of track position from the other suggested factors of social class background (measured by father's occupation), intelligence (measured by IQ— admittedly not a perfectly acceptable measure), and previous academic performance (measured by grade point average for the last semester of the ninth year).

Through use of a weighted percentage technique known as test factor standardization, we found that even when the effects of IQ, social class and previous performance are ruled out, there is still a sizable difference in grade point average between the two tracks. With the influence of the first three factors eliminated we nevertheless find that 30 percent of the college prep, as opposed to a mere 4 percent of the noncollege group attained the top quarter of their class; and that only 12 percent of the college prep, as opposed to 35 percent of the noncollege group, fell into the bottom quarter. These figures, which are similar for boys and girls, further show that track position has an independent effect on academic achievement which is greater than the effect of each of the other three factors—social class, IQ and past performance. In particular, assignment to the noncollege track has a strong negative influence on a student's grades.

Looking at dropout rate, and again controlling for social class background, IQ and past performance, we find that track position in itself has an independent influence which is higher than the effect of any of the other three factors. In other words, even when we rule out the effect of these three factors, non-college-bound students still dropped out in considerably greater porportion than college-bound-students (19 percent vs. 4 percent).

So our evidence points to the conclusion that the superior academic performance of the college-bound students, and the inferior performance of the noncollege students is partly caused by the tracking system. Our data do not explain how this happens, but several studies of similar educational arrangements, as well as basic principles of social psychology do provide a

number of probable explanations. The first point has to do with the pupil's self-image.

Stigma. Assignment to the lower track in the schools we studied carried with it a strong stigma. As David Mallory was told by an American boy, "Around here you are *nothing* if you're not college prep." A non-college prep girl in one of the schools we studied told me that she always carried her "general" track books upside down because of the humiliation she felt at being seen with them as she walked through the halls.

The corroding effect of such stigmatizing is well known. As Patricia Sexton has put it, "He [the low track student] is bright enough to catch on very quickly to the fact that he is not considered very bright. He comes to accept this unflattering appraisal because, after all, the school should know."

One ex-delinquent in Washington, D.C. told one of us how the stigma from this low track affected him.

It really don't have to be the tests, but after the tests, there shouldn't be no separation in the classes. Because, as I say again, I felt good when I was with my class, but when they went and separated us—that changed us. That changed our ideas, our thinking, the way we thought about each other and turned us to enemies toward each other—because they said I was dumb and they were smart. When you first go to junior high school you do feel something inside—it's like ego. You have been from elementary to junior high, you feel great inside. You say, well daggone, I'm going to deal with the *people* here now, I am in junior high school. You get this shirt that says Brown Junior High or whatever the name is and you are proud of that shirt. But then you go up there and the teacher says—"Well, so and so, you're in the basic section,

you can't go with the other kids." The devil with the whole thing—you lose—something in you—like it just goes out of you.

Did you think the other guys were smarter than you? Not at first—I used to think I was just as smart as anybody in the school—I knew I was smart. I knew some people were smarter, and I *wanted* to go to school, I wanted to get a diploma and go to college and help people and everything. I stepped into there in junior high—I felt like a fool going to school—I really felt like a fool. *Why?* Because I felt like I wasn't a part of the school. I couldn't get on special patrols, because I wasn't qualified.

What happened between the seventh and ninth grades? I started losing faith in myself—after the teachers kept downing me. You hear "a guy's in basic section, he's dumb" and all this. Each year—"you're ignorant—you're stupid."

Considerable research shows that such erosion of self-esteem greatly increases the chances of academic failure, as well as dropping out and causing "trouble" both inside and outside of school.

Moreover, this lowered self-image is reinforced by the expectations that others have toward a person in the non-college-bound group.

The Self-fulfilling Prophecy. A related explanation rich in implications comes from David Hargreaves' *Social Relations in a Secondary School*, a study of the psychological, behavioral and educational consequences of the student's position in the streaming system of an English secondary modern school. In "Lumley School," the students (all boys) were assigned to one of five streams on the basis of ability and achievement, with

the score on the "11-plus" examination playing the major role.

Like the schools we studied, students in the different streams were publicly recognized as high or low in status and were fairly rigidly segregated, both formally in different classes and informally in friendship groups. It is quite probable, then, that Hargreaves' explanations for the greater antischool attitudes, animosity toward teachers, academic failure, disruptive behavior and delinquency among the low stream boys apply to the noncollege prep students we studied as well. In fact, the negative effects of the tracking system on non-college-bound students may be even stronger in our two high schools, since the Lumley streaming system was much more open and flexible, with students moving from one stream to another several times during their four-year careers.

As we noted, a popular explanation for the greater failure and misbehavior among low stream or non-college-bound students is that they come from homes that fail to provide the same skills, ambition or conforming attitude as higher stream or college-bound students. Hargreaves demonstrates that there is some validity to this position: in his study, low stream boys more often came from homes that provided less encouragement for academic achievement and higher level occupations, and that were less oriented to the other values of the school and teachers. Similar differences may have existed among the students we studied, although their effects have been markedly reduced by our control for father's occupation, IQ and previous achievement.

But Hargreaves provides a convincing case for the

position that whatever the differences in skills, ambition, self-esteem or educational commitment that the students brought to school, they were magnified by what happened to them in school, largely because low stream boys were the victims of a self-fulfilling prophecy in their relations with teachers, with respect to both academic performance and classroom behavior. Teachers of higher stream boys expected higher performance and got it. Similarly, boys who wore the label of streams "C" or "D" were more likely to be seen by teachers as limited in ability and troublemakers, and were treated accordingly.

In a streamed school the teacher categorizes the pupils not only in terms of the inferences he makes of the child's class room behavior but also from the child's stream level. It is for this reason that the teacher can rebuke an "A" stream boy for being like a "D" stream boy. The teacher has learned to *expect* certain kinds of behavior from members of different streams. . . . It would be hardly surprising if "good" pupils thus became "better" and the "bad" pupils become "worse." It is, in short, an example of a self-fulfilling prophecy. The negative expectations of the teacher reinforce the negative behavioral tendencies.

A recent study by Rosenthal and Jacobson in an American elementary school lends further evidence to the position that teacher expectations influence student's performance. In this study, the influence is a positive one. Teachers of children randomly assigned to experimental groups were told at the beginning of the year to expect "unusual intellectual" gains, while teachers of the control group children were told nothing. After eight months, and again after two years,

the experimental group children, the "intellectual spurt-
ers," showed significantly greater gains in IQ and grades.
Further, they were rated by the teachers as being
significantly more curious, interesting, happy and more
likely to succeed in the future. Such findings are
consistent with theories of interpersonal influence and
with the interactional or labelling view of deviant
behavior.

If, as often claimed, American teachers underestimate
the learning potential of low track students and expect
more negative attitudes and greater trouble from them,
it may well be that they partially cause the very failure,
alienation, lack of involvement, dropping out and
rebellion they are seeking to prevent. As Hargreaves says
of Lumley, "It is important to stress that if this effect
of categorization is real, it is entirely unintended by the
teachers. They do not wish to make low streams more
difficult than they are!" Yet the negative self-fulfilling
prophecy was probably real, if unintended and unrecog-
nized, in our two schools as well as in Lumley.

Two further consequences of the expectation that
students in the noncollege group will learn less well are
differences in grading policies and in teacher effective-
ness.

Grading Policies. In the two schools we studied, our
interviews strongly hint at the existence of grade ceilings
for noncollege prep students and grade floors for
college-bound students. That is, by virtue of being
located in a college preparatory section or course,
college prep students could seldom receive any grade
lower than "B" or "C," while students in non-college-
bound sections or courses found it difficult to gain any
grade higher than "C," even though their objective
performance may have been equivalent to a college prep

"B." Several teachers explicitly called our attention to this practice, the rationale being that noncollege prep students do not deserve the same objective grade rewards as college prep students, since they "clearly" are less bright and perform less well. To the extent that grade ceilings do operate for non-college-bound students, the lower grades that result from this policy, almost by definition, can hardly have a beneficial effect on motivation and commitment.

Teaching Effectiveness. Finally, numerous investigations of ability grouping, as well as the English study by Hargreaves, have reported that teachers of higher ability groups are likely to teach in a more interesting and effective manner than teachers of lower ability groups. Such a difference is predictable from what we know about the effects of reciprocal interaction between teacher and class. Even when the same individual teaches both types of classes in the course of the day, as was the case for most teachers in the two schools in this study, he is likely to be "up" for college prep classes and "down" for noncollege prep classes—and to bring out the same reaction from his students.

A final and crucial factor that contributes to the poorer performance and lower interest in school of non-college-bound students is the relation between school work and the adult career after school.

Future Payoff. Non-college-bound students often develop progressively more negative attitudes toward school, especially formal academic work, because they see grades—and indeed school itself—as having little future relevance or payoff. This is not the case for college prep students. For them, grades are a means toward the identifiable and meaningful end of qualifying for college, while among the non-college-bound,

grades are seen as far less important for entry into an occupation or a vocational school. This difference in the practical importance of grades is magnified by the perception among non-college-bound students that it is pointless to put much effort into school work, since it will be unrelated to the later world of work anyway. In a study of *Rebellion in a High School* in this country, Arthur Stinchcombe describes the alienation of non-college-bound high school students:

The major practical conclusion of the analysis above is that rebellious behavior is largely a reaction to the school itself and to its promises, not a failure of the family or community. High school students can be motivated to conform by paying them in the realistic coin of future advantage. Except perhaps for pathological cases, any student can be motivated to conform if the school can realistically promise something valuable to him as a reward for working hard. But for a large part of the population, especially the adolescent who will enter the male working class or the female candidates for early marriage, the school has nothing to offer. . . . In order to secure conformity from students, a high school must articulate academic work with careers of students.

Being on the lower track has other negative consequences for the student which go beyond the depressing influence on his academic performance and motivation. We can use the principles just discussed to explain our findings with regard to different rates of participation in school activities and acts of misbehavior.

For example, the explanations having to do with self-image and the expectations of others suggest that assignment to the non-college-bound track has a dampening effect on commitment to school in general, since

it is the school which originally categorized these students as inferior. Thus, assignment to the lower track may be seen as independently contributing to resentment, frustration and hostility in school, leading to lack of involvement in all school activities, and finally ending in active withdrawal. The self-exclusion of the noncollege group from the mainstream of college student life is probably enhanced by intentional or unintentional exclusion by other students and teachers.

Using the same type of reasons, while we cannot prove a definite causal linkage between track position and misbehavior, it seems highly likely that assignment to the non-college prep track often leads to resentment, declining commitment to school, and rebellion against it, expressed in lack of respect for the school's authority or acts of disobedience against it. As Albert Cohen argued over a decade ago in *Delinquent Boys,* delinquency may well be largely a rebellion against the school and its standards by teenagers who feel they cannot get anywhere by attempting to adhere to such standards. Our analysis suggests that a key factor in such rebellion is noncollege prep status in the school's tracking system, with the vicious cycle of low achievement and inferior self-image that go along with it.

This conclusion is further supported by Hargreaves' findings on the effect of streaming at Lumley:

There is a real sense in which the school can be regarded as a generator of delinquency. Although the aims and efforts of the teachers are directed towards deleting such tendencies, the organization of the school and its influence on subcultural development unintentionally fosters delinquent values. . . . For low stream boys . . . school simultaneously exposes them to these values and deprives them of status in these

terms. It is at this point they may begin to reject the values because they cannot succeed in them. The school provides a mechanism through the streaming system whereby their failure is effected and institutionalized, and also provides a situation in which they can congregate together in low streams.

Hargreaves' last point suggests a very important explanation for the greater degree of deviant behavior among the non-college-bound.

The Student Subculture. Assignment to a lower stream at Lumley meant a boy was immediately immersed in a student subculture that stressed and rewarded antagonistic attitudes and behavior toward teachers and all they stood for. If a boy was assigned to the "A" stream, he was drawn toward the values of teachers, not only by the higher expectations and more positive rewards from the teachers themselves, but from other students as well. The converse was true of lower stream boys, who accorded each other high status for doing the opposite of what teachers wanted. Because of class scheduling, little opportunity developed for interaction and friendship across streams. The result was a progressive polarization and hardening of the high and low stream subcultures between first and fourth years and a progressively greater negative attitude across stream lines, with quite predictable consequences.

The informal pressures within the low streams tend to work directly against the assumption of the teachers that boys will regard promotion into a higher stream as a desirable goal. The boys from the low streams were very reluctant to ascend to higher streams because their stereotypes of "A" and "B" stream boys were defined in terms of values alien to their own and because promotion would involve rejection

by their low stream friends. The teachers were not fully aware that this unwillingness to be promoted to a higher stream led the high informal status boys to depress their performance in examinations. This fear of promotion adds to our list of factors leading to the formation of anti-academic attitudes among low stream boys.

Observations and interviews in the two American schools we studied confirmed a similar polarization and reluctance by noncollege prep students to pursue the academic goals rewarded by teachers and college prep students. Teachers, however, seldom saw the antischool attitudes of noncollege prep students as arising out of the tracking system—or anything else about the school—but out of adverse home influences, limited intelligence or psychological problems.

Implications. These, then, are some of the ways the schools we studied contributed to the greater rates of failure, academic decline, uninvolvement in school activities, misbehavior and delinquency among non-college-bound students. We can only speculate, of course, about the generalizability of these findings to other schools. However, there is little reason to think that the two schools we studied were unusual or unrepresentative and, despite differences in size and social class composition, the findings are virtually identical in both—and are consistent with the speculations, criticisms and unsystematic observations of numerous writers. To the extent the findings are valid and general, they strongly suggest that, through their tracking system, the schools are partly causing many of the very problems they are trying to solve and are posing an important barrier to equal educational opportunity to lower income and black students, who are dispropor-

tionately assigned to the non-college prep track. The notion that schools help cause low achievement, deterioration of educational commitment and involvement, the dropout problem, misbehavior and delinquency is foreign and repulsive to many teachers, administrators and parents. Yet our evidence is entirely consistent with Kai Erikson's observation that "...deviant forms of conduct often seem to derive nourishment from the very agencies devised to inhibit them."

What, then, are the implications from this study? Some might argue that, despite the negative side effects we have shown, tracking systems are essential for effective teaching, especially for students with high ability, as well as for adjusting students early in their careers to the status levels they will occupy in the adult occupational system. We contend that however reasonable this may sound, the negative effects demonstrated here offset and call into serious question any presumed gains from tracking.

Others might contend that the negative outcomes we have documented can be eliminated by raising teachers' expectations of non-college track students, making concerted efforts to reduce the stigma attached to noncollege classes, assigning good teachers to non-college track classes, rewarding them for doing an effective job at turning on their students, and developing fair and equitable grading practices in both college prep and non-college prep classes.

Attractive as they may appear, efforts like these will be fruitless, so long as tracking systems, and indeed schools as we now know them, remain unchanged. What is needed are wholly new, experimental environments of teaching-learning-living, even outside today's public schools, if necessary. Such schools of the future must

address themselves to two sets of problems highlighted by our findings: ensuring equality of opportunity for students now "locked out" by tracking, and offering—to all students—a far more fulfilling and satisfying learning process.

One approach to building greater equality of opportunity, as well as fulfillment, into existing or new secondary schools is the New Careers model. This model, which provides for fundamentally different linkages between educational and occupational careers, is based on the recognition that present options for entering the world of work are narrowly limited: one acquires a high school diploma and goes to work, or he first goes to college and perhaps then to a graduate or professional school. (Along the way, of course, young men must cope with the draft.)

The New Careers model provides for new options. Here the youth who does not want to attend college or would not qualify according to usual criteria, is given the opportunity to attend high school part-time while working in a lower level position in an expanded professional career hierarchy (including such new positions as teacher aide and teacher associate in education). Such a person would then have the options of moving up through progressively more demanding educational and work stages; and moving back and forth between the work place, the high school and then the college. As ideally conceived, this model would allow able and aspiring persons ultimately to progress to the level of the fully certified teacher, nurse, librarian, social worker, or public administrator. While the New Careers model has been developed and tried primarily in the human service sector of the economy, we have pointed out elsewhere that it is also applicable to the industrial

and business sector as well. (See Walter E. Schafer and
Kenneth Polk, "Delinquency and the Schools," *Task
Force Report: Juvenile Delinquency and Youth Crime:*
The President's Commission on Law Enforcement and
Administration of Justice, U.S. Government Printing
Office, 1967.)

This alternative means of linking education with work
has a number of advantages: students can try different
occupations while still in school; students can earn while
studying; they can spend more time outside the four
walls of the school, learning what can best be learned in
the work place; less stigma will accrue to those not
immediately college-bound, since they too will have a
future; studying and learning will be inherently more
relevant because it will relate to a career in which they
are actively involved; teachers of such students will be
less likely to develop lower expectations because these
youth too will have an unlimited, open-ended future;
and antischool subcultures will be less likely to develop,
since education will not be as negative, frustrating or
stigmatizing.

To ensure equality of opportunity is not enough.
Merely to open the channels for lower income youth to
flow into educational careers that are now turning off
millions of middle class, college-bound youth is hardly
doing anyone a favor. Though not reflected in our data,
many middle class students now find school even less
tolerable than do low income youth. The empty grade-
scrambling, teacher-pleasing and stultifying passivity
such youth must endure stands in greater and greater
contrast to their home and other non-school environ-
ments which usually yield much greater excitement,
challenge and reward. More and more are dropping out
psychologically, turning instead to drugs, apathy or

political activism, often of an unthinking and self-defeating kind.

What is needed, then are entirely new and different models that will assure not only equality of opportunity but also much more in the way of an enriching and rewarding growth process. Educational environments of the future, incorporating New Careers as well as other new forms, must follow several simple guidelines.

First, successful new learning environments must be based on the recognition and acceptance of each individual's uniqueness. Each person must be allowed and stimulated to develop, learn and grow as an individual, not as a standardized occupant of any gross human category. As Kenneth Keniston stated in *The Uncommitted,* "Human diversity and variety must not only be tolerated, but rejoiced in, applauded, and encouraged."

At the beginning, we pointed out that tracking was an educational response to the increased pupil diversity created by pressure on adolescents from employers, parents and educators themselves to stay in school longer. While it may be an efficient way to screen large numbers of youth out of the educational and economic systems, and while it may be bureaucratically convenient, tracking is crude at best and destructive at worst in psychological and educational terms. Predictably, the occupants of the categories created by tracking come to be perceived, treated and taught according to what they are thought to have in common: college material or not college material, bright or not bright, motivated or not motivated, fast or not fast. Yet psychologists of individual differences and learning have told us for years what every parent already knows from common sense and experience: each child is unique in

aptitudes, style of interaction, learning style and rate, energy level, interests, self-attitudes, reactions to challenge and stress, and in countless other ways. New educational environments must be adaptable to these differences.

The second guideline must be that the potential for individual growth and development is virtually unlimited and must be freed and stimulated to develop as fully as possible during each student's lifetime. We must stop assuming human potential is somehow fixed or circumscribed. Tragically, tracking—and indeed the whole structure of schooling—is founded on this premise. George Leonard puts it well in his *Education and Ecstacy:* ". . .the task of *preventing* the new generation from changing in any deep or significant way is precisely what most societies require of their educators." Not surprisingly, then, "The most obvious barrier between our children and the kind of education that can free their enormous potential seems to be the educational system itself: a vast, suffocating web of people, practices, and presumptions, kindly in intent, ponderous in response." In building new environments for becoming—with rich and limitless opportunities for exploration into self and others, other places, times and ideas, and the unknown—educators can play a part in seeing to it that more than today's mere fraction of potential learning and growing is unleashed.

The third guideline must be that "learning is sheer delight," to quote Leonard. For the non-college bound—indeed for the vast majority, including neat and tidy "high achievers"—"schooling" (we can hardly call it learning) is the very opposite. Tragically, Leonard may be all too right: "A visitor from another planet might conclude that our schools are hell-bent on creating—in a

society that offers leisure and demands creativity—a generation of joyless drudges . . .when joy is absent, the effectiveness of the learning process falls and falls until the human being is operating hesitantly, grudgingly, fearfully at only a tiny fraction of his potential." For joy to enter learning, "cognitive learning" must be reunited with affective, physical and behavioral growth. The payoff must be now. Will learning then stop with the diploma?

If new learning-teaching-living environments follow these simple guidelines, not only will the negative effects of tracking be eliminated, but several features of the student role that alienate all types of students can also be avoided: passivity, subordination, forced separation from self, fragmented sequencing of learning, age segregation, isolation from community life with the unrealities of school that follow, an almost exclusive instrumental emphasis on future gains from schooling.

In summary, then, education must afford a chance for every student to experience an individualized, mind-expanding, joy-producing educational process, based on equity of opportunity. But it must do even more. Education must, in the final analysis, address itself to the vital issues of man and his survival. Educators then can take a long step toward preserving life itself.

"Right answers," specialization, standardization, narrow competition, eager acquisition, aggression, detachment from the self. Without them, it has seemed, the social machinery would break down. Do not call the schools cruel or unnatural for furthering what society had demanded. The reason we now need radical reform in education is that society's demands are changing radically. It is quite safe to say that the

human characteristics now being inculcated will not work much longer. Already they are not only inappropriate, but destructive. If education continues along the old tack, humanity sooner or later will simply destroy itself (Leonard.)

We must start now.

October 1970

FURTHER READING:

New Careers for the Poor, by Arthur Pearl and Frank Riessman (New York: Free Press, 1965) presents a thorough and insightful description of the rationale and operation of the New Careers program of job creation and training.

Social Relations in a Secondary School, David H. Hargreaves (New York: Humanities Press, 1967) is an excellent comprehensive study of a Secondary Modern School in England which points up the pervasiveness of tracking (they call it streaming) in molding the structure of social relations in the school.

"Delinquency and the Schools," by Walter E. Schafer and Kenneth Polk, in *Task Force Report: Juvenile Delinquency and Youth Crime* (President's Commission on Law Enforcement and Administration of Justice, 1967), is a comprehensive study of the effect of the schools on delinquency.

Rich Man's Qualifications
for Poor Man's Jobs

IVAR BERG

It is now a well-known fact that America offers more and more jobs to skilled workers while the increase in unskilled jobs has slowed down. Newspaper articles regularly remind us that we have a shortage of computer programmers, and, at the same time, too many unskilled laborers. The conventional solution is to correct the shortcomings of the labor force by educating more of the unemployed. Apart from its practical difficulties, this solution begs the important question: Are academic credentials important for doing the job—or just for getting it?

My studies of manpower use indicate that although in recent years requirements for many jobs have been upgraded because of technological and other changes, in many cases education requirements have been raised arbitrarily. In short, many employers demand too much education for the jobs they offer.

Education has become the most popular solution to America's social and economic ills. Our faith in education as *the* cure for unemployment partly reflects our inclination as a society to diagnose problems in individualistic terms. Both current and classical economic theories merely reinforce these attitudes; both assume that the labor supply can be significantly changed by investments in education and health. Meanwhile private employers, on the other side of the law of supply and demand, are held to be merely reacting to the imperatives that generate the need for better educated manpower.

Certainly the government cannot force private employers to hire people who have limited educations. Throughout our history and supported by our economic theory, we have limited the government's power to deal with private employers. According to law and the sentiments that support it, the rights of property owners and the protection of their property are essential functions of government, and cannot or should not be tampered with. In received economic doctrine, business stands apart as an independent variable. As such, business activity controls the demand for labor, and the best way the government has to reduce unemployment is by stimulating business growth.

Some of the methods the government uses to do this are direct subsidies, depreciation allowances, zoning regulations, fair-trade laws, tax holidays and credit guarantees. In return for these benefits, governments at all levels ultimately expect more jobs will be generated and more people employed. But when the market for labor does not work out according to theory, when employer demand does not increase to match the number of job seekers, attention shifts to the supply of

labor. The educational, emotional, social and even moral shortcomings of those who stand outside the boundaries of the social system have to be eliminated, we are told—and education seems to be the best way of doing it.

Unfortunately, economists and public planners usually assume that the education that employers require for the jobs they offer is altogether beneficial to the firm. Higher education, it is thought, means better performance on the job. A close look at the data, however, shows that here reality does not usually correspond with theory.

In recent years, the number of higher-level jobs has not increased as much as personnel directors lead us to believe. The big increase, rather, has been in middle-level jobs—for high-school graduates and college dropouts. This becomes clear when the percentages of jobs requiring the three different levels of education are compared with the percentages of the labor force that roughly match these categories. The comparison of census data with the U.S. Employment Service's descriptions of 4,000 different jobs also shows that 1) high-education jobs have expanded somewhat faster for men than for women; 2) those jobs in the middle have expanded faster for women than for men; and 3) that highly educated people are employed in jobs that require *less* education than these people actually have.

The fact is that our highly educated people are competing with lesser educated people for the jobs in the middle. In Monroe County, N.Y. (which includes Buffalo), the National Industrial Conference Board has graphically demonstrated this fact. Educational requirements for most jobs, the board has reported, vary with the academic calendar: Thus, requirements rise as the

end of the school year approaches and new graduates flood the market. Employers whose job openings fall in the middle category believe that by employing people with higher-than-necessary educations they are benefiting from the increasing educational achievements of the work force. Yet the data suggests that there is a "shortage" of high-school graduates and of people with post high school educations short of college degrees while there is a "surplus" of college graduates, especially females.

The economic and sociological theories that pour out of university computers have given more and more support to the idea that we, as a society, have more options in dealing with the supply side of employment—with the characteristics of the work force—than with the demand.

These studies try to relate education to higher salaries; they assume that the income a person earns is a valid measure of his job performance. The salaries of better-educated people, however, may not be closely related to the work they do. Female college graduates are often employed as secretaries; many teachers and social workers earn less than plumbers and others who belong to effective unions. What these rate-of-return studies lack is productivity data isolated according to job and the specific person performing the job.

In any event, it is circular reasoning to relate wage and salary data to educational achievements. Education is often, after all, the most important criterion for a person's getting a job in the first place! The argument that salaries may be used to measure the value of education and to measure the "value added" to the firm by employees of different educational backgrounds, may simply confirm what it sets out to prove. In jobs

for which educational requirements have not been thoughtfully studied, the argument is not an argument at all, but a self-fulfilling prophecy.

Despite the many attempts to relate a person's achievements to the wages he receives, researchers usually find that the traits, aptitudes and educational achievements of workers vary as greatly *within* job categories as they do *between* them. That is, people in job A differ as much from one another as they differ from people in job B. Only a small percentage of the labor force—those in the highest and those in the lowest job levels—are exceptions. And once workers become members of the labor force, personal virtues at even the lower job levels do not account for wage differences—intelligent, well-educated, low-level workers don't necessarily earn more than others at the bottom of the ladder. Marcia Freedman's study of employment patterns for Columbia's Conservation of Human Resources project indicates that, although many rungs of the organizational ladder are linked to differences in pay, these rungs are not closely related to differences in the employees' skills and training.

Educational requirements continue to go up, yet most employers have made no effort to find out whether people with better educations make better workers than people with inferior educations. Using data collected from private firms, the military, the federal civil service, and public-educational systems, and some collected from scratch, I have concentrated on this one basic question.

Business managers, supported by government leaders and academics interested in employment problems, have well-developed ideas about the value of a worker's educational achievement. They assert that with each

increment of education—especially those associated with a certificate, diploma or degree, the worker's attitude is better, his trainability is greater, his capacity for adaptation is more developed, and his prospects for promotions are rosier. At the same time, those workers with more modest educations, and especially those who drop out of school, are held to be less intelligent, less adaptable, less self-disciplined, less personable and less articulate.

The findings in my studies do not support these assertions.

A comparison of 4,000 insurance agents in a major company in the Greater New York area showed that an employee's productivity—measured by the dollar value of the policies he sold—did not vary in any systematic way with his years of formal education. In other words, those salesmen with less education brought as much money into the company as their better educated peers. When an employee's experience was taken into account, it was clear that those with *less* education and *more* experience sold the most policies. Thus, even an employer whose success in business depends on the social and psychological intangibles of a customer-client relationship may not benefit from having highly educated employees. Other factors such as the influence of colleagues and family obligations were more significant in explaining the productivity of agents.

In another insurance agency, the job performances of 200 young female clerks were gauged from the number of merit salary increases they had received. Researchers discovered that there were *no* differences in the performance records of these women that could easily be attributed to differences in their educational backgrounds. Once again, focusing on the educational

achievements of job applicants actually diverted attention from characteristics that are really relevant to job performance.

At a major weekly news magazine, the variation in educational achievement among over 100 employees was greater than among the insurance clerks. The magazine hired female college graduates, as well as high school graduates, for clerical-secretarial positions. While the employers argued that the girls needed their college degrees to qualify for future editorial jobs, most editorial positions were *not* filled by former secretaries, whether college graduates or not, but by college graduates who directly entered into those positions. And although the personnel director was skeptical of supervisors' evaluations of the secretaries, the supervisors determined the salary increases, and as many selective merit-pay increases were awarded to the lesser-educated secretaries as to the better-educated secretaries.

Executives of a larger well-known chemical company in New York told me that the best technicians in their research laboratory were those with the highest educational achievement. Therefore, in screening job applicants, they gave greater weight to a person's educational background than to his other characteristics. Yet, statistical analysis of relevant data revealed that the rate of turnover in the firm was positively associated with the employees' educational achievement. And a close look at the "reasons for leaving" given by the departing technicians showed that they intended to continue their educations. Furthermore, lesser-educated technicians earned higher performance evaluations than did their better-educated peers. Understandably, the employer was shocked by these findings.

The New York State Department of Labor's 1964 survey of employers suggests that technicians often possess educational achievements far beyond what employers themselves think is ideal for effective performance. Thousands of companies reported their minimal educational requirements to the Labor Department, along with their ideal requirements and the actual educators of the technicians they employed. In many industries and in respect to most types of technicians, the workers were better educated than they were required to be; in 10 out of 16 technical categories they were even better educated than their employers dared hope, exceeding the "ideal" requirements set down by the employers.

Upper- and middle-level employees are not the only ones who are overqualified for their jobs. Nor is the phenomenon only to be observed in metropolitan New York. In a study of eight Mississippi trouser plants, researchers found that the more education an employee had, the less productive she was. Several hundred female operators were paid by "piece work" and their wages therefore were a valid test of workers' productivity. Furthermore this study showed that educational achievement was positively associated with turnover: The better-educated employee was more likely to quit her job.

Education's negative relationship to jobs can be measured not only by the productivity and turnover of personnel, but also by worker satisfaction. It may be argued that dissatisfaction among workers leads to a desirable measure of labor mobility, but the funds a company spends to improve employee morale and make managerial personnel more sensitive to the needs of their subordinates strongly suggest that employers are

aware of the harm caused by worker dissatisfaction. Roper Associates once took a representative sample of 3,000 blue-collar workers in 16 industries in all parts of the United States. Among workers in lower-skilled jobs, dissatisfaction was found to increase as their educational achievements increased.

These studies of private firms suggest that many better-educated workers are assigned to jobs requiring low skills and that among the results are high turnover rates, low productivity and worker dissatisfaction. Nonetheless, the disadvantages of "overeducation" are best illustrated by employment practices of public-school systems.

Many school districts, to encourage their teachers to be highly educated, base teachers' salaries upon the number of credits they earn toward higher degrees. However, data from the National Opinion Research Center and the National Science Foundation's 1962 study of 4,000 teachers show that, like employees elsewhere, teachers become restless as their educational achievements rise. Elementary and secondary school teachers who have master's degrees are less likely to stay in their jobs than teachers with bachelor's degrees. And in a similar study done by Columbia Teachers College, it was evident that teachers with master's degrees were likely to have held jobs in more than one school system.

Thus, for school systems to tie pay increases to extra credits seems to be self-defeating. Teachers who earn extra credits apparently feel that their educational achievements reach a point beyond which they are overtrained for their jobs, and they then want to get administrative jobs or leave education for better paying jobs in industry. The school districts are, in a sense, encouraging teachers not to teach. This practice impedes

the upgrading of teacher qualifications in another way. Thanks to the extra-credit system, schools of education have a steady supply of students and therefore are under little pressure to furnish better and more relevant courses.

For the most part, though, employers in the public sector do not suffer from problems of unrealistic educational requirements. For a variety of reasons, they do not enjoy favored positions in the labor market and consequently have not been able to raise educational requirements nearly so fast as the private employer has. But for this reason alone, the experiences of government agencies are significant. How well do their employees with low-education backgrounds perform their jobs?

The pressure on the armed forces to make do with "what they get" has forced them to study their experiences with personnel. Their investigations clearly show that a person's educational achievement is not a good clue to his performance. Indeed, general tests developed for technical, military classifications and aptitude tests designed to screen individual candidates for training programs have turned out to be far better indicators of a person's performance.

In a 1948 study of Air Force personnel, high-school graduates were compared with nongraduates in their performance on the Army Classification Tests and on 13 tests that later became part of the Airman Classification Battery. The military's conclusion: "High-school graduates were not uniformly and markedly superior to non-graduates. . . .High-school graduation, unless supplemented by other screening measures such as tests or the careful review of the actual high-school record, does not insure that a basic trainee will be of high potential usefulness to the Air Force."

In 1963, the Air Force studied 4,458 graduates of eight technical courses. Comparing their performances in such courses as Reciprocating Engine Mechanic, Weather Observer, Accounting, and Finance Specialist with the education they received before entering the service, the Air Force found that a high-school diploma only modestly predicted the grades the airmen got in the Air Force courses. In other Air Force studies, aptitude tests were consistently found to correlate well with a person's proficiency and performance, while educational achievement rarely accounted for more than 4 percent of the variations.

These Air Force data do not conclude that education is unimportant, or that formal learning experiences are irrelevant. Rather, it points out the folly of confusing a man's driver's license with his driving ability. Just as different communities have different safety standards, so schools and school systems employ different kinds of teachers and practices. It should surprise no one that a person's credentials, by themselves, predict his performance so poorly.

Army and Navy studies confirm the Air Force findings. When 415 electronic technicians' scores on 17 concrete tasks were analyzed in conjunction with their age, pay grades and education, education was found to be negatively associated with performance. When the Navy updated this study, the outcome was the same. For high performance in repairing complicated electronic testing equipment, experience proved more significant than formal education.

Perhaps the military's most impressive data came from its experiments with "salvage" programs, in which illiterates and men who earn low scores on military classification tests are given remedial training. According

to research reports, these efforts have been uniformly successful—as many graduates of these programs develop into useful servicemen as the average, normal members of groups with which they have been regularly compared.

In a 1955 study done for the Navy, educational achievements were not found to be related to the performance of 1,370 recruits who attended "recruit preparatory training" courses. Neither were educational achievements related to the grades the recruits received from their company commanders and their instructors, nor to their success or failure in completing recruit training. In some instances, the low-scoring candidates with modest educational backgrounds performed at higher levels than better-educated men with high General Classification Test scores. The military recently expanded its "salvage" program with Project 100,000, and preliminary results tend to confirm the fact that training on the job is more important than educational credentials.

Military findings also parallel civilian studies of turnover rates. Reenlistment in the Navy is nearly twice as high among those men who have completed fewer than 12 years of school. But reenlistment in the military, of course, is related to the fact that the civilian economy does not particularly favor ex-servicemen who have modest educational achievements.

Wartime employment trends make the same point. During World War II, when demand for labor was high, both public and private employers adapted their recruiting and training to the labor supply. Productivity soared while a wide range of people mastered skills almost entirely without regard to their personal characteristics or previous circumstances. Labor's rapid adjustment on

the job was considered surprising; after the war, it was also considered to be expensive. Labor costs, it was argued, had gone up during the war, and unit productivity figures were cited as evidence. These figures, however, may have been misleading. Since the majority of wartime laborers were employed in industries with "cost-plus" contracts—where the government agreed to reimburse the contractor for all costs, plus a certain percentage of profit—such arrangements may have reduced the employer's incentives to control costs. The important lesson from the war period seems to be that people quickly adjust to work requirements once they are on the job.

A 5 percent sample of 180,000 men in the federal civil service shows that while the number of promotions a person gets is associated with his years of education, the link is far from complete. Education has a greater bearing on a person's rank at entry into the civil service than on his prospects for a promotion. Except for grades 11-15, in accounting for the promotion rates of civil servants, length of service and age are far more significant than education. A closer look at one government agency will perhaps clarify these points.

Few organizations in the United States have had to adapt to major technological changes as much as the Federal Aviation Agency has. Responsible among other things for the direction and control of all flights in the United States, it operates the control-tower facilities at all public airports. With the advent of jet-powered flights, the F.A.A. had to handle very quickly the horrendous technical problems posed by faster aircraft and more flights. Since no civilian employer requires the services needed by the F.A.A. in this area, the agency must train its own technicians and control-tower people.

The agency inventively confronted the challenge by hiring and training many new people and promoting those trained personnel it already had. Working with the background data on 507 men--all the air-traffic controllers who had attained grade 14 or above—it would seem that, at this high level, education would surely prove its worth.

Yet in fact these men had received very little formal education, and almost no technical managerial training except for the rigorous on-the-job training given by the F.A.A. itself. Of the 507 men in the sample, 211, or 42 percent, had no education or training beyond high school. An additional 48, or 10 percent, were high-school graduates who had had executive-training courses. Thus, more than half of the men had had no academic training beyond high school. There were, however, no patterns in the differences among the men in grades 13 or 15 with respect to education. That is, education and training were *not* related to the higher grade.

The F.A.A.'s amazing safety record and the honors and awards given to the tower controllers are good indicators of the men's performance. The F.A.A.'s Executive Selection and Inventory System records 21 different kinds of honors or awards. Only one-third of the men have never received any award at all. Half of the 77 percent who have been honored have been honored more than once. And a relatively high percentage of those with no education beyond high school received four or more awards; those with a B.A. degree were least likely to receive these many honors. Other breakdowns of the data confirm that education is not a factor in the daily performance of one of the truly demanding decision-making jobs in America.

The findings reported in these pages raise serious questions about the usefulness of raising educational requirements for jobs. They suggest that the use of formal education as a sovereign screening device for jobs adequately performed by people of lower educational achievements may result in serious costs—high turnover, employee dissatisfactions, and poorer performance. Programs calculated to improve employees' educations probably aim at the wrong targets, while programs calculated to reward better-educated people are likely to miss their targets. It would be more useful to aim at employers' policies and practices that block organizational mobility and seal off entry jobs.

Given the facts that there are more job openings in the middle, and that many people are overqualified for the jobs they do have, policies aimed at upgrading the educational achievements of the low-income population seem at best naïve. It would make better sense to upgrade people in the middle to higher jobs and upgrade those in lower-level jobs to middle positions, providing each group with an education appropriate to their age, needs and ambitions. The competition for lower-level jobs would then be reduced, and large numbers of drop-outs could move into them. (Only after young people, accustomed to a good income, develop middle-class aspirations are they apparently interested in pursuing the balance of their educations.) Current attempts to upgrade the labor supply also seem questionable in light of what psychologists and sociologists have to say. Changing people's attitudes, self-images and achievements is either enormously time-consuming—sometimes requiring half a generation—or it is impossible. At any rate, it is always risky.

If the much-maligned attitudes of low-income Americans were changed without establishing a full-employment economy, we might simply be adding fuel to the smoldering hatreds of the more ambitious, more frustrated groups in our urban ghettos. And if we wish to do something about the supposed shortcomings in the low-income Negro families, it will clearly require changes in those welfare arrangements that now contribute to family dissolution. The point is that rather than concentrate on the supply of labor, we must reconsider our reluctance to alter the demand for labor. We must have more realistic employment requirements.

Unfortunately, attempts to change people through education have been supported by liberal-intellectuals who place great value upon education and look appreciatively upon the economic benefits accruing to better educated Americans. Indeed, one of the few elements of consensus in present-day American politics may well be the reduction of the gap between the conservative and liberal estimate of the worth of education.

Obviously, the myths perpetuated about society's need for highly-educated citizens work to the disadvantage of less-educated people, particularly nonwhites who are handicapped whatever the state of the economy. Information obtained by economist Dale Hiestand of Columbia does not increase one's confidence that educational programs designed to help disadvantaged people over 14 years old will prove dramatically beneficial. Hiestand's studies show that even though the best-educated nonwhites tend to have more job mobility, they are more likely to enter occupations that are vacated by whites than to compete with whites for new jobs. Since the competition for middle-education jobs is

already very intense, it will be difficult to leapfrog
Negroes into jobs not yet vacated by whites, or into new
jobs that whites are likely to monopolize.

Now, nothing in the foregoing analysis should be
construed as suggesting that education is a waste of
time. Many jobs, as was stated at the outset, have
changed, and the need for education undoubtedly grows
quite aside from the monetary benefits individuals
derive from their educations. But I think it is fundamen-
tally subversive of education and of democratic values
not to see that, in relation to jobs, education has its
limits.

As the burden of evidence in this chapter suggests,
the crucial employment issue is not the "quality of the
work force." It is the overall level of employment and
the demand for labor in a less than full-employment
economy.

March 1969

About the Authors

George W. Albee ("A Revolution in Treatment of the Retarded") is a professor of psychology at Case Western Reserve University. Albee was a past director of the Task Force on Manpower of the Joint Commission on Mental Illness and Health.

Ivar Berg ("Rich Man's Qualifications for Poor Man's Jobs") is Associate Dean of Faculties and a professor at Columbia University. Berg has written or edited numerous publications in the area of business and its administration.

David Buckholdt ("Changing the Game from 'Get the Teacher' to 'Learn' ") is associate director of the Central Midwestern Regional Educational Laboratories. Buckholdt does experiments in the public schools with hyperaggresive and environmentally retarded children in the ghetto.

Donald Bushell ("Changing the Game from 'Get the Teacher' to 'Learn' ") is an assistant professor of sociology at the University of Kansas.

Mihaly Csikszentmihaly ("The Creative Artist as an Explorer") is an author of short stories and essays and translator of fiction and poetry. He is associate professor in the Committee on Human Development and in the College at the University of Chicago.

Desmond Ellis ("Changing the Game from 'Get the Teacher' to 'Learn' ") is an assistant professor of sociology at the University of North Carolina.

Daniel Ferritor ("Changing the Game from 'Get the Teacher' to 'Learn' ") is associate director of the Central Midwestern Regional Educational Laboratories. He conducts experiments with autistic children.

Estelle Fuchs ("How Teachers Learn to Help Children Fail") is a professor in the department of educational foundations, Hunter College of the City University of New York. Recent publications include studies of teachers in city schools, the Danish free schools and American Indians at school.

281

Jacob W. Getzels ("The Creative Artist as an Explorer") is R. Wendell Harrison Distinguished Service Professor in the departments of education and psychology at the University of Chicago. He has published extensively on creative thinking and on organizational behavior.

Robert V. Hamblin ("Changing the Game from 'Get the Teacher' to 'Learn' ") is a professor of sociology and psychology at the University of Arizona. He is completing work on *The Humanization Process: A Social Exchange Analysis of Children's Acculturation Problems* and *Foundations of a New Social Science*.

Jules Henry ("Of Achievement, Hope, and Time in Poverty") authored *Culture Against Man*. He was a professor of anthropology at Washington University.

Jerry Hirsch ("Genetics and Competence: Do Heritability Indices Predict Educability?") is professor of psychology and zoology, University of Illinois, Champaign. He is American editor of *Animal Behaviour*.

John L. Horn ("Intelligence—Why It Grows, Why It Declines") is the author of articles on the development and assessment of personality and intelligence, and abnormal and social psychology. He is professor of psychology at the University of Denver, Denver, Colorado.

J. McVicker Hunt ("The Role of Experience in the Development of Competence") is professor of psychology and of elementary education at the University of Illinois. (For more detail see the cover.)

Carol Olexa ("Programmed for Social Class: Tracking in High School") is a faculty member at Evergreen State College, Olympia, Washington. She is the co-author, with Walter E. Schaefer, of *Tracking and Opportunity*.

Kenneth Polk ("Programmed for Social Class: Tracking in High School") is principal investigator, Marion County (Oregon) Youth Study. Polk is an associate professor of sociology at the University of Oregon.

Ray C. Rist ("The Self-Fulfilling Prophecy in Ghetto Education") is an assistant professor of sociology, Portland State University.

He has publications in urban education, black studies, Canadian public housing, poverty and pornography.

Walter E. Schaefer ("Programmed for Social Class: Tracking in High School") is associate professor of sociology and of the School of Community Service and Public Affairs, University of Oregon.

Karl E. Taeuber ("The Demographic Context of Metropolitan Education") is professor of sociology at the University of Wisconsin. He is co-author of *Negroes in Cities: Residential Segregation and Neighborhood Change*.

Michael A. Wallach ("Creativity and Intelligence in Children") is professor of psychology at Duke University and editor of the *Journal of Personality*. His most recent articles consider the subjects of the talented student and creativity.